TOOTS™

"Think out of the Square"

www.tootsbooks.com

Murray Books

TOOTS ™

"Think out of the Square"

www.tootsbooks.com

MUSIC

MUSIC

TOOTS™

"Think out of the Square"

First published in 2007
by Murray Books (Australia)
Reprinted in 2008
This edition printed in 2011
www.murraybooks.com

ISBN: 978-0-9803829-2-1

Design and Production: Peter Murray

Author: Peter Murray

All images: Getty Images

INSIDE

THE BIRTH OF ROCK 'N' ROLL

Music has always transported me to a place and time. I simply needs to hear a song from any decade and can immediately place myself within the period. Its a wonderful thing.

My introduction to music was in the early sixties when the airwaves were filled with the soulful sounds of the Mills Brothers, Nat King Cole and the instrumental talents of Acker Bilk and the Shadows. The middle of this decade saw the introduction of Rock 'n' Roll with Elvis, Bill Hayley and the Comets and several other golden oldies who changed music styles forever. The Beatles came along in the late sixties and with them we saw the rise and rise of hundreds of new artists who forced a change in the style and direction of music that for me, was remarkable, and it saw me enter a new phase of my personal life when I decided to be a part of this exciting period.

In the early seventies, I played in many bands and toured as a bass player, singer and guitarist. It was a wonderful journey that eventually took me around the world and back again. I eventually settled down to become a disco disc-jockey.

This book is not an encyclopedia of music through the ages, it is a record of the music that made an impression on me over four decades – from the sixties to the nineties. It has been impossible to include every major artist in these pages but plans are already underway to release 'Music That Rocked The World 2' as well as a book totally devoted to R&B.

With the birth of Rock 'n' Roll, popular culture was changed completely. Before the 'rebellious' sounds of Bill Haley and the Comets, Buddy Holly or Elvis Presley, the music scene was far more conventional – as was the lifestyle. Activities such as unwed sexual relations, motorcycle rides and certain types of dancing were socially prohibited. Middle-class white society prospered, resigned, self-satisfied and suspicious of its neighbours – particularly its black neighbours.

Rhythm and blues music dominated the American south and targeted a black audience in the late 1940s. The catchy tunes and suggestive lyrics were thought improper in the mainstream,

until white entertainers began to cover rhythm and blues songs. During the 1950s the term rock and roll was actually a synonym for black R&B music. Rock 'n' roll was first released by small, independent record companies and promoted by radio disc jockeys like Alan Freed, who used the term rock 'n' roll to help attract white audiences unfamiliar with black music. Indeed, the appeal of rock 'n' roll to white middle-class teenagers was immediate and caught the major record companies by surprise. The new genre was a combination of rhythm and blues, known as jump blues, the gospel-influenced vocal-group style known as doo wop, the piano-blues style known as boogie-woogie (or barrelhouse), and the country-music style known as honky tonk.

The post-war prosperity experienced in most western societies also contributed to the popularity of rock 'n' roll. Suddenly, teenagers had more money and leisure time and marketers began to target their susceptibility. Movies such as The Wild One, Rebel Without a Cause and Blackboard Jungle were made for a teenage audience and promoted the non-compliance of rock music. The most successful rock 'n' roll artists wrote and performed songs about love, sexuality, identity crises, personal freedom, and other issues that were of particular interest to teenagers.

Technological impacts were also a major influence. In 1951 the colour television was introduced to American families, car radios became common place and portable transistor radios were very popular. Musically, technology also opened new doors with the invention of the electric guitar and electric bass guitar as well as amplifiers.

The group Bill Haley and the Comets had the first big rock 'n' roll hit with the song 'Rock Around the Clock' in 1955 and many would follow. However, the golden age of rock and roll only lasted five years, from 1955 to 1959. It is exemplified by the recordings of Chuck Berry, Elvis Presley, Little Richard, and Buddy Holly.

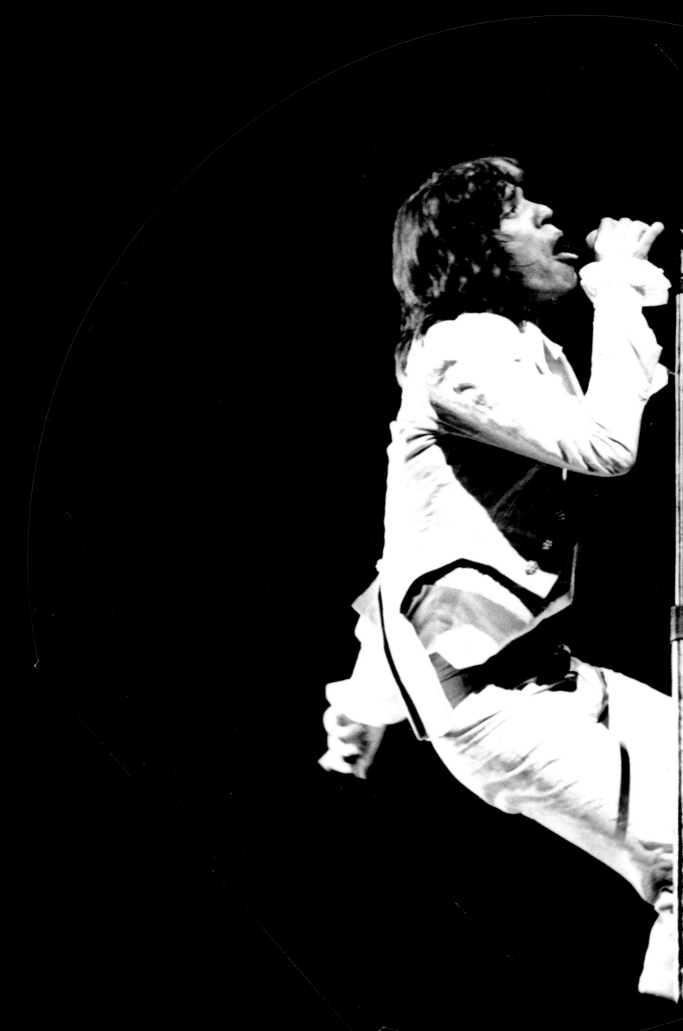

By the early 1960s, the popular music industry was assembling professional songwriters, hired studio musicians, and teenage crooners to mass-produce songs that imitated late-1950s rock and roll.

The Facts

• March 21, 1952 – the rock 'n' roll frenzy officially begins when a riot breaks out at Alan Freed's concert event, the Moondog Coronation Ball.

• September 1952 – American Bandstand is broadcast for the first time. It is originally called 'Bob Horn's Bandstand'.

• 1954 – The term rock 'n' roll is first used at a concert promoted by Alan Freed known as the Rock 'n' Roll Jubilee. Freed tries to copyright the term but is denied.

• July 1955 – The first rock 'n' roll song (Rock Around the Clock by Bill Haley and the Comets) makes it to number 1 on the charts. It stays there for eight weeks.

• April 1956 – Heartbreak Hotel reaches number 1. It is the first hit for Elvis Presley. Hollywood realises the popularity of rock 'n' roll and releases the music related movies: Don't Knock the Rock, The Girl Can't Help It, Rock Around the Clock, Shake Rattle and Rock!, Rock Pretty Baby and Love Me Tender.

• 1957 – Buddy Holly gains international attention with his hit 'That'll be the day'.

• February 3, 1959 – Buddy Holly, Ritchie Valens and The big Bopper are killed in a plane crash.

Over 50 percent of all chart records are rock related.

Music during the 1960s was dominated by psychedelic rock from artists such as The Doors, Jimmy Hendrix and The Who. The youth at the time were often referred to as hippies who characteristically rejected materialism and authority, protested against the Vietnam War, supported the civil rights movement, dressed unconventionally, and experimented with sex and illicit drugs.

The Woodstock Festival was a defining event for the late 1960s and early 70s and celebrated peace and the music of the era. Taking place near Woodstock, New York, on August 15, 16, and 17, 1969, it became a symbol of the 1960s American counterculture and a milestone in the history of rock music. Woodstock was devised by Michael Lang, then the manager of a rock band, an executive at Capitol Records; and two venture capitalists, John Roberts and Joel Rosenman. Their original plan was to build a recording studio in Woodstock, a small town in the Catskill Mountains, a music resort and artists' colony. It housed a year-round recording artists lived in the area such as campuses for art students and many Bob Dylan and The Band. The Woodstock Music and Art Fair was organised to promote the idea of the new recording studio. The music festival was expected to attract 50,000 to 100,000 people but eventually it was clear that the audience was going to be much larger.

Traffic jams kilometres long blocked most roads leading to the area as the festival began. It was decided that admission fees would be too hard to monitor with people constantly leaving and returning to the festival, so they were dropped. Crowds were so large that helicopters had to fly in food and medical supplies as blocked traffic routes made access the farm impossible. Many of the musical acts had to be dropped in by helicopters because of the same problem.

The world's greatest event making it a monumental experience. Performers included Creedence Clearwater Revival, Joe Cocker, Grateful Dead, Ravi Shankar Stills Nash and Young, Crosby and Janis Joplin. Jimi Hendrix was the final act of the festival; he played a solo guitar rendition of 'The Star Spangled Banner.'

Creedence Clearwater Revival ▲

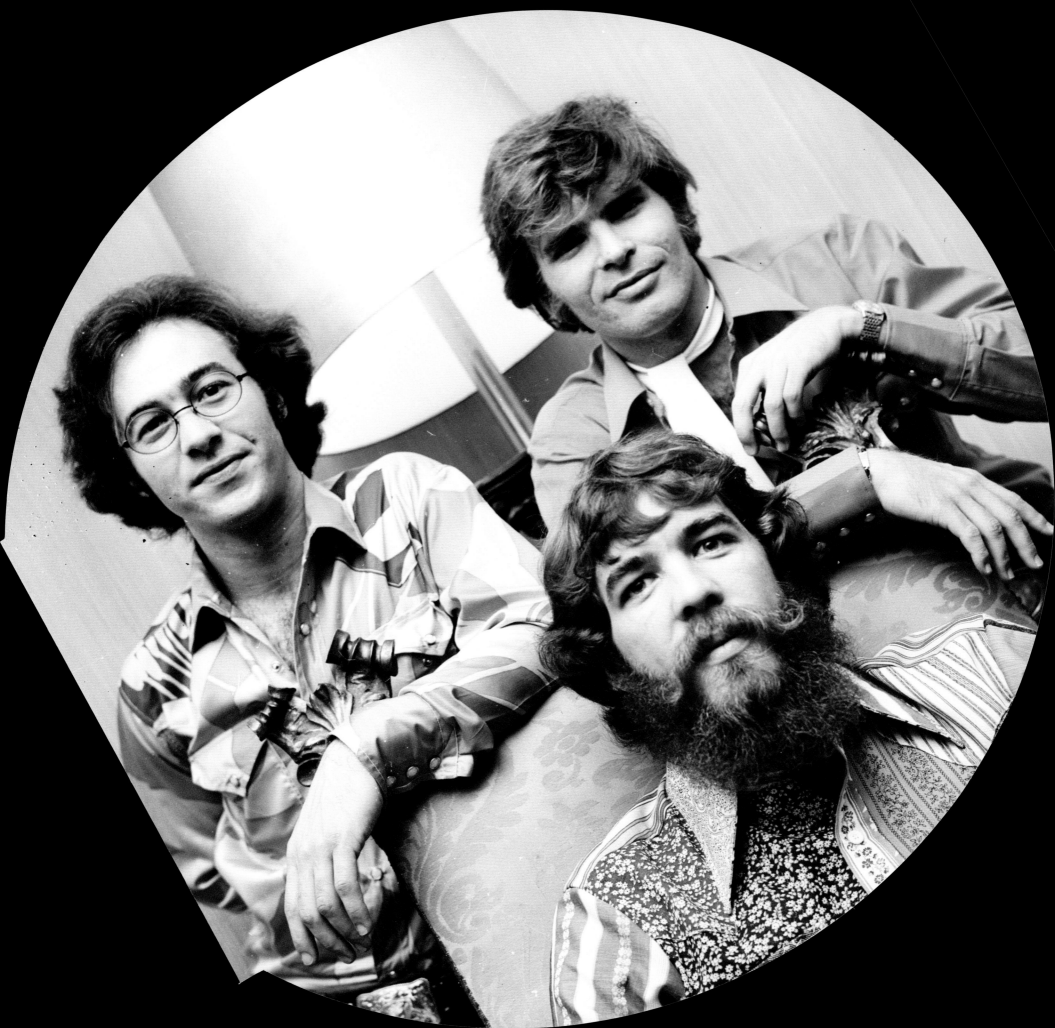

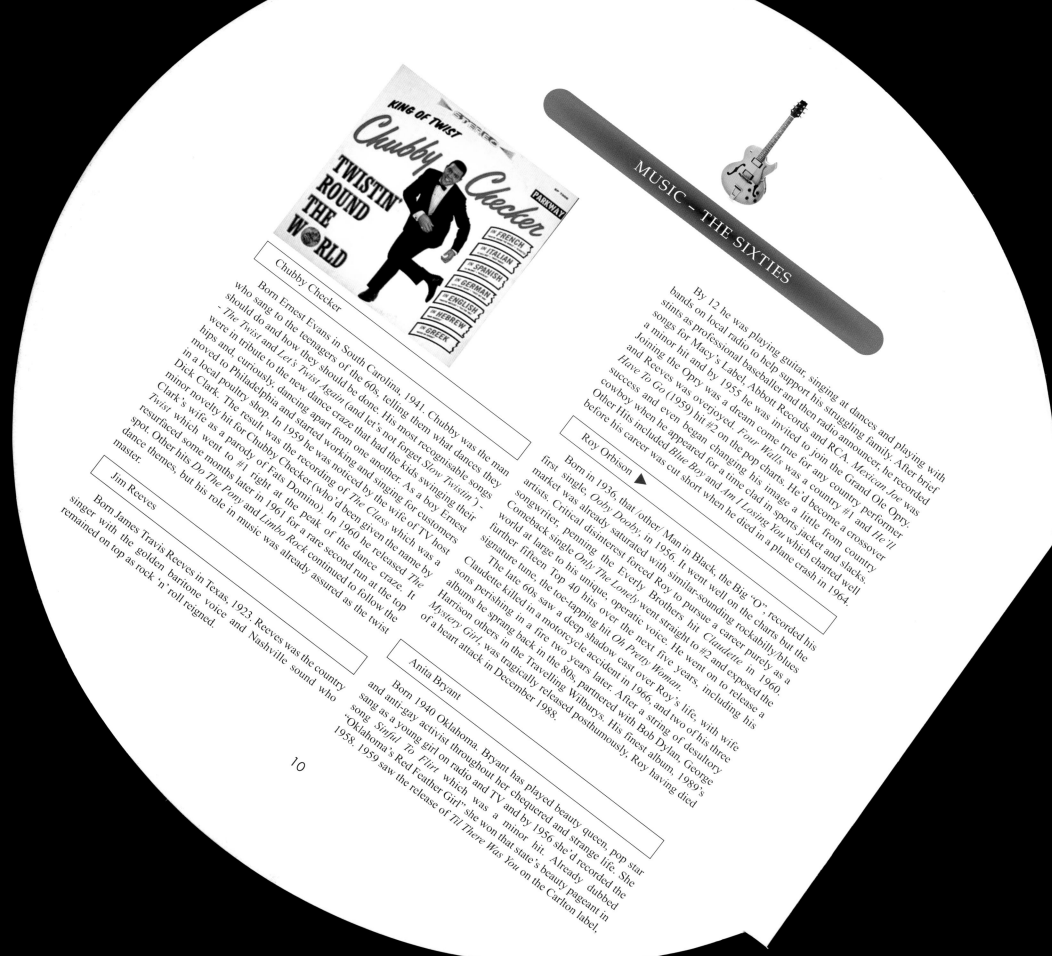

Chubby Checker

Born Ernest Evans in South Carolina, 1941. Chubby was the man who sang to the teenagers of the 60s, telling them what dances they should do and how they should be done. His most recognisable songs - *The Twist* and *Let's Twist Again* (and let's not forget *Slow Twistin'*) - were in tribute to the new dance craze that had the kids swinging their hips and, curiously, dancing apart from one another. As a boy Ernest moved to Philadelphia and started working and singing for customers in a local poultry shop. In 1959 he was noticed by the wife of TV host Dick Clark. The result was the recording of *The Class* which was a minor novelty hit for Chubby Checker (who'd been given the name by Clark's wife as a parody of Fats Domino). In 1960 he released *The Twist* which went to #1 right at the peak of the dance craze. It resurfaced some months later in 1961 for a rare second run at the top spot. Other hits *Do The Pony* and *Limbo Rock* continued to follow the dance themes, but his role in music was already assured as the twist master.

Jim Reeves

Born James Travis Reeves in Texas, 1923. Reeves was the country singer with the golden baritone voice and Nashville sound who remained on top as rock 'n' roll reigned.

By 12 he was playing guitar, singing at dances and playing with bands on local radio to help support his struggling family. After brief stints as professional baseball and then radio announcer, he recorded songs for Macy's Label. Abbott Records and RCA. *Mexican Joe* was a minor hit and by 1955 he was invited to join the Grand Ole Opry. Joining the Opry was a dream come true for any country performer and Reeves was overjoyed. *Four Walls* was a country #1 and *He'll Have To Go* (1959) hit #2 on the pop charts. He'd become a crossover success and even began changing his image a little from country cowboy when he appeared for a time clad in sports jacket and slacks. Other Hits included *Blue Boy* and *Am I Losing You* which charted well before his career was cut short when he died in a plane crash in 1964.

Roy Orbison ▲

Born in 1936, that /other/ Man in Black, the Big "O", recorded his first single, *Ooby Dooby*, in 1956. It went well on the charts but the market was already saturated with similar-sounding rockabilly/blues artists. Critical disinterest forced Roy to pursue a career purely as a songwriter, penning the Everly Brothers hit *Claudette* in 1960. Comeback single *Only The Lonely* went straight to #2 and exposed the world at large to his unique, operatic voice. He went on to release a further fifteen Top 40 hits over the next five years, including his signature tune, the toe-tapping hit *Oh Pretty Woman*.

The late 60s saw a deep shadow cast over Roy's life, with wife Claudette killed in a motorcycle accident in 1966, and two of his three sons perishing in a fire two years later. After a string of desultory albums he sprang back in the 80s, partnered with Bob Dylan, George Harrison others in the Travelling Wilburys. His finest album, 1989's *Mystery Girl*, was tragically released posthumously. Roy having died of a heart attack in December 1988.

Anita Bryant

Born 1940 Oklahoma. Bryant has played beauty queen, pop star and anti-gay activist throughout her chequered and strange life. She sang as a young girl on radio and TV and by 1956 she'd recorded the song *Sinful To Flirt* which was a minor hit. Already dubbed "Oklahoma's Red Feather Girl" she won that state's beauty pageant in 1958. 1959 saw the release of *Til There Was You* on the Carlton label.

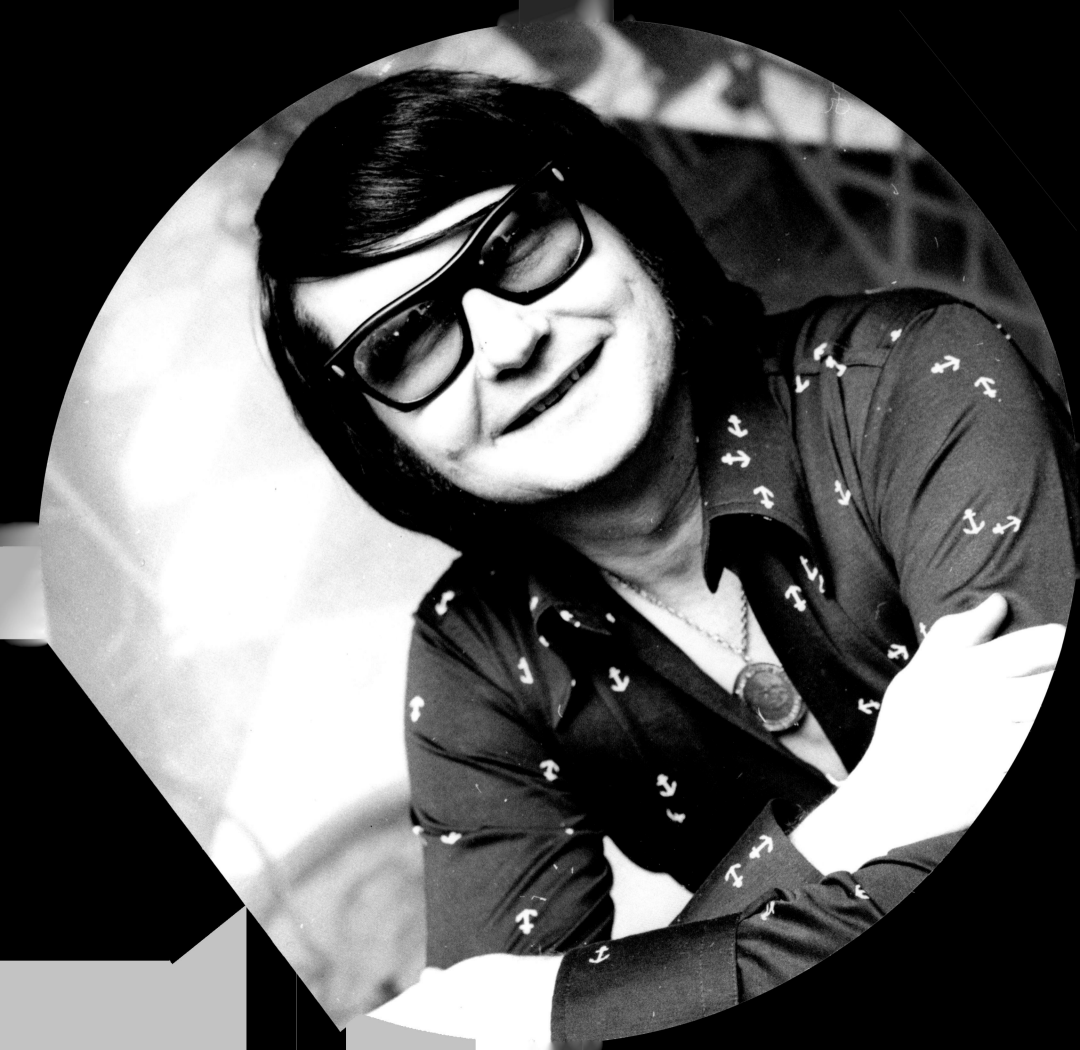

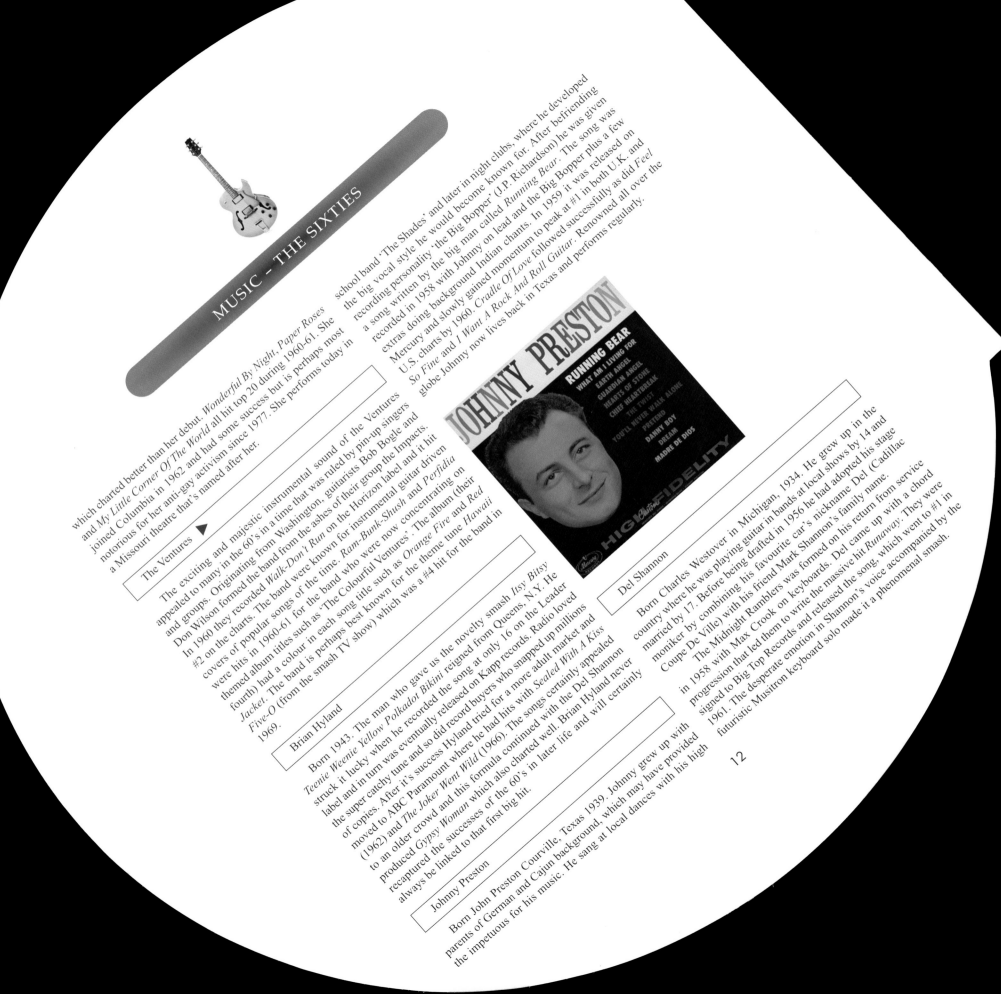

which charted better than her debut. *Wonderful By Night, Paper Roses* and *My Little Corner Of The World* all hit top 20 during 1960-61. She joined Columbia in 1962 and had some success but is perhaps most notorious for her anti-gay activism since 1977. She performs today in a Missouri theatre that's named after her.

The Ventures ▶

The exciting and majestic instrumental sound of the Ventures appealed to many in the 60's in a time that was ruled by pin-up singers and groups. Originating from Washington, guitarists Bob Bogle and Don Wilson formed the band from the ashes of their group the Impacts. In 1960 they recorded *Walk-Don't Run* on the Horizon label and it hit #2 on the charts. The band were known for instrumental guitar driven covers of popular songs of the time. *Ram-Bunk-Shush* and *Perfidia* were hits in 1960-61 for the band who were now concentrating on themed album titles such as 'The Colourful Ventures'. The album (their fourth) had a colour in each song title such as *Orange Fire* and *Red Jacket*. The band is perhaps best known for the theme tune *Hawaii Five-O* (from the smash TV show) which was a #4 hit for the band in 1969.

Brian Hyland

Born 1943. The man who gave us the novelty smash *Itsy Bitsy Teenie Weenie Yellow Polkadot Bikini* reigned from Queens, N.Y. He struck it lucky when he recorded the song at only 16 on the Leader label and in turn was eventually released on Kapp records. Radio loved the super catchy tune and so did record buyers who snapped up millions of copies. After it's success Hyland tried for a more adult market and moved to ABC Paramount where he had hits with *Sealed With A Kiss* (1962) and *The Joker Went Wild* (1966). The songs certainly appealed to an older crowd and this formula continued with the Del Shannon produced *Gypsy Woman* which also charted well. Brian Hyland never recaptured the successes of the 60's in later life and will certainly always be linked to that first big hit.

school band 'The Shades' and later in night clubs, where he developed the big vocal style he would become known for. After befriending recording personality 'the Big Bopper' (J.P. Richardson) he was given a song written by the big man called *Running Bear*. The song was recorded in 1958 with Johnny on lead and the Big Bopper plus a few extras doing background Indian chants. In 1959 it was released on Mercury and slowly gained momentum to peak at #1 in both U.K. and U.S. charts by 1960. *Cradle Of Love* followed successfully as did *Feel So Fine* and *I Want A Rock And Roll Guitar*. Renowned all over the globe Johnny now lives back in Texas and performs regularly.

Del Shannon

Born Charles Westover in Michigan, 1934. He grew up in the country where he was playing guitar in bands at local shows by 14 and married by 17. Before being drafted in 1956 he had adopted his stage moniker by combining his favourite car's nickname Del (Cadillac Coupe De Ville) with his friend Mark Shannon's family name. The Midnight Ramblers was formed on his return from service in 1958 with Max Crook on keyboards. Del came up with a chord progression that led them to write the massive hit *Runaway*. They were signed to Big Top Records and released the song, which went to #1 in 1961. The desperate emotion in Shannon's voice accompanied by the futuristic Musitron keyboard solo made it a phenomenal smash.

Johnny Preston

Born John Preston Courville, Texas 1939. Johnny grew up with parents of German and Cajun background, which may have provided the impetuous for his music. He sang at local dances with his high

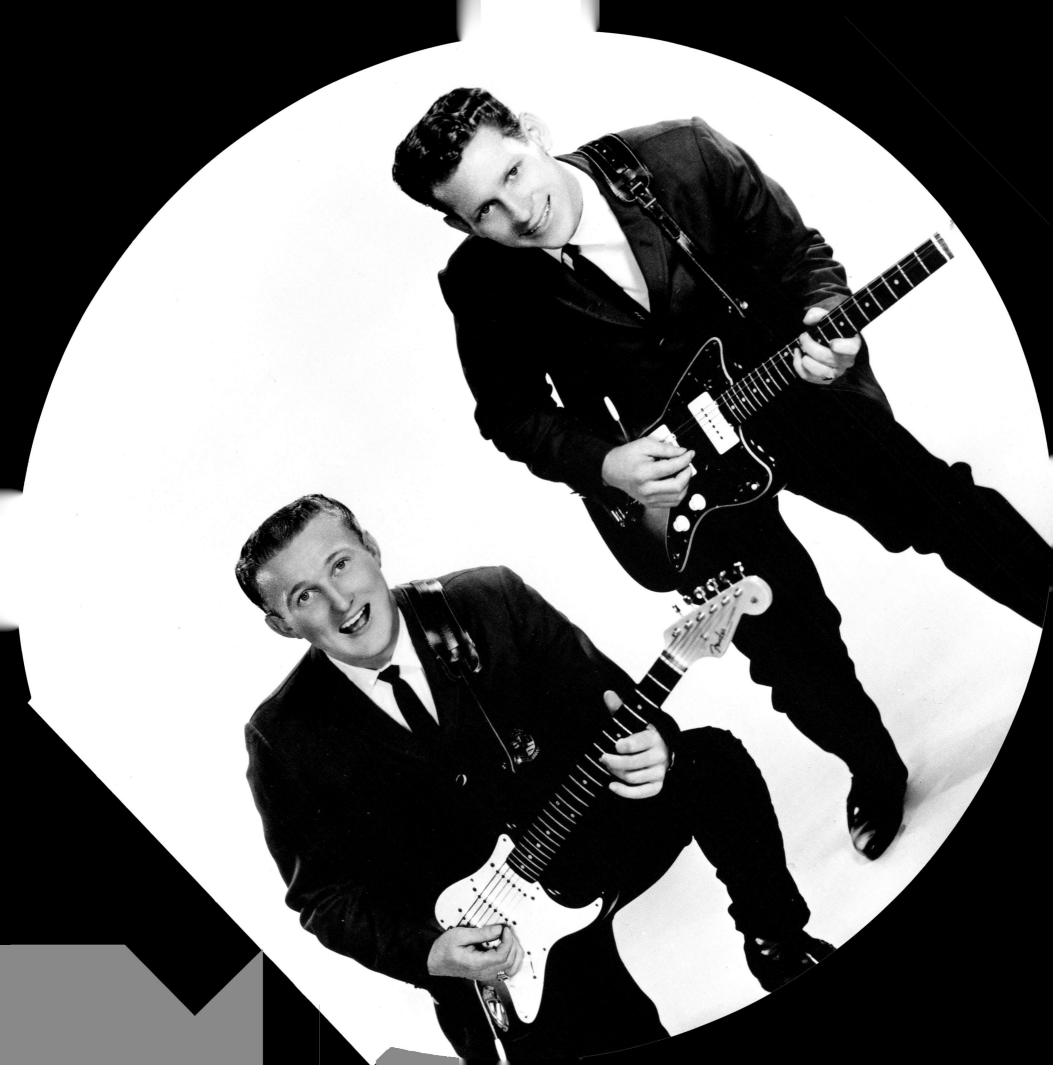

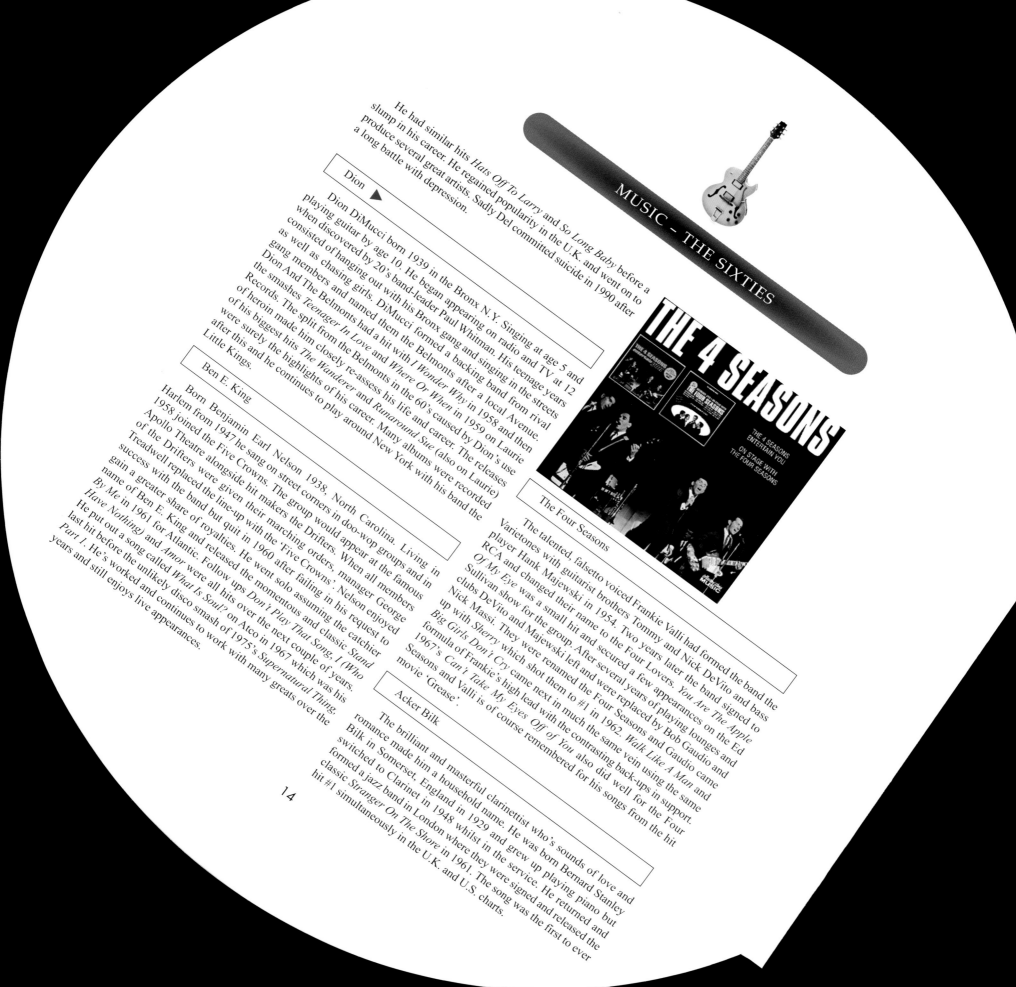

He had similar hits *Hats Off To Larry* and *So Long Baby* before a slump in his career. He regained popularity in the U.K. and went on to produce several great artists. Sadly Del committed suicide in 1990 after a long battle with depression.

Dion ▲

Dion DiMucci born 1939 in the Bronx N.Y. Singing at age 5 and playing guitar by age 10. He began appearing on radio and TV at 12 when discovered by 20's band-leader Paul Whitman. His teenage years consisted of hanging out with his Bronx gang and singing in the streets as well as chasing girls. DiMucci formed a backing band from rival gang members and named them the Belmonts after a local Avenue. Dion And The Belmonts had a hit with *I Wonder Why* in 1958 and then the smashes *Teenager In Love* and *Where Or When* in 1959 on Laurie Records. The split from the Belmonts in the 60's caused by Dion's use of heroin made him closely re-assess his life and career. The releases of his biggest hits *The Wanderer* and *Runaround Sue* (also on Laurie) were surely the highlights of his career. Many albums were recorded after this and he continues to play around New York with his band the Little Kings.

Ben E. King

Born Benjamin Earl Nelson 1938, North Carolina. Living in Harlem from 1947 he sang on street corners in doo-wop groups and in 1958 joined the Five Crowns. The group would appear at the famous Apollo Theatre alongside hit makers the Drifters. When all members of the Drifters were given their marching orders, manager George Treadwell replaced the line-up with the 'Five Crowns'. Nelson enjoyed success with the band but quit in 1960 after failing in his request to gain a greater share of royalties. He went solo assuming the catchier name of Ben E. King and released the momentous and classic *Stand By Me* in 1961 for Atlantic. Follow ups *Don't Play That Song, I (Who Have Nothing)* and *Amor* were all hits over the next couple of years. He put out a song called *What Is Soul?* on Atco in 1967 which was his last hit before the unlikely disco smash of 1975's *Supernatural Thing, Part 1*. He's worked and continues to work with many greats over the years and still enjoys live appearances.

The Four Seasons

The talented, falsetto voiced Frankie Valli had formed the band the Varietones with guitarist brothers Tommy and Nick DeVito and bass player Hank Majewski in 1954. Two years later the band signed to RCA and changed their name to the Four Lovers. *You Are The Apple Of My Eye* was a small hit and secured a few appearances on the Ed Sullivan show for the group. After several years of playing lounges and clubs DeVito and Majewski left and were replaced by Bob Gaudio and Nick Massi. They were renamed the Four Seasons and Gaudio came up with *Sherry* which shot them to #1 in 1962. *Walk Like A Man* and *Big Girls Don't Cry* came next in much the same vein using the same formula of Frankie's high lead with the contrasting back-ups in support. 1967's *Can't Take My Eyes Off of You* also did well for the Four Seasons and Valli is of course remembered for his songs from the hit movie 'Grease'.

Acker Bilk

The brilliant and masterful clarinettist who's sounds of love and romance made him a household name. He was born Bernard Stanley Bilk in Somerset, England in 1929 and grew up playing piano but switched to Clarinet in 1948 whilst in the service. He returned and formed a jazz band in London where they were signed and released the classic *Stranger On The Shore* in 1961. The song was the first to ever hit #1 simultaneously in the U.K. and U.S. charts.

14

THE 4 SEASONS

THE 4 SEASONS ENTERTAIN YOU ON STAGE WITH THE FOUR SEASONS

The Four Seasons

Ray Stevens ▶

Born Harold Ray Ragsdale, 1939 in Georgia. The funny man of pop who created *The Streak* and *Mr Businessman* was playing piano at age 7 and realised right there he wanted to pursue music in earnest. He'd soak up the varied styles of songs he heard on radio and by 15 was playing in his band the 'The Barons' at parties. He moved to Atlanta at 17 and through a meeting with radio man Bill Lowery he gained a contract with Prep Records. He'd only just begun to write songs and *Silver Bracelet* which was one of his prototypes was a local hit. He moved again to Nashville and began doing session work for Mercury where he penned the song *Ahab The Arab*. The song was a #5 hit in 1962. His talent for winding social commentary into comic songs was becoming apparent to all. In 1970 he had his first #1 with *Everything Is Beautiful* for which he scored a Grammy. *The Streak* followed and also hit #1. Ray is certainly a musical wit and continues in the same vein today. Who else would pose the question *Would Jesus Wear A Rolex?*.

He was amassive star in demand and his long and prolific career resulted. Around the same time he had hits with *Somerset* and eventually the albums 'Evergreen', 'Sheer Magic' and 'The One For Me' which all sold millions worldwide. His talent and obvious appeal to all nations due to the instrumental nature of the music assures Acker (a nickname that means 'friend' or 'mate') of longevity in our memories. He remains performing today.

The Crystals

This Brooklyn all girl group helped producer Phil Spector define his famous "Wall Of Sound" recording technique. 1961's breakthrough *There's No Other (Like My Baby)* made it to #5 on R&B charts and established the Crystals' arrival. Also recorded on Spector's 'Philles' label was 'Uptown' in 1962, which gave them their best sales yet. In 1963 singer Darlene Love joined the group and *He's A Rebel*, a song written by Gene Pitney, was released and eclipsed all previous sales by hitting #1 and selling millions. Lead vocal duties would change again and in 1963 singer La La Brooks took the role with *Then He Kissed Me* and *Da Doo Ron Ron (When He Walked Me Home)* which were both smash hits for the girls. The songs and sounds of the Crystals were certainly an influential part of the 60's. The group continues to re-appear in various forms as the years since their heyday have passed.

Gene Chandler

Born Eugene Dixon "The Duke Of Earl" with his top hat, cape, monocle and cane embodied the subject of his first and most powerful hit's name. Chandler had joined R&B group the Du-Kays in 1957 before his time in the service and re-joined in 1960 afterward to be signed to Nat Records in Chicago. They recorded *Night Owl, The Girl Is Evil* and *Duke Of Earl* on Nat but it wasn't until the latter was released on VeeJay records that it made its mark. Under the solo title of Gene Chandler (whilst remaining signed as Gene Dixon with the Du-Kays on Nat) *Duke* was released in 1962 and hit #1 within no time. He also had hits with the Curtis Mayfield songs *Rainbow* and *A Man's Temptation*. The great man with the smooth and rich voice turned to production of other artists in the 70's and today lives in his home town of Chicago.

Cliff Richard & The Shadows

YESTERDAY TODAY

Cliff Richard and the Shadows

Biography and Discography in English and German by Otto Kemper and Friends

Born Harry Webb in India, 1940. Sir Cliff Richard was the guitarist/singer responsible for forming English pop group the Shadows in the late 50's, who's sound included the melodic guitar mastery of legendary member Hank B. Marvin. The earliest line-up recorded the candy sweet *Schoolboy Crush* and the more rocking tune *Move It!*

16

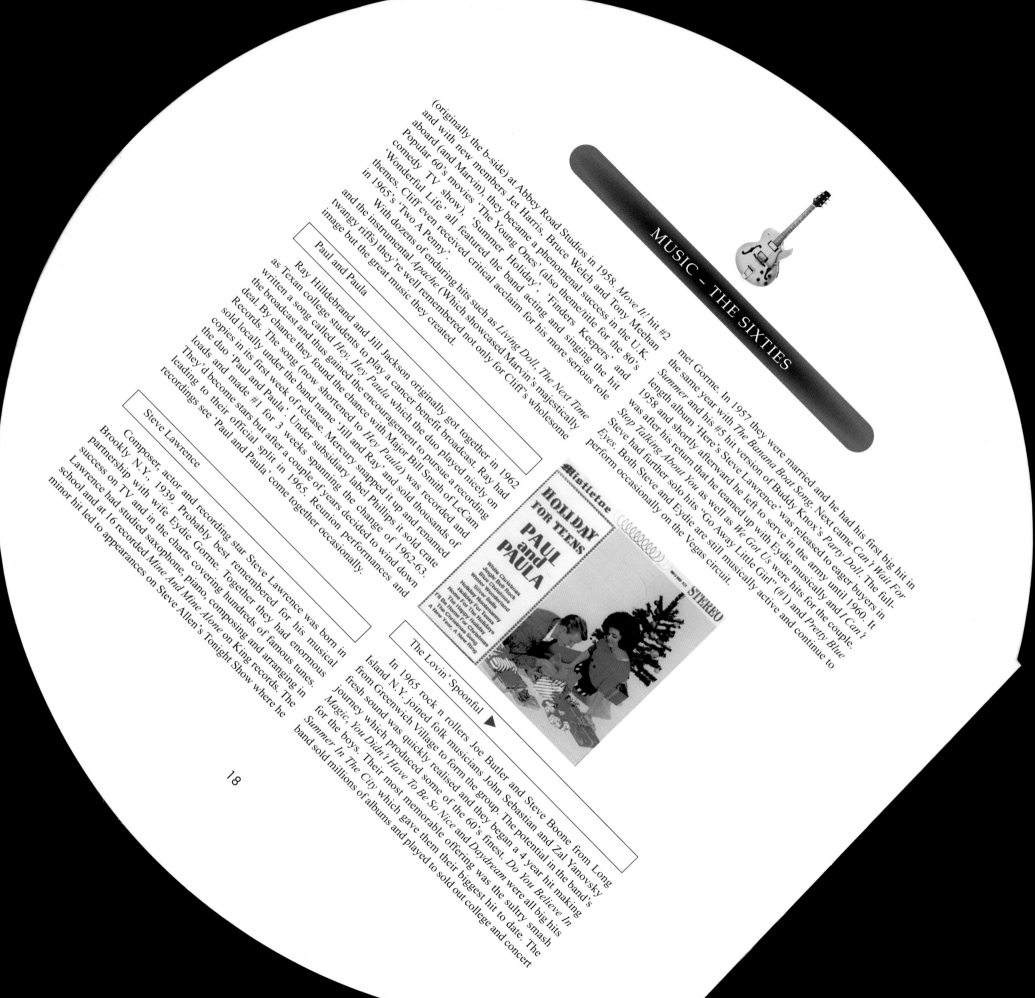

(originally the b-side) at Abbey Road Studios in 1958. *Move It!* hit #2 and with new members Jet Harris, Bruce Welch and Tony Meehan aboard (and Marvin), they became a phenomenal success in the U.K. Popular 60's movies 'The Young Ones' (also theme/title for the 80's comedy TV show), 'Summer Holiday', 'Finders Keepers' and 'Wonderful Life' all featured the band acting and singing the hit themes. Cliff even received critical acclaim for his more serious role in 1965's 'Two A Penny'.

With dozens of enduring hits such as *Living Doll, The Next Time* and the instrumental *Apache* (Which showcased Marvin's majestically twangy riffs) they're well remembered not only for Cliff's wholesome image but the great music they created.

met Gorme. In 1957 they were married and he had his first big hit in the same year with *The Banana Boat Song*. Next came *Can't Wait For Summer* and his #5 hit version of Buddy Knox's *Party Doll*. The full-length album 'Here's Steve Lawrence' was released to eager buyers in 1958 and shortly afterward he left to serve in the army until 1960. It was after his return that he teamed up with Eydie musically and *I Can't Stop Talking About You* as well as *We Got Us* were hits for the couple. Steve had further solo hits "Go Away Little Girl" (#1) and *Pretty Blue Eyes*. Both Steve and Eydie are still musically active and continue to perform occasionally on the Vegas circuit.

Paul and Paula

Ray Hilldebrand and Jill Jackson originally got together in 1962 as Texan college students to play a cancer benefit broadcast. Ray had written a song called *Hey, Hey Paula* which the duo played nicely on the broadcast and thus gained the encouragement to pursue a recording deal. By chance they found the chance with Major Bill Smith of LeCam Records. The song (now shortened to *Hey, Paula*) was recorded and sold locally under the band name 'Jill and Ray' and sold thousands of copies in its first week of release. Mercury snapped it up and renamed the duo 'Paul and Paula'. Under subsidiary label Phillips it sold crate loads and made #1 for 3 weeks spanning the change of 1962-63. They'd become stars but after a couple of years decided to wind down leading to their official split in 1965. Reunion performances and recordings see 'Paul and Paula' come together occasionally.

Steve Lawrence

Composer, actor and recording star Steve Lawrence was born in Brookly N.Y., 1939. Probably best remembered for his musical partnership with wife Eydie Gorme. Together they had enormous success on TV and in the charts covering hundreds of famous tunes. Lawrence had studied saxophone, piano, composing and arranging in school and at 16 recorded *Mine And Mine Alone* on King records. The minor hit led to appearances on Steve Allen's Tonight Show where he

Mistletoe
HOLIDAY FOR TEENS
PAUL and PAULA
STEREO

The Lovin' Spoonful ▲

In 1965 rock n rollers Joe Butler and Steve Boone from Long Island N.Y. joined folk musicians John Sebastian and Zal Yanovsky from Greenwich Village to form the group. The potential in the band's fresh sound was quickly realised and they began a 4 year hit making journey which produced some of the 60's finest. *Do You Believe In Magic, You Didn't Have To Be So Nice* and *Daydream* were all big hits for the boys. Their most memorable offering was the sultry smash *Summer In The City* which gave them their biggest hit to date. The band sold millions of albums and played to sold out college and concert

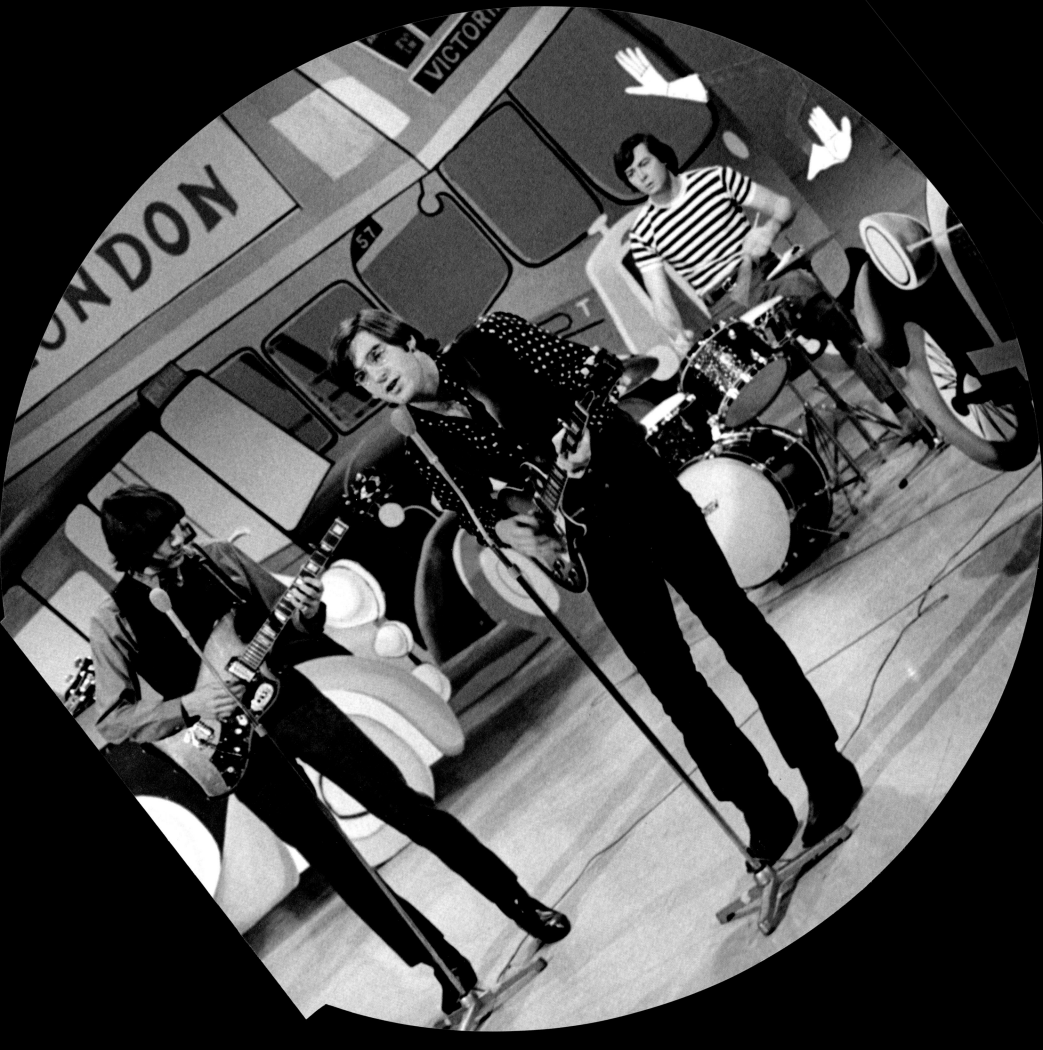

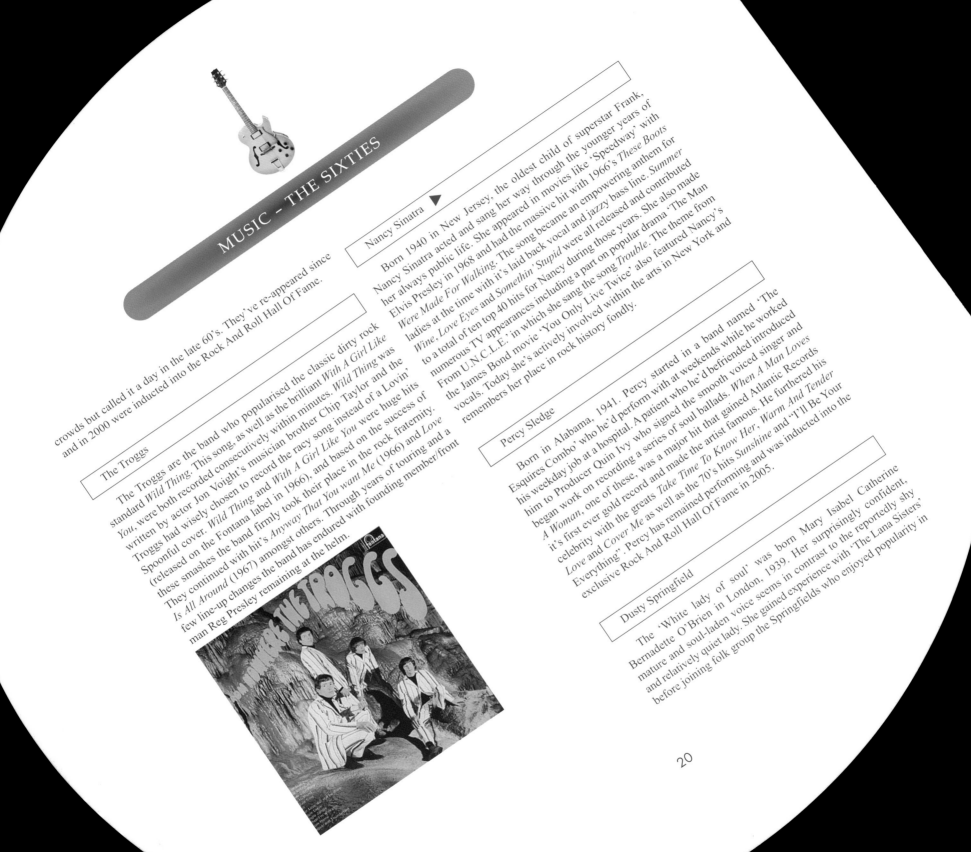

The Troggs

The Troggs are the band who popularised the classic dirty rock standard *Wild Thing*. This song, as well as the brilliant *With A Girl Like You*, were both recorded consecutively within minutes. *Wild Thing* was written by actor Jon Voight's musician brother Chip Taylor and the Troggs had wisely chosen to record the racy song instead of a Lovin' Spoonful cover. *Wild Thing* and *With A Girl Like You* were huge hits (released on the Fontana label in 1966), and based on the success of these smashes the band firmly took their place in the rock fraternity. They continued with hit's *Anyway That You want Me* (1966) and *Love Is All Around* (1967) amongst others. Through years of touring and a few line-up changes the band has endured with founding member/front man Reg Presley remaining at the helm. crowds but called it a day in the late 60's. They've re-appeared since and in 2000 were inducted into the Rock And Roll Hall Of Fame.

Nancy Sinatra ▶

Born 1940 in New Jersey, the oldest child of superstar Frank, Nancy Sinatra acted and sang her way through the younger years of her always public life. She appeared in movies like 'Speedway' with Elvis Presley in 1968 and had the massive hit with 1966's *These Boots Were Made For Walking*. The song became an empowering anthem for ladies at the time with it's laid back vocal and jazzy bass line. *Summer Wine*, *Love Eyes* and *Somethin' Stupid* were all released and contributed to a total of ten top 40 hits for Nancy during those years. She also made numerous TV appearances including a part on popular drama 'The Man From U.N.C.L.E.' in which she sang the song *Trouble*. The theme from the James Bond movie 'You Only Live Twice' also featured Nancy's vocals. Today she's actively involved within the arts in New York and remembers her place in rock history fondly.

Percy Sledge

Born in Alabama, 1941. Percy started in a band named 'The Esquires Combo' who he'd perform with at weekends while he worked his weekday job at a hospital. A patient who he'd befriended introduced him to Producer Quin Ivy who signed the smooth voiced singer and began work on recording a series of soul ballads. *When A Man Loves A Woman*, one of these, was a major hit that gained Atlantic Records it's first ever gold record and made the artist famous. He furthered his celebrity with the greats *Take Time To Know Her*, *Warm And Tender Love* and *Cover Me* as well as the 70's hits *Sunshine* and "I'll Be Your Everything". Percy has remained performing and was inducted into the exclusive Rock And Roll Hall Of Fame in 2005.

Dusty Springfield

The 'White lady of soul' was born Mary Isabel Catherine Bernadette O'Brien in London, 1939. Her surprisingly confident, mature and soul-laden voice seems in contrast to the reportedly shy and relatively quiet lady. She gained experience with 'The Lana Sisters' before joining folk group the Springfields who enjoyed popularity in

20

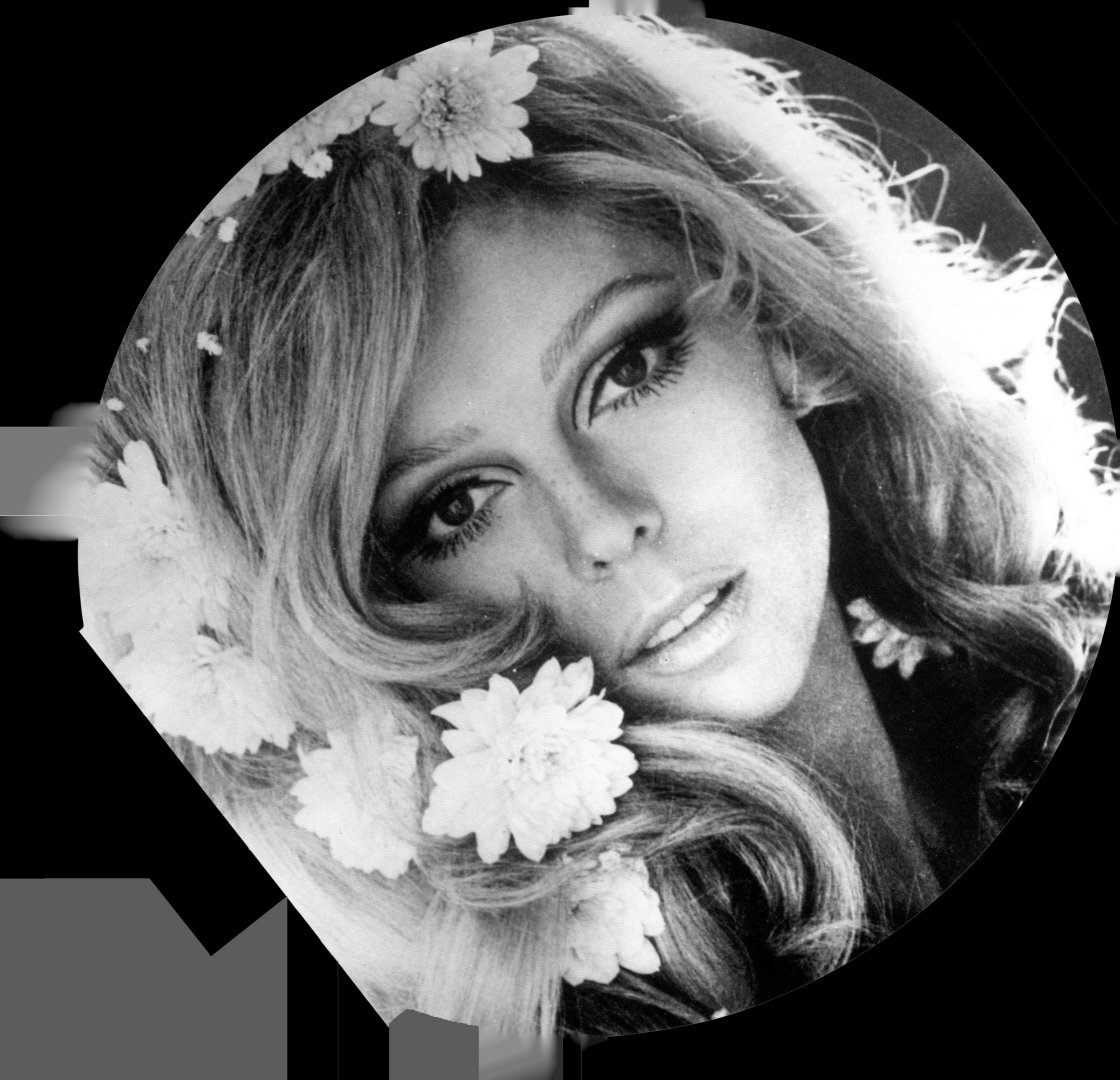

the U.S. as well as at home in the U.K. She soon became tired of the band and armed with her new stage name she struck out solo with 1963's *I Only Want To Be With You*. The song was a hit on both sides of the Atlantic and introduced her soul influenced singing style to music lovers. In all she had 17 hits in the charts from 1963-69 including *You Don't Have To Say You Love Me* and *Wishin' And Hopin'*. Frenzied fans would scream at Dusty's TV appearances and her constant touring endeared her to listeners everywhere. The album *Dusty In Memphis* (1969) contained the classic Bacharach-David tune *Son Of A Preacher Man* which was one of Dusty's biggest and most memorable hits along with 1972's *I Just Don't Know What To Do With Myself*. She spent the next decades between work and retirement and sadly passed away in 1999 after battling breast cancer.

after 4 years). Through a versatile career Lulu has received hundreds of accolades and recently released an album of duets.

Los Bravos

This Spanish five-piece led by singer Mike Kogel were a complete rarity in that they were perhaps the first band from a non-english speaking country to have a #4 hit in the U.S. with 1966's *Black Is Black*. The song hit #2 in the U.K and was massively popular with it's stomping beat and enormous vocal. Some compared the sound of the group to Gene Pitney and even believed the single to have been released by him. Later in 1966 they had follow up success with the single *I Don't Care* which made top 20 in the U.K. but they never out-performed their first and biggest hit after that. They did however maintain a huge fan base in Europe despite releasing most material in English. They remain best known for that one great tune.

Lulu

Born Marie McDonald McLaughlin Lawrie, 1948 in Glasgow, Scotland. Her shortened stage name was created by manager Marion Massey early in her career. Lulu's smash hit song and performance in 1967's "To Sir With Love" (song/movie title) alongside brilliant actor Sidney Poitier was perhaps the most memorable moment of her career. She played character Barbara Pegg in the movie who memorably sang the beautiful title song and won critical acclaim for the role. She'd already come to notoriety with her hit version of the Isley Brother's *Shout* (1964 on Decca) as well as numerous TV and radio appearances. The late 60's saw Lulu hosting her own popular BBC TV shows as well as her marriage to Maurice Gibb of the Bee Gees (which ended

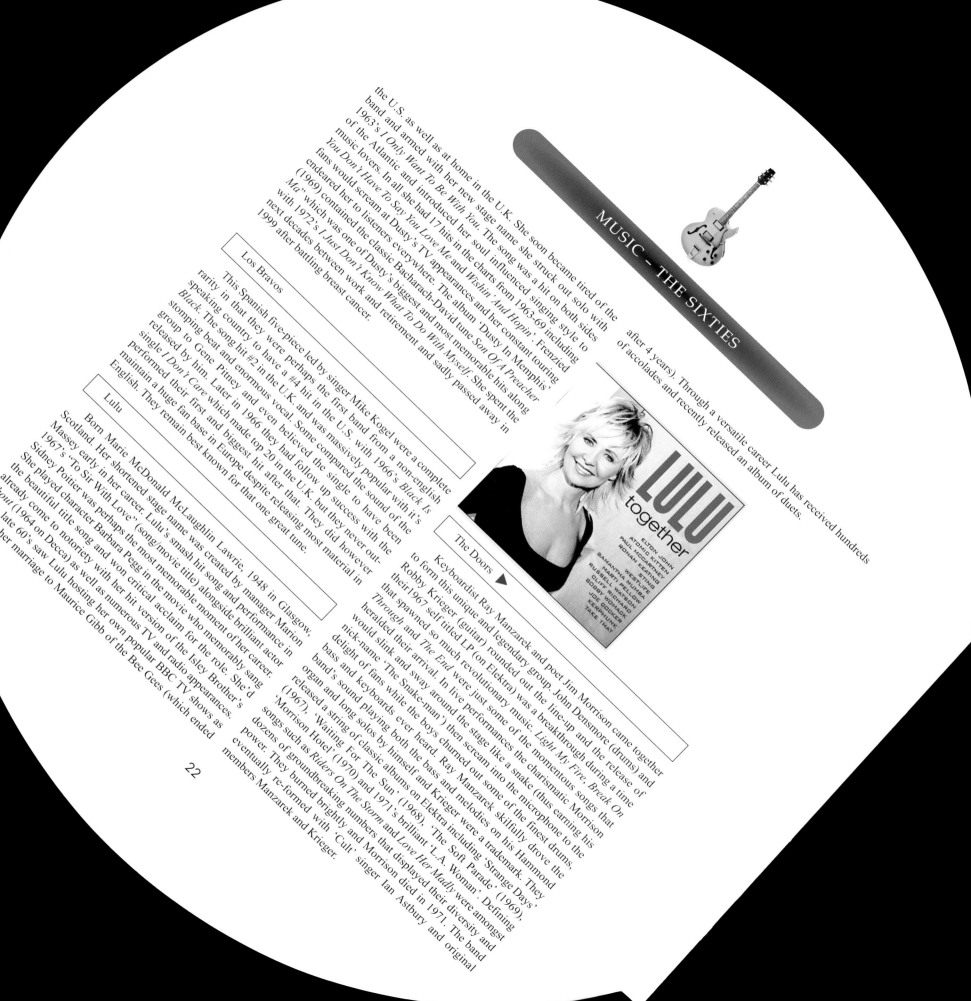

LULU
together

ELTON JOHN
ATOMIC KITTEN
PAUL MCCARTNEY
RONAN KEATING
WESTLIFE
STING
SAMANTHA MUMBA
MARTI PELLOW
RUSSELL WATSON
CLIFF RICHARD
BOBBY WOMACK
JOE COCKER
KERPHUNK
TAKE THAT

The Doors ▶

Keyboardist Ray Manzarek and poet Jim Morrison came together to form this unique and legendary group. John Densmore (drums) and Robby Krieger (guitar) rounded out the line-up and the release of their 1967 self-titled LP (on Elektra) was a breakthrough during a time that spawned so much revolutionary music. *Light My Fire*, *Break On Through* and *The End* were just some of the momentous songs that heralded their arrival. In live performances the charismatic Morrison would slink and sway around the stage like a snake (thus earning his nick-name 'The Snake-man') then scream into the microphone to the delight of fans while the boys churned out some of the finest drums, bass and keyboards ever heard. Ray Manzarek skilfully drove the band's sound playing both the bass and melodies on his Hammond organ and long solos by himself and Krieger were a trademark. They released a string of classic albums on Elektra including 'Strange Days' (1967), 'Waiting For The Sun' (1968), 'The Soft Parade' (1969), 'Morrison Hotel' (1970) and 1971's brilliant 'L.A. Woman'. Defining songs such as *Riders On The Storm* and *Love Her Madly* were amongst dozens of groundbreaking numbers that displayed their diversity and power. They burned brightly and Morrison died in 1971. The band eventually re-formed with 'Cult' singer Ian Astbury and original members Manzarek and Krieger.

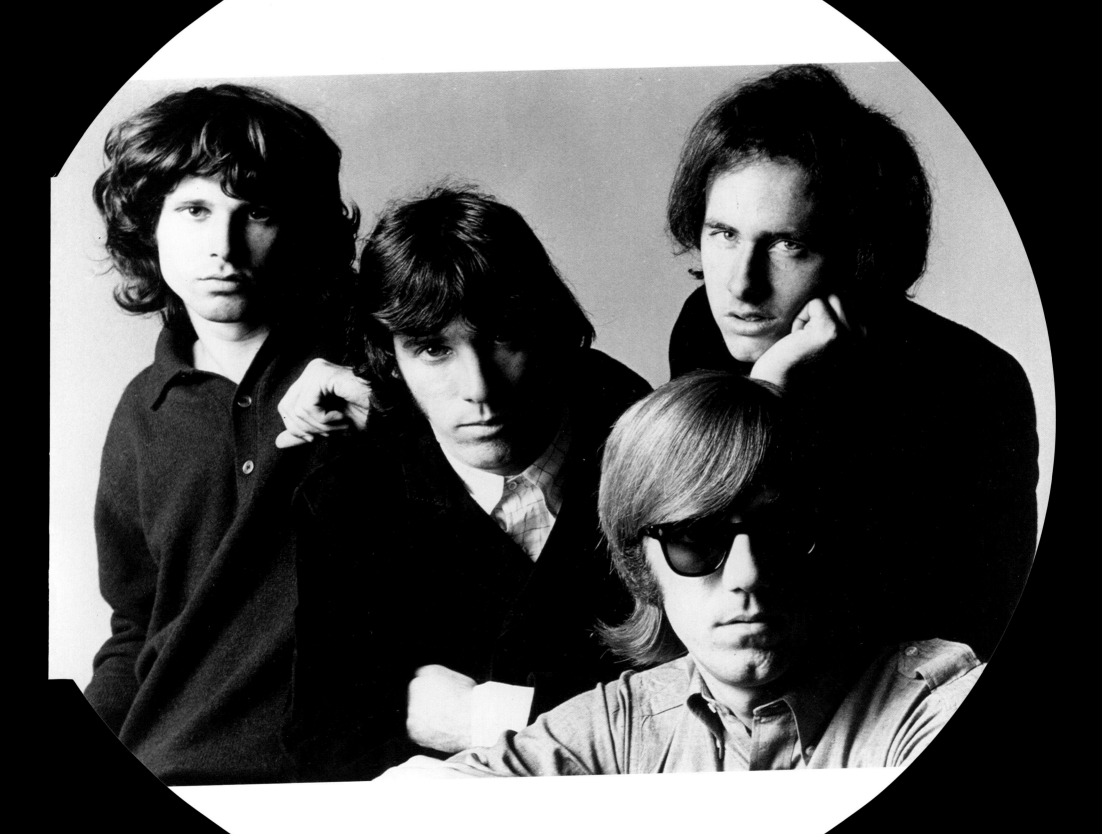

The Box Tops

Originally 'Ronnie And The DeVilles' from Memphis, Tennessee. In 1967 members Alex Chilton (vocal), Bill Cunningham (bass), John Evans (guitar), Danny Smythe (drums), and Gary Talley (lead guitar) recorded their bluesy #1 smash hit *The Letter* at 'American' studios in Memphis. Another group named the DeVilles were fairly well established so they decided on the Box Tops as the new band name. *The Letter* won Cashbox Magazine's "Record Of The Year" as well as a couple of Grammy nominations and launched the boys into the spotlight. The song *Neon Rainbow* was released shortly afterward but didn't chart as well. By 1968 members Evans and Smythe were replaced by Rick Allen and Tom Boggs and in 1969 they released *Cry Like A Baby* which made #2. After an exciting few years of making some great music, the group disbanded in the 70's.

The Turtles

Howard Kaylan and Mark Volman (a.k.a. Flo and Eddie) were the singing, saxophone blowing founders of the Turtles (originally named 'The Crossfires') of N.Y. They renamed themselves to suit the bands of the time and released Dylan's *It Aint Me Babe* on the White Whale label in 1964, which went top five. The single *You Baby* did reasonably well for the band who were also an early exponent of acid-rock with their feedback laden performances, druggy lyrics and bizarre versions of standards like *Tobacco Road*. The Turtles were a weird parody of the Beatles musically, but shared the stove-piped trousers and attempts at eastern influenced music. The band eventually became embroiled within bitter lawsuits surrounding debt and folded in 1970. Kaylan and Volman joined Frank Zappa's 'Mothers Of Invention' and enjoyed more musically groundbreaking times.

The Beach Boys

For a bunch of guys who didn't exactly all surf, the Beach Boys embodied the sound perfectly. Reigning from Hawthorne, California were brothers Carl, Dennis and Brian Wilson who teamed up with cousin Mike Love and friend Al Jardine to form the group. Young musical genius Brian Wilson was a big fan of vocal group 'The Four Freshman' and inspired by them, he taught his band to sing in harmony. They wrote *Surfin'*, and *Surfin Safari* which were titles suggested by Dennis who was the band's only surfer. Demo versions of the songs were made and in 1962, *Surfin'* was released on X Records and made #75 on the charts. Eventually *Surfin Safari* was picked up by Capitol Records and when released like *Surfin' USA*, *Little Deuce Coupe*, the Beach Boys became a sensation and the classics rolled like *Surfin' USA*, *Little Deuce Coupe*, *Fun, Fun, Fun, Help Me Rhonda* and dozens more. Early success was followed by a change in direction with the brilliant song *Good Vibrations* and the masterpiece albums 'Pet Sounds' as well as the recently uncovered 'Smile'. The Beach Boys music shares a place with the most enduring music to have come from the era.

Peter, Paul and Mary ▶

Peter Yarrow, Noel Paul Stookey and Mary Travers met up in the thriving folk environs of Greenwich Village, New York City in the early 60's. Yarrow the scholar, Stookey the stand-up comic and Travers who was a member of Peter Seeger's "Song Swappers" formed Peter, Paul and Mary and after playing sets at seminal folk clubs like New York's "Blue Angel" they became a sensation. Their self-titled 1962 debut LP was released on Warner Brothers Records and the song *if I Had A Hammer* became an anthem during the peak of the folk period.

Its simple, socialist undertones were apparent but the song was beautifully sung and for whichever reason it gave the band an enormous jump-start. 1963's controversial *Puff The Magic Dragon* and Dylan's *Blowin' In The Wind* were also big hits as was John Denver's *Leaving On A Jet Plane* in 1969. The band that truly stands for human rights still play and remain active in the causes of freedom.

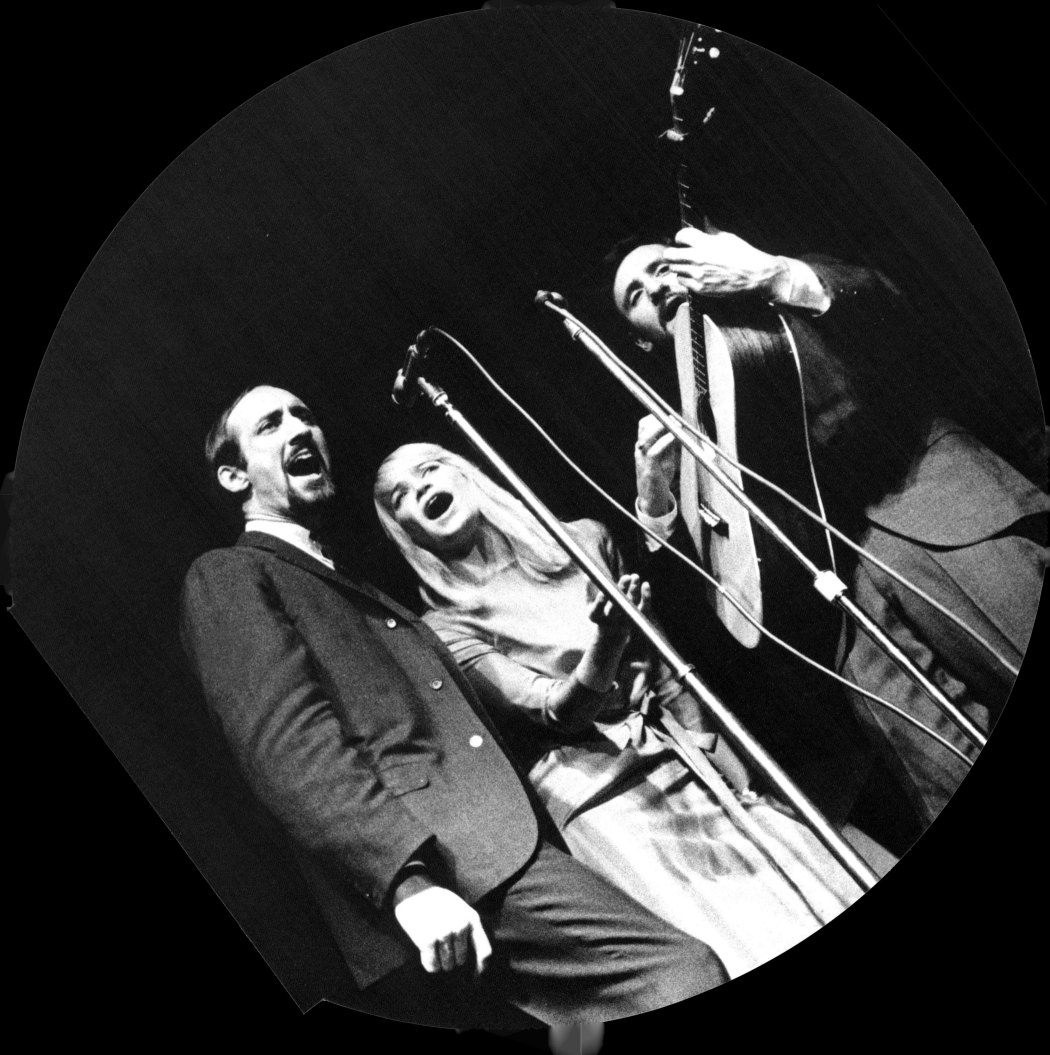

Trini Lopez

Born Trinidad Lopez in Dallas, Texas, 1937. His poor father had taught him to play guitar and the young Trini would busk on street corners to help his struggling family. At 18 he released *The Right To Rock* on King Records and had a minor hit with the song. He was given mostly country material to record but had a breakthrough with the Skyliners *Since I Don't Have You* which went top ten. A chance meeting with Frank Sinatra in 1960 resulted in Lopez being signed to Ol' Blue Eyes own Reprise Records and his debut LP 'Trini Lopez At PJ's' was recorded and went to #1 in the singles charts and *If I Had A Hammer* from the album also hit #1. A lively version of the folk standard *La Bamba*, *I'm Coming Home Cindy* and *Kansas City* were also hits for the man who's singing and resulting acting career spans many decades and rolls on.

Martha And The Vandellas

Martha Reeves was singing with recording artists 'The Fascinations', 'The Del-Phis' and as back-up singer to Marvin Gaye before teaming up with Rosalind Ashford and Betty Kelly to record on Berry Gordy's new label in 1962. The trio was named Martha And The Vandellas in tribute to Van Dyke Street in Detroit and singer Della Reese who they admired. They created the seminal R&B girl group style that was slightly more roots-based than that of their sister group the Supremes. This was displayed on the smash hit classics *Heat Wave* (1963), *Dancing In The Street* (1964), *Nowhere To Run* (1965) and *I'm Ready For Love* (1966). These R&B/soul gems were enjoyed then and now and through various line-up changes the group endured to become Rock And Roll Hall Of Fame inductees in 1995.

Rufus Thomas

Born 1917 in Mississippi, his family moved to Memphis when he was 2 and as a teenager he performed with the vaudeville troupe "The Rabbit Foot Minstrels". Here he honed his comedy, singing and dancing skills and began appearing in the famous Beale Street clubs of Memphis. During the 40's and 50's he hosted amateur evenings at the Palace Theatre where greats like B.B. King would pass through. In 1953, after a stint as DJ on local black-operated station WDIA, he

recorded the national hit *Bear Cat* for the fledgling Sun Records (then called Memphis Recording Studio). On Stax Records he released a duet with his daughter in 1959 called *Cause I Love You* which gave the new label a hit. Thomas is perhaps best known for 1964's *Walking The Dog* and 1967's *Do The Funky Chicken* which were novelty smashes but he's also well remembered for his own funky/blues/soul song writing hits *Push And Pull* and *The Breakdown*. He produced 1971 afterward which 2001 leaving his undeniable passed away in contribution to the Memphis sound.

RUFUS THOMAS
FUNKIEST MAN ALIVE

THE STAX FUNK SESSIONS 1967-1975

Bob Dylan ▶

Robert Allen Zimmerman was born in Minnesota, 1941. He learned to play guitar and harmonica in school but as a teenager fronted a Jerry Lee Lewis style garage band as pianist. Inspired by poet Dylan Thomas and musician Woody Guthrie he met blues musician Jesse Fuller in 1960 who helped him decide to move to New York. He arrived in 1961 and began playing the coffee houses of Greenwich Village, who's audiences took to him almost immediately. The believable vagabond folk image he'd created was ripe for the times and after being sought by Columbia A&R rep John Hammond his debut self-titled LP was released in 1962. It contained covers he'd been playing plus a couple of his own songs and only sold in moderate amounts. Next came an album titled 'The Freewheelin' Bob Dylan' which contained his own protest-style number *Blowin' In The Wind*. This song was covered soon afterward and became a hit for Peter, Paul and Mary which in turn

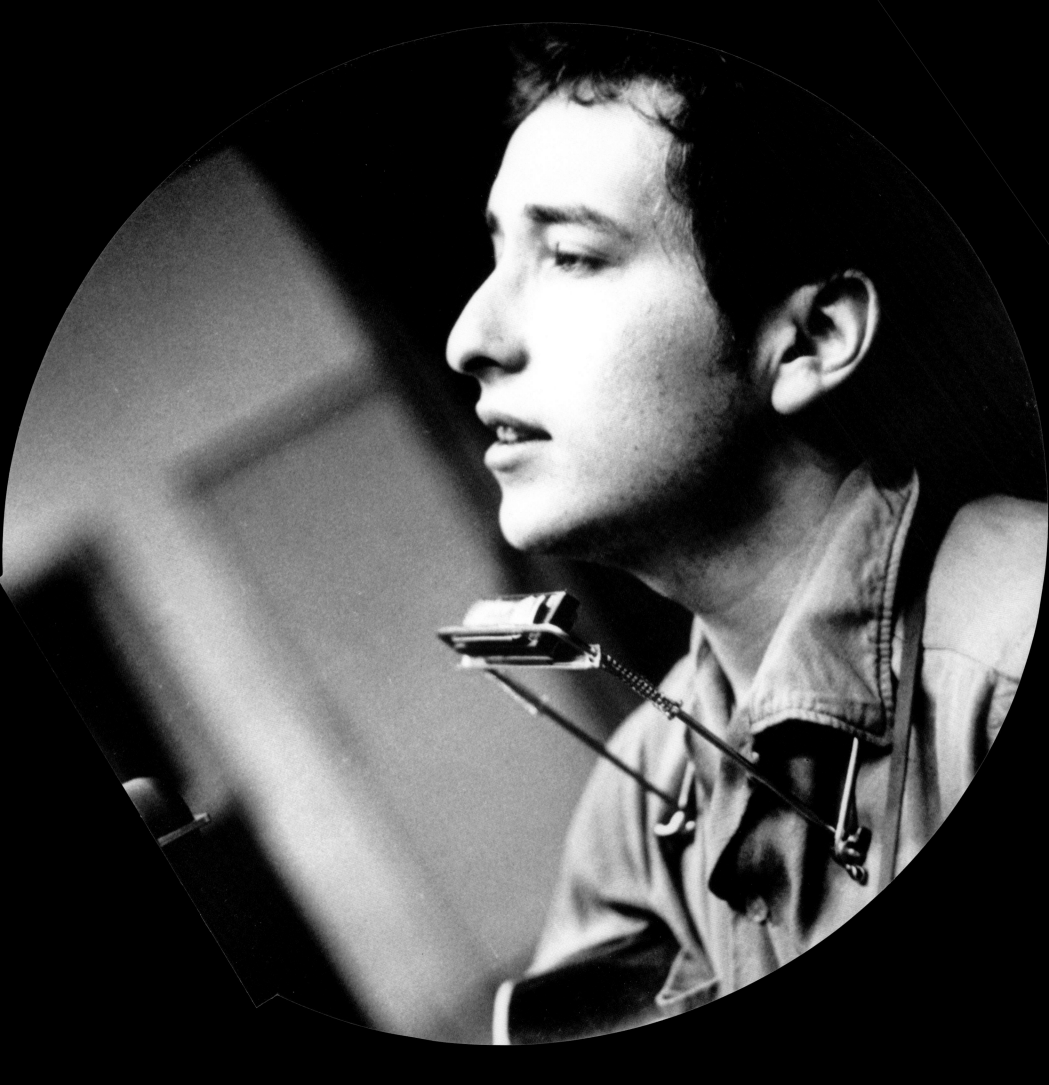

made the original and it's author a hit. This initial success spawned a prolific career and life of incredible events. Dylan is the nasally voiced genius musician who transcends his unique but simple performances with the quality of the music. Stand-out albums include 'The Times They Are A-Changin', 'Highway 61 Revisited', 'Blonde On Blonde' (all between 1960-69) and the 70's 'Hard Rain', 'Blood On The Tracks', and 'Desire'. Dylan has never stopped and you can see him perform today.

Manfred Mann ▶

Manfred Lubowitz was born in Johannesburg, South Africa in 1940. He was playing piano as a youngster and by his teens had cultivated a deep love of playing jazz and blues. Moving to England in the early 60's, he eventually formed a band together with drummer Mike Hugg which would become known simply as Manfred Mann. Completing the group were Mike Vickers on flute/guitar, Paul Jones (Harp, Vocals) and Tom McGuinness on bass. The big early hit was 1964's *Doo Wah Diddy Diddy* (HMV Label) which was preceded earlier that year by top ten hit *5-4-3-2-1*. The run of chart success continued with *Come Tomorrow* (1966) and 1969's *Fox On The Run* before they disbanded that year. In 1970 Lubowitz (now referred to simply as 'Manfred') formed the Manfred Mann Earth Band and released a swirling electronic version of Bruce Springsteen's song *Blinded By The Light*, his finest single to date. A reformed 'Earth Band' released the comeback album 'Soft Vengeance' in 1997 and toured extensively.

The Supremes

Originally called the Primettes, the Supremes began when members Florence Ballard and Mary Wilson met at a talent contest. Joined by Diane Ross (later Diana) and Betty Travis they began appearing in clubs and pestering Motown Records for an audition. Eventually they secured a recording session as the Supremes in 1960 but the results were unfruitful. In 1963 they released the classic *Where Did Our Love Go* which gave them the #1 spot on pop and R&B charts. With Diana on lead they continued with 1964's *Baby Love* which was #1 in the U.K. and U.S. charts. Further success came with *Stop In The Name Of Love*, *Come See About Me* and *Back In My Arms Again* (1965) all hitting the top spot. *Keep Me Hangin' On* and *You Can't Hurry Love* were hits in 1966 for the Supremes who continued performing their repertoire for years through many line-up changes.

Peter And Gordon

Peter Asher and Gordon Waller of Peter and Gordon were the U.K.'s equivalent of the Everly Brothers. They met in 1961 at school in London where Peter was the jazz and folk fan whilst Gordon was the rock'n'roller. They played pubs, clubs and parties until being spotted by EMI A&R man Norman Newell who signed the pair to the label. Songs released were mostly covers like *I Go To Pieces* and *A World Without Love*, the latter written by Lennon-McCartney. McCartney's girlfriend Jane Asher was Peter's sister thus providing the connection. McCartney continued to write songs for them including *Nobody I Know* and *I Don't Want To See You Again* both going top 20 in 1964 for Peter and Gordon who would pen the b-sides themselves. Success in the U.S. top 40 came with tracks *To Know You Is To Love You* and *True Love Ways* before their 1968 split. Both remain active today be it musically or within production roles.

The Animals

Eric Burdon (vocals), Alan Price (organ), Bryan Chas Chandler (bass), Hilton Valentine (guitar) and John Steel (drums) made up the band from Newcastle-on-Tyne in north-east England. With Burdon's "likely lad" looks and hard, bluesy but melodic vocals they were a

THE SUPREMES GOLD

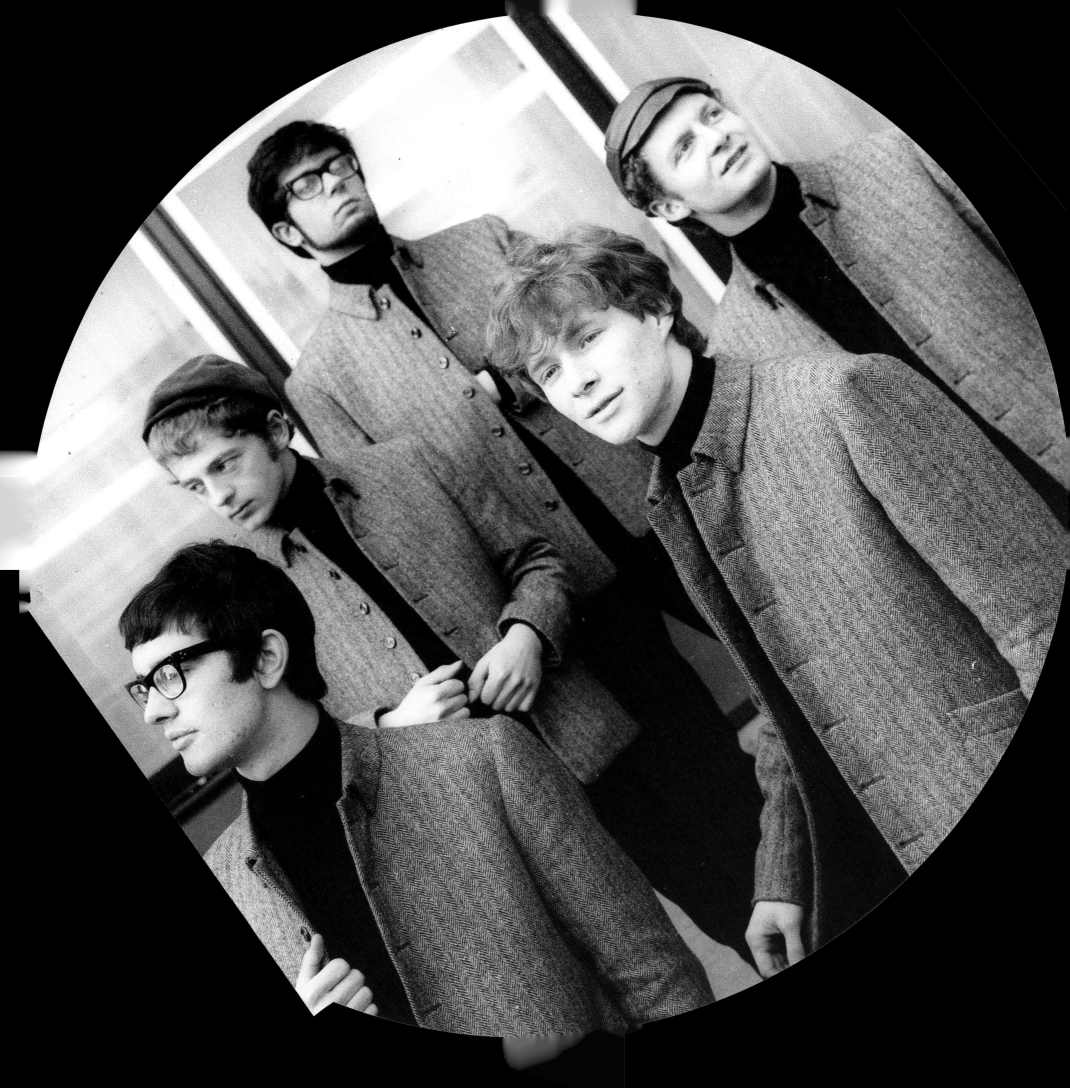

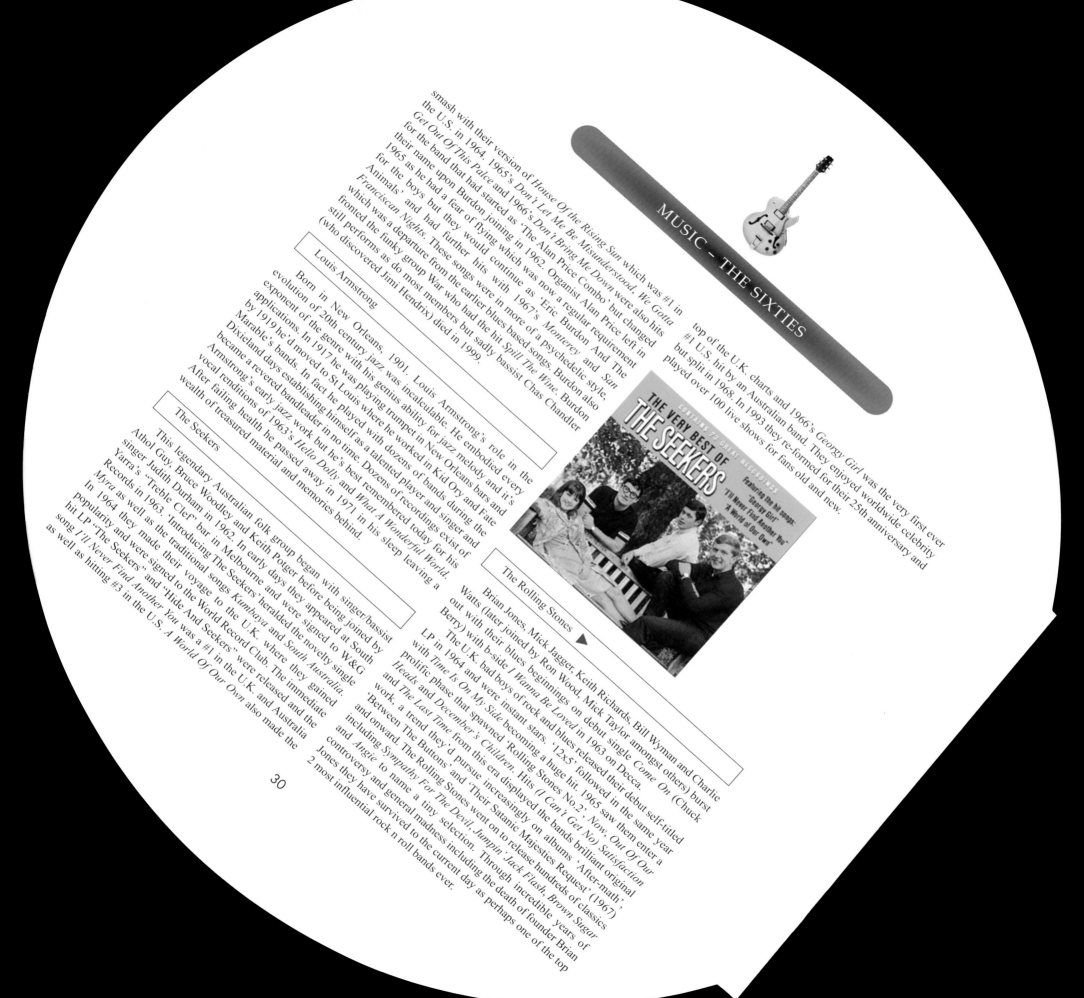

smash with their version of *House Of the Rising Sun* which was #1 in the U.S. in 1964. 1965's *Don't Let Me Be Misunderstood*, *We Gotta Get Out Of This Palce* and 1966's *Don't Bring Me Down* were also hits for the band that had started as 'The Alan Price Combo' but changed their name upon Burdon joining in 1962. Organist Alan Price left in 1965 as he had a fear of flying which was now a regular requirement for the boys but they would continue as 'Eric Burdon And The Animals', and had further hits with 1967's *Monterey* and *San Franciscan Nights*. These songs were in more of a psychedelic style, which was a departure from the earlier blues based songs. Burdon also fronted the funky group War who had the hit *Spill The Wine*. Burdon still performs as do most members but sadly bassist Chas Chandler (who discovered Jimi Hendrix) died in 1999.

Louis Armstrong

Born in New Orleans, 1901. Louis Armstrong's role in the evolution of 20th century jazz was incalculable. He embodied every exponent of the genre with his genius ability for jazz melody and it's applications. In 1917 he was playing trumpet in New Orleans bars and by 1919 he'd moved to St Louis where he worked in Kid Ory and Fate Marable's bands. In fact he played with dozens of bands during the Dixieland days establishing himself as a talented player and singer and became a revered bandleader in no time. Dozens of recordings exist of Armstrong's early jazz work but he's best remembered today for his vocal renditions of 1963's *Hello Dolly* and *What A Wonderful World*. After failing health he passed away in 1971 in his sleep leaving a wealth of treasured material and memories behind.

The Seekers

This legendary Australian folk group began with singer/bassist Athol Guy, Bruce Woodley and Keith Potger before being joined by singer Judith Durham in 1962. In early days they appeared at South Yarra's "Treble Clef" bar in Melbourne and were signed to W&G Records in 1963. 'Introducing The Seekers' heralded the novelty single *Myra* as well as the traditional songs *Kumbaya* and *South Australia*. In 1964 they made their voyage to the U.K. where they gained popularity and were signed to the World Record Club. The immediate hit LP "The Seekers' and 'Hide And Seekers" were released and the song *I'll Never Find Another You* was a #1 in the U.K. and Australia as well as hitting #3 in the U.S. *A World Of Our Own* also made the

top of the U.K. charts and 1966's *Georgy Girl* was the very first ever #1 U.S. hit by an Australian band. They enjoyed worldwide celebrity but split in 1968. In 1993 they re-formed for their 25th anniversary and played over 100 live shows for fans old and new.

The Rolling Stones ▲

The Rolling Stones

Brian Jones, Mick Jagger, Keith Richards, Bill Wyman and Charlie Watts (later joined by Ron Wood, Mick Taylor amongst others) burst out with their blues beginnings on debut single *Come On* (Chuck Berry) with b-side *I Wanna Be Loved* in 1963 on Decca.

The U.K. bad boys of rock and blues released their debut self-titled LP in 1964 and were instant stars. '12x5' followed in the same year with *Time Is On My Side* becoming a huge hit. 1965 saw them enter a prolific phase that spawned 'Rolling Stones No.2', *Now*, *Out Of Our Heads* and *December's Children*. Hits *(I Can't Get No) Satisfaction* and *The Last Time* from this era displayed the bands brilliant original work, a trend they'd pursue increasingly on albums 'After-math', 'Between The Buttons', and 'Their Satanic Majesties Request' (1967) and onward. The Rolling Stones went on to release hundreds of classics including *Sympathy For The Devil*, *Jumpin' Jack Flash*, *Brown Sugar* and *Angie* to name a tiny selection. Through incredible years of controversy and general madness including the death of founder Brian Jones they have survived to the current day as perhaps one of the top 2 most influential rock n roll bands ever.

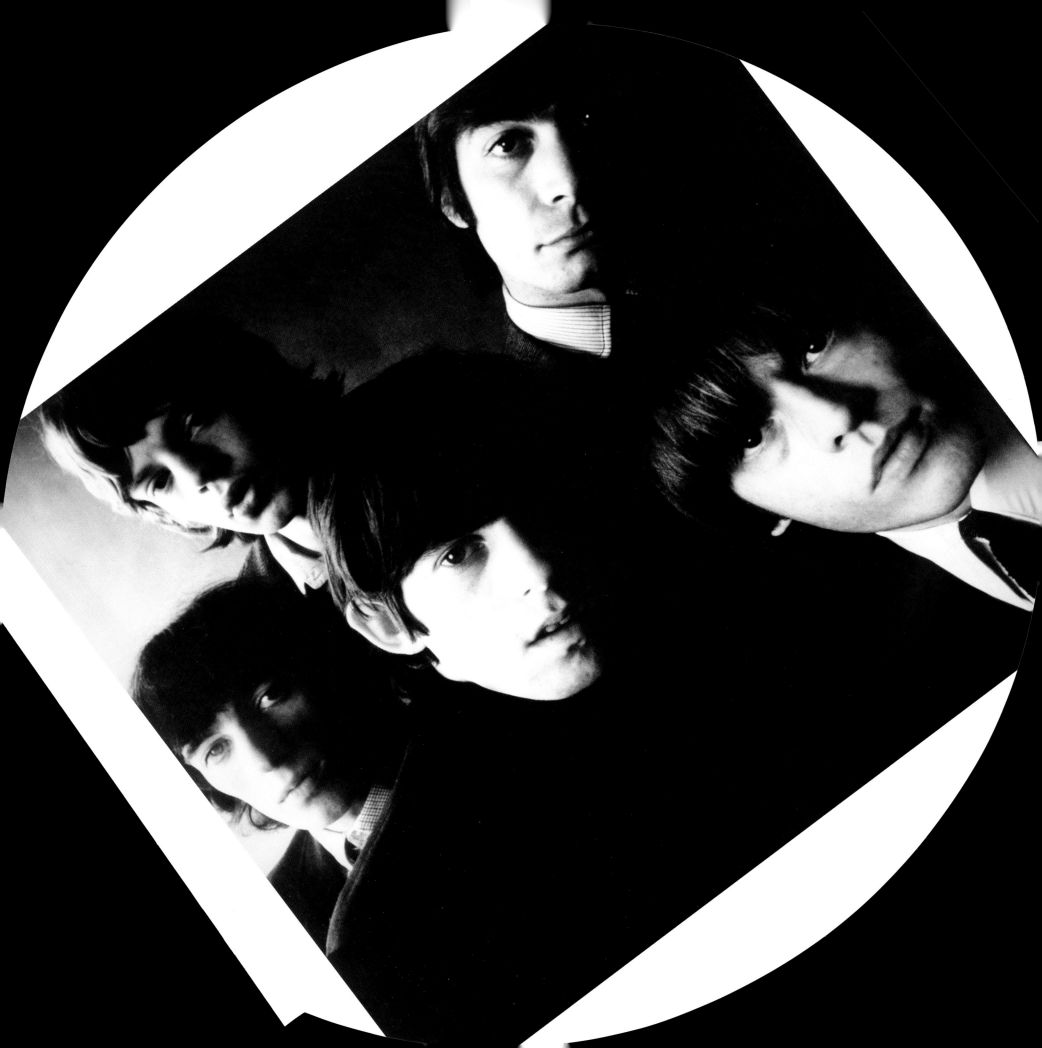

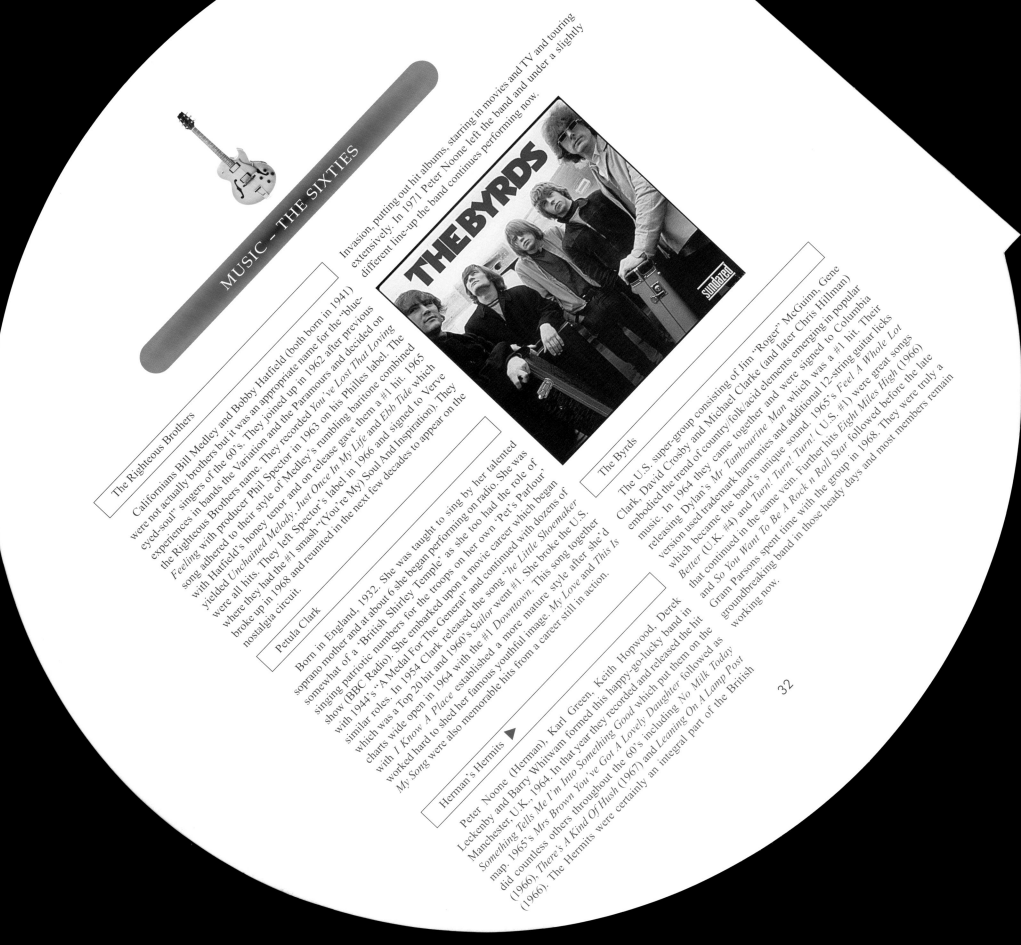

The Righteous Brothers

Californians Bill Medley and Bobby Hatfield (both born in 1941) were not actually brothers but it was an appropriate name for the "blue-eyed-soul" singers of the 60's. They joined up in 1962 after previous experiences in bands the Variation and the Paramours and decided on the Righteous Brothers name. They recorded *You've Lost That Loving Feeling* with producer Phil Spector in 1965 on his Philles label. The song adhered to their style of Medley's rumbling baritone combined with Hatfield's honey tenor and on release gave them a #1 hit. 1965 yielded *Unchained Melody, Just Once In My Life* and *Ebb Tide* which were all hits. They left Spector's label in 1966 and signed to Verve where they had the #1 smash "(You're My) Soul And Inspiration). They broke up in 1968 and reunited in the next few decades to appear on the nostalgia circuit.

Petula Clark

Born in England, 1932. She was taught to sing by her talented soprano mother and at about 6 she began performing on radio. She was somewhat of a 'British Shirley Temple' as she too had the role of singing patriotic numbers for the troops on her own 'Pet's Parlour' show (BBC Radio). She embarked upon a movie career which began with 1944's "A Medal For The General" and continued with dozens of similar roles. In 1954 Clark released the song "he Little Shoemaker" which was a Top 20 hit and 1960's *Sailor* went #1. She broke the U.S. charts wide open in 1964 with the #1 *Downtown*. This song together with *I Know A Place* established a more mature style after she'd worked hard to shed her famous youthful image. *My Love* and *This Is My Song* were also memorable hits from a career still in action.

Herman's Hermits ▶

Peter Noone (Herman), Karl Green, Keith Hopwood, Derek Leckenby and Barry Whitwam formed this happy-go-lucky band in Manchester, U.K., 1964. In that year they recorded and released the hit *Something Tells Me I'm Into Something Good* which put them on the map. 1965's *Mrs Brown You've Got A Lovely Daughter* followed as did countless others throughout the 60's including *No Milk Today* (1966), *There's A Kind Of Hush* (1967) and *Leaning On A Lamp Post* (1966). The Hermits were certainly an integral part of the British

Invasion, putting out hit albums, starring in movies and TV and touring extensively. In 1971 Peter Noone left the band and under a slightly different line-up the band continues performing now.

The Byrds

The U.S. super-group consisting of Jim "Roger" McGuinn, Gene Clark, David Crosby and Michael Clarke (and later Chris Hillman) embodied the trend of country/folk/acid elements emerging in popular music. In 1964 they came together and were signed to Columbia releasing Dylan's *Mr Tambourine Man* which was a #1 hit. Their version used trademark harmonies and additional 12-string guitar licks which became the band's unique sound. 1965's *Feel A Whole Lot Better* (U.K. #4) and *Turn! Turn! Turn!* (U.S. #1) were great songs that continued in the same vein. Further hits *Eight Miles High* (1966) and *So You Want To Be A Rock n Roll Star* followed before the late Gram Parsons spent time with the group in 1968. They were truly a groundbreaking band in those heady days and most members remain working now.

32

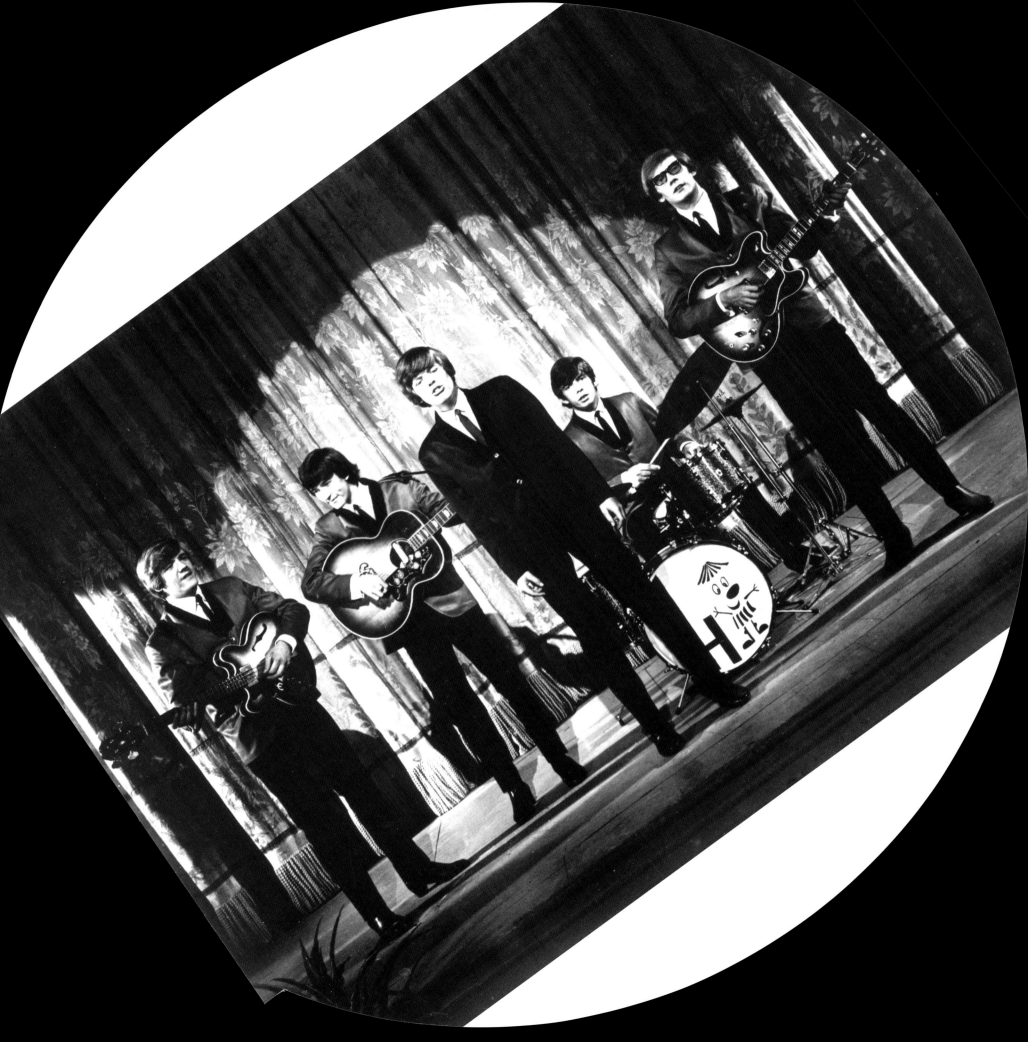

The Temptations

Otis Miles (Otis Williams), Melvin Franklin, Eddie Kendricks, Paul Williams and Al Bryant (and later David Ruffin) became the mighty 'Tempts' in 1960 when three high school groups combined to give the world arguably the greatest known soul act of all time. Signed to Motown Records they released *Isn't She Pretty* and *Dream Come True* in 1962, which both showed promise but didn't chart too well. Al Bryant left the group and singer David Ruffin was to step in. They cut Smokey Robinson's *The Way You Do The Things You Do* in 1963 and it was a bigger success but 1964's *My Girl* with Ruffin on lead was the breakthrough. With it's superb vocal and smooth back-ups sung in perfect harmony it was a sensational hit going #1. They followed with *Get Ready* (1965), *Aint Too Proud To Beg* (1966) and teamed up with the Supremes for 1969's massive *I'm Gonna Make You Love Me*. The masters of soul were inducted into the Rock And Roll Hall Of Fame in 1989.

The Four Tops

Formed in 1954 and originally called 'The Four Aims', the group consisted of Levi Stubbs, Abdul "Duke" Fakir, Renaldo "Obie" Benson and Lawrence Payton. They changed their name to the catchier Four Tops and performed in clubs for years releasing sub-standard records on various labels. They finally struck lucky in 1964 on Motown Records with *Baby I Need Your Lovin* which hit #11 and elevated the group to star status. By 1966 they'd released *Same Old Song*, #1 hits *I Can't Help Myself* and *Reach Out And I'll Be There* which gave them a reputation for pumping out some of the most heart-felt soul music of the time. They continued to play and changed direction somewhat in the 70's but are best remembered for their classic selections of the mid 60's.

Donovan

Born Donovan Leitch in Glasgow, Scotland, 1946. Suffering polio as a youngster he overcame the illness to become a talented young singer and was a part of the 1964 south coast folk scene. After appearing on TV's "Ready-Steady-Go" he had a hit with his own composition *Catch The Wind*. The single *Colours* was also a success and at 18 he'd arrived on the burgeoning folk scene. His style began to solidify with the album 'Fairy-Tale' and the track *Jersey Thursday*"was a solid hit. By 1969 he'd released the psychedelic hits *Mellow Yellow* (with Paul McCartney on back-up vocal), *Sunshine Superman* and *Hurdy Gurdy Man* (with Jeff Beck on guitar). Donovan hit his peak, retired and actually lived in the Californian desert for years before recently returning to his craft.

The Hollies ▶

Formed in the early 60's, The Hollies (Bobby Elliot, Bernie Calvert, Tony Hicks and Graham Nash) were perhaps the most 'Beatle-alike' band of the British Invasion. On Parlophone records (also the Beatles' label) they released *Just One Look* in 1963, already recorded by Doris Troy the song was a huge hit for the boys. Through the mid 60's they released the fantastic *Bus Stop* as well as *Look Through Any Window* and *I'm Alive*. The squeaky clean group had become famous independent of their Fab Four friends. Member Graham Nash was to go on to help form Crosby, Stills, Nash & Young who were an acclaimed success. The Hollies continued touring and with altered line-up they still perform their memorable repertoire.

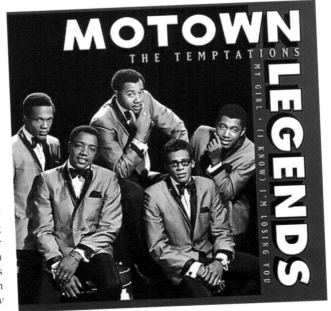

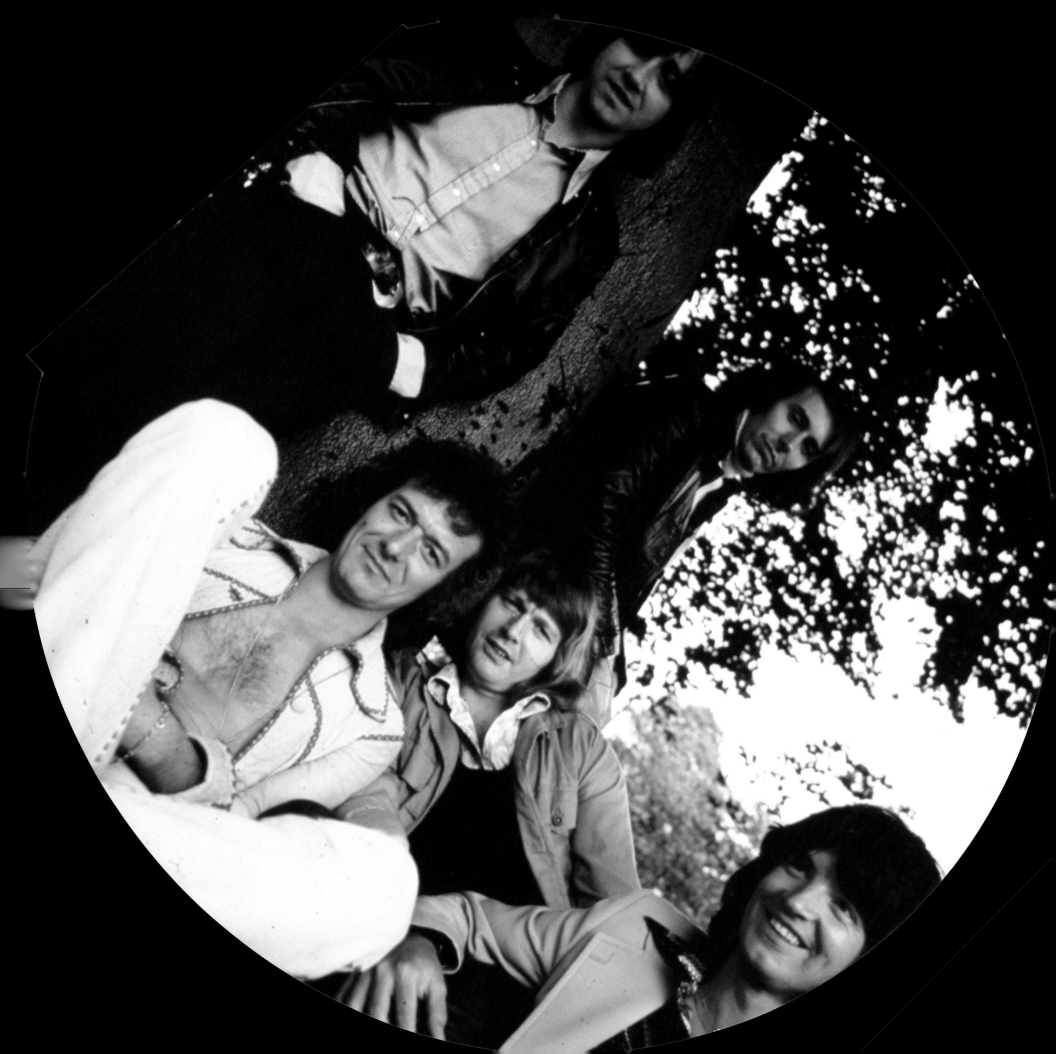

Sonny & Cher

American favourites Salvatore "Sonny" Bono (born 1935) and Cherilyn Sarkasian Lapierre (born 1946) first appeared together in a combo called Caeser and Cleo. Bono was already working for Berry Gordy Jnr of Motown and met Lapierre in 1963 who'd recorded a song called *Ringo, I Love You*. He became interested in her and not only musically. They formed a duo known for their wise-cracking banter and as Sonny & Cher they released *I Got You Babe* and *The Beat Goes On* for Atco Records which were their biggest hits. They spent years married (divorced since) and whilst neither was initially a great vocalist they continued to have chart success and of course their own prime time TV show. Cher has matured and endured musically and maintains a strong solo career whilst sadly Sonny died in a skiing accident in 1998.

The Monkees

Davy Jones (U.K.), Michael Nesmith, Micky Dolenz and Peter Tork made up the four actor/singers who were assembled by TV producers Bob Rafelson and Bert Schneider to create the zany musical comedy show. Inspired by the Beatles' "Hard Day's Night" antics on film they tried to create a catchy TV version. The successful U.S. show resulted complete with catchy songs penned by Carole King, Gerry Goffin and Neil Diamond amongst others. Although the actual Monkees didn't really play on them and between (not unusual in the music industry) they did sing on them and their albums. The Monkees released many hit records. These included singles *Hey, Hey Were The Monkees*, *Last Train To Clarksville*, *I'm A Believer*, *Words* and *Stepping Stone*. They did appear live for a series of shows in 1967 as the unlikely headline to support act Jimi Hendrix. Reunion tours have ensued in the years since but the original TV series remains best remembered.

The Who ▲

Roger Daltrey (vocals), Pete Townshend (guitar), Keith Moon (drums) and John Entwistle (bass) formed the legendary U.K. group that thrived and evolved for years beyond the British Invasion's initial phase. The band was formed when school friends Daltrey, Townshend and Entwistle recruited colourful character Keith Moon in the early 60's and by 1965 had released hits *I Can't Explain* and the youth anthem *My Generation*. These early songs, which began to display Townshend's genius writing ability, completely summed up the feel of the era and The Who became a sensation. They released debut LP 'The Who Sings My Generation', in 1966 for Festival Records. Success followed and their renowned microphone swinging, instrument smashing wild antics on stage elevated them to super star status. The string of classic hits put out over the next few years included *Happy Jack*, *I Can See For Miles*, *Magic Bus* and *Substitute*. 1971's released the album version of 'Tommy'. The amazing LP which boasted *Pinball Wizard* and the resulting movie were a bizarre musical Townshend had cooked up named 'Tommy'. The amazing LP. In 1969 The Who 'Who's Next and 1978's 'Who Are You' saw them remain pioneers of pop music with a different sounding yet equally great set of songs released. Sadly Keith Moon and John Entwistle have passed on but the timeless music of the Who will live for some time yet.

The Mamas And The Papas

Made up of Cass Elliot (Mama Cass), Holly Michelle Gilliam (Michele Phillips), John Phillips and Denny Doherty. In 1962 they formed the folk inspired group in California where they released debut LP 'If You Can Believe Your Eyes And Ears' (1966 on Dunhill). It contained the smash single *California Dreamin'* and The Mamas And The Papas had arrived. The sound was perfect for the flower-power scene and they struck it big. John Phillips would write beautifully

36

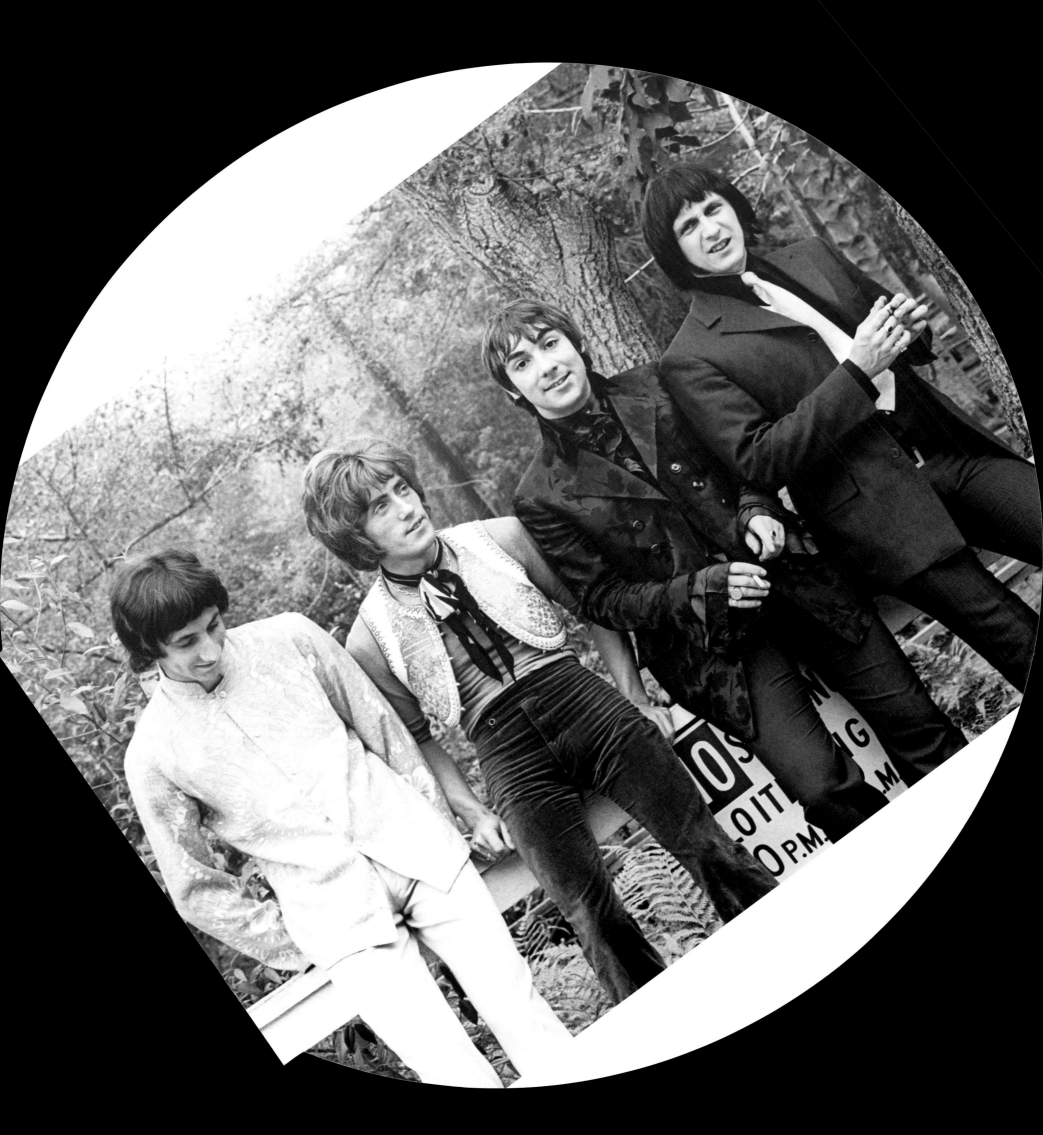

constructed songs teeming with harmonies and social reference that played an important role in the changing times. Further hits *Monday, Monday* and *Dedicated To The One I Love* followed and with popular *larger than life* Mama Cass often on to pen the classic *San Francisco* into history. John Phillips went on to lead vocal they etched themselves before he passed away in 2001 as did Cass Elliot in 1971.

Simon And Garfunkel

Paul Simon and Arthur Garfunkel were school friends in mid 50's New York City when they began playing together. As 'Tom and Jerry' they released *Hey Schoolgirl* in 1957 and had a #49 Billboard hit. They broke temporarily to complete studies and had a re-united as Simon & Garfunkel to release 1964's *Wednesday Morning 3AM* (Columbia). The debut album sold poorly and Paul Simon left for the U.K. where he recorded a solo LP 'The Paul Simon Songbook' in 1965. Later that year one of the tracks from '3AM', *The Sound Of Silence* was being played increasingly on radio stations and with a modified electric sound it was re-released and hit #1. This spurred them to give it another try which resulted in the classics *Bridge Over Troubled Water, Cecilia, The Boxer* and *The 59th Street Bridge Song (Feelin' Groovy)* as well as many others. Paul Simon's success as a solo artist and Garfunkel's acting marked another split in the 70's however the group has re-united since, even as recently as Rome's 2004 Colosseum appearance.

Gladys Knight And The Pips

Gladys and brother Bubba teamed up with cousins William Guest and Edward Patten in the early 60's to form the group and released minor hits *Every Beat Of My Heart* and *Letter Full Of Tears*. The songs came out on small time labels but drew the attention of Motown Records to whom they signed in 1965. Their classic funk infused version of *Heard It Through The Grapevine* was released and became a pop and R&B smash. Gladys' smooth yet gutsy soul voice was also perfect for ballads *Neither One Of Us* and *If I Were Your Woman* where they did well for Motown. In 1973 they changed to Buddah Records which produced slicker sounding hits including *I've Got To Use My Imagination* and *Midnight Train To Georgia*. This era gave Gladys Knight And The Pips their greatest chart success to date. Eventually they went their separate ways and Gladys is now happily involved in Gospel Music.

GLADYS KNIGHT & THE PIPS GOLD

Cat Stevens

Born Steve Georgiou in England, 1947. Descended from Swedish and Greek lineage he had an early success with his 'Matthew And Son' album released in 1967 with the title single going #2. *I'm Gonna Get Me A Gun* from the same album made #6. After a two year break brought on by tuberculosis he returned as Cat Stevens and made some of the best albums to have emerged in popular music. 1970's 'Tea For The Tillerman' and 1971's 'Teaser And The Firecat' boasted the hits *Wild World, Morning Has Broken, Moonshadow, Father And Son, Peace Train* amongst others and put Cat at the forefront of socially influenced song writing. His popularity slowed as the 70's progressed and he surprised all changing his name to Yusuf Islam and converted to the Muslim faith. He still plays music today and maintains a role in matters related to the release of his back catalogue.

Procol Harem

Their massive 1967 hit *Whiter Shade Of Pale* on Decca Records was the defining moment for members Gary Brooke and Keith Reid. They were already studio musicians who began playing the song live only after it was released. With their somewhat experimental yet classic blues based sound they also had a hit with the song *Conquistador*. The band was renowned for its revolving roster of players which included brilliant guitar man Robin Trower. Procol Harem had one other hit with

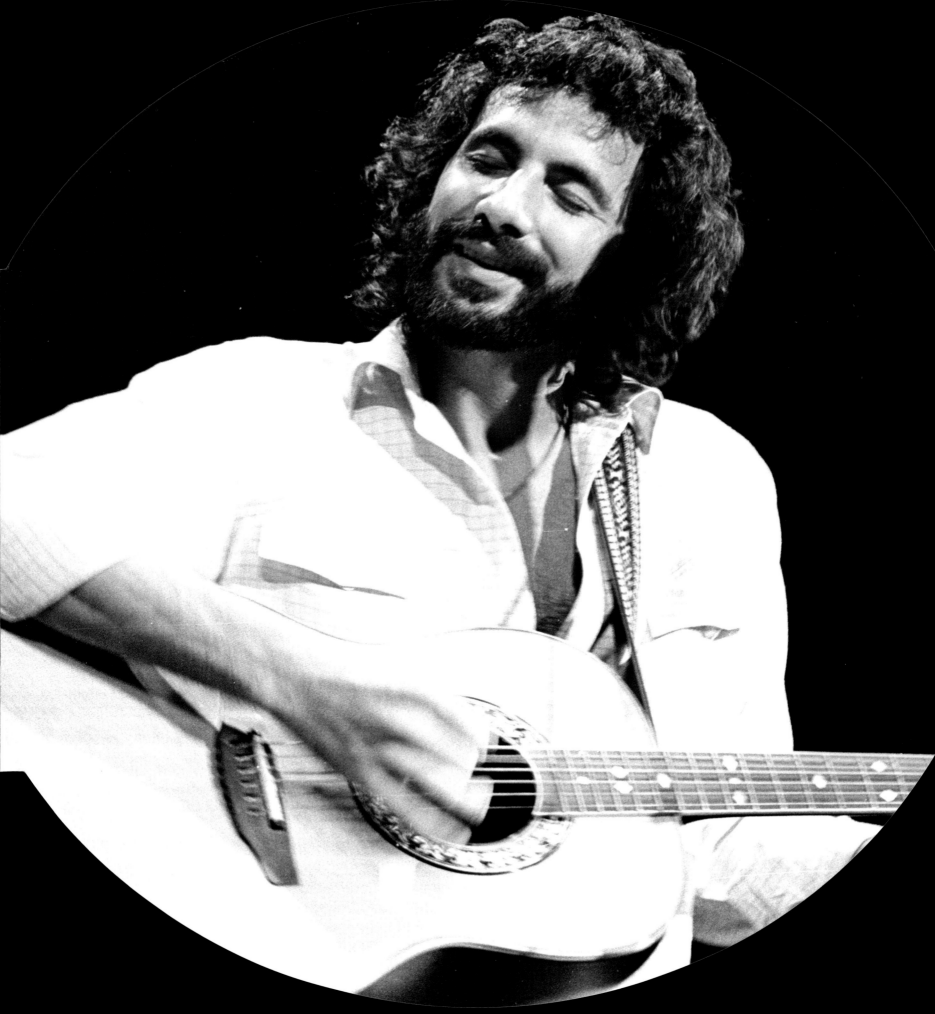

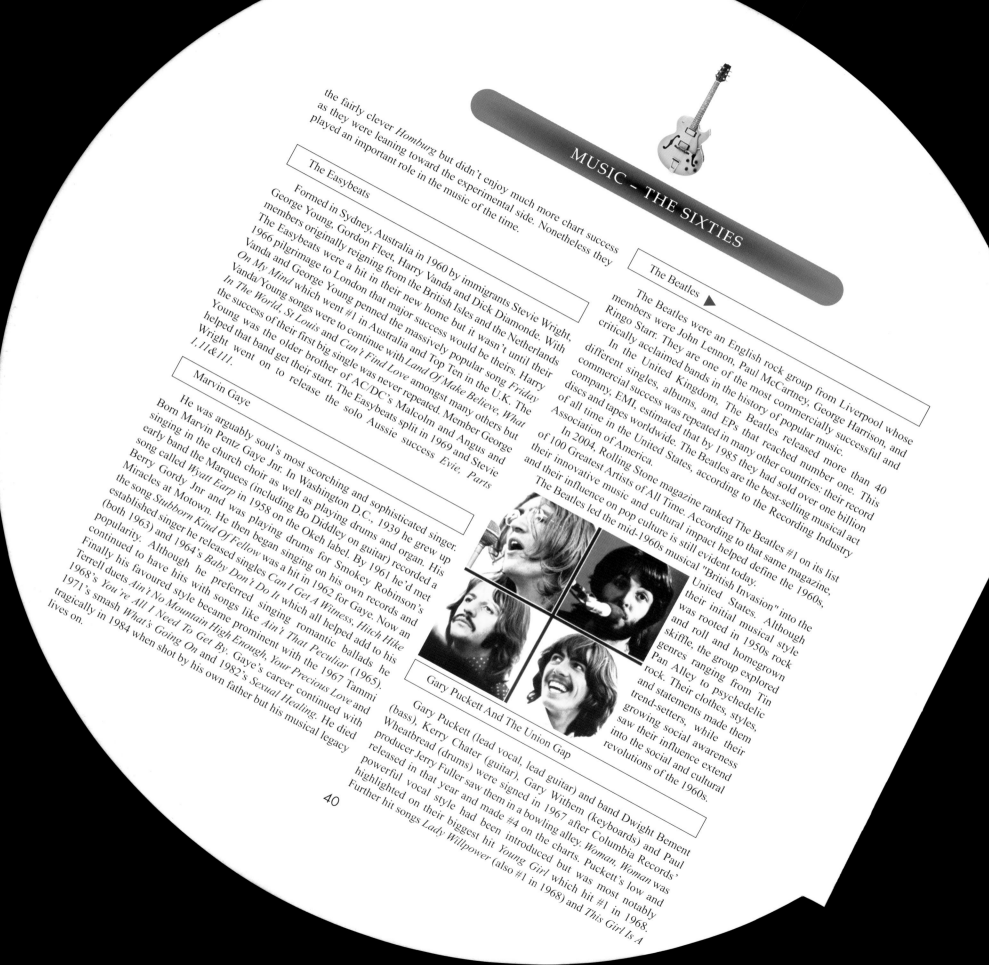

the fairly clever *Homburg* but didn't enjoy much more chart success as they were leaning toward the experimental side. Nonetheless they played an important role in the music of the time.

The Easybeats

Formed in Sydney, Australia in 1960 by immigrants Stevie Wright, George Young, Gordon Fleet, Harry Vanda and Dick Diamonde. With members originally reigning from the British Isles and the Netherlands The Easybeats were a hit in their new home but it wasn't until their 1966 pilgrimage to London that major success would be theirs. Harry Vanda and George Young penned the massively popular song *Friday On My Mind* which went #1 in Australia and Top Ten in the U.K. The Vanda/Young songs were to continue with *Land Of Make Believe, What In The World, St Louis* and *Can't Find Love* amongst many others but the success of their first big single was never repeated. Member George Young was the older brother of AC/DC's Malcolm and Angus and helped that band get their start. The Easybeats split in 1969 and Stevie Wright went on to release the solo Aussie success *Evie, Parts 1,11&111.*

Marvin Gaye

He was arguably soul's most scorching and sophisticated singer. Born Marvin Pentz Gaye Jnr. In Washington D.C. 1939 he grew up singing in the church choir as well as playing drums and organ. His early band the Marquees (including Bo Diddley on guitar) recorded a song called *Wyatt Earp* in 1958 on the Okeh label. By 1961 he'd met Berry Gordy Jnr and was playing drums for Smokey Robinson's Miracles at Motown. He then began singing on his own records and established singer he released singles *Can I Get A Witness, Hitch Hike* (both 1963) and 1964's *Baby Don't Do It* which all helped add to his popularity. Although he preferred singing romantic ballads he continued to have hits with songs like *Ain't That Peculiar* (1965). Finally his favoured style became prominent with the 1967 Tammi Terrell duets *Ain't No Mountain High Enough, Your Precious Love* and 1968's *You're All I Need To Get By.* Gaye's career continued with 1971's smash *What's Going On* and 1982's *Sexual Healing.* He died tragically in 1984 when shot by his own father but his musical legacy lives on.

The Beatles

The Beatles were an English rock group from Liverpool whose members were John Lennon, Paul McCartney, George Harrison, and Ringo Starr. They are one of the most commercially successful and critically acclaimed bands in the history of popular music.

In the United Kingdom, The Beatles released more than 40 different singles, albums, and EPs that reached number one. This commercial success was repeated in many other countries: their record company, EMI, estimated that by 1985 they had sold over one billion discs and tapes worldwide. The Beatles are the best-selling musical act of all time in the United States, according to the Recording Industry Association of America.

In 2004, Rolling Stone magazine ranked The Beatles #1 on its list of 100 Greatest Artists of All Time. According to that same magazine, their innovative music and cultural impact helped define the 1960s, and their influence on pop culture is still evident today.

The Beatles led the mid-1960s musical "British Invasion" into the United States. Although their initial musical style was rooted in 1950s rock and roll and homegrown skiffle, the group explored genres ranging from Tin Pan Alley to psychedelic rock. Their clothes, styles, and statements made them trend-setters, while their growing social awareness saw their influence extend into the social and cultural revolutions of the 1960s.

Gary Puckett And The Union Gap

Gary Puckett (lead vocal, lead guitar) and band Dwight Bement (bass), Kerry Chater (guitar), Gary Withem (keyboards) and Paul Wheatbread (drums) were signed in 1967 after Columbia Records' producer Jerry Fuller saw them in a bowling alley. *Woman, Woman* was released in that year and made #4 on the charts. Puckett's low and powerful vocal style had been introduced but was most notably highlighted on their biggest hit *Young Girl* which hit #1 in 1968. Further hit songs *Lady Willpower* (also #1 in 1968) and *This Girl Is A*

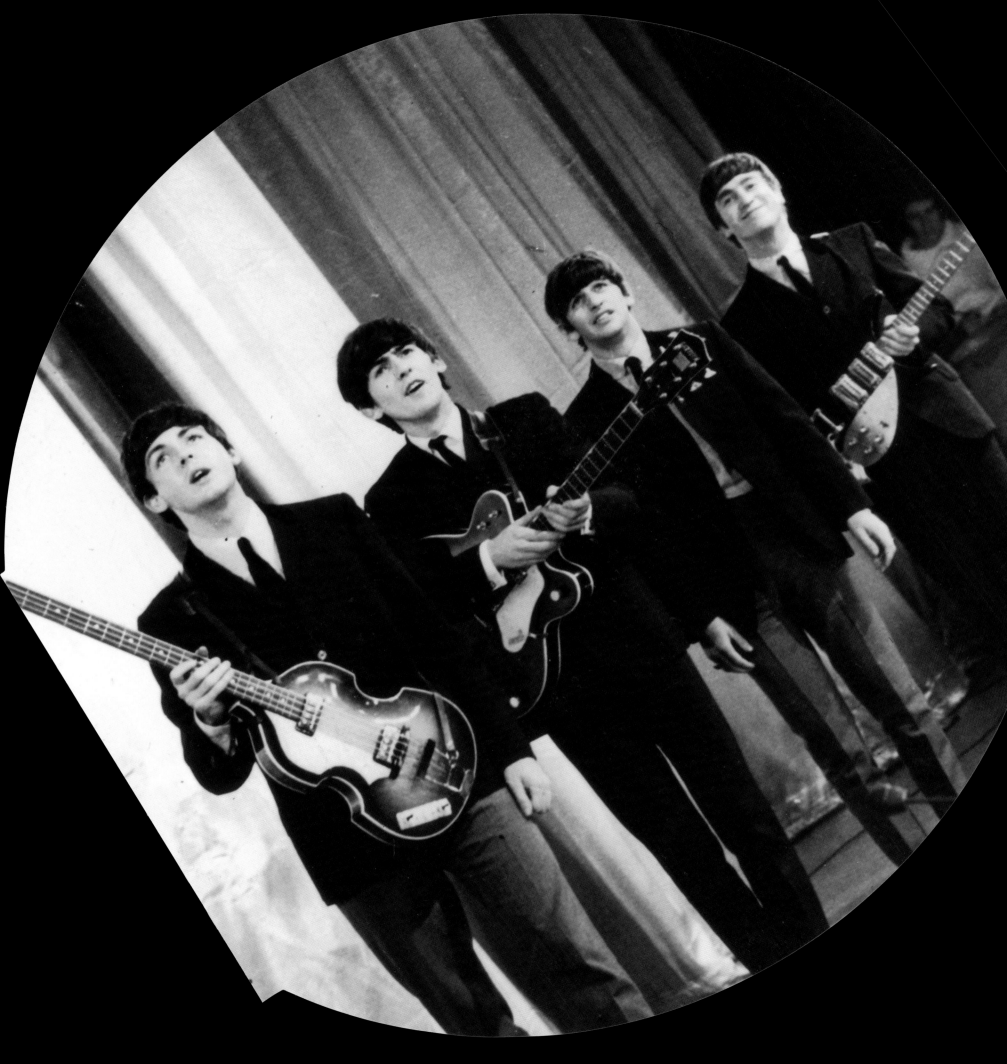

Woman Now (1969) would follow but their signature *Young Girl* would be the most enduring. Ironically the friendly Puckett's easy-going personality seemed at odds with his enormous stage persona and voice. Whatever the case they were one of the greatest and most unique acts to have emerged from the 60's.

Richard Harris

Born in Ireland, 1930, Harris was the charismatic singer/actor who'd started on the stage playing King Arthur in 'Camelot' and ended a legendary career after completing roles in modern epics 'Gladiator' and the 'Harry Potter' series of movies. In the late 60's he showcased his singing talent with the release of LPs 'A Tramp Shining', 'MacArthur Park', 'The Yard Went On Forever' and later in 1982 the original London cast recording of 'Camelot'. With his trademark well enunciated vocals he sang *If You Must Leave My Life* and *Lovers Such As I*, as well as dozens of other ballads plus some slightly more up-tempo numbers. Most of this work was achieved in collaboration with music man Jimmy Webb who helped write and produce the material. Other memorable moments include 1973's 'Jonathan Livingston Seagull' and his music combined with his innumerable acting achievements made for a rich life. He passed away in 2002 at age 72.

Steppenwolf ▲

The remarkable John Kay was born Joachim Krauledat in East Germany, 1944. After escaping the communist block country he wound up in Canada and then San Francisco in 1965. The mostly blind singer had played in the band Sparrow but after little success he formed Steppenwolf in 1967. The third single released by the band was the classic *Born To Be Wild* which boasted the line "Heavy Metal Thunder" and gave name to the new style of music. *Born To Be Wild* remains one of the greatest and most simple rock anthems and was used in Dennis Hopper's landmark film 'Easy Rider'. *Magic Carpet Ride* was the next single and also became a million-seller. The next few releases including *Who Needs Ya, Rock Me* and *Move Over* didn't sell as well but kept the band in the charts. They split in the mid-seventies but have reunited and had a full touring schedule in 2005.

Jose Feliciano

This blind genius guitarist and singer was born in Puerto Rico, 1945. At age five he moved with his poor family to New York City. He'd taught himself concertina and guitar by the time he was a teenager using only records he'd listened to. After playing in clubs around Greenwich Village he made a trip to Argentina in 1966 where he was signed to RCA Records. Feliciano recorded some old 'bolero' songs in his own style and the results were amazing. *Usted* and *Poquita Fe* were smash hits in South America which sparked a run of three LPs that were to make him a local star. Back in the states he was encouraged to release a version of the Doors' *Light My Fire* which he'd applied his unique jazz and pop influences on to come up with a smouldering version. It was a #1 hit in the U.S. in 1968 and his versions of *Che Sera* and the Christmas standard *Feliz Navidad* were also smashes for Jose. Through countless albums and appearances both solo and with an array of other artists, he remains extremely popular in many countries and can be easily found still playing currently.

The American Breed

The Chicago band was known formerly as 'Gary And The Nite Lites' before changing their name to American Breed. Gary Loizzo, Al Ciner, Charles Colbert and Lee Graziano broke out with 1967's super-catchy *Bend Me, Shape Me*. The single went gold for the boys and they also enjoyed Top 30 success with *Step Out Of Your Mind*. The pop

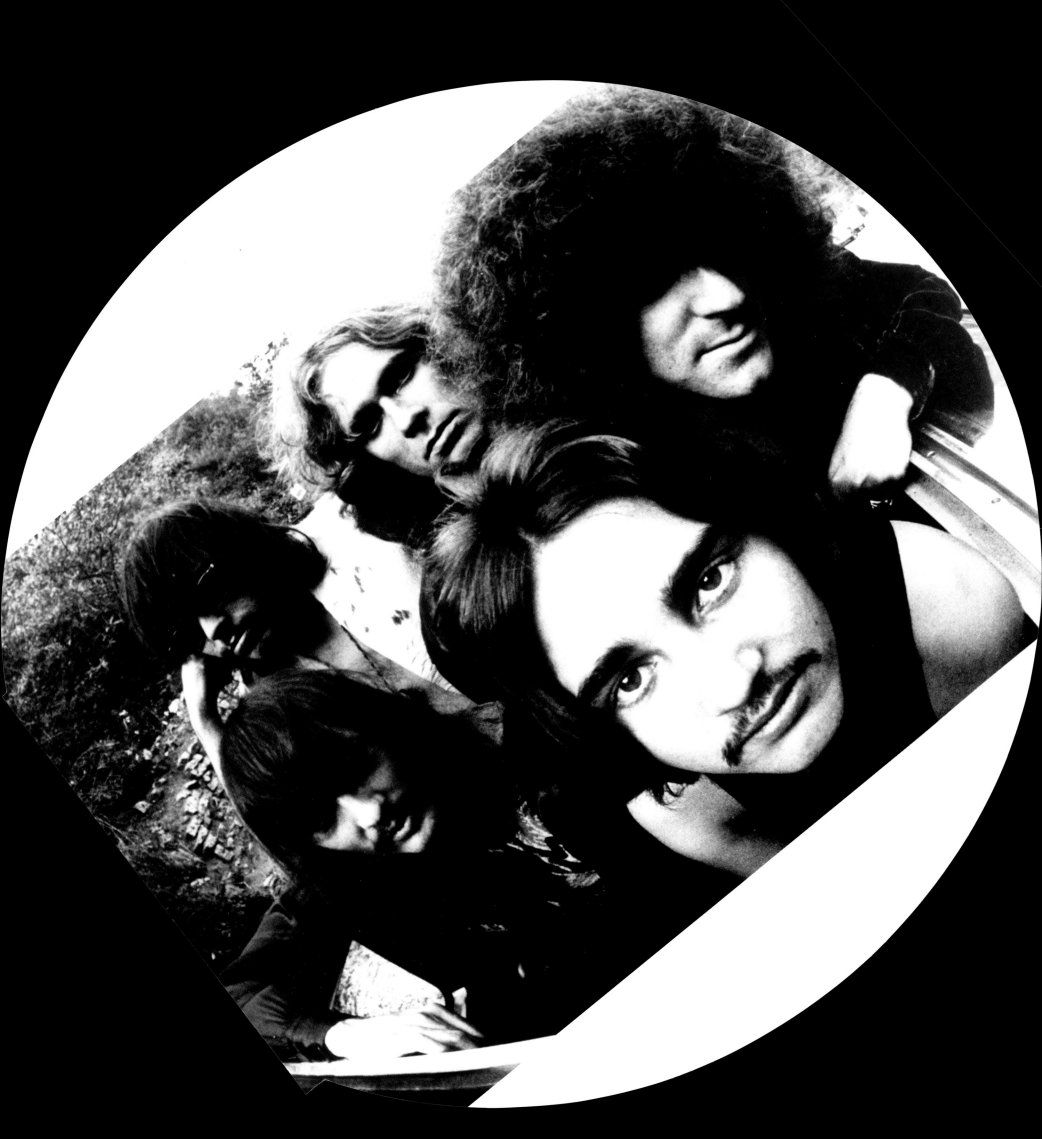

laden soul songs continued with 1968's *Green Light* but the band had run its course and had nothing new to offer. Members Ciner, Colbert and Graziano evolved into the funk-soul group 'Ask Rufus' (later just 'Rufus') which was eventually joined by singer/percussionist Chaka Khan.

Woman followed it into the top ten. *Fireball* and *Machine Head* also topped the album chart. The latter included, perennial favourite *Smoke On The Water*. Although the platinum-selling, *Made In Japan* captured their live prowess, relations within Deep Purple were increasingly strained. *Who Do We Think We Are!* marked the end of this line-up as Gillan and Glover departed. David Coverdale (vocals) and Glenn Hughes (bass) brought new inspiration to the group and the releases *Burn* and *Stormbringer* both reached the top ten.

Cream

Cream were the British super group that consisted of Yardbirds' guitarist Eric Clapton, bassist/singer Jack Bruce and drummer Ginger Baker. Their short lived career (about two years) was to have a profound influence on popular music and they were also hailed as the first "power-trio". In 1966 Clapton joined Baker and Bruce who had both played with 'The Graham Bond Organisation' (a British R&B blues band) to form Cream. The LP 'Fresh Cream' was released in 1967 and went Top Ten. Singles *I Feel Free* and *N.S.U* displayed the new blues based style of their original work. They really broke through with LP 'Disraeli Gears' which came out later that year and spawned the singles *Strange Brew* and *Sunshine Of Your Love*. They were a hit with U.S. and U.K. crowds and enjoyed massive success with next album 'Wheels Of Fire' (1968) which contained the majestic *White Room*. These songs contain some of the richest vocals and classic guitar riffs known then or now. Final album 'Goodbye' released in 1969 yielded one more hit with *Badge* which was co-written with George Harrison. Cream split in that year and whilst Baker and Bruce remained musically active, member Eric Clapton went on to even greater successes.

Deep Purple

The English hard rock band Deep Purple formed in 1968. Deep Purple's debut album, *Shades of Deep Purple* included rearrangements of well-known songs, such as *Hey Joe* and *Hush*, the latter becoming a top five US hit. Subsequent releases, *The Book Of Taliesyn* and *Deep Purple* also featured covers like Ike and Tina Turner's *River Deep Mountain High*. In July 1969, Rod Evans and Nick Simper left the group and Ian Gillan (vocals) and Roger Glover (bass) joined the line-up. *Concerto for Group and Orchestra* was recorded with the London Philharmonic Orchestra. Its follow-up, *Deep Purple In Rock*, established the band as a leading heavy metal attraction and introduced the singles, *Speed King* and *Child In Time*. *Black Night*, reached number two and *Strange Kind of*

The Bee Gees

The Bee Gees comprised twins Maurice and Robin Gibb (born 22 December 1949) and elder brother Barry Gibb (born 1 September 1946) – their name was an abbreviation of the Brothers Gibb. The children of a showbusiness family, they played as a child act in several of the London's cinemas. In 1958, the Gibb family emigrated to Australia and the brothers continued performing as a harmony trio. The singles, written by Barry. While *Spicks and Specks* topped the Australian charts, the brothers were on their way to London for an audition with Robert Stigwood. This lead to a record contract with Polydor and the release of the haunting single *New York Mining Disaster 1941*. A second release was *To Love Somebody* and their debut album, *Bee Gees' First* was a hit. By 1967, the Bee Gees had registered their first UK number one single with *Massachusetts*, followed by *Words*. In late 1970, they two major US hits, *Lonely Days* and the chart-

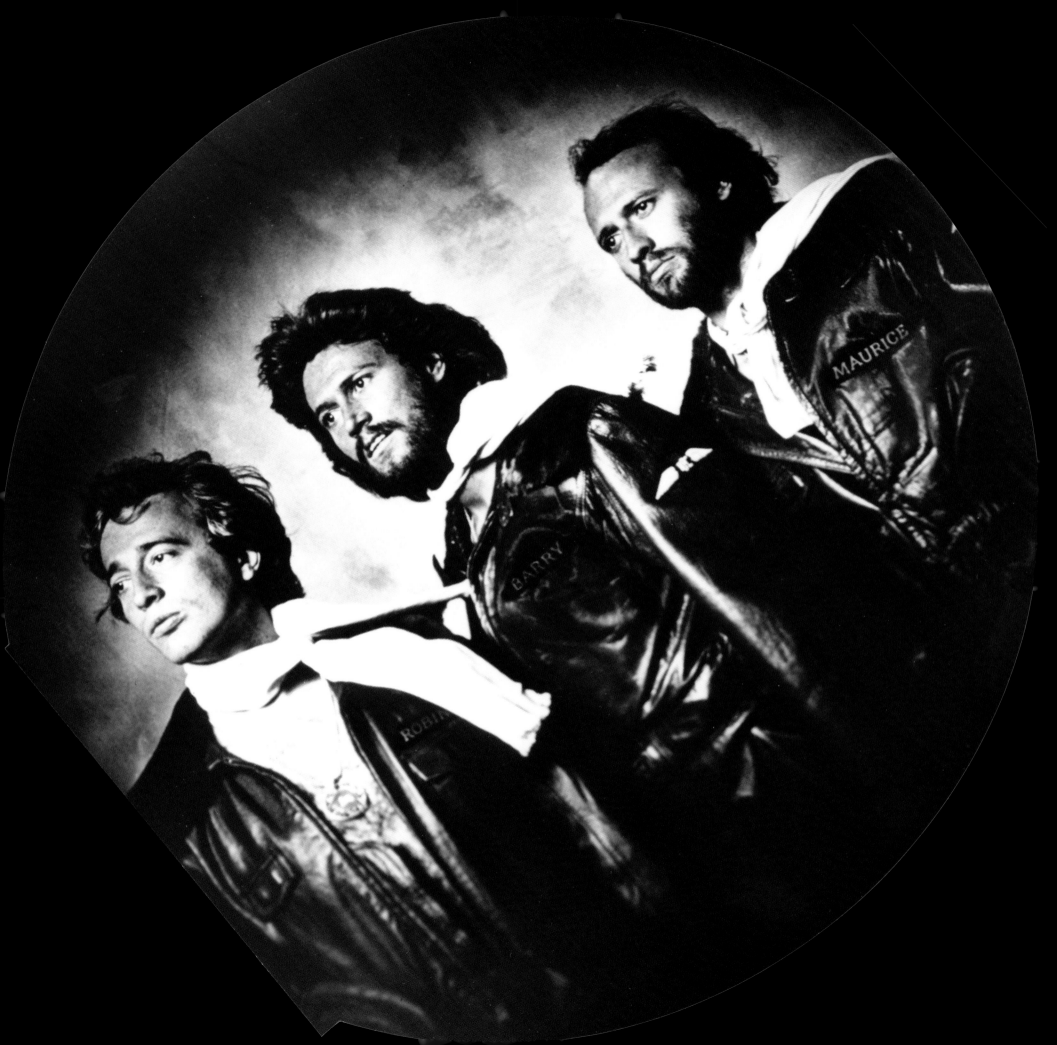

topping *How Can You Mend A Broken Heart*. After the 1972 hits *My World* and *Run to Me*, the group's appeal diminished. The Bee Gees reinvented themselves in the mid-1970s as evidenced by the release of *Nights on Broadway*. Their album, *Children of the World* went platinum in the US. They recorded the soundtracks to *Saturday Night Fever* and the single *You Should Be Dancing* reached number one in the US. *Stayin' Alive*. Barry dueted with Barbara Streisand on *Guilty* and *Heartbreaker* with Dionne Warwick. He also wrote *Islands In The Stream* – a hit for Kenny Rogers and Dolly Parton and *Chain Reaction* for Diana Ross. The Bee Gees' 1987 release *ESP* was viewed as a comeback album and included *You Win Again* – their fifth UK number one. Maurice Gibb passed away in 2004.

Mama Cass

She sang with The Smoothies, The Journeymen, The Halifax Three, The Mugwumps, Dave Mason, Denny Doherty and most notably the Mamas And The Papas. Born Ellen Naomi Cohen in 1941, she became an integral part of the New York and Californian folk scenes in the early 60's singing with many of the greats of that genre. Her sense of humour, charisma and amazing vocal ability endeared her to fans and friends and helped her create a great deal of fantastic music before her untimely death in 1974 (of heart attack and not a ham sandwich as popular belief has it). Solo hits after Mamas And The Papas included *Make Your Own Kind Of Music* and *It's Getting 'Better'*. The big lady's big musical contribution during the early decades of pop will not soon be forgotten.

Tom Jones

Born Thomas Jones Woodward in South Wales, 1940. Jones would sing in the family lounge room as well as in the local choir as a boy. He was married by 17 with a son and in 1963 was playing around dance halls and clubs with band Tommy And The Senators. His massive voice got the attention of manager Gordon Mills who moved Tom to London and got him signed to Decca in 1964. The single *It's Not Unusual* was released and the saucy number was a hit on both sides of the Atlantic. He was now appearing with the Spencer Davis Group and the Rolling Stones in concerts and his songs *What's New Pussycat, Never Fall In Love Again, Delilah* and *Help Yourself* were all racing up the charts. Jones had become a major celebrity who befriended musicians such as Elvis Presley - an avid fan of the Welshman. His ever-evolving career

has had amazing longevity with modern hits such as his cover of Prince's *Kiss*.

Status Quo ▲

Francis Rossi, Alan Lancaster, Roy Lines, Rick Parfitt and John Coghlan made up the group once known as 'The Spectres'. The band was signed to Piccadilly Records in 1966 but were largely unsuccessful with several flop singles released. In 1967 Rick Parfitt from 'The Highlights' joined and they renamed themselves Status Quo. *Pictures Of Matchstick Men* and *Ice In The Sun* (both 1968) gave the band early top ten hits and notoriety but it wasn't until the release of the 1971 LP 'Dog Of Two Head' they'd fully taken upon the blues rock style their better known sound would appear. With *Greasy Spoon* and *Down The Dustpipe* (both 1970) were released that they are now renowned for and subsequent singles *Caroline*, *Roll Over Lay Down, Rockin' All Over The World* and *Whatever You Want* were all massive hits. The 'Quo' are still as active as ever with regular tours and recording.

Sly And The Family Stone

Sylvester Stewart was born in Texas, 1944. His family moved to San Francisco in the 50's and as a high school student he gained the nick-name Sly and joined rock n roll band 'Joey Piazza And The Continentals'. The multi-instrumentalist had stints as radio DJ and record producer with Autumn Records before forming Sly And The Family Stone in the 60's. The line-up was Cynthia Robinson, Jerry Martini, Rosie Stone, Freddie Stone, Greg Errico and Larry Graham and was perhaps the first popular band to include black, white, male and female members. In 1967 they released the debut LP 'A Whole New Thing' and by the next year had a hit with *Dance To The Music* (Top 10 U.S. charts). The psychedelic funk sound pioneered by the band was further showcased on hits *Thank You* and *Family Affair*. Sly has unfortunately experienced personal and drug-related problems over the years but the rest of the band remain active - especially the now legendary bassist and funk musician extroidanaire Larry Graham.

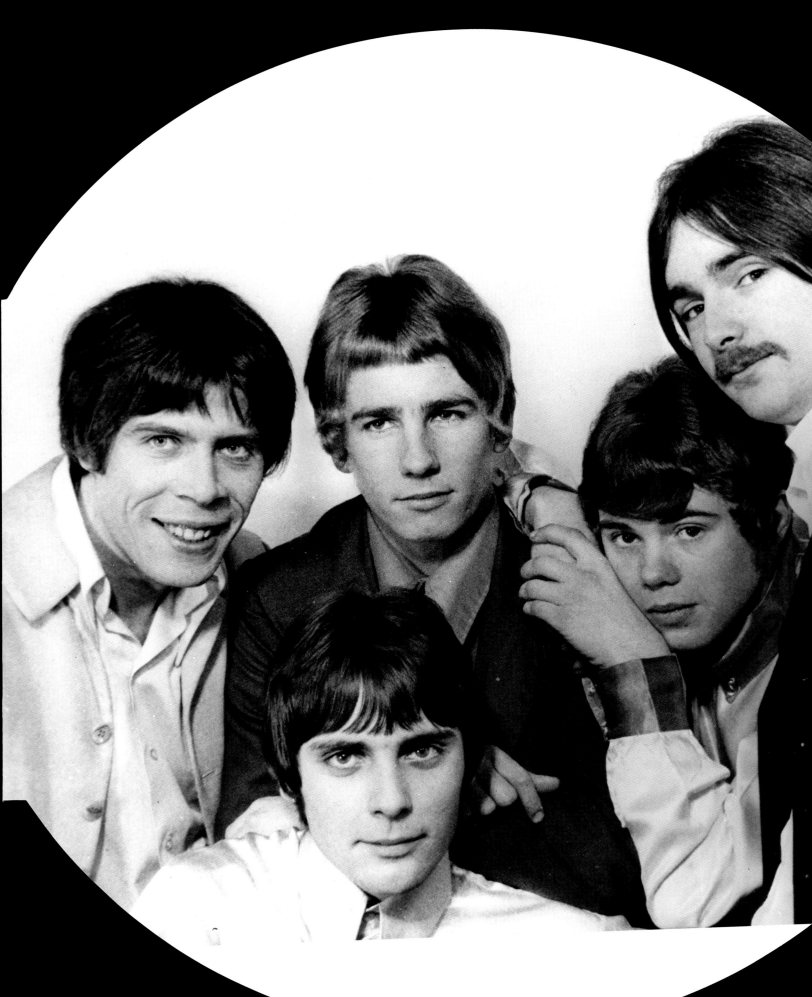

MUSIC – THE SIXTIES

Neil Diamond

Born Neil Leslie Diamond 1941. Neil was handed a guitar on his 16th birthday and he'd penned his first song *Hear Them Bells* for his girlfriend at the time. In 1962 he was signed to Columbia Records and by 1966 had his first memorable song *Solitary Man*. He'd begun to make his mark but later that year he would come up with hits *Cherry Cherry* and *I'm A Believer* (a huge hit for the Monkees). He continued the run with 1967's *Red, Red Wine* and 1968's *Shilo* before moving to MCA Records. It was here that he wrote the enormous hit *Sweet Caroline* (1969) as well as *Crunchy Granola Suite* (1969) and *He Ain't Heavy...He's My Brother* (1970). He also penned the classic *Song Sung Blue* and *You Don't Bring Me Flowers* and is best remembered for his 1972 hit live album "Hot August Night". With trademark raspy deep voice Neil continues touring and recording today.

Zager And Evans

Denny Zager, Rick Evans, Dave Trupp and Mark Dalton formed Zager And Evans in Nebraska in the late 60's. They're biggest hit *In The Year 2525* was the Orwellian/Huxley style 'doomsday for mankind' song that inspired the minds of music listeners. The song hit #1 in 1969 but the band never came close to repeating this success (second single *Mr Turnkey* made #106 on the charts). Zager And Evans were not a band by which fans could really stand by but the compelling song was as big a hit as many around the time.

Creedence Clearwater Revival

John Fogerty, Tom Fogerty, Stu Cook and Doug Clifford formed this swamp-rock band in a time where simple rock songs were not the current flavour. Breaking through the folk and pop invasions they released their debut self-titled LP in 1968 on Fantasy Records. The single *Suzy Q (parts1&2)* made #11 on the charts and the album went gold. 'Creedence' were launched and second album 'Bayou Country' heralded the standard *Proud Mary* which like all their songs was written by John Fogerty. This song really showed what they were capable of and others like *Bad Moon Rising, Down On The Corner, Lookin' Out My Back Door, Fortunate Son, Travelin' Band* and their cover of Screamin' Jay Hawkins' *I Put A Spell On You* were all smashes for the group. Mis-handling of the band's affairs caused problems over

the years which were eventually resolved and now John Fogerty tours performing the original material.

Blood, Sweat And Tears

Formed by keyboardist Al Kooper and guitarist Steve Katz, the band debuted with the brilliant LP 'Child Is Father To The Man' in 1968. The swirling blues-jazz sound complete with horns was launched on the album which contained no real singles and thus was not promoted on radio. In 1969 Al Kooper left and the line-up was augmented by about eight new players with Katz remaining. *You've Made Me So Very Happy* and *Spinning Wheel* were released and the band's second album (self-titled) was a greater commercial success. After multiple line-up changes and the creation of some excellent groundbreaking and experimental music the band folded in 1976 with members having various successes afterward.

The Spencer Davis Group

The one-time languages student and teacher formed this band responsible for the hits *Keep On Runnin', Gimme Some Lovin', Somebody Help Me* and *I'm A Man* which really defined the times. The group was rounded out with Pete York and brothers Muff and Steve Winwood. Steve went on to form the legendary group Blind Faith with Eric Clapton and had a hugely successful solo career after that. From 1965 the band released many albums which contained the powerful hammond organ meets guitar sound that would become hugely popular. Spencer went on to work for Island records developing talents like Bob Marley and Robert Palmer and now plays with the band 'Rock And Roll Army'.

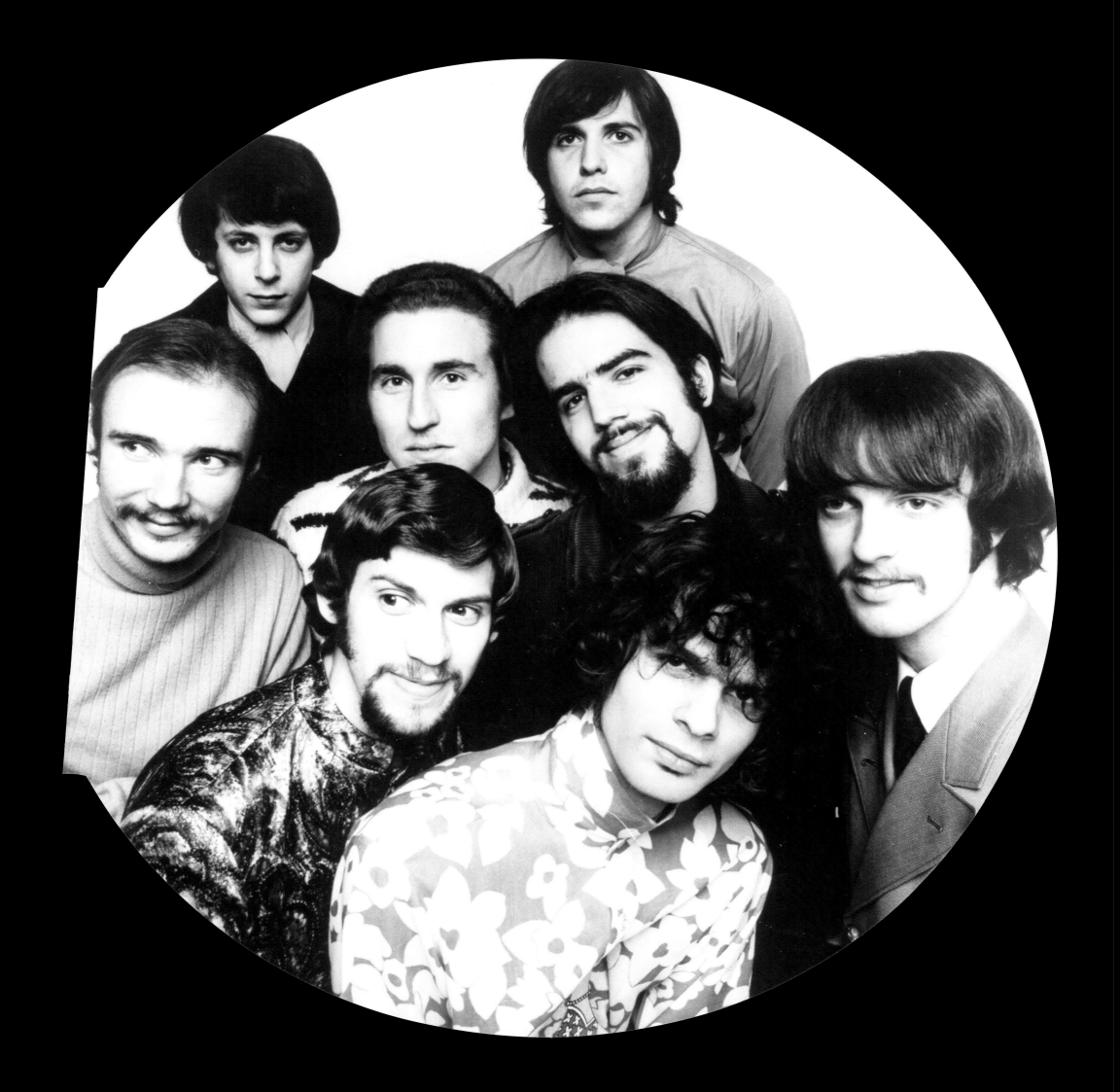

THE SEVENTIES

During the last half of the 1960s the foundations of funk music had been laid by musicians such as James Brown, Sly and the Family Stone and The Temptations. However, it was not until the 1970s that funk music opened the doors to the disco subculture. After rock music's domination of the past 20 years, dance music was reincarnated through the disco. With new instruments such as synthesisers and electronic sounds, music had taken a completely different form unrecognisable from past records.

The female aspect was much more relevant in disco-music than it had ever been in rock music. Several of the early disco singles were sung by women, such as Gloria Gaynor and Grace Jones, establishing a primacy that would endure through the years.

Abba released their song 'Dancing Queen' in 1976. The single went to number one in America and their album broke all advance order records. The band had become so popular that their own movie was released and world tours persisted for almost a decade. The Swedish pop group was the most successful one from their native country and second only to The Beatles in total worldwide sales.

In 1977 the film 'Saturday Night Fever' officially launched disco fever around the world. Millions of kids stopped dreaming of becoming guitarists and started dreaming of becoming acrobatic dancers. Soon disco-music was becoming a mass-market phenomenon. The movie also launched the international stardom of the Bee Gees into participate in the creation to the soundtrack for Saturday Night Fever, and the album broke multiple records for soundtrack sales. Three Bee Gees hits - 'Stayin' Alive', 'How Deep Is Your Love?' and 'Night Fever' reached number 1, launching the most popular age of disco. The album has since sold over 15 million copies worldwide, making it the best selling soundtrack of all time.

After enjoying several years as the leading music genre in wester cultures, disco was rapidly declining in popularity and viability. Music listeners were being drawn to heavy metal and punk music as the 1970s ended. The golden era of disco music essentially ended in 1979, just as Michael Jackson became a solo artist. Jackson went on to release the greatest selling album of all time, Thriller, in 1981 using the disco genre as its backbone. The new form of music used a trivial collage of pop-soul tunes and dance beats, orchestrated by employing state-of-the-art technology such as synthesisers. Though the disco era was relatively short lived, elements of it can be seen in today's dance music.

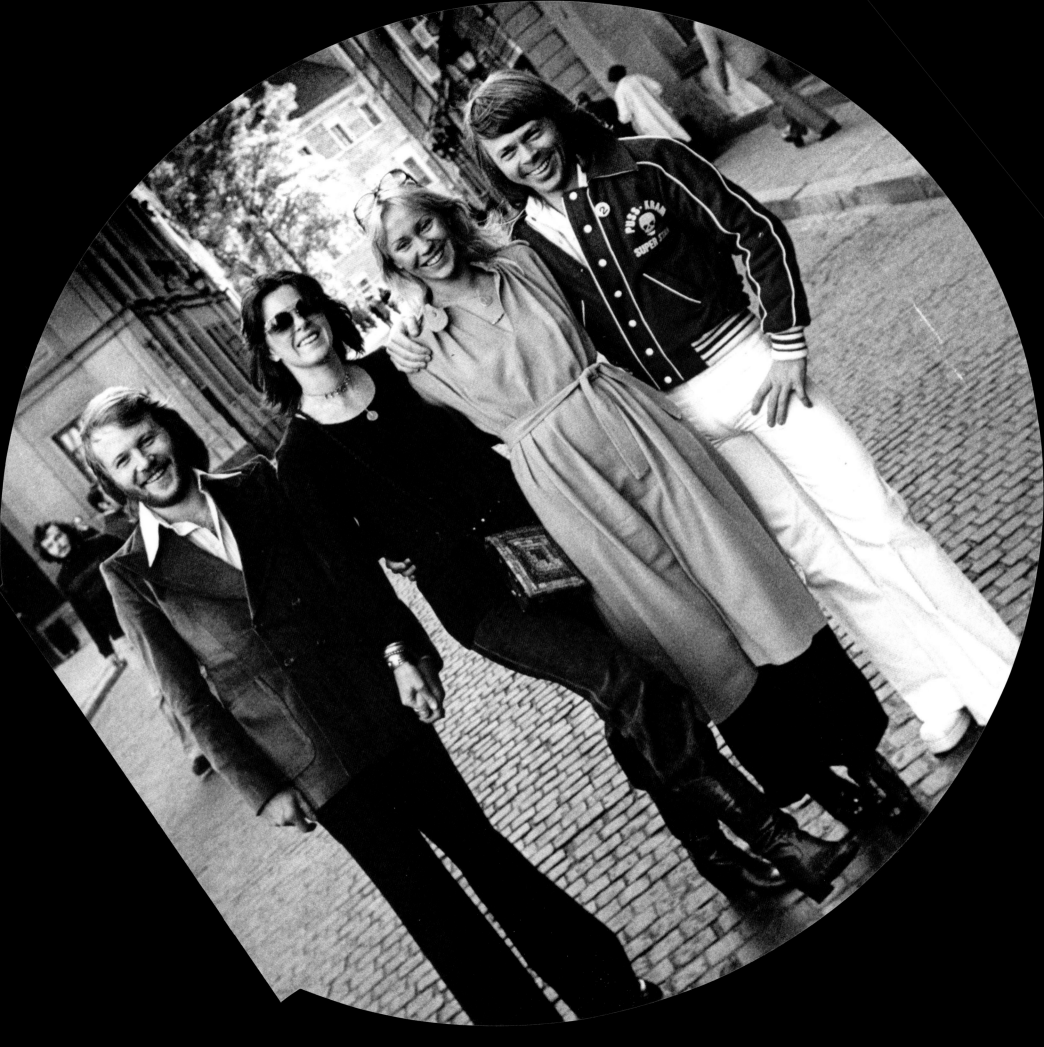

Simon & Garfunkel

American folk rock artists, Paul Simon (born 14 October 1941) and Art Garfunkel (born 5 November 1941) scored a US hit with *Hey, Schoolgirl* in 1957. After reuniting, they parted and returned to college. After producing one album, *Wednesday Morning, 3AM*, which included *The Sound of Silence*, initially failed to sell. Simon went to London where he released *The Paul Simon Songbook*. In the meantime, producer Tom Wilson incorporated electric instrumentation onto the acoustic recording of (renamed) *The Sounds Of Silence*. It subsequently became a classic and went to the top of the US charts. Between 1965 and 1970, Simon & Garfunkel became one of the most successful recording duos in the history of popular music. They were awarded gold records for *Parsley, Sage, Rosemary and Thyme*, *The Sounds of Silence*, *Wednesday Morning, 3AM* and *Bridge Over Troubled Water* which won five Grammy Awards. The partnership dissolved amidst musical disagreements and a realisation that they had grown apart.

The Guess Who

The Guess Who were Canada's most popular rock band in the 1960s and early 1970s. The Guess Who released their debut album *Shakin' all over*. In order to give the impression the group were English, Quality Records printed *Guess Who?* on the cover, and the group adopted this as their new name. In 1967, they had their first UK chart single with *His Girl*. They recorded Coca-Cola commercials and appeared on the television programme 'Let's Go'. In 1969, the single *These Eyes* reached number one in Canada and The Guess Who were signed with RCA records. In 1970 *These Eyes* reached number six in the US. In 1970, *American Woman* became The Guess Who's only US number one. The album *American Woman* was the group's only top ten album in the US. They continued to release charting singles and albums in the early 1970s, including *Albert Flasher* and *Rain Dance*. Their *Greatest Hits* reached number 12. Their well-known single *Clap For The Wolfman*, was written for US disc jockey Wolfman Jack and reached number six in the USA in 1974.

The Carpenters ▶

The Carpenters were a brother and sister duo from Connecticut; Richard Carpenter (born 15 October 1946) was on piano, and Karen Carpenter (born 2 March 1950) on vocals and drums. Along with Wes Jacobs (on bass and tuba) and session bassist Joe Osborn, they won a battle of the bands contest at the Hollywood Bowl and were signed to RCA Records. Jacobs left the group in 1967 to study music. In 1968 Herb Alpert heard some demos The Carpenters had recorded and signed them to A&M Records. In 1969, their debut album *Offering* was issued, but failed to chart. In 1970, a version of Hal David and Burt Bacharach's *Close to You* gave them a number one hit in the USA. The same year, they reached number two in the US singles charts with the Paul Williams/Roger Nichols composition, *We've Only Just Begun* which scored The Carpenters 1971 Grammy Awards for Best New Artist and Best Vocal Performance. In the late 1970s, they had success with cover versions of Herman's Hermits, *There's A Kind of Hush* and Klaatu's *Calling Occupants Of Interplanetary Craft*. In 1983 Karen Carpenter passed away from complications brought on by her struggle with anorexia nervosa. Later that year, Richard Carpenter completed and released *Voice of the Heart*, the album they had been working on.

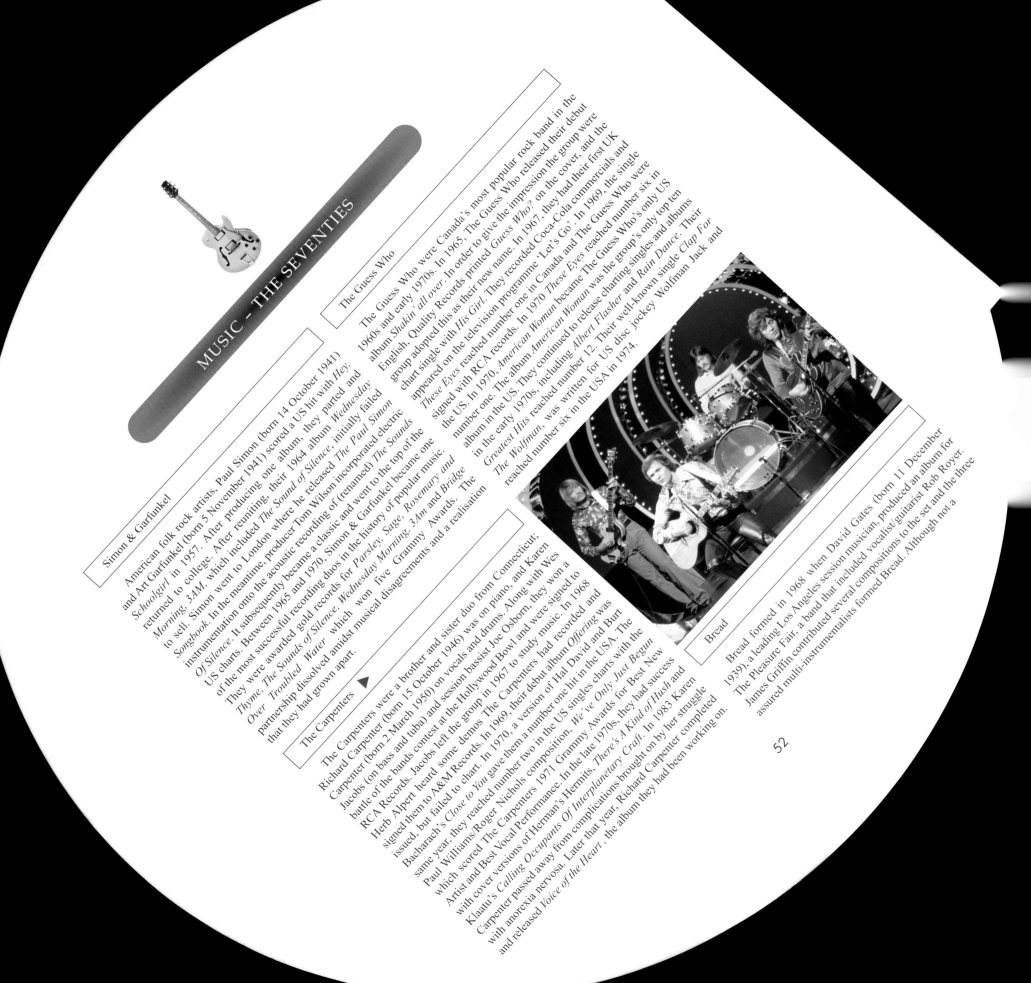

Bread

Bread formed in 1968 when David Gates (born 11 December 1939), a leading Los Angeles session musician, produced an album for The Pleasure Fair, a band that included vocalist/guitarist Rob Royer. James Griffin contributed several compositions to the set and the three assured multi-instrumentalists formed Bread. Although not a

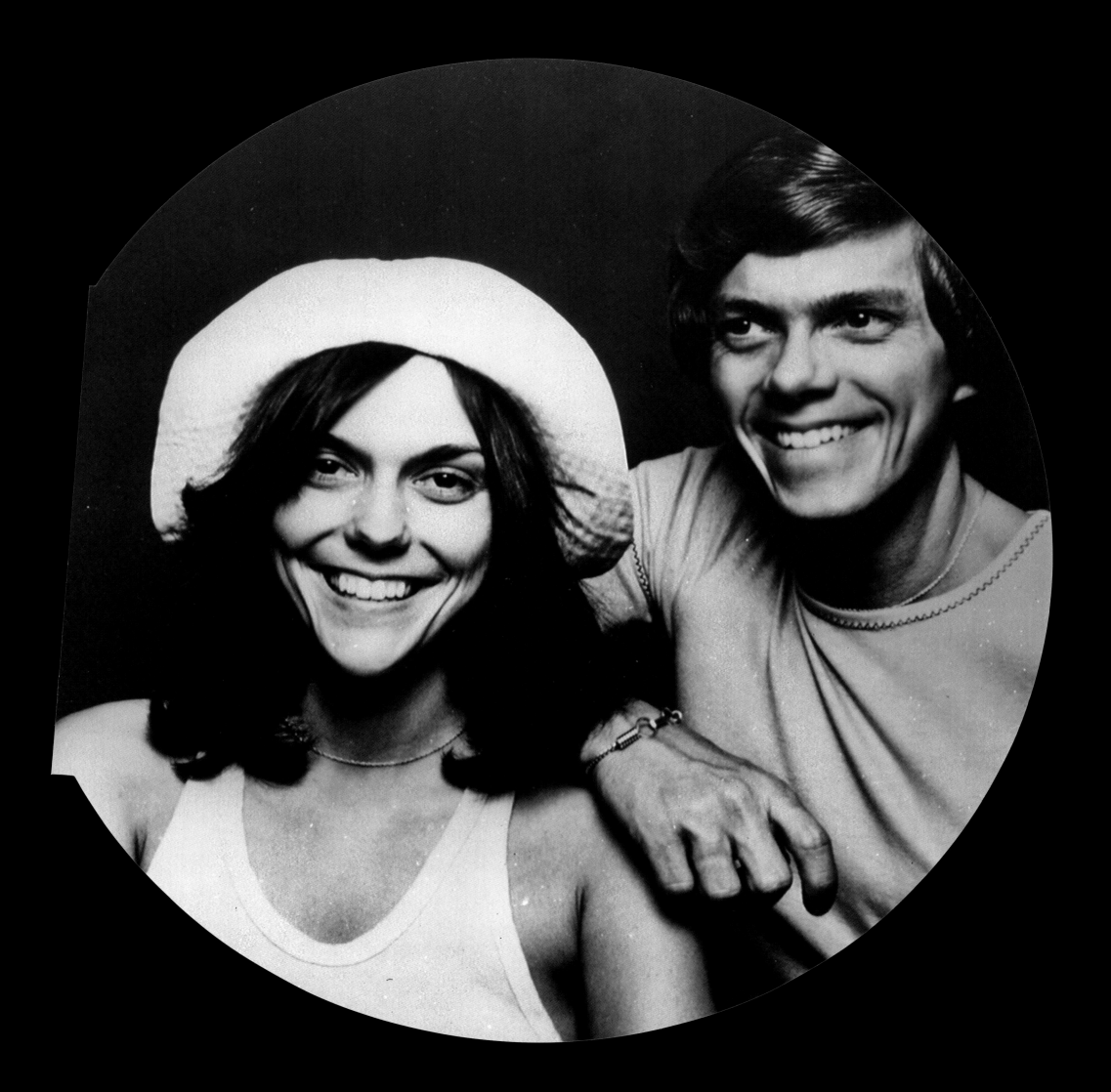

commercial success, Bread's 1969 self-titled debut album established a penchant for melodic, soft rock. Mike Botts augmented the line-up for their second album, *On the Waters*, which included the million-selling US chart topper *Make It With You*. This success lead to *It Don't Matter to Me* (taken from *Bread*), becoming a top ten hit. They embarked on a tour and released *Manna* in 1971which launched another top ten hit *If*. After a series of line-up changes, the single, *Baby I'm-A Want You* was released and became a number three hit. *Everything I Own* reached number five in 1972 and the album *Baby I'm-A Want You* was released and became Bread's most successful album. Their fifth album *Guitar Man* was also released in 1972. The group disbanded in 1973 as a result of friction between Gates and Griffin but regrouped in 1976 releasing *Lost Without Your Love* in 1997, the title track becoming their last top ten hit.

Marmalade

A Scottish pop/rock band, formed in the early 1960s, Marmalade played mostly covers and became confident live performers. They had minor hits with their first three singles, the first of which was produced by George Martin. In total, Marmalade had eight top ten hits including *Ob-la-di Ob-la-da* which was released in 1968. In 1969, they signed a contract with Decca, which gave them the freedom to write and record the material of their choice. *Reflections Of My Life*. An article in the UK tabloid 'News of The World' wrote about drummer Whitehead's debauched activities, which gave Marmalade additional publicity and they had a number one hit single with *Radancer* in 1972. They continued to record throughout the 1970s, and returned to the UK top ten with *Falling Apart at the Seams*. Junior Campbell, an original member of the band, wrote the theme tune for the children's programme *Thomas the Tank Engine*.

Shocking Blue ▲

The Dutch rock band Shocking Blue were formed in 1967 by ex-Motions guitarist Robbie van Leeuwen. This Dutch quartet originally featured lead vocalist Fred de Wilde, bass player Klasje van der Wal and drummer Cornelious van der Beek. After a minor hit *Lucy Brown is Back In Town*, the line-up changed after de Wilde was replaced by Mariska Veres. Veres vamped up the group's image and another hit *Send Me a Postcard Darling* ensued. Next came *Venus*, a massive European hit that also went on to top the US charts in 1970. The all-girl group Bananarama had a hit with their 1980s version of *Venus*. Van Leeuwen composed most of Shocking Blue's material. *At Home* contained *California, Here I Come* and *The Butterfly And I*. A sitar was featured on *Acka Raga*. Shocking Blue remained largely a pop unit and they had another minor hit with *Mighty Joe*, a *Railroad Man*. Van der Wal in Holland and *Never Marry a Railroad Man* was replaced by Henk Smitskamp in 1971 and van Leeuwen withdrew two years later and Martin van Wijk was brought in as a replacement. Shocking Blue split up the following year and Mariska Veres embarked on a solo career.

John Lennon

Born on 9 October 1940 in Liverpool, England, John Winston Lennon was a member of the world's most successful group, The Beatles. John Lennon's solo career began in 1968 with *Unfinished Music No. 1: Two Virgins*. The same year in 1968 with *Unfinished Music No. 2: Life With The Lions*. With his wife Yoko Ono, Lennon attempted to raise public awareness about world peace. Along with their music, he and Ono staged events such as a 'bed-in' at the Amsterdam Hilton as well as 'black bag' appearances on stage. He returned his MBE in a protest against the Biafran and Vietnam wars. 1971 was his most creative year and he released the album *Imagine*, with hits *Power To The People, Happy Xmas (War Is Over)* and the title track. He released *Mind Games* in 1973, a year also famous for his separation from Yoko Ono and the lost weekend' where Lennon spent many months in Los Angeles in a haze of drugs and alcohol. *Walls and Bridges* was released in 1974 and had two major hits, *Whatever Gets You Through The Night* (written with Elton John) and *#9 Dream*. Lennon's final concert appearance was with Elton John at Madison Square Garden and he reunited with Yoko Ono around this period. He was senselessly gunned down outside his New York home by a deranged fan on 8 December 1980.

Norman Greenbaum

Born on 20 November 1942, Norman Greenbaum first hit the US charts as the founder of the Los Angeles band, Dr West's Medicine Show And Junk Band with the novelty song *The Eggplant That Ate Chicago*. After this group broke up in 1967, Greenbaum retired from the music business and ran a dairy farm in California (he later recorded

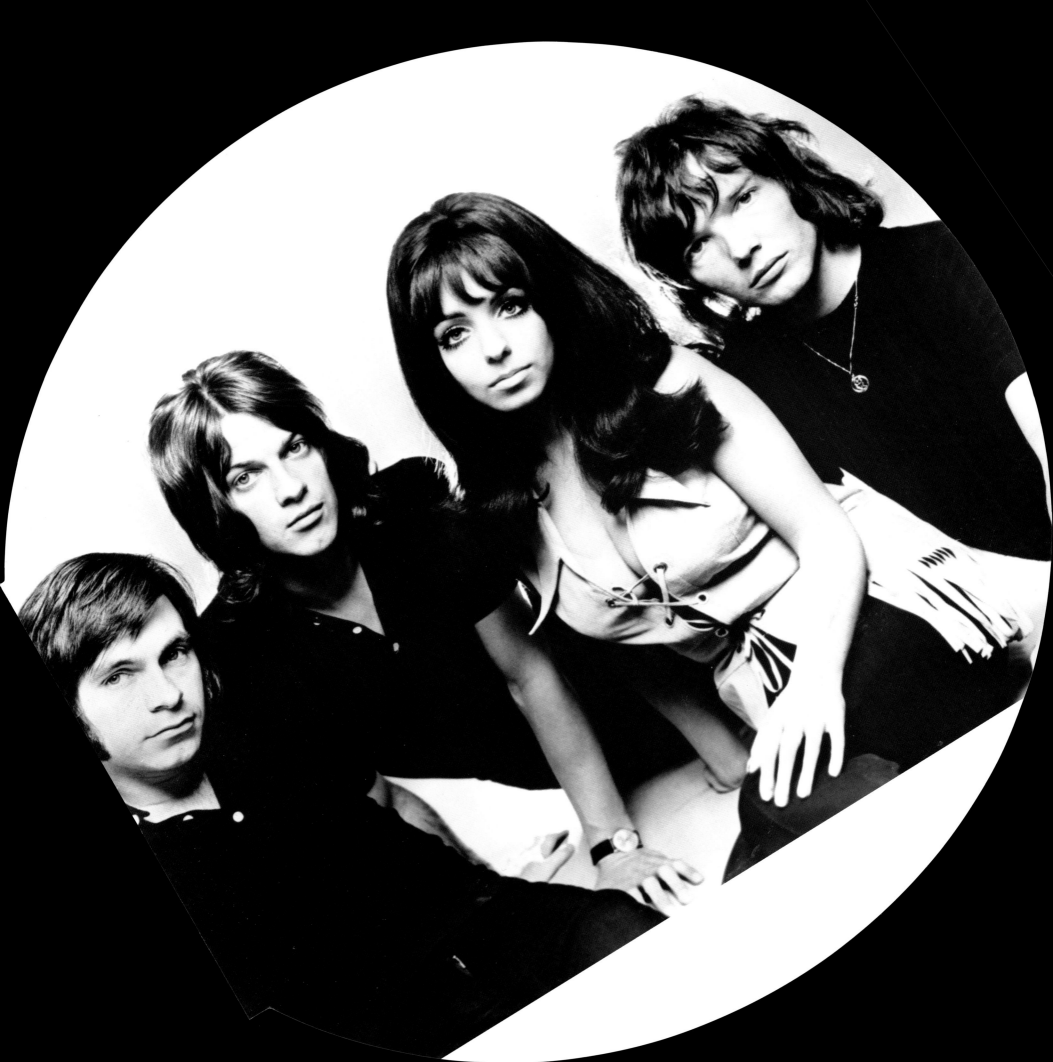

Milk Cow Blues). In 1970, one of Greenbaum's recordings, the uplifting *Spirit in the Sky*, reached number three in the US charts as well as the UK top ten. After this success he recorded a couple of other albums but *Spirit in the Sky* remained a one-hit-wonder. In 1986, the group Doctor and the Medics revived *Spirit in The Sky* and it hit number one in the UK charts for the second time. In the 1990s, *Spirit in the Sky* was used in the Tom Hanks movie *Apollo 13*, leading to the release of a new compilation album.

James Taylor ▶

Born in Massachusetts on 12 March 1948, James Taylor was the embodiment of the American singer-songwriter in the late 1960s and early 1970s, his work a blend of R&B, soul and rock 'n' roll classics. He was married to Carly Simon for ten years and struggled with heroin addiction in the early part of his career. He released *James Taylor* in 1968, which included the hits *Carolina in my Mind* and *Something in the Way She Moves*. His next album *Sweet Baby James*, recorded with friends 'Kootch', Leland Sklar, Russ Kunkel and Carole King, spent two years in the US charts and contained the song *Fire and Rain*. The follow-up *Mud Slide Slim and the Blue Horizon* consolidated the previous success and included Carole King's *You've Got a Friend*. James Taylor worked with Beach Boys' Dennis Wilson on the cult drag-race movie *Two-Lane Blacktop* and released *One Man Dog* in 1972, which had another hit, *Don't Let Me Be Lonely Tonight*. After a period of not so successful recordings, Taylor released the immaculate album *That's Why I'm Here* with *Fire and Rain* in 1985. He received a Grammy award in 1997 for the album *Hourglass*.

Edison Lighthouse

This UK pop group featured session singer Tony Burrows, who also sang with White Plains, The Brotherhood of Man and the Pipkins. The backing musicians were originally part of the band Greenfield Hammer. The Tony Macaulay/Barry Mason composition *Love Grows (Where My Rosemary Goes)* was a hit in 1970 and reached number one in the UK and also hit the US top five. At that stage, Burrows had moved on to other projects, leaving the backing musicians to continue under the name Edison. Macaulay conjured up another line-up with the name Edison Lighthouse for recording and touring purposes. This incarnation managed inclusion in the UK Top 50 with, *It's up to you Petula* before disappearing from the music scene.

Free

Formed in London, England in 1968, the rock band Free originally comprised Paul Rodgers (vocals), Paul Kossoff (guitar), Andy Fraser (bass) and Simon Kirke (drums). After their debut album, *Tons of Sobs*, the group honed a more individual style with their second album *Free*. The album's songs such as, *I'll be Creeping* were powerful and original. Free reached its commercial peak on *Fire and Water*, which featured the ballads *Heavy Load*, *Oh I Wept* and *All Right Now*. Free broke up in 1971, as *My Brother Jake* hit the charts. The following year their sixth album *Free at Last* included another UK top 20 entry *Little Bit of Love*. Their final album *Heartbreaker* was released in 1973.

▲ **Badfinger**

Most famous for the single, *I can't live, I can't live anymore (Without You)*, Badfinger's original line-up was Pete Ham (vocals), Mike Gibbins (drums), Tom Evans (guitar) and Ron Griffiths (bass). Griffiths left in 1969 and was replaced by Joey Molland. Badfinger had a hit in the UK and US with *Come And Get It*, written by Paul

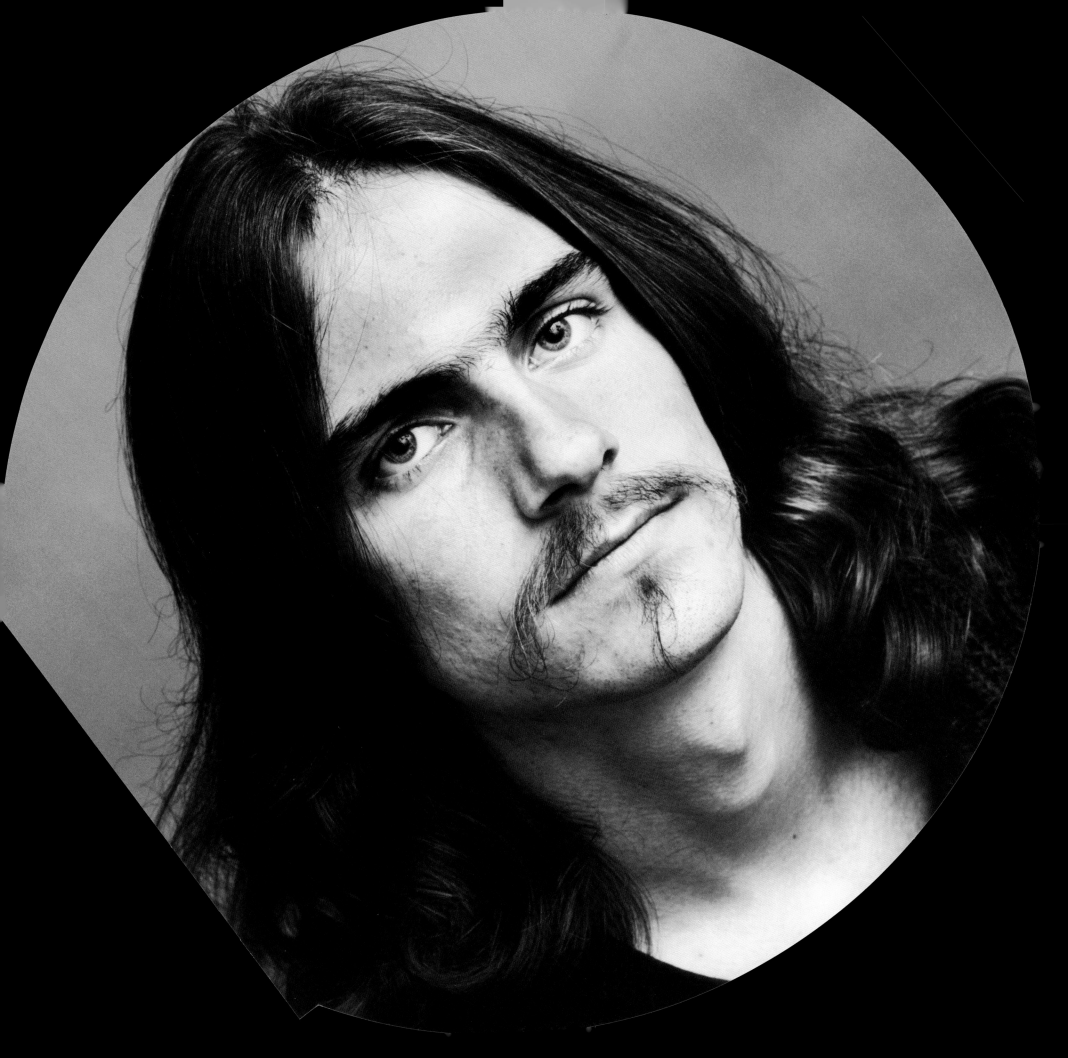

McCartney. In order to increase their public profile, Badfinger contributed to the soundtrack for *The Magic Christian* which starred Peter Sellers and Ringo Starr. The Beatles influence is evident in *No Matter What*, another top ten hit in the UK and US. The albums *No Dice* and *Straight Up* were released in 1970 and 1971. In 1972, Nilsson enjoyed a huge transatlantic chart topper with the Ham/Evans ballad, *Without You*. In 1975, Pete Ham hanged himself after a period of personal difficulties and Badfinger split up. Joey Molland and Tom Evans re-formed Badfinger four years later but in 1983, Tom Evans committed suicide.

Hall, *Hot Streets*, and their other greatest hits albums.) By the early 1970s, Chicago retreated from their jazz sound and produced more mainstream pop such as *Colour My World*, *If You Leave Me Now* and *Hard To Say I'm Sorry*: Five consecutive Chicago albums topped the charts between 1972 and 1975 and *Chicago X* was awarded a Best Album Grammy in 1977. In 1978, founding member Terry Kath, died from a self-inflicted gunshot wound. Singer, Pete Cetera has continued to pursue a successful solo career.

Santana

▲

Formed in 1966, the band Santana pioneered Afro-Latin rock. The original line-up comprised Carlos Santana (guitar, vocals), Gregg Rolie (keyboards, vocals), Michael Shrieve (drums), David Brown, Marcus Malone and Mike Carabello. Later members included Neal Schon (guitar), Jose Chepito Areas, Tom Coster, Armando Peraza, Raul Rekow, Graham Lear, Orestes Vilato and Coke Escovedo. Carlos Santana has maintained his role as leader through constant line-up changes. The Woodstock Festival in 1969 was the group's major breakthrough and Santana's first three albums, *Santana*, *Abraxas* and *Santana III*, spent several months at the top of the US charts. These albums included the hit singles *Jino*, *Evil Ways* and *Black Magic Woman*. The 1972 release, *Caravanserai*, marked a change of style after considerable changes to Santana's original line-up. Carlos Santana scored the music for *La Bamba* in 1986.

Chicago

Formed in Chigaco in 1966, the group Chicago had a continuous series of hits throughout the 1970s and 1980s. They were initially known as the Missing Links, the Big Thing and then the Chicago Transit Authority. In 1969, manager Jim Guercio secured the group a contract with Columbia Records and Chicago's self-titled album was released the same year. Although it never made the top ten, the album remained on the US charts for 171 weeks. Chicago had hits with the singles, *Does Anybody Really Know What Time It Is?* and *Beginnings*. In 1970, they released *Chicago II*. (By 1991, they had released up to *Chicago 21* with the exceptions of the boxed set, *Chicago At Carnegie*

The Band

The Canadian-American rock group The Band had their big break in 1965 when they were chosen to tour with Bob Dylan as his backing band. The Band achieved fame with their 1968 release *Music from Big Pink*. The cover of this album featured a painting by Bob Dylan. A second album *The Band* was released in 1969 and the group emerged from their past association with Bob Dylan. The singles *Up On Cripple Creek* and *The Night They Drove Off* were popular radio tracks. They released a third album *Stage Fright* in 1970 and a fourth *Cahoots* in 1971. During 1973, The Band was one of the featured groups at the rock concert held in Watkins Glen in New York, attended by an estimated 600,000. With versions of songs made famous by The Platters, Fats Domino and others, *Moondog Matinée* was released in 1974 and The Band embarked on a national tour with Bob Dylan. The album *Northern Light, Southern Cross* was released in 1975 and was

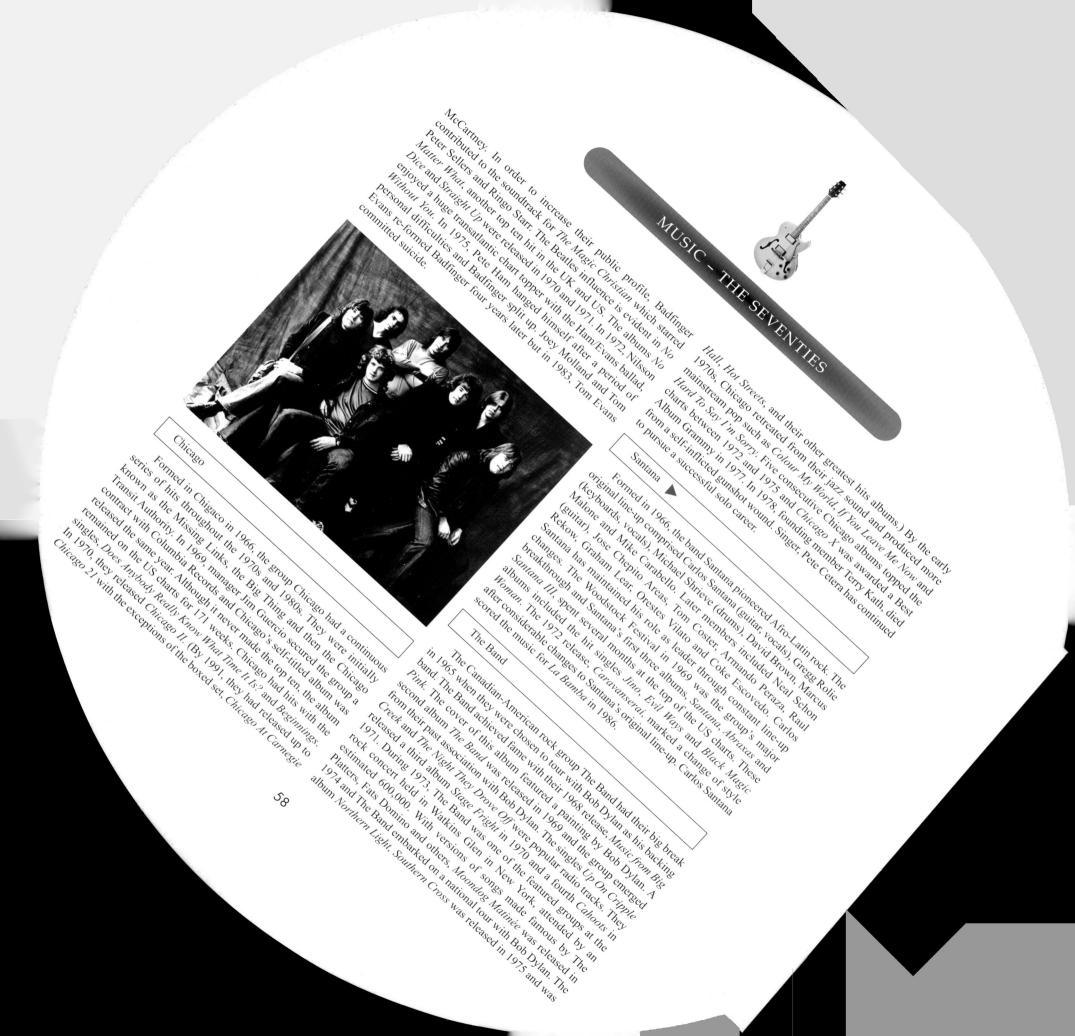

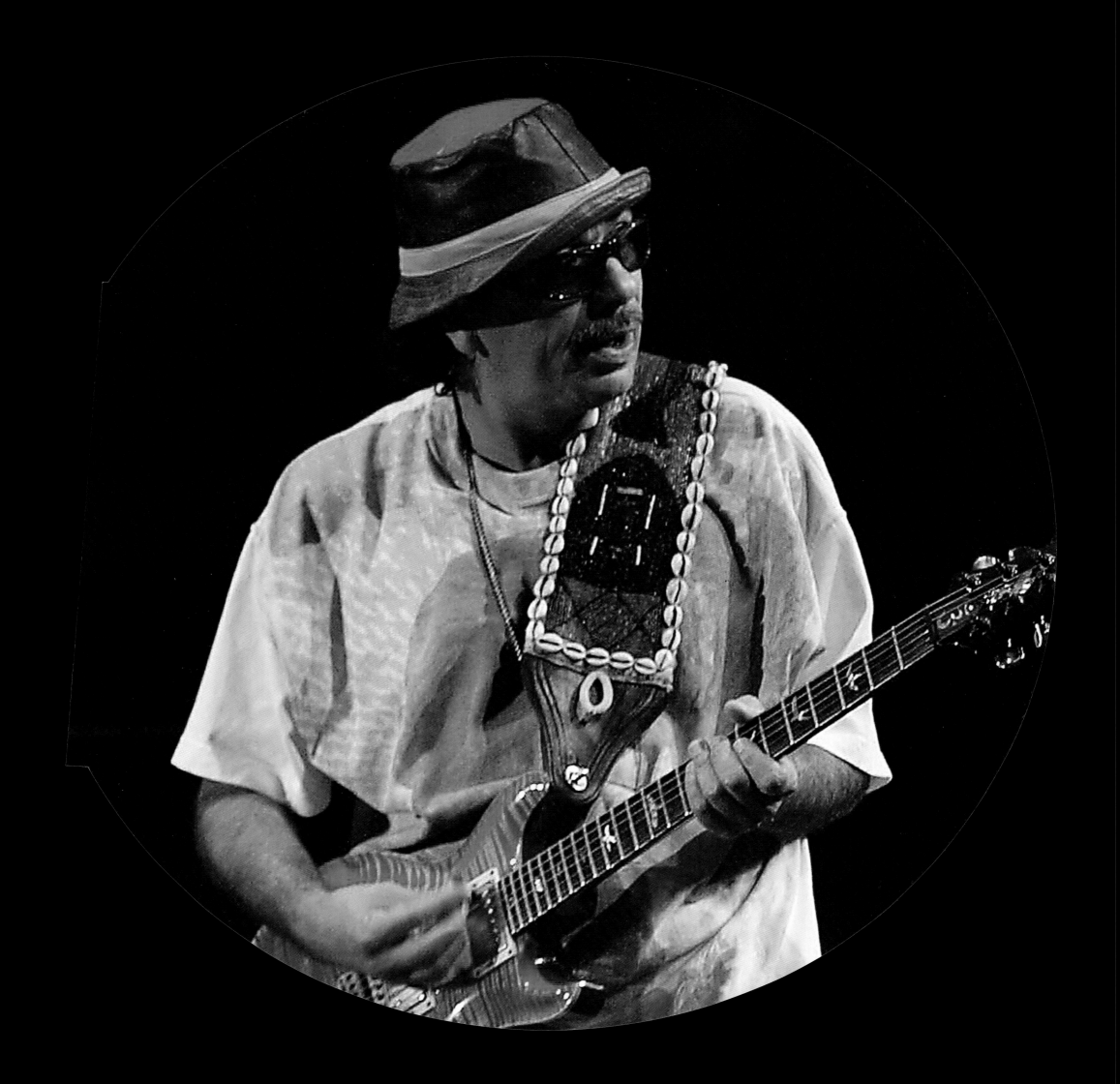

Crosby, Stills, Nash & Young

Crosby, Stills, Nash & Young were a vocal and instrumental group featuring David Crosby, Stephen Stills, Graham Nash and Neil Young. In 1969 they appeared at the Woodstock Festival which established them as instant superstars. Their 1970 album, *Déjà Vu*, was a hit and one of the most celebrated works of the early 1970s. The combined creativity produced *Carry on*, *4 & 20*, *Country Girl*, *Teach Your Children* and *Almost Cut my Hair*, one of the great anti-establishment songs of the period. The release of *Four Way Street* showcased their brilliant and contrasting acoustic and electric sets. By the time of its release in 1971, the group essentially disbanded to pursue solo projects. They reunited in 1974 and undertook a stadium tour. They continue to tour today without Neil Young.

James Brown

Born on 3 May 1933, James Brown was an R&B artist and sold millions of records in the US from the 1950s onward. He was known as the king of R&B in the US from the 1950s. During the 1970s, he appeared on either the top 100 singles or album charts. Throughout the 1970s, he released new recordings and retrospective collections including *Soul Classics, Volume I*, *There it is*, *Payback*, *Everybody's Doin' The Hustle*, *Get Up Offa That Thing*, *Mutha's nature*, *Jam/1980s*. *Take a Look at Those Cakes* and *Original Disco Man*. His singles hits included *Let A Man Come in and Do the Popcorn (Part 2)*, *Brother Rapp*, *Super Bad (Parts 1 & 2)*, *Get Up*, and *I Feel Like Being a Sex Machine (Parts 1 & 2)*. Brown passed away On December 25, 2006 from congestive heart failure resulting from complications of pneumonia.

Ike and Tina Turner

Ike Turner, guitarist, pianist, singer, and record producer was born on 5 November 1939. Tina Turner, singer, dancer and songwriter was born Anna Mae Bullock on 26 November 1939. Ike and married in 1958. Toward the end of the 1960s, the Turners were asked to accompany the Rolling Stones on an American tour. Their growing list

of hits included *River Deep Mountain High*, released in 1970 In 1971, they earned a gold record for their single of Credence Clearwater Revival's *Proud Mary* and released the best-seller *Workin' Together*. In 1973, Ike and Tina Turner had a hit with the single *Nutbush City Limits*. Outwardly all was fine, but in their private lives, Ike and Tina's relationship was deteriorating. In the mid-1970s, Tina left the group in the middle of a tour. She divorced Ike in 1976 and went on to pursue a successful solo career.

Rod Stewart

Born Roderick David Stewart on 10 January 1945 in London, by the mid-1960s, Rod Stewart had become well-known in R&B circles. He gained national exposure through his membership of the Jeff Beck Group and The Faces with Ron Wood. *Gasoline Alley* was his breakthrough album with its title track and the single *Lady Day*. Stewart gained superstar status after the release of his next two albums *Every Picture Tells a Story* and *Never A Dull Moment*. Hits from these albums included *Maggie May* and *You Wear It Well*. *Atlantic Crossing* was his next critical success with its singles *Sailing* and *Drift Away*. The second half of the 1970s saw the release of other chart toppers such as *The First Cut is the Deepest*, *Hot Legs* and *Do ya think I'm sexy*. Throughout the 1980s, Rod Stewart adopted a jetsetting lifestyle. He continues to release chart-topping albums as well as touring around the world.

Carole King ▲

Born Carole Klein on 9 February 1942, Carole King was a proficient pianist from the age of four and a prolific songwriter by the time she was a teenager. She recorded demos, sang back-up and worked on arrangements for Neil Sedaka and in the late 1950s released the singles *The Right Girl*, *Babysittin'*, *Queen of the Beach* and *Oh Neil*, in response to Sedaka's *Oh Carol*. With her husband Gerry Goffin, she wrote the Shirelle's *Will You Still Love Me Tomorrow*, Bobby Vee's *Take Good Care of My Baby*, the Drifters' *Up on the Roof* and Little Eva's *The Loco-Motion*. It Might as Well Rain Until September provided King with a solo hit in 1962. During the 1960s, she wrote *You Make Me Feel Like A Natural Woman* for Aretha Franklin. In 1967, Goffin and King dissolved their partnership and marriage. The breakup was reflected in the 1967 single, *The Road To*

seen as a major comeback. A 'best-of' album was released in 1976 and The Band had a final tour that year.

60

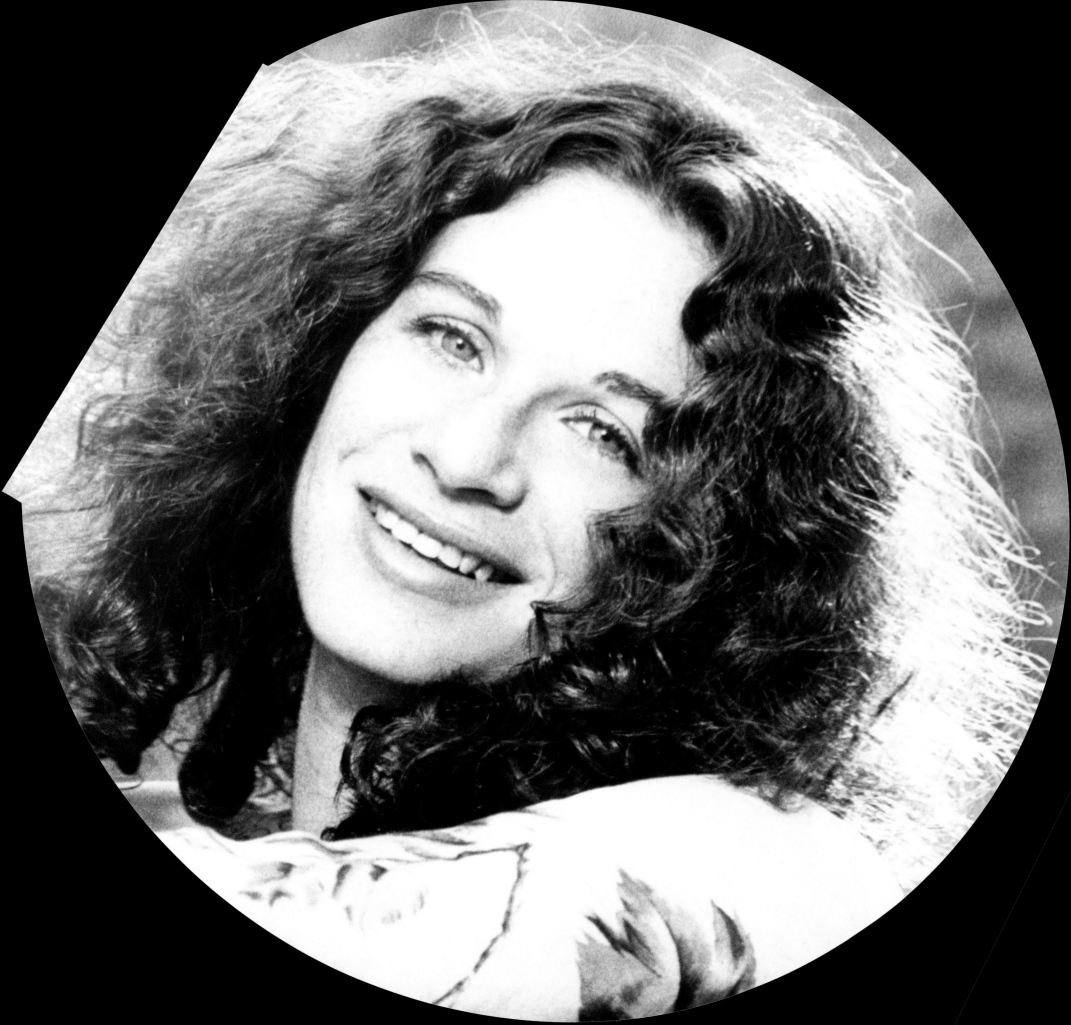

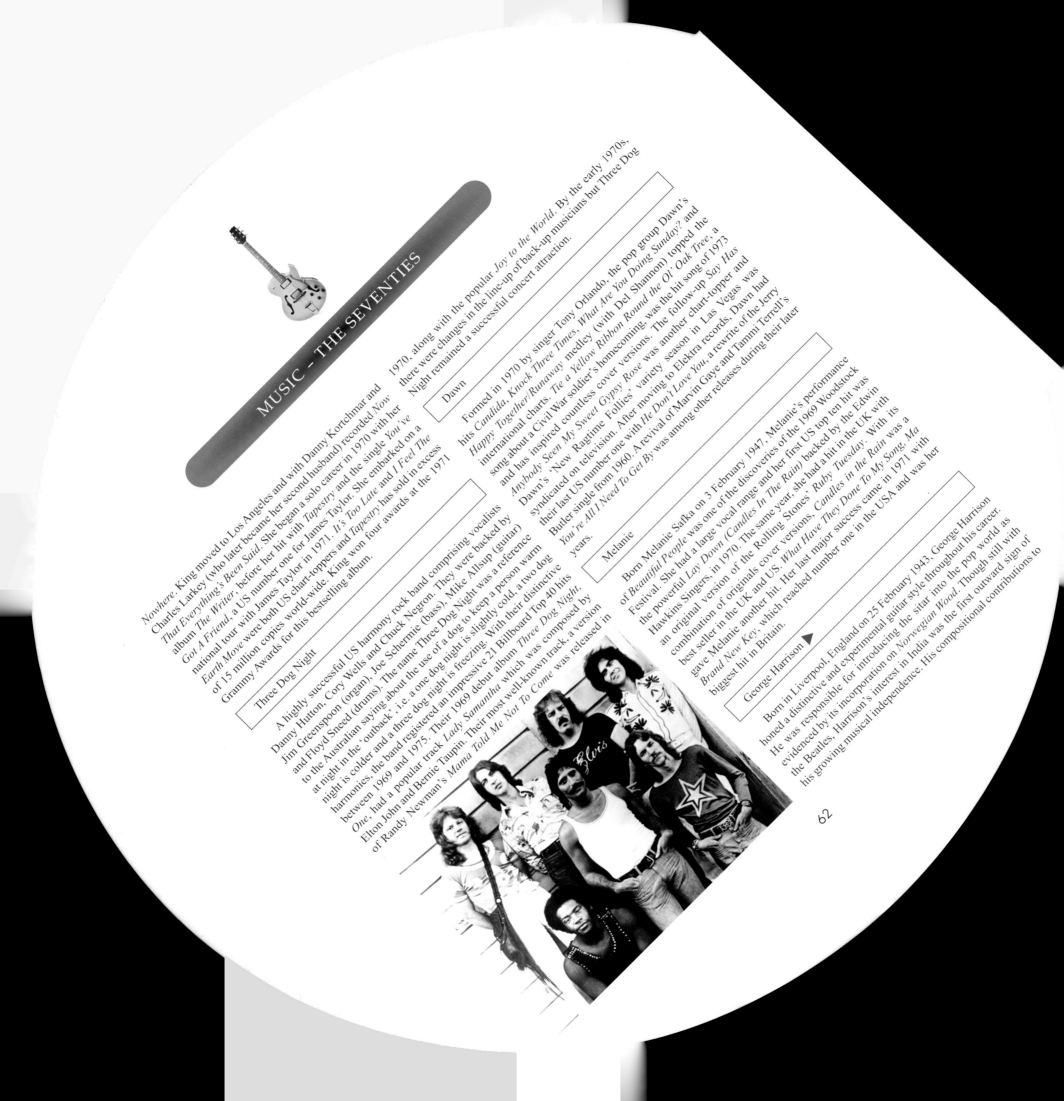

Nowhere. King moved to Los Angeles and with Danny Kortchmar and Charles Larkey (who later became her second husband) recorded *Now That Everything's Been Said*. She began a solo career in 1970 with her album *The Writer*, before her hit with *Tapestry* and the single *You've Got A Friend*, a US number one for James Taylor. She embarked on a national tour with James Taylor in 1971. *It's Too Late* and *I Feel The Earth Move* were both US chart-toppers and *Tapestry* has sold in excess of 15 million copies world-wide. King won four awards at the 1971 Grammy Awards for this bestselling album.

Three Dog Night

A highly successful US harmony rock band comprising vocalists Danny Hutton, Cory Wells and Chuck Negron. They were backed by Jim Greenspoon (organ), Joe Schermie (bass), Mike Allsup (guitar) and Floyd Speed (drums). The name Three Dog Night was a reference to the Australian saying about the use of a dog to keep a person warm at night in the 'outback'; i.e. a one dog night is slightly cold, a two dog night is colder and a three dog night is freezing. With their distinctive harmonies, the band registered an impressive 21 Billboard Top 40 hits between 1969 and 1975. Their 1969 debut album *Three Dog Night, One*, had a popular track *Lady Samantha* which was composed by Elton John and Bernie Taupin. Their most well-known track, a version of Randy Newman's *Mama Told Me Not To Come* was released in

Dawn

1970, along with the popular *Joy to the World*. By the early 1970s, there were changes in the line-up of back-up musicians but Three Dog Night remained a successful concert attraction.

Formed in 1970 by singer Tony Orlando, the pop group Dawn's hits *Candida*, *Knock Three Times*, *What Are You Doing Sunday?* and *Happy Together/Runaway* medley (with Del Shannon) topped the international charts. *Tie a Yellow Ribbon Round the Ol' Oak Tree*, a song about a Civil War soldier's homecoming, was the hit song of 1973 and has inspired countless cover versions. The follow-up *Say Has Anybody Seen My Sweet Gypsy Rose* was another chart-topper and Dawn's 'New Ragtime Follies' variety season in Las Vegas was syndicated on television. After moving to Elektra records, Dawn had their last US number one with *He Don't Love You*, a rewrite of the Jerry Butler single from 1960. A revival of Marvin Gaye and Tammi Terrell's *You're All I Need To Get By* was among other releases during their later years.

Melanie

Born Melanie Safka on 3 February 1947, Melanie's performance of *Beautiful People* was one of the discoveries of the 1969 Woodstock Festival. She had a large vocal range and her first US top ten hit was the powerful *Lay Down (Candles In The Rain)* backed by the Edwin Hawkins Singers, in 1970. The same year, she had a hit in the UK with an original version of the Rolling Stones' *Ruby Tuesday*. With its combination of originals cover versions, *Candles in the Rain* was a best seller in the UK and US. *What Have They Done To My Song, Ma* gave Melanie another hit. Her last major success came in 1971 with *Brand New Key*, which reached number one in the USA and was her biggest hit in Britain.

George Harrison ▶

Born in Liverpool, England on 25 February 1943, George Harrison honed a distinctive and experimental guitar style throughout his career. He was responsible for introducing the sitar into the pop world as evidenced by its incorporation on *Norwegian Wood*. Though still with the Beatles, Harrison's interest in India was the first outward sign of his growing musical independence. His compositional contributions to

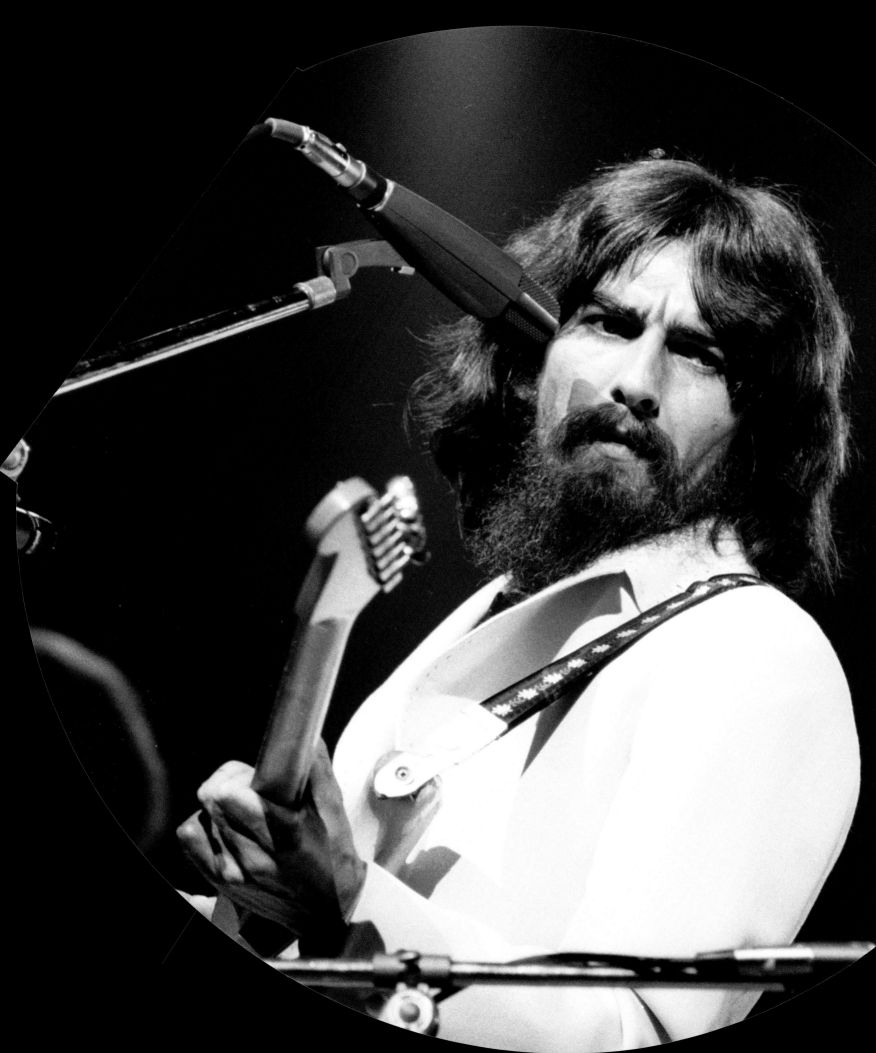

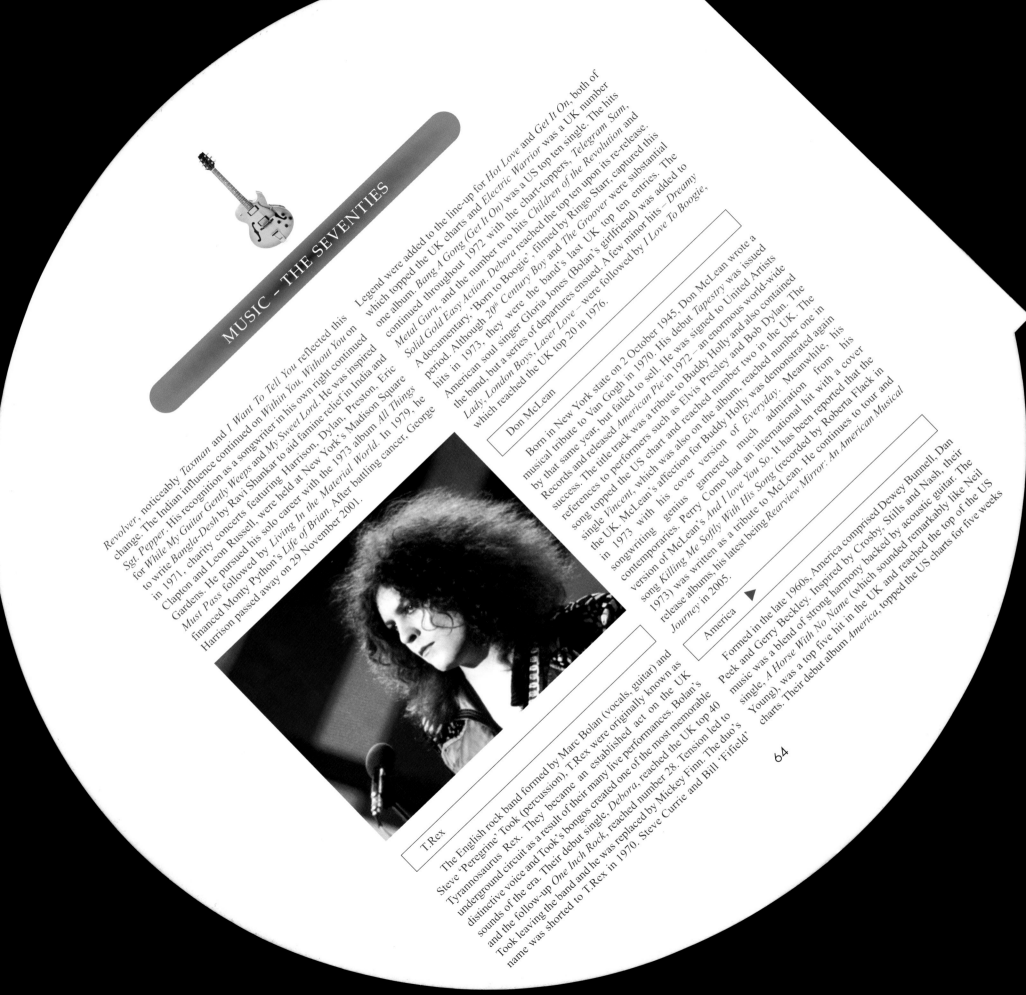

MUSIC - THE SEVENTIES

Revolver, noticeably *Taxman* and *I Want To Tell You* reflected this change. The Indian influence continued on *Within You, Without You* on *Sgt. Pepper*. His recognition as a songwriter in his own right continued for *While My Guitar Gently Weeps* and *My Sweet Lord*. He was inspired to write *Bangla-Desh* by Ravi Shankar to aid famine relief in India and in 1971, charity concerts featuring Harrison, Dylan, Preston, Eric Clapton and Leon Russell, were held at New York's Madison Square Gardens. He pursued his solo career with the 1973 album *All Things Must Pass* followed by *Living In the Material World*. In 1979, he financed Monty Python's *Life of Brian*. After battling cancer, George Harrison passed away on 29 November 2001.

Legend were added to the line-up for *Hot Love* and *Get It On*, both of which topped the UK charts and *Electric Warrior* was a UK number one album. *Bang A Gong (Get It On)* was a US top ten single. The hits continued throughout 1972 with the chart-toppers, *Telegram Sam*, *Metal Guru*, and the number two hits *Children of the Revolution* and *Solid Gold Easy Action*. *Debora* reached the top ten upon its re-release. A documentary, 'Born to Boogie', filmed by Ringo Starr, captured this period. Although *20th Century Boy* and *The Groover* were substantial hits in 1973, they were the band's last UK top ten entries. The American soul singer Gloria Jones (Bolan's girlfriend) was added to the band, but a series of departures ensued. A few minor hits – *Dreamy Lady, London Boys, Laser Love* – were followed by *I Love To Boogie*, which reached the UK top 20 in 1976.

Don McLean

Born in New York state on 2 October 1945, Don McLean wrote a musical tribute to Van Gogh in 1970. His debut *Tapestry* was issued by that same year, but failed to sell. He was signed to United Artists Records and released *American Pie* in 1972 – an enormous world-wide success. The title track was a tribute to Buddy Holly and also contained references to performers such as Elvis Presley and Bob Dylan. The song topped the US chart and reached number two in the UK. The single *Vincent*, which was also on the album, reached number one in the UK. McLean's affection for Buddy Holly was demonstrated again in 1973 with his cover version of *Everyday*. Meanwhile, his songwriting genius garnered much admiration from his contemporaries. Perry Como had an international hit with a cover version of McLean's *And I love You So*. It has been reported that the song *Killing Me Softly With His Song* (recorded by Roberta Flack in 1973) was written as a tribute to McLean. He continues to tour and release albums, his latest being *Rearview Mirror: An American Musical Journey* in 2005.

America ▶

Formed in the late 1960s, America comprised Dewey Bunnell, Dan Peek and Gerry Beckley. Inspired by Crosby, Stills and Nash, their music was a blend of strong harmony backed by acoustic guitar. The single, *A Horse With No Name* (which sounded remarkably like Neil Young), was a top five hit in the UK and reached the top of the US charts. Their debut album *America*, topped the US charts for five weeks

T.Rex

The English rock band formed by Marc Bolan (vocals, guitar) and Steve 'Peregrine' Took (percussion), T.Rex were originally known as Tyrannosaurus Rex. They became an established act on the UK underground circuit as a result of their many live performances. Bolan's distinctive voice and Took's bongos created one of the most memorable sounds of the era. Their debut single, *Debora*, reached the UK top 40 and the follow-up *One Inch Rock*, reached number 28. Tension led to Took leaving the band and he was replaced by Mickey Finn. The duo's name was shorted to T.Rex in 1970. Steve Currie and Bill 'Fifield'

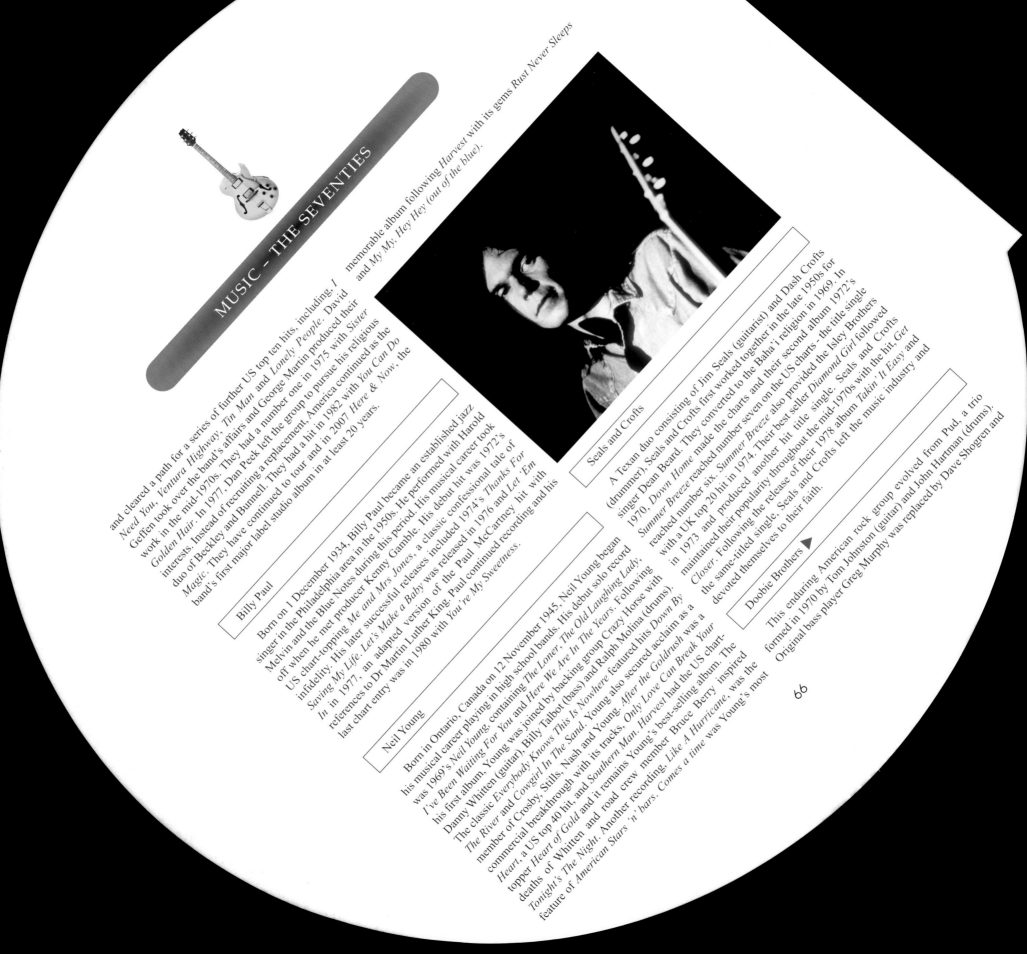

and cleared a path for a series of further US top ten hits, including *I Need You*, *Ventura Highway*, *Tin Man* and *Lonely People*. David Geffen took over the band's affairs and George Martin produced their work in the mid-1970s. In 1977, Dan Peek left the group to pursue his religious interests. Instead of recruiting a replacement, America continued as the duo of Beckley and Bunnell. They had a hit in 1982 with *You Can Do Magic*. They have continued to tour and in 2007 *Here & Now*, the

memorable album following *Harvest* with its gems *Rust Never Sleeps* and *My My, Hey Hey (out of the blue)*.

band's first major label studio album in at least 20 years.

Billy Paul

Born on 1 December 1934, Billy Paul became an established jazz singer in the Philadelphia area in the 1950s. He performed with Harold Melvin and the Blue Notes during this period. His musical career took off when he met producer Kenny Gamble. His debut hit was 1972's US chart-topping *Me and Mrs Jones*, a classic confessional tale of infidelity. His later successful releases included 1974's *Thanks For Saving My Life*. *Let's Make a Baby* was released in 1976 and *Let 'Em In* in 1977, an adapted version of the Paul McCartney hit with references to Dr Martin Luther King. Paul continued recording and his last chart entry was in 1980 with *You're My Sweetness*.

Neil Young

Born in Ontario, Canada on 12 November 1945, Neil Young began his musical career playing in high school bands. His debut solo record was 1969's *Neil Young*, containing *The Loner*, *The Old Laughing Lady*, *I've Been Waiting For You* and *Here We Are In The Years*. Following his first album, Young was joined by backing group Crazy Horse with Danny Whitten (guitar), Billy Talbot (bass) and Ralph Molina (drums). The classic *Everybody Knows This Is Nowhere* featured hits *Down By The River* and *Cowgirl In The Sand*. Young also secured acclaim as a member of Crosby, Stills, Nash and Young. *After the Goldrush* was a commercial breakthrough with its tracks, *Only Love Can Break Your Heart*, a US top 40 hit, and *Southern Man*. *Harvest* had the US chart-topper *Heart of Gold* and it remains Young's best-selling album. The deaths of Whitten and road crew member Bruce Berry inspired *Tonight's The Night*. Another recording, *Like A Hurricane*, was the feature of *American Stars 'n' bars*. *Comes a time* was Young's most

Seals and Crofts

A Texan duo consisting of Jim Seals (guitarist) and Dash Crofts (drummer), Seals and Crofts first worked together in the late 1950s for singer Dean Beard. They converted to the Baha'i religion in 1969. In 1970, *Down Home* reached the charts and their second album 1972's *Summer Breeze* made the charts seven on the US charts - the title single *Summer Breeze* reached number six. *Summer Breeze* also provided the Isley Brothers with a UK top 20 hit in 1974. Their best seller *Diamond Girl* followed in 1973 and produced another hit title single. Seals and Crofts maintained their popularity throughout the mid-1970s with the hit, *Get Closer*. Following the release of their 1978 album *Takin' It Easy* and the same-titled single, Seals and Crofts left the music industry and devoted themselves to their faith.

Doobie Brothers ▼

This enduring American rock group evolved from Pud, a trio formed in 1970 by Tom Johnston (guitar) and John Hartman (drums). Original bass player Greg Murphy was replaced by Dave Shogren and

the addition of Patrick Simmons (guitar) expanded the line-up. The band became known as the Doobie Brothers – a reference to marijuana cigarettes. Their 1971 debut album was commercially unsuccessful and a new bass player, Tiran Porter and second drummer, Michael Hossack, joined the line-up for their next release, *Toulouse Street*. The single, *Listen to the music* was a hit from this album. Their next release, *Captain And Me* contained two US hits *Long Train Running* and *China Grove*, while the telling, *What Were Once Vices Are Now Habits* featured the Doobie Brothers' first US chart-topper, *Black Water*. Hossack was replaced by Keith Knudsen for *Stampede* which also introduced ex-Steely Dan guitarist Jeff 'skunk' Baxter. The album *Minute By Minute* featured the US number one single, *What A Fool Believes*.

| Argent |

When the 1960s English rock group, The Zombies fell apart, keyboardist Rod Argent (born 14 June 1945) formed a band that would showcase his skill as a songwriter and pianist. He assembled Russ Ballard (guitar, vocals), Waltham Cross (guitar, vocals), Bob Henrit (drums) and Jim Rodford (bass). Argent's acclaimed debut included Ballard's *Liar*, a song that was one of their concert staples and was a US top ten hit for the band Three Dog Night in 1971. *All Together Now* featured *Hold Your Head Up*, a top five hit in the US and the UK. Similarly, *In Deep* produced a memorable hit, *God Gave Rock 'N' Roll To You*, which was also a 1992 when covered by Kiss. Ballard left the group in 1974 to pursue a solo career and was replaced by John Verity (guitar, bass, vocals) and John Grimaldi (cello, mandolin, violin). From this point, Argent's success diminished and they disbanded in 1976.

| Alice Cooper |

Born Vincent Damon Furnier on 4 February 1948, Alice Cooper became known as the 'master of shock rock' during the 1970s, and continues to be popular. His band deliberately set out to shock their audiences and Furnier concocted an outrageously attired persona to attract attention. In 1969, Frank Zappa signed the Alice Cooper Band to his new Straight Records label. They recorded two albums *Pretties For You* and *Easy Action*. Cooper continued his shock tactics – using a guillotine and electric chair as stage props and a live snake as part of his wardrobe. His trademark appearance was completed by the thick,

black eye make-up that would drip down his face while he was performing. As the band and its singer's reputation spread, their records began to sell. In 1971, *Eighteen* was their first single to reach the US charts, at number 21. The breakthrough came the following year with the *School's Out* single and album, both of which made the US and UK top ten. A series of bestselling albums followed: *Billion Dollar Babies*, *Muscle Of Love* and *Alice Cooper's Greatest Hits*. *Welcome To My Nightmare* was Cooper's most well-known solo album which was released when the band split up and Cooper had officially adopted 'Alice Cooper' as his own name.

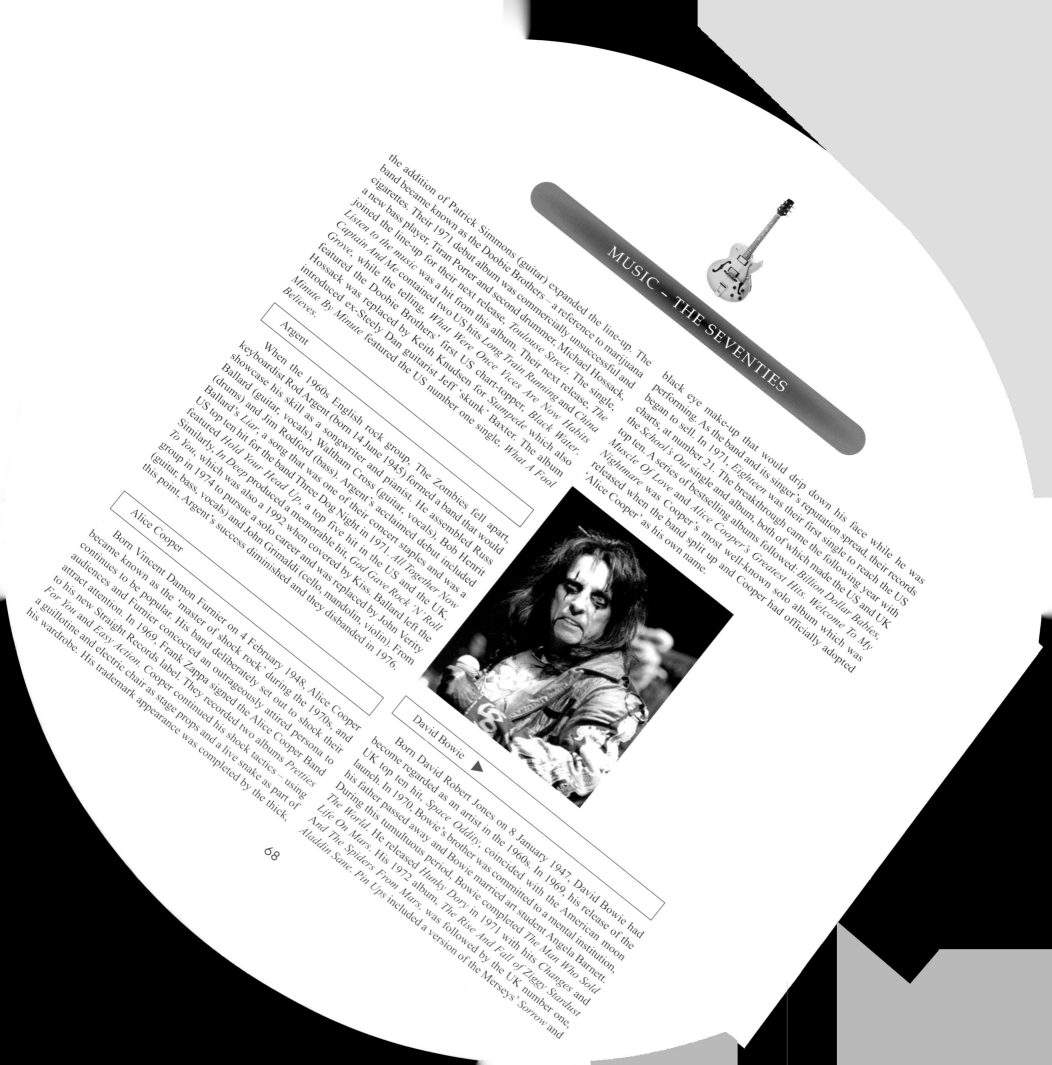

| David Bowie | ▲

Born David Robert Jones on 8 January 1947, David Bowie had become regarded as an artist in the 1960s. In 1969, his release of the UK top ten hit, *Space Oddity*, coincided with the American moon launch. In 1970, Bowie's brother was committed to a mental institution, his father passed away and Bowie married art student Angela Barnett. During this tumultuous period, Bowie completed *The Man Who Sold The World*. He released *Hunky Dory* in 1971 with hits *Changes* and *Life On Mars*. His 1972 album, *The Rise And Fall of Ziggy Stardust And The Spiders From Mars*, was followed by the UK number one, *Aladdin Sane*. *Pin Ups* included a version of the Merseys' *Sorrow* and

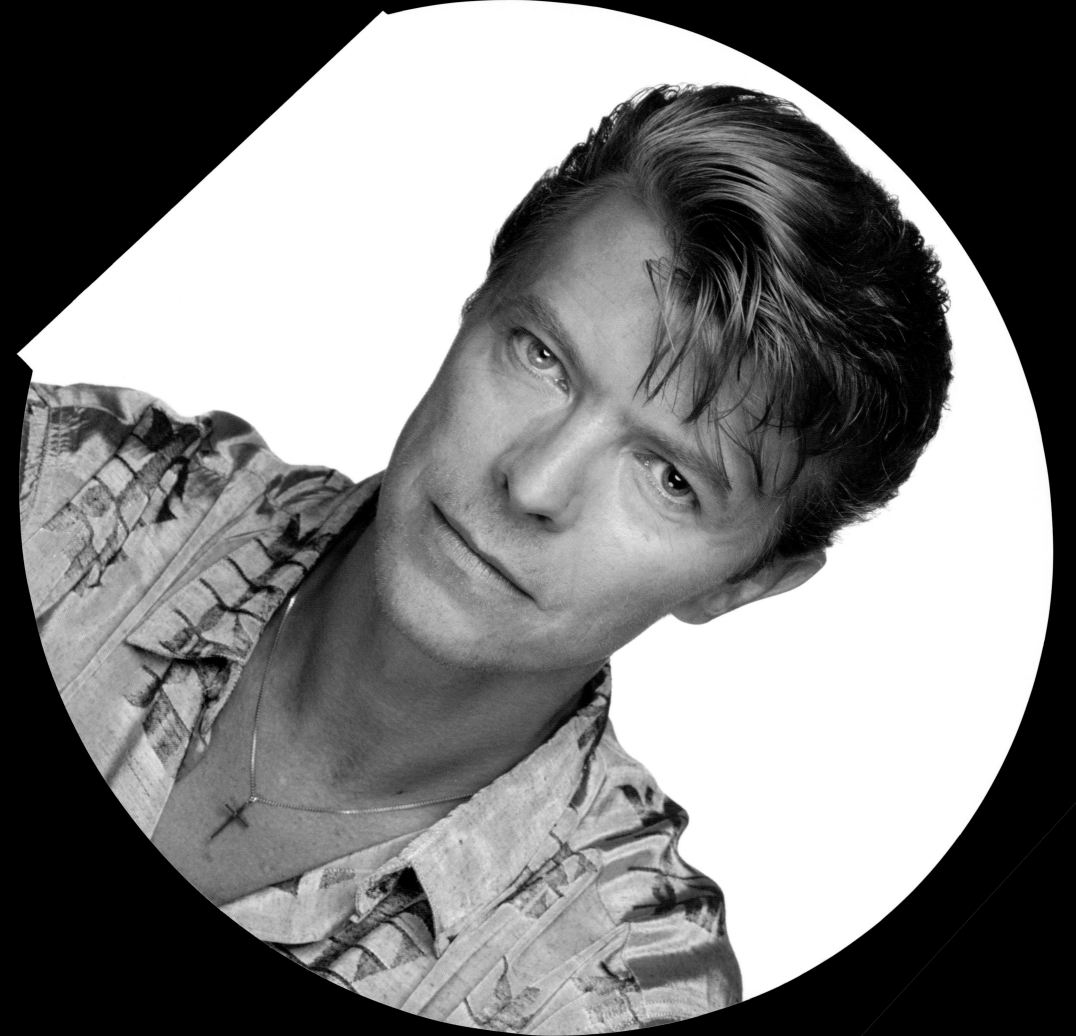

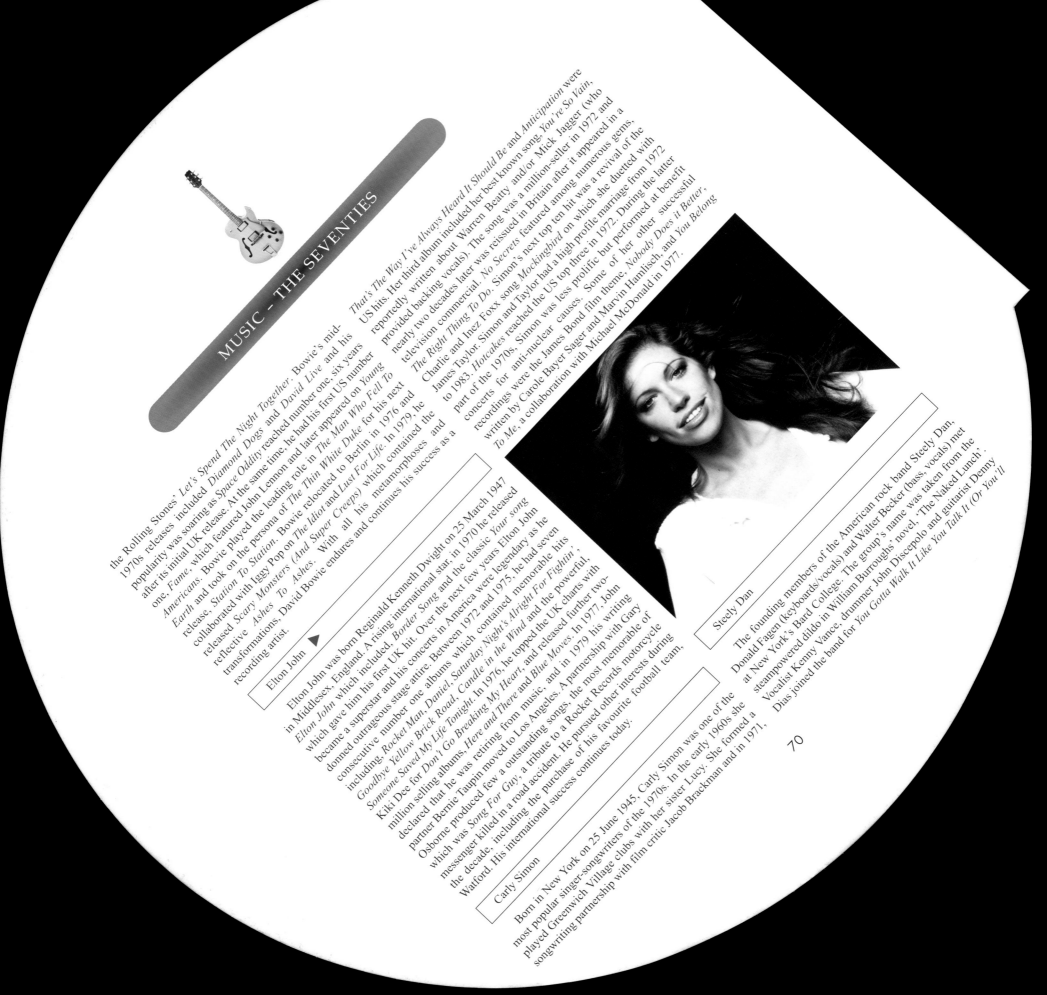

the Rolling Stones' *Let's Spend The Night Together*. Bowie's mid-1970s releases included *Diamond Dogs* and *David Live* and his popularity was soaring as *Space Oddity* reached number one, six years after its initial UK release. At the same time, he had his first US number one, *Fame*, which featured John Lennon and later appeared on *Young Americans*. Bowie played the leading role in *The Man Who Fell To Earth* and took on the persona of *The Thin White Duke* for his next release, *Station To Station*. Bowie relocated to Berlin in 1976 and collaborated with Iggy Pop on *The Idiot* and *Lust For Life*. In 1979, he released *Scary Monsters (And Super Creeps)* which contained the reflective *Ashes To Ashes*. With all his metamorphoses and transformations, David Bowie endures and continues his success as a recording artist.

That's The Way I've Always Heard It Should Be and *Anticipation* were US hits. Her third album included her best known song, *You're So Vain*, reportedly written about Warren Beatty and/or Mick Jagger (who provided backing vocals). The song was a million-seller in 1972 and nearly two decades later was reissued in Britain after it appeared in a television commercial. *No Secrets* featured among numerous gems, *The Right Thing To Do*. Simon's next top ten hit was a revival of the Charlie and Inez Foxx song *Mockingbird* on which she duetted with James Taylor. Simon and Taylor had a high profile marriage from 1972 to 1983. *Hotcakes* reached the US top three in 1972. During the latter part of the 1970s, Simon was less prolific but performed at benefit concerts for anti-nuclear causes. Some of her other successful recordings were the James Bond film theme, *Nobody Does it Better*, written by Carole Bayer Sager and Marvin Hamlisch, and *You Belong To Me*, a collaboration with Michael McDonald in 1977.

Elton John ▶

Elton John was born Reginald Kenneth Dwight on 25 March 1947 in Middlesex, England. A rising international star, in 1970 he released *Elton John* which included, *Border Song* and the classic *Your song* which gave him his first UK hit. Over the next few years Elton John became a superstar and his concerts in America were legendary as he donned outrageous stage attire. Between 1972 and 1975, he had seven consecutive number one albums which contained memorable hits including, *Rocket Man*, *Daniel*, *Saturday Night's Alright For Fightin'*, *Goodbye Yellow Brick Road*, *Candle in the Wind* and the powerful, *Someone Saved My Life Tonight*. In 1976, he topped the UK charts with *Kiki Dee for Don't Go Breaking My Heart*, and released further two-million selling albums, *Here and There* and *Blue Moves*. In 1977, John declared that he was retiring from music, and in 1979 his writing partner Bernie Taupin moved to Los Angeles. A partnership with Gary Osborne produced few a outstanding songs, the most memorable of which was *Song For Guy*, a tribute to a Rocket Records motorcycle messenger killed in a road accident. He pursued other interests during the decade, including the purchase of his favourite football team, Watford. His international success continues today.

Steely Dan

The founding members of the American rock band Steely Dan, Donald Fagen (keyboards/vocals) and Walter Becker (bass, vocals) met at New York's Bard College. The group's name was taken from the steampowered dildo in William Burroughs' novel, 'The Naked Lunch'. Vocalist Kenny Vance, drummer John Discepolo and guitarist Denny Dias joined the band for *You Gotta Walk It Like You Talk It (Or You'll*

Carly Simon

Born in New York on 25 June 1945, Carly Simon was one of the most popular singer-songwriters of the 1970s. In the early 1960s she played Greenwich Village clubs with her sister Lucy. She formed a songwriting partnership with film critic Jacob Brackman and in 1971,

70

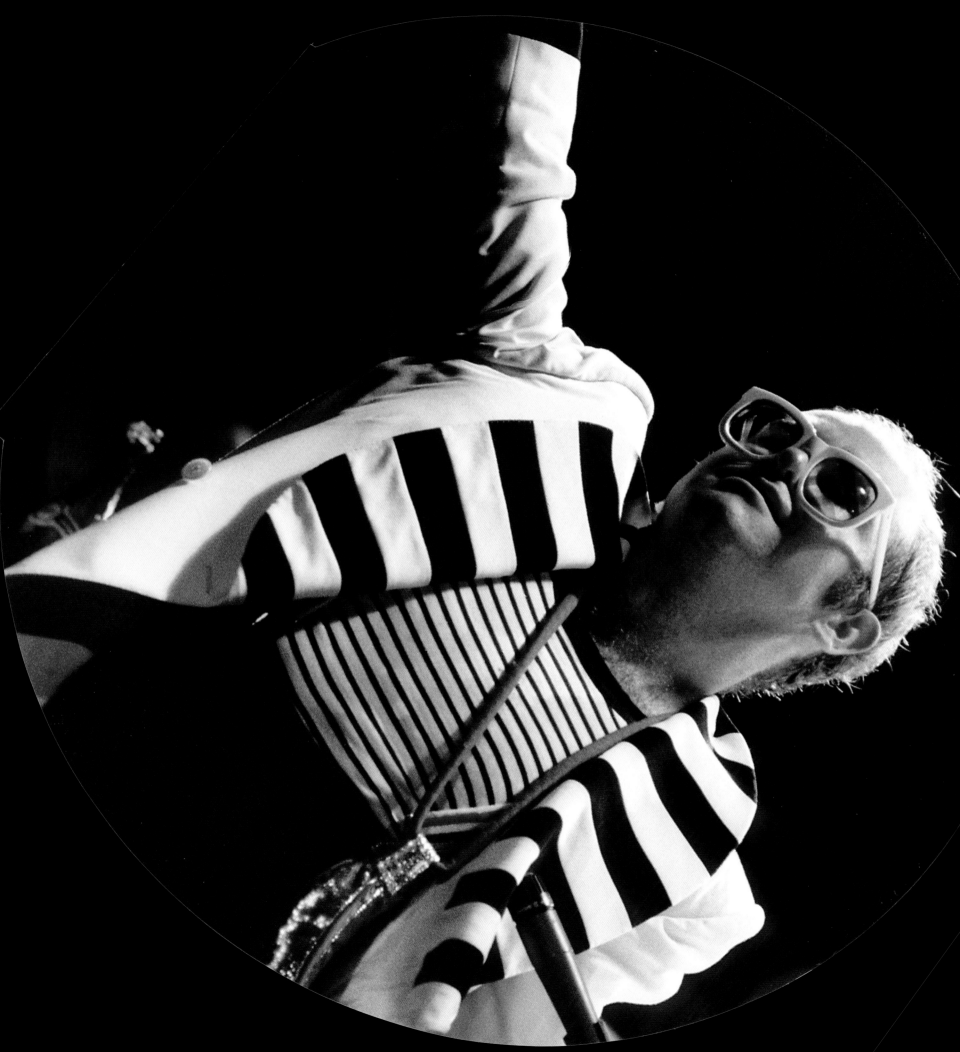

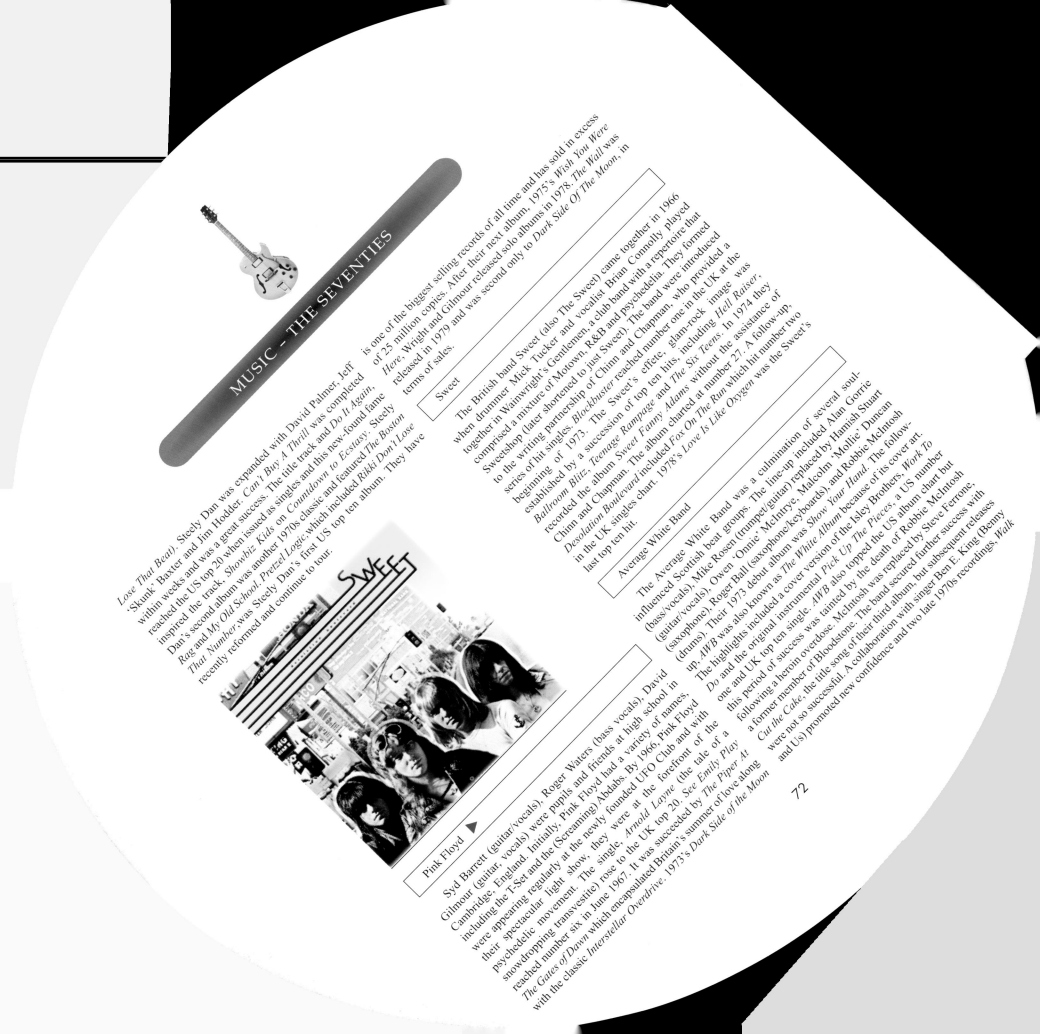

Lose That Beat). Steely Dan was expanded with David Palmer, Jeff 'Skunk' Baxter and Jim Hodder. *Can't Buy A Thrill* was completed within weeks and was a great success. The title track and *Do It Again,* reached the US top 20 when issued as singles and this new-found fame inspired the track, *Showbiz Kids* on *Countdown to Ecstasy.* Steely Dan's second album was another 1970s classic and featured *The Boston Rag* and *My Old School. Pretzel Logic,* which included *Rikki Don't Lose That Number,* was Steely Dan's first US top ten album. They have recently reformed and continue to tour.

Sweet

The British band Sweet (also The Sweet) came together in 1966 when drummer Mick Tucker and vocalist Brian Connolly played together in Wainwright's Gentlemen, a club band with a repertoire that comprised a mixture of Motown, R&B and psychedelia. They formed Sweetshop (later shortened to just Sweet). The band were introduced to the writing partnership of Chinn and Chapman, who provided a series of hit singles. *Blockbuster* reached number one in the UK at the beginning of 1973. The Sweet's effete, glam-rock image was established by a succession of top ten hits, including *Hell Raiser, Ballroom Blitz, Teenage Rampage* and *The Six Teens.* In 1974 they recorded the album *Sweet Fanny Adams* without the assistance of Chinn and Chapman. The album charted at number 27. A follow-up, *Desolation Boulevard* included *Fox On The Run* which hit number two in the UK singles chart. 1978's *Love Is Like Oxygen* was the Sweet's last top ten hit.

Average White Band

The Average White Band was a culmination of several soul-influenced Scottish beat groups. The line-up included Alan Gorrie (bass/vocals), Mike Rosen (trumpet/guitar) replaced by Hamish Stuart (guitar/vocals), Owen 'Onnie' McIntyre, Malcolm 'Mollie' Duncan (saxophone), Roger Ball (saxophone/keyboards), and Robbie McIntosh (drums). Their 1973 debut album was *Show Your Hand.* The follow-up, *AWB* was also known as *The White Album* because of its cover art. The highlights included a cover version of the Isley Brothers, *Work To Do* and the original instrumental *Pick Up The Pieces,* a US number one and UK top ten single. *AWB* also topped the US album chart but this period of success was tainted by the death of Robbie McIntosh following a heroin overdose. McIntosh was replaced by Steve Ferrone, a former member of Bloodstone. The band secured further success with *Cut the Cake,* the title song of their third album, but subsequent releases were not so successful. A collaboration with singer Ben E. King (Benny and Us) promoted new confidence and two late 1970s recordings, *Walk*

Pink Floyd ▶

Syd Barrett (guitar/vocals), Roger Waters (bass vocals), David Gilmour (guitar, vocals) were pupils and friends at high school in Canbridge, England. Initially, Pink Floyd had a variety of names, including the T-Set and the (Screaming) Abdabs. By 1966, Pink Floyd were appearing regularly at the newly founded UFO Club and with their spectacular light show, they were at the forefront of a psychedelic movement. The single, *Arnold Layne* (the tale of a snowdropping transvestite) rose to the UK top 20. *See Emily Play* reached number six in June 1967. It was succeeded by *The Piper At The Gates of Dawn* which encapsulated Britain's summer of love along with the classic *Interstellar Overdrive.* 1973's *Dark Side of the Moon*

72

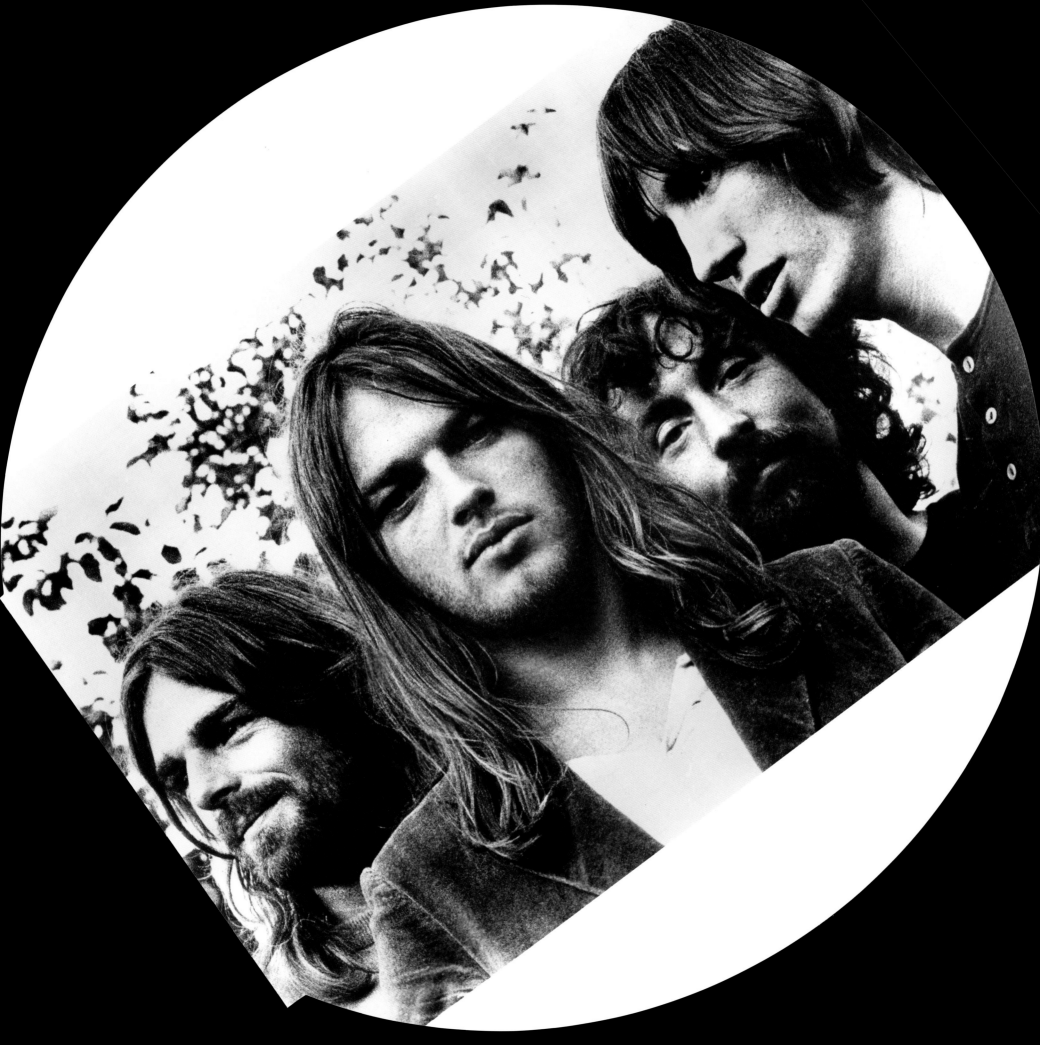

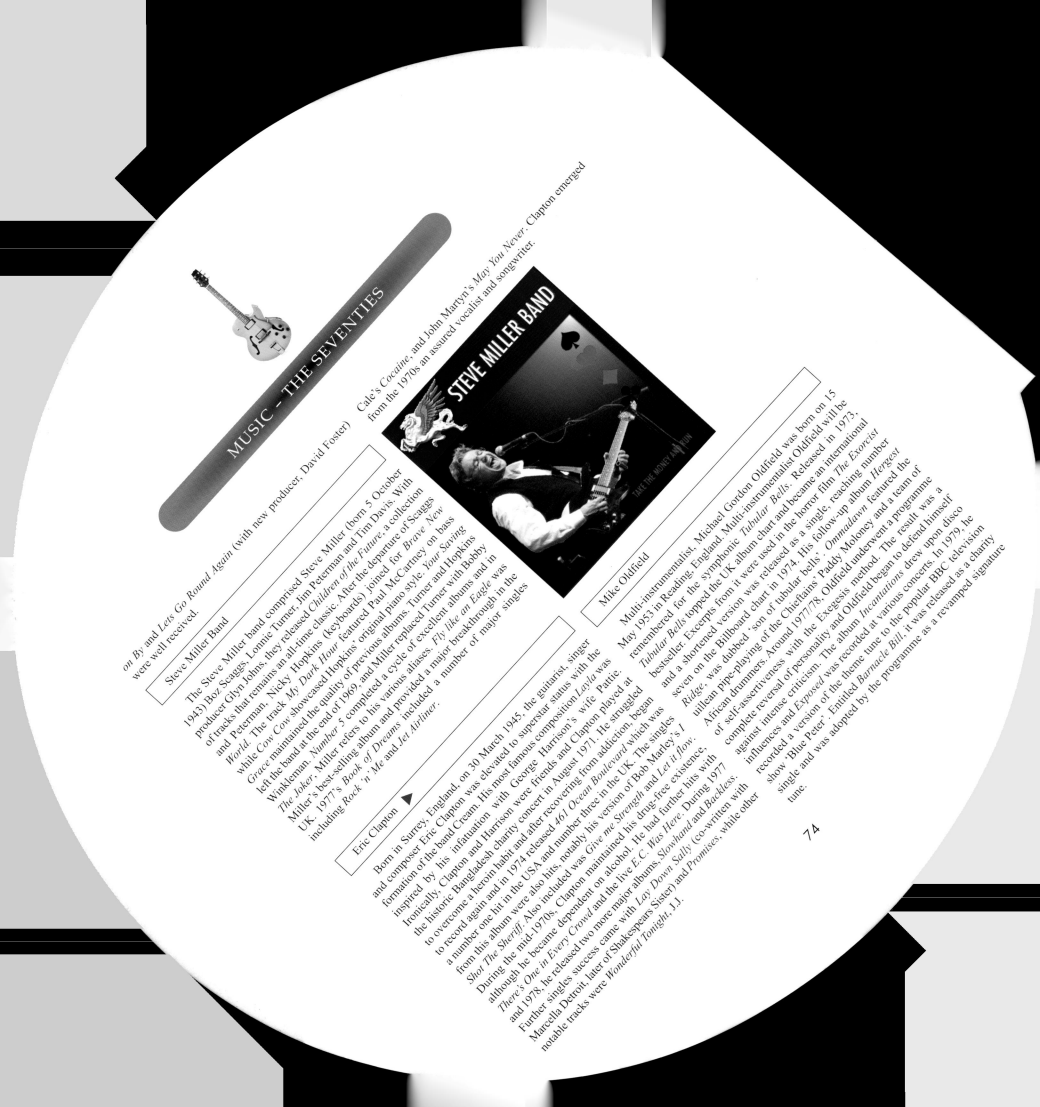

Steve Miller Band

The Steve Miller band comprised Steve Miller (born 5 October 1943) Boz Scaggs, Lonnie Turner, Jim Peterman and Tim Davis. With producer Glyn Johns, they released *Children of the Future*, a collection of tracks that remains an all-time classic. After the departure of Scaggs and Peterman, Nicky Hopkins (keyboards) joined for *Brave New World*. The track *My Dark Hour* featured Paul McCartney on bass while *Cow Cow* showcased Hopkins' original piano style. *Your Saving Grace* maintained the quality of previous albums. Turner and Hopkins left the band at the end of 1969, and Miller replaced Turner with Bobby Winkleman. *Number 5* completed a cycle of excellent albums and in *The Joker*, Miller refers to his various aliases. *Fly like an Eagle* was Miller's best-selling album and provided a major breakthrough in the UK. 1977's *Book of Dreams* included a number of major singles including *Rock 'n' Me* and *Jet Airliner*.

Mike Oldfield

Multi-instrumentalist, Michael Gordon Oldfield was born on 15 May 1953 in Reading, England. Multi-instrumentalist Oldfield will be remembered for the symphonic *Tubular Bells*. Released in 1973, *Tubular Bells* topped the UK album chart and became an international bestseller. Excerpts from it were used in the horror film *The Exorcist* and a shortened version was released as a single, reaching number seven on the Billboard chart in 1974. His follow-up album *Hergest Ridge*, was dubbed 'son of tubular bells'. *Ommadawn* featured the uilleann pipe-playing of the Chieftains' Paddy Moloney and a team of African drummers. Around 1977/78, Oldfield underwent a programme of self-assertiveness with the Exegesis method. The result was a complete reversal of personality and Oldfield began to defend himself against intense criticism. The album *Incantations* drew upon disco influences and *Exposed* was recorded at various concerts. In 1979, he recorded a version of the theme tune to the popular BBC television show 'Blue Peter'. Entitled *Barnacle Bill*, it was released as a charity single and was adopted by the programme as a revamped signature tune.

▶ Eric Clapton

Born in Surrey, England, on 30 March 1945, the guitarist, singer and composer Eric Clapton was elevated to superstar status with the formation of the band Cream. His most famous composition *Layla* was inspired by his infatuation with George Harrison's wife Pattie. Ironically, Clapton and Harrison were friends and Clapton played at the historic Bangladesh charity concert in August 1971. He struggled to overcome a heroin habit and after recovering from addiction, began to record again and in 1974 released *461 Ocean Boulevard* which was a number one hit in the USA and number three in the UK. The singles from this album were also hits, notably his version of Bob Marley's *I Shot The Sheriff*. Also included was *Give me Strength* and *Let it flow*. During the mid-1970s, Clapton maintained his drug-free existence, although he became dependent on alcohol. He had further hits with *There's One in Every Crowd* and the live *E.C. Was Here*. During 1977 and 1978, he released two more major albums, *Slowhand* and *Backless*. Further singles success came with *Lay Down Sally* (co-written with Marcella Detroit, later of Shakespears Sister) and *Promises*, while other notable tracks were *Wonderful Tonight*, J.J.

on *By* and *Lets Go Round Again* (with new producer, David Foster) were well received.

Cale's *Cocaine*, and John Martyn's *May You Never*, Clapton emerged from the 1970s an assured vocalist and songwriter.

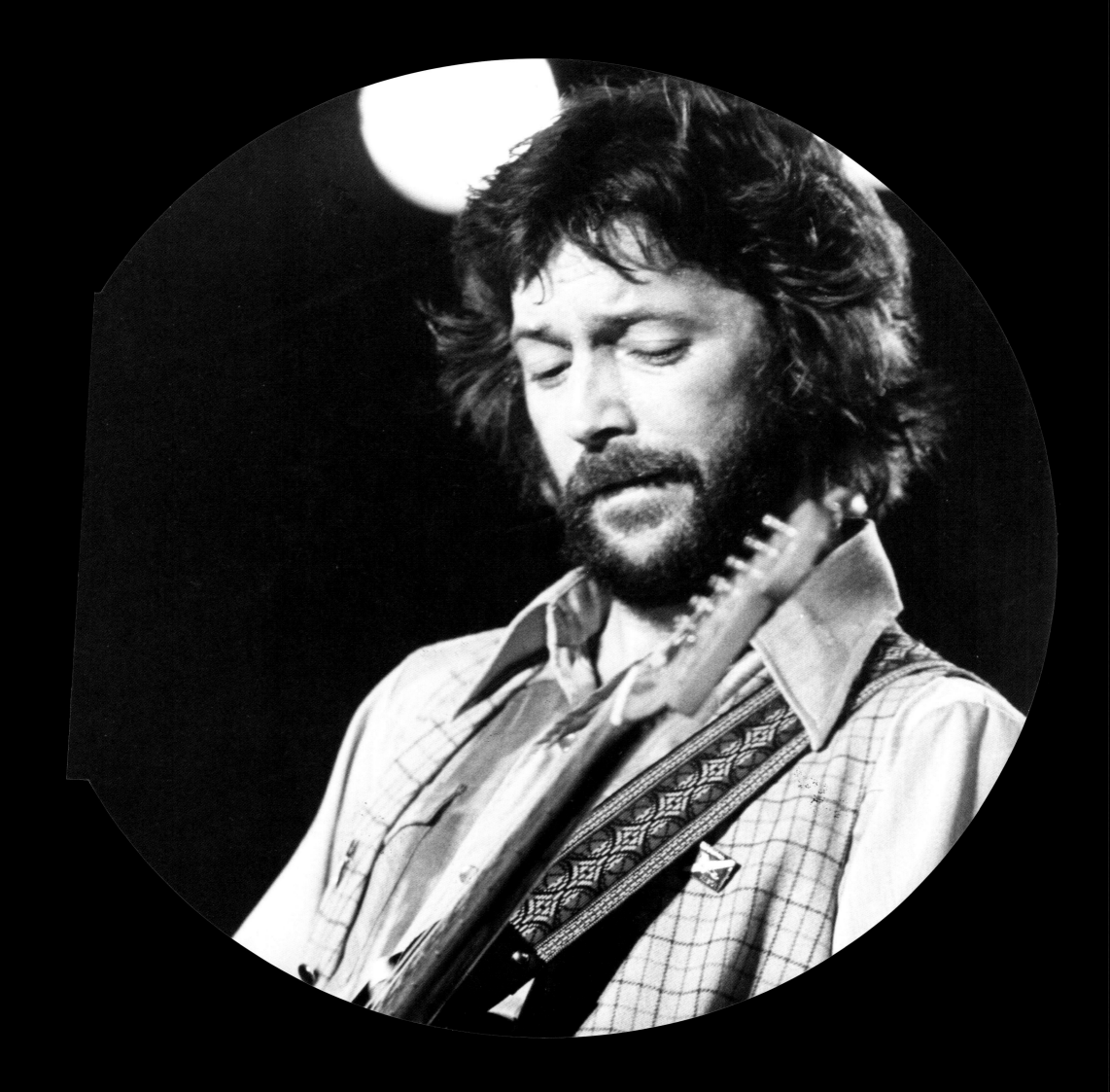

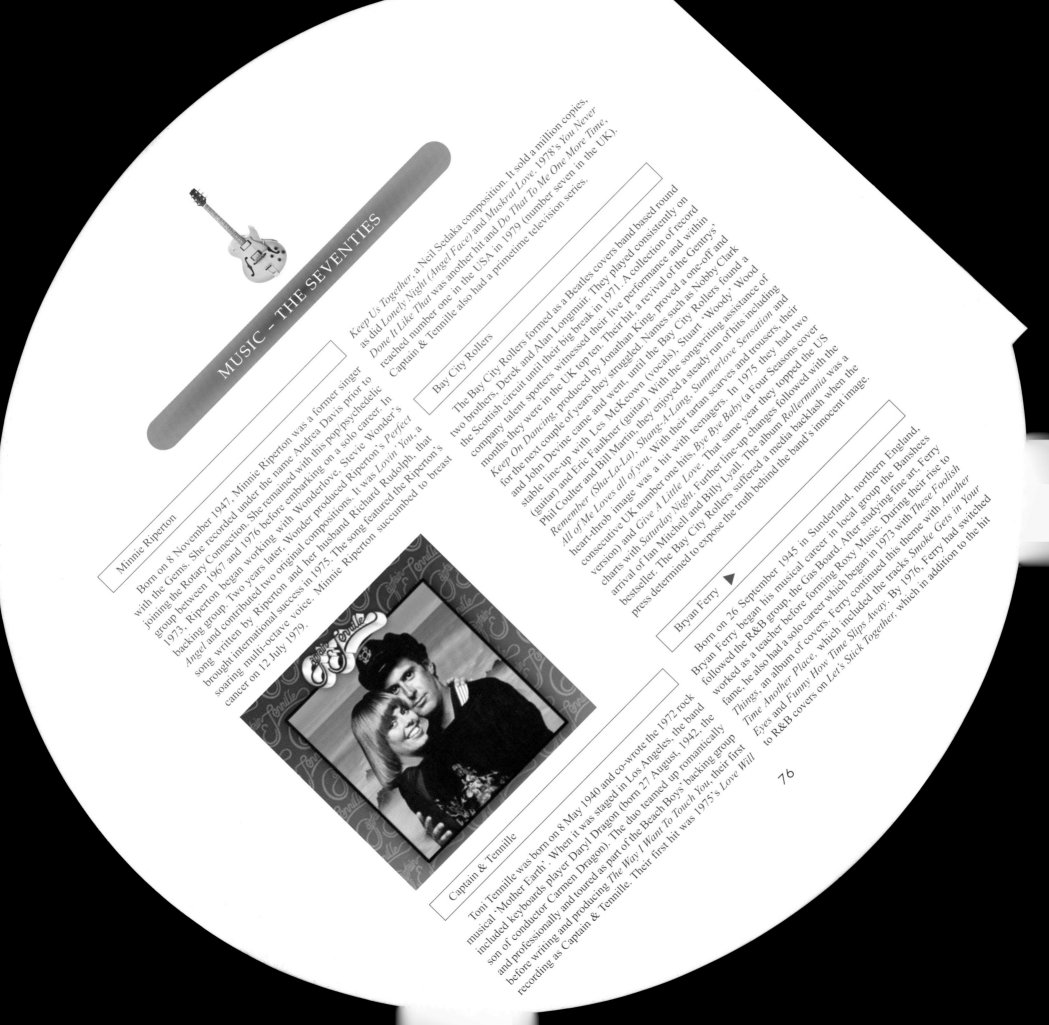

MUSIC – THE SEVENTIES

Minnie Riperton

Born on 8 November 1947, Minnie Riperton was a former singer with the Gems. She recorded under the name Andrea Davis prior to joining the Rotary Connection. She remained with this pop/psychedelic group between 1967 and 1976 before embarking on a solo career. In 1973, Riperton began working with Wonderlove. Stevie Wonder's backing group. Two years later, Wonder produced Riperton's *Perfect Angel* and contributed two original compositions. It was *Lovin' You*, a song written by Riperton and her husband Richard Rudolph, that brought international success in 1975. The song featured the Riperton's soaring multi-octave voice. Minnie Riperton succumbed to breast cancer on 12 July 1979.

Captain & Tennille

Toni Tennille was born on 8 May 1940 and co-wrote the 1972 rock musical 'Mother Earth'. When it was staged in Los Angeles, the band included keyboards player Daryl Dragon (born 27 August, 1942, the son of conductor Carmen Dragon). The duo teamed up romantically and professionally and toured as part of the Beach Boys' backing group before writing and producing *The Way I Want To Touch You*, their first recording as Captain & Tennille. Their first hit was 1975's *Love Will*

Keep Us Together, a Neil Sedaka composition. It sold a million copies, as did *Lonely Night (Angel Face)* and *Muskrat Love*. 1978's *You Never Done It Like That* was another hit and *Do That To Me One More Time*, reached number one in the USA in 1979 (number seven in the UK). Captain & Tennille also had a primetime television series.

Bay City Rollers

The Bay City Rollers formed as a Beatles covers band based round two brothers, Derek and Alan Longmuir. They played consistently on the Scottish circuit until their big break in 1971. A collection of record company talent spotters witnessed their live performance and within months they were in the UK top ten. Their hit, a revival of the Gentrys' *Keep On Dancing*, produced by Jonathan King, proved a one-off and for the next couple of years they struggled. Names such as Nobby Clark and John Devine came and went, until the Bay City Rollers found a stable line-up with Les McKeown (vocals), Stuart 'Woody' Wood (guitar) and Eric Faulkner (guitar), they enjoyed a steady run of hits including Phil Coulter and Bill Martin, *Shang-A-Lang*, *Summerlove Sensation* and *Remember (Sha-La-La)*, With the songwriting assistance of *All of Me Loves all of you*. 1975 they had two consecutive UK number one hits, *Bye Bye Baby* (a Four Seasons cover version) and *Give A Little Love*. That same year they topped the US charts with *Saturday Night*. Further line-up changes followed with the arrival of Ian Mitchell and Billy Lyall. The album *Rollermania* was a bestseller. The Bay City Rollers suffered a media backlash when the heart-throb image was a hit with teenagers. In their tartan scarves and trousers, their press determined to expose the truth behind the band's innocent image.

Bryan Ferry ▶

Born on 26 September 1945 in Sunderland, northern England, Bryan Ferry began his musical career in local group the Banshees followed the R&B group, the Gas Board. After studying fine art, Ferry worked as a teacher before forming Roxy Music. During their rise to fame, he also had a solo career which began in 1973 with *These Foolish Things*, an album of covers. Ferry continued this theme with *Another Time Another Place*, which included the tracks *Smoke Gets in Your Eyes* and *Funny How Time Slips Away*. By 1976, Ferry had switched to R&B covers on *Let's Stick Together*, which in addition to the hit

76

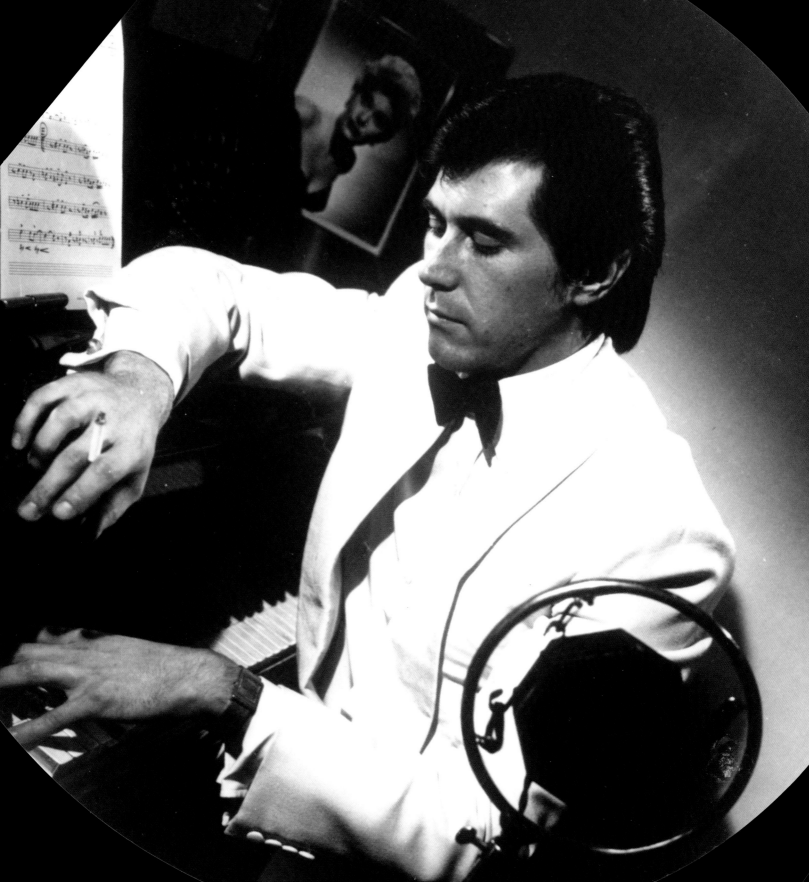

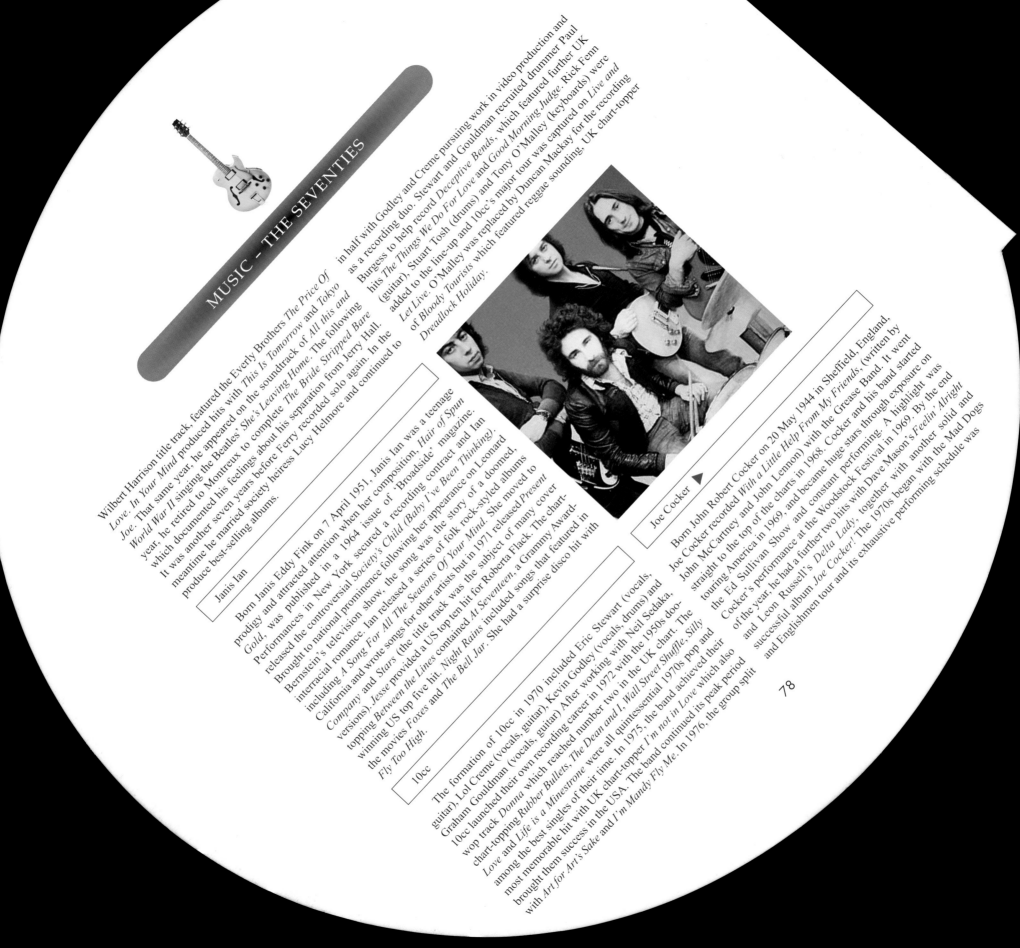

MUSIC – THE SEVENTIES

Wilbert Harrison title track, featured the Everly Brothers *The Price Of Love*. *In Your Mind* produced hits with *This Is Tomorrow* and *Tokyo Joe*. That same year, he appeared on the soundtrack of *All this and World War II* singing the Beatles' *She's Leaving Home*. The following year, he retired to Montreux to complete *The Bride Stripped Bare* which documented his feelings about his separation from Jerry Hall. It was another seven years before Ferry recorded solo again. In the meantime he married society heiress Lucy Helmore and continued to produce best-selling albums.

in half with Godley and Creme pursuing work in video production and as a recording duo. Stewart and Gouldman recruited drummer Paul Burgess to help record *Deceptive Bends*, which featured further UK hits *The Things We Do For Love* and *Good Morning Judge*. Rick Fenn (guitar), Stuart Tosh (drums) and Tony O'Malley (keyboards) were added to the line-up and 10cc's major tour was captured on *Live and Let Live*. O'Malley was replaced by Duncan Mackay for the recording of *Bloody Tourists* which featured reggae sounding, UK chart-topper *Dreadlock Holiday*.

Janis Ian

Born Janis Eddy Fink on 7 April 1951, Janis Ian was a teenage prodigy and attracted attention when her composition, *Hair of Spun Gold*, was published in a 1964 issue of 'Broadside' magazine. Performances in New York secured a recording contract and Ian released the controversial *Society's Child (Baby I've Been Thinking)*. Brought to national prominence following her appearance on Leonard Bernstein's television show, the song was the story of a doomed, interracial romance. Ian released a series of folk rock-styled albums including *A Song For All The Seasons Of Your Mind*. She moved to California and wrote songs for other artists but in 1971 released *Present Company* and *Stars* (the title track was the subject of many cover versions). *Jesse* provided a US top ten hit for Roberta Flack. The chart-topping *Between the Lines* contained *At Seventeen*, a Grammy Award-winning US top five hit. *Night Rains* included songs that featured in the movies *Foxes* and *The Bell Jar*. She had a surprise disco hit with *Fly Too High*.

Joe Cocker ▶

Born John Robert Cocker on 20 May 1944 in Sheffield, England, Joe Cocker recorded *With a Little Help From My Friends*, (written by John McCartney and John Lennon) with the Grease Band. It went straight to the top of the charts in 1968. Cocker and his band started touring America in 1969, and became huge stars through exposure on the Ed Sullivan Show and constant performing. A highlight was Cocker's performance at the Woodstock Festival in 1969. By the end of the year, he had a further two hits with Dave Mason's *Feelin' Alright* and Leon Russell's *Delta Lady*; together with another solid and successful album *Joe Cocker!* The 1970s began with the Mad Dogs and Englishmen tour and its exhaustive performing schedule was

10cc

The formation of 10cc in 1970 included Eric Stewart (vocals, guitar), Lol Creme (vocals, guitar) Kevin Godley (vocals, drums) and Graham Gouldman (vocals, guitar) After working with Neil Sedaka, 10cc launched their own recording career in 1972 with the UK chart. The wop track *Donna* which reached number two in the UK chart. The chart-topping *Rubber Bullets*, *The Dean and I*, *Wall Street Shuffle*, *Silly Love* and *Life is a Minestrone* were all quintessential 1970s pop and among the best singles of their time. In 1975, the band achieved their most memorable hit with UK chart-topper *I'm not in Love* which also brought them success in the USA. The band continued its peak period with *Art for Art's Sake* and *I'm Mandy Fly Me*. In 1976, the group split

78

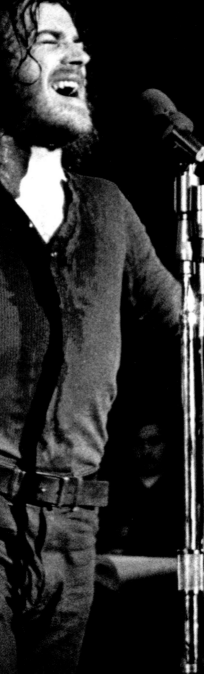

presented on a subsequent film and double album. Cocker spiralled into alcohol and drug addiction which lasted through most of the decade. He was deported from Australia during a 1972 tour and was often so drunk he was unable to perform. He recorded Gregg Allman's *Midnight Rider*, *You are so Beautiful* and *Put Out The Light*.

Bad Company

Bad Company was an English heavy rock group formed in 1973, with a line-up comprising Paul Rodgers (vocals, guitar), Mick Ralphs (vocals, guitar) and Boz Burrell (bass), Simon Kirke (vocals). Their best-selling debut established their sound and a series of albums and stadium tours throughout the mid-1970s brought them chart success in the US and UK. They achieved singles success with a number of powerful songs like *Can't Get Enough* and *Feel like Makin' Love*. A three-year break ended with the release of *Rough Diamonds*, another UK top 20 album success. After nearly a decade of performing, and producing albums, Bad Company dissolved in 1983.

Queen ▲

Queen began life as a glam rock unit in 1972. Brian May (guitar), Roger Taylor (drums), Freddie Mercury and John Deacon (bass). They issued a self-titled album, a fusion of 1970s glam and late 1960s heavy rock. The toured extensively and recorded a second album, *Queen* fulfilled their early promise by reaching the UK top five. *Seven Seas of Rhye* gave them their first hit single (UK number ten), and *Sheer Heart Attack* reached number two in the UK album charts. *Killer Queen* from the album was also the band's first US hit, reaching number 12 in May 1975. The same year they completed the epic seven-minute single into a mini opera. It remained at number one for *Bohemian Rhapsody*, in which Mercury succeeded in transforming a nine weeks. The album *A Night at the Opera*, was one of the most expensive and expansive albums of its period. *A Day At the Races* was their next release and the singles *Somebody to Love* and *We are the Champions* both reached number two in the UK. *Crazy Little Thing Called Love* and *Another one Bites The Dust* were both hits. *The Game* gave Queen their first US number one album in 1980. Freddy Mercury passed away from an AIDS-related illness on 24 November 1991.

Wings

Paul McCartney's first post-Beatles music venture. Wings achieved eight top ten albums in both the UK and US and *Mull of Kintyre* remains one of the biggest-selling singles of all time. The band was formed during the summer of 1971, McCartney and wife Linda being augmented by Denny Seiwell (drums) and Denny Laine (ex-Moody Blues on guitar/vocals). The early part of 1972 was taken up by the joined at the end of 1971. Guitarist Henry McCullough (ex-Grease band) famous 'surprise' college gigs around the UK. In 1973 Wings scored a double number one in the US with album *Red Rose Speedway* and *My Love*. They had the hit theme song from the James Bond movie *Live and let die*. Their most acclaimed album, *Band on the Run* topped the album charts in the UK and US, and kicked off 1974 by yielding two transatlantic top ten singles in *Jet* and *Band on the Run* (the latter topping the US charts). Under the name the Country Hams they released *Walking in the Park with Eloise* in 1974. A new line-up preceded the single *Venus and Mars*, another number one in the UK and USA, *Wings at the speed of Sound* toured the US, and the resulting live triple *Wings over America* was huge. 1979's *Back to the Egg* failed to impress and Wings did not repeat earlier success.

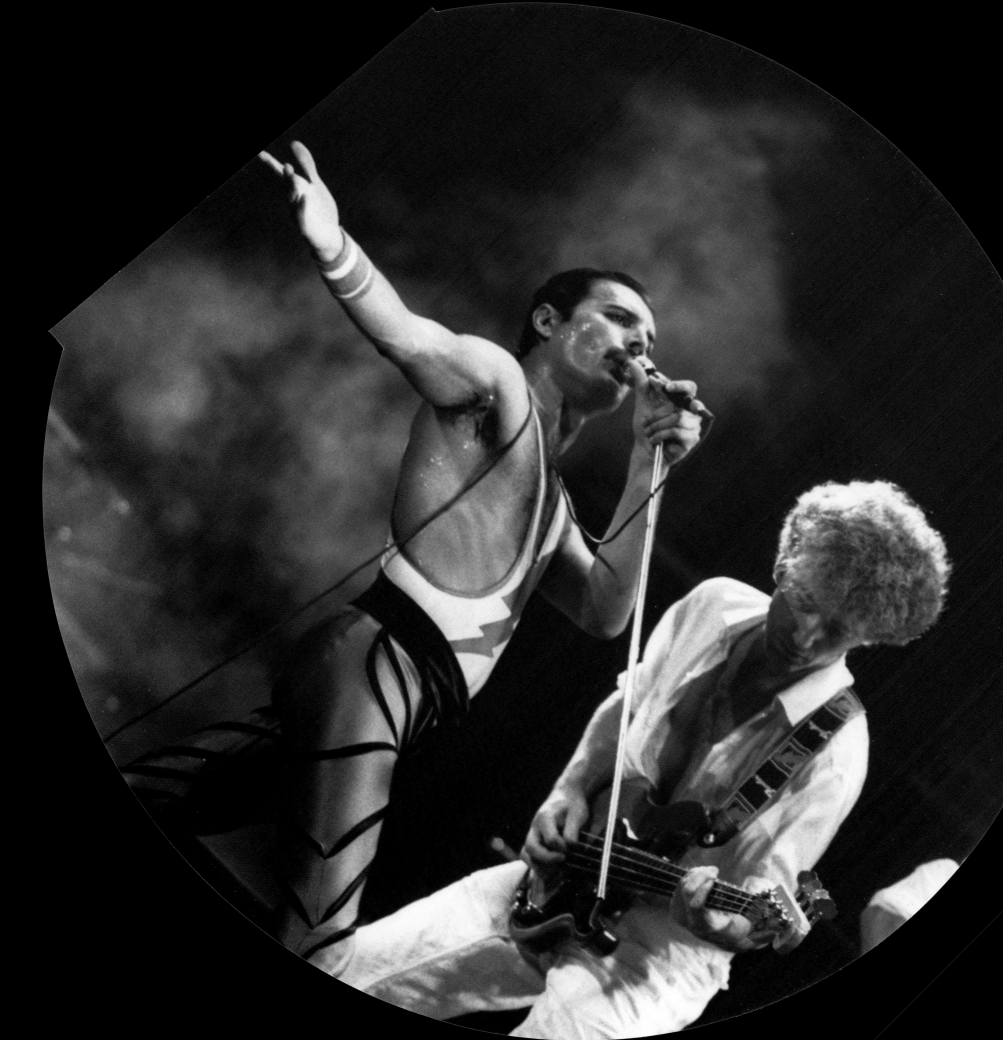

Barry Manilow

Born Barry Alan Pincus on 17 June 1943 in Brooklyn, New York, Barry Manilow has been an immensely popular singer, pianist and composer since the mid-1970s. Manilow studied music at the Juilliard School and worked as an arranger for CBS-TV. In 1972, he played accompanist to Bette Midler, who was then a cult performer in New York. After an unsuccessful debut album, he took the powerful ballad *Mandy* to number one in America. The song had previously been a UK hit for its co-writer Scott English, as *Brandy*. Among his biggest hits were *Could it be Magic* (1975), *I write the songs* (composed by the Beach Boys' Bruce Johnston –1976), *Tryin' to get the feeling again* (1976), *Looks Like We Made it* (1977), *Can't Smile Without You* (1978), the upbeat *Copacobana (at the copa)* (1978), *Somewhere in the Night* (1979), *Ships* (1979) and *I made it through the rain* (1980).

Manhattan Transfer

Formed in 1969, the band Manhattan Transfer covered a variety of styles, their trademark being their use of exquisite vocal harmony. They were popular on the New York cabaret circuit. The first version of the group broke up in 1971. An unlikely pop act, they nonetheless charted on both sides of the Atlantic. It was symptomatic of their lack of crossover appeal that the hits were different in the UK and the USA, and indeed their versatility splintered their audience. Fans of the ballad *Chanson D'Amour*, did not always go for the gospel of *Operator*, or a jazz tune like *Tuxedo Junction*. Their power is in their breathtaking vocal abilities, strong musicianship and slick live shows. They recorded the album *Jukin'* in 1971 as a tribute to the 1940s. The second album *The Manhattan Transfer* (1975) made them international stars. *Coming Out* (1976), *Pastiche* (1978) and 1979's *Extensions* turned them from novelty act to chamber performers.

Rocket Records label. He produced her 'comeback' set, *Loving & Free*, with the hit *Amoureuse*. Dee charted successfully with *I got the music in me* (1974) and *(you don't know) How glad I am* (1975), fronting the Kiki Dee band. Her duet with John, *Don't go breaking my heart*, topped the UK and US charts in 1976 and is probably the best remembered hit.

Bellamy Brothers

Homer Howard Bellamy and David Milton Bellamy became one of the top country acts of the 1970s and 1980s after beginning their career in pop and soul. The brothers formed the band Jericho in 1968, but disbanded three years later. They then began writing songs for other artists, and David's *Spiders and snakes* was a hit for Jim Stafford in 1973/74. The Bellamy Brothers signed to Warner Brothers the following year and in 1976 reached the top of the US and UK charts with *Let your love flow*. Although they continued to release albums and singles for the next few years, their days as a pop act were over. In 1979, the ambiguously and suggestively titled *If I said you had a beautiful body (would you hold it against me?)* became the first of ten country chart singles for the duo. This became their biggest hit in the UK where it reached the top three.

◄ Kiki Dee

Born Pauline Matthews on 6 March 1947 in Yorkshire, England, Kiki Dee made her recording debut in 1963 with the Mitch Murray-penned *Early Night*. Her skilled interpretations of contemporary soul hits secured a recording deal with Tamla/Motown Records in 1969, the first white British act to be so honoured. Unable to attain her due commercial success, the despondent singer sought cabaret work in Europe and South Africa. In 1973 she signed up with Elton John's

82

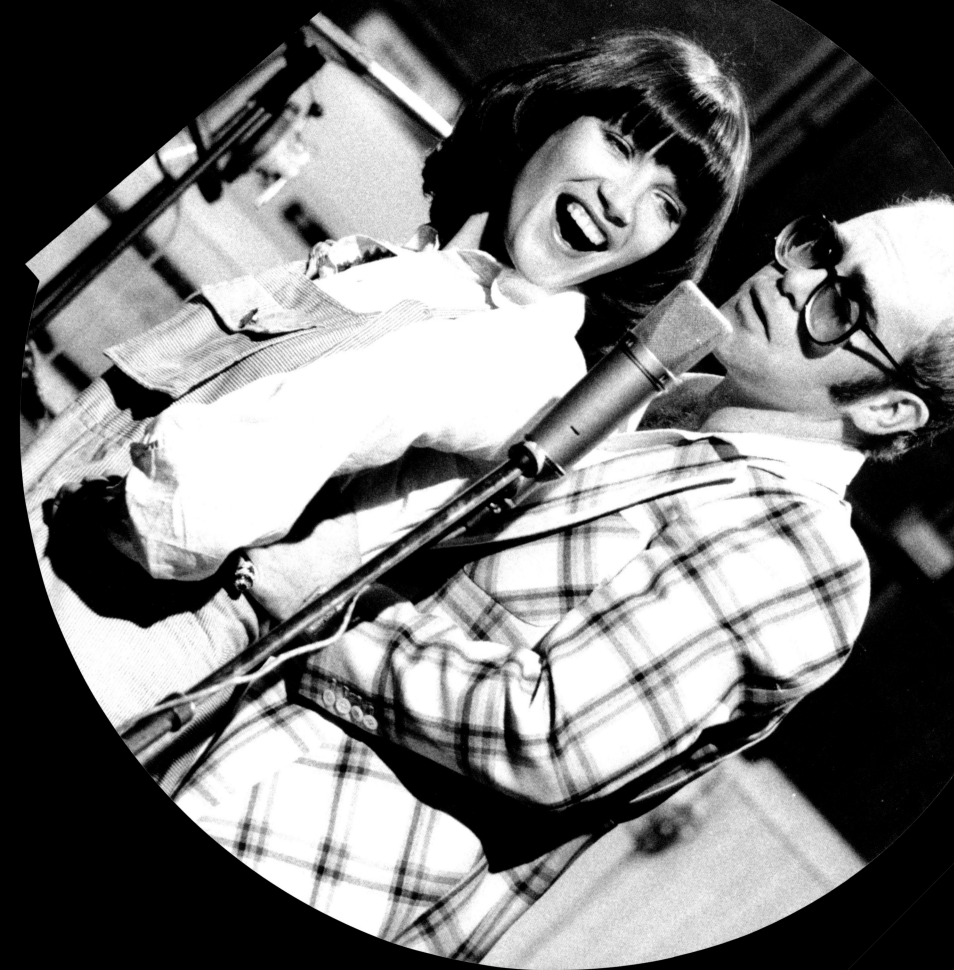

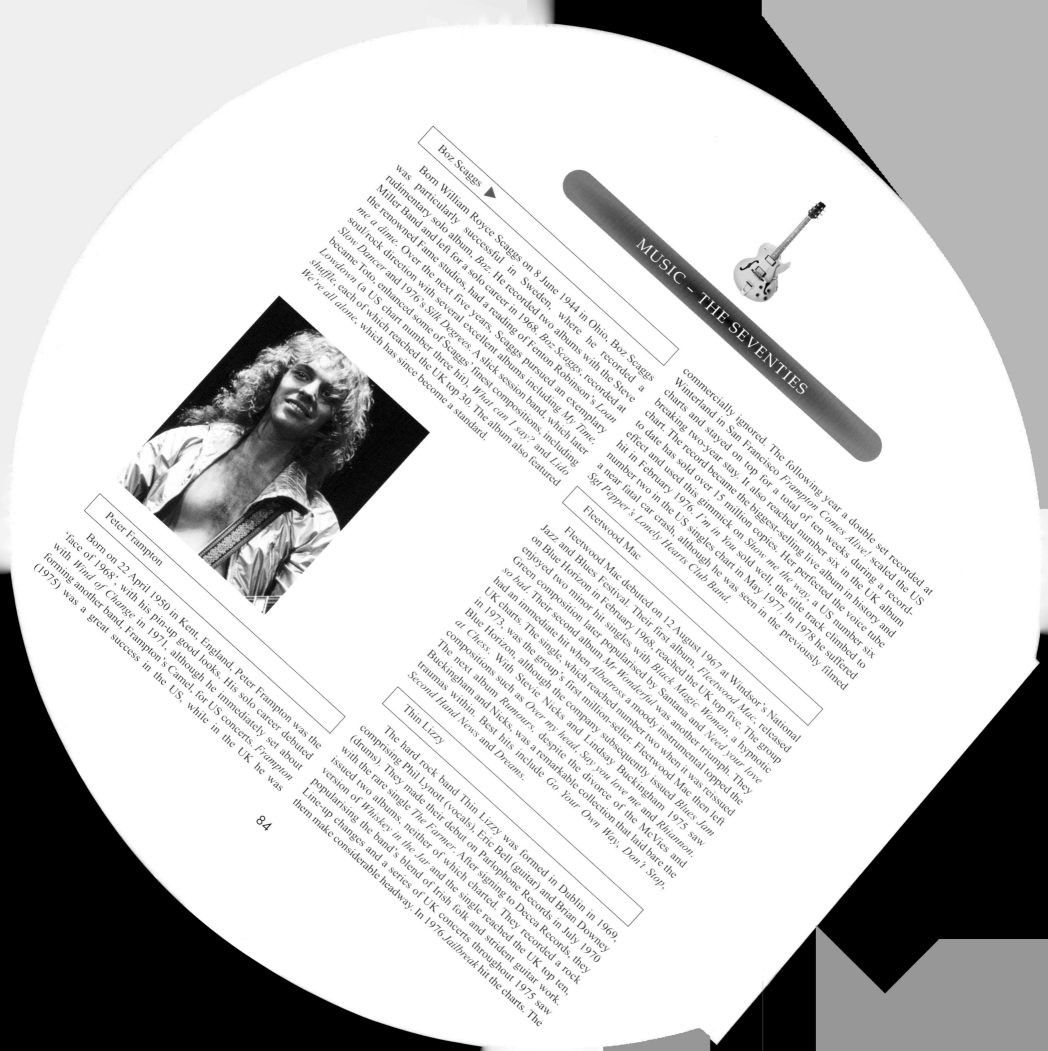

Boz Scaggs ▲

Born William Royce Scaggs on 8 June 1944 in Ohio. Boz Scaggs was particularly successful in Sweden, where he recorded a rudimentary solo album, *Boz*. He recorded two albums with the Steve Miller Band and left for a solo career in 1968. *Boz Scaggs*, recorded at the renowned Fame studios, had a reading of Fenton Robinson's *Loan me a dime*. Over the next five years, Scaggs pursued an exemplary soul/rock direction with several excellent albums including *My Time, Slow Dancer* and 1976's *Silk Degrees*. A slick session band, which later became Toto, enhanced some of Scaggs' finest compositions, including *Lowdown* (a US chart number three hit), *What can I say?*, and *Lido shuffle*, each of which reached the UK top 30. The album also featured *We're all alone*, which has since become a standard.

Peter Frampton

Born on 22 April 1950 in Kent, England, Peter Frampton was the 'face of 1968', with his pin-up good looks. His solo career debuted with *Wind of Change* in 1971, although he immediately set about forming another band, Frampton's Camel, for US concerts. *Frampton* (1975) was a great success in the US, while in the UK he was commercially ignored. The following year a double set recorded at Winterland in San Francisco *Frampton Comes Alive!*, scaled the US charts and stayed on top for a total of ten weeks during a record-breaking two-year stay. It also reached number six in the UK album chart. The record became the biggest-selling live album in history and to date has sold over 15 million copies. He perfected the voice tube effect and used this gimmick on *Show me the way*, a US number six hit in February 1976. *I'm in You* sold well, the title track climbed to number two in the US singles chart in May 1977. In 1978 he suffered a near fatal car crash, although he was seen in the previously filmed *Sgt Pepper's Lonely Hearts Club Band*.

Fleetwood Mac

Fleetwood Mac debuted on 12 August 1967 at Windsor's National Jazz and Blues Festival. Their first album, *Fleetwood Mac*, released on Blue Horizon in February 1968, reached the UK top five. The group enjoyed two minor hit singles with *Black Magic Woman*, a Peter Green composition later popularised by Santana and *Need your love so bad*. Their second album *Mr Wonderful* was another triumph. They had an immediate hit when *Albatross* a moody instrumental topped the UK charts. The single, which reached number two when it was reissued in 1973, was the group's first million-seller. Fleetwood Mac then left Blue Horizon, although the company subsequently issued *Blues Jam at Chess*. With Stevie Nicks and Lindsay Buckingham compositions such as *Over my head, Say you love me* and *Rhiannon*. The next album *Rumours*, despite the divorce of the McVies and Buckingham and Nicks was a remarkable collection that laid bare the traumas within. Best hits include *Go Your Own Way, Don't Stop, Second Hand News* and *Dreams*.

Thin Lizzy

The hard rock band Thin Lizzy was formed in Dublin in 1969, comprising Phil Lynott (vocals), Eric Bell (guitar) and Brian Downey (drums). They made their debut on Parlophone Records in July 1970 with the rare single *The Farmer*. After signing to Decca Records, they issued two albums, neither of which charted. They recorded a rock version of *Whiskey in the Jar* and the single reached the UK top ten, popularising the band's blend of Irish folk and strident guitar work. Line-up changes and a series of UK concerts throughout 1975 saw them make considerable headway. In 1976 *Jailbreak* hit the charts. The

single *The Boys Are Back in Town* reached the UK top ten and US top 20 and was voted single of the year by the influential *New Music Express*. Another UK top 20 followed with the scathing *Don't Believe a Word* drawn from *Johnny The Fox*. Both *Dancin' In the Moonlight (it's caught me in the spotlight)* and the album *Bad Reputation* were UK top ten hits and were followed by the double album *Live and Dangerous*. Their 1979 hits include top 20 singles *Waiting for an Alibi* and *Do Anything you Want to* plus the bestselling album *Black Rose*. Phil Lynott died of heart failure and pneumonia on January 4, 1986 at the age of 36.

Leo Sayer

Born Gerard Hugh Sayer on 21 May 1948 in Sussex, England, Leo Sayer's heyday was the 1970s. In 1971 he formed Patches who were managed by Dave Courtney, to whose melodies he provided lyrics. Sayer reached the UK number one spot with 1973's *The Show Must Go On*. After *One man band* and *Long tall glasses* (US hot hundred breakthrough) came the severing of Sayer's partnership with Courtney in 1975 during the making of *Another Year*. 1976 brought a US million-seller in *You make me feel like dancing*. The ballad *When I need you* marked Sayer's commercial peak at home where the BBC engaged him for two television series. However, with the title track of *Thunder in my Heart* halting just outside the UK top 20, hits suddenly became harder to come by. 1978's *I can't stop loving you (though I try)* and revivals of Buddy Holly's *Raining in my heart* and Bobby Vee's *More than I can say* were his last unequivocal smashes as his 1983 chart swansong (with *Till you come back to me*) loomed nearer.

Foreigner

The US rock band Foreigner comprises Mick Jones, Ian McDonald, Lou Gramm, Al Greenwood, Dennis Elliott and Ed Gagliardi (replaced by Rick Wills in 1980). Atlantic Records agreed to handle the band and Ian and Mick helped co-produce the first disc, *Foreigner*, in 1977. As the year went by, it had two top ten singles, *Feels like the first time* and *Cold as ice*. The album eventually sold four million copies world-wide. They were a finalist in the Grammy Awards' Best New Artist category. By 1977, the band was in the studio again working on its follow-up *Double Vision*. Mick was the main songwriter. Foreigner then embarked on its *Around the world in 42 days* tour, which started off before 300,000 people at the California Jan II festival and continued to Japan, Hong Kong, Australia, Greece and Germany. The single *Hot blooded* came out and went gold. Two months later, another single, the album's title song, won similar accreditation. 1979s *Head Games* provided hit singles during 1979 and 1980 *Dirty white boy*, the title song and *Women*. Their biggest hit came in 1984, with *I Want to Know What Love is* from the album *Agent Provocateur*.

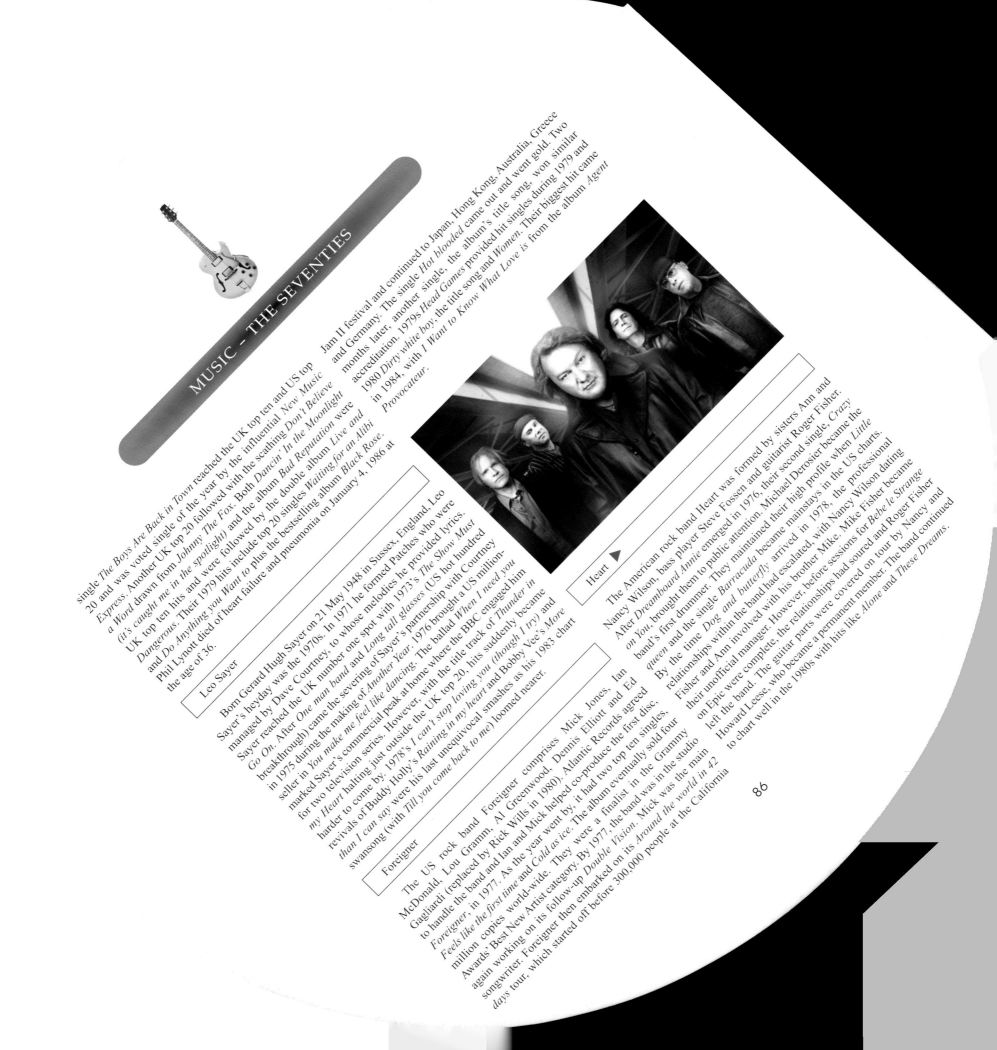

◀ Heart

Heart

The American rock band Heart was formed by sisters Ann and Nancy Wilson, bass player Steve Fossen and guitarist Roger Fisher. After *Dreamboat Annie* emerged in 1976, their second single, *Crazy on You*, brought them to public attention. Michael Derosier became the band's first drummer. They maintained their high profile when *Little queen* and the single *Barracuda* became mainstays in the US charts. By the time *Dog and butterfly* arrived in 1978, the professional relationships within the band had escalated, with Nancy Wilson dating Fisher and Ann involved with the band. Mike Fisher became their unofficial manager. However, before sessions for *Bebe le Strange* on Epic were complete, the relationships had soured and Roger Fisher left the band. The guitar parts were covered on tour by Nancy and Howard Leese, who became a permanent member. The band continued to chart well in the 1980s with hits like *Alone* and *These Dreams*.

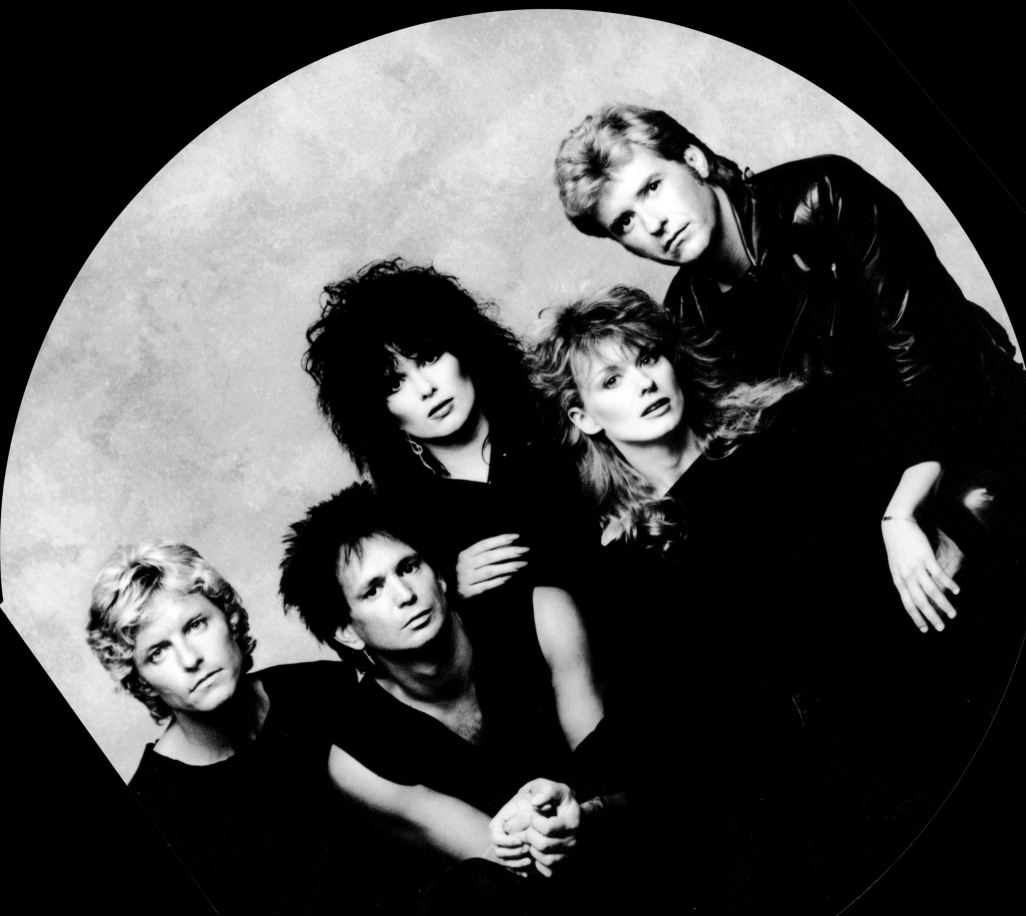

MUSIC – THE SEVENTIES

Supertramp

In 1969, while playing with the Joint in Munich, Davies met Dutch millionaire Stanley August Miesegaes, who offered to finance a new band. The British progressive rock band Supertramp were signed by A&M Records on the strength of their demo tapes. The debut *Supertramp* was an unspectacular affair. The follow-up, *Indelibly Stamped* was similarly unsuccessful and meandering but the controversial cover created most interest, depicting a busty, naked tattooed female. They had a hit with *Crime of The Century* becoming one of the top-selling albums of 1974, reaching UK number four. The band had refined their keyboard-dominated sound and produced an album that was well reviewed. Their debut hit *Dreamer* was taken from the album, while *Bloody well right* was a top 40 hit in the USA, going on to become one of their classic live numbers. The choral *Give a little bit* with its infectious acoustic guitar introduction was a minor transatlantic hit in 1977. Supertramp were elevated to rock's first division with the faultless *Breakfast in America* and four of the tracks became hits: *The logical song*, *Goodbye stranger*, *Take the long way home* and the title track. The album stayed on top of the US charts for six weeks and became their biggest seller with over 18 million copies to date.

Electric Light Orchestra

Electric Light Orchestra, also known as E.L.O. were a rock music group from Birmingham, England. Their first single, *10538 overture*, was a UK top ten single in 1972. *ELO II* scored a top ten single with an indulgent version of Chuck Berry's *Roll over Beethoven*. They enjoyed a third hit with *Showdown*. *Can't get it out of my head* reached the US top ten and helped the album *Eldorado* to achieve gold status. The line-up stabilised around Jeff Lynne, Bev Beven, Richard Tandy and Hugh McDowell, Kelly Groucutt (bass), Mik Kaminski (violin) and Melvyn Gale (cello). They became a start attraction on America's lucrative stadium circuit and achieved considerable success with albums *A New World Record*, *Out of the blue* and *Discovery*. Lynne's compositions successfully steered the line between pop and rock. Between 1976 and 1981 ELO scored an unbroken run of 15 UK top 20 singles, including *Livin' thing* (1976), *Telephone line* (1977), *Mr Blue Sky* (1978), *Don't bring me down* (1979) and *Xanadu*, a chart topping collaboration with Olivia Newton-John, taken from the movie of the same name.

Blondie ▶

Blondie was formed in New York City in 1974 with Deborah Harry (vocals), Chris Stein (guitar), Fred Smith (bass) and Bill O'Connor (drums). Smith and O'Connor left and James Destri (keyboards) and Gary Valentine (bass) and Clement Burke (drums) joined. *Plastic Letters* contained two UK top ten hits in *Denis* and *(I'm always touched by your) Presence dear*. *Parallel Lines*, produced by Mike Chapman, included the UK chart-topping *Heart of glass* and *Sunday girl* - both 1979. *Eat to the Beat* confirmed Blondie's dalliance with disco following *Heart of glass* and the set spawned two highly successful UK singles in *Dreaming* and the chart-topping *Atomic*. *Call me*, produced by Giorgio Moroder, was taken from the soundtrack of the movie *American Gigolo* and reached number one in both the UK and US. *Autoamerican* provided two further US chart-toppers in *The tide is high* and *Rapture*, while the former song, originally recorded by reggae group the Paragons, reached the same position in Britain.

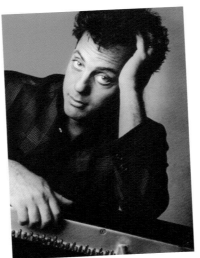

Billy Joel

The singer, pianist, band leader and songwriter Billy Joel was born in Hicksville, Long Island, New York, on 9 May 1949. A rock and pop

superstar by the end of the 1970s, Billy Joel disdained the easy road to fame and fortune. He formed a duo, Attila, with drummer Jon Small from The Hassles at the end of the 1960s. Their epic album was *Attila* (1970). Billy also became increasingly involved in original songwriting. A demo of some of that material led to a contract with Family Productions in 1971 for a solo album *Cold Spring Harbor* which came out in 1972 with Paramount Records. *Captain Jack* was given considerable airplay and Columbia sought Joel out and signed him in 1973. He released *Piano man*, a song that served as the title track for the album released later. His next album *Streetlight serenade* came out in 1974. The single *The Entertainer* showed up on the charts. In 1975, he went back to New York and released the single *Say goodbye to Hollywood*. The new album *Turnstiles* came out and included other tracks like *Summer, Highland Falls*, and *New York state of mind*. After finishing an extensive concert tour, he returned to the studios for a new collection under supervision of producer Phil Ramone. The multi-platinum result was *The Stranger* (1977) with the singles *Movin' out (Anthony's song)* and *Just the way you are*. In 1978, the latter became CBS Records' first single to be certified gold that year. At the same time, *Movin' out* was reissued and became a top 20 entrant. In May, a third single *Only the good die young* was released. In 1978, he won two Grammy awards for *Just the way You Are* (Record of the year and Song of the year). 1979 saw the release of *52nd Street*. His success has continued with hits like *Innocent Man, Tell Her About It* and *Uptown Girl* in the 1980s.

including jazz, soul, rock, reggae and blues. In 1970 he joined jazz-rock fusion band Dada, featuring singer Elkie Brooks. In 1971, Brooks and Palmer formed rhythm and blues group, Vinegar Joe, and Palmer sang and played rhythm guitar. They signed to Island Records for three albums: *Vinegar Joe* (1972), *Rock'n'Roll Gypsies* (1972) and *Six Star General* (1973). Palmer then signed solo for *Sneakin' Sally Through the Alley* recorded in New Orleans in 1974. Relocating from London to New York, he released *Pressure Drop* in 1976 featuring Motown bassist James Jamerson. The album was most noted for its cover art of a nude girl on a balcony. Palmer then moved to the Bahamas and in 1978 had a US Billboard top 50 album with *Double Fun*. Palmer's next album was an artistic departure in a rockier direction. *Secrets* produced his second top 20 single with Moon Martin's *Bad case of loving you (doctor doctor)*. He passed away on 26 September 2003.

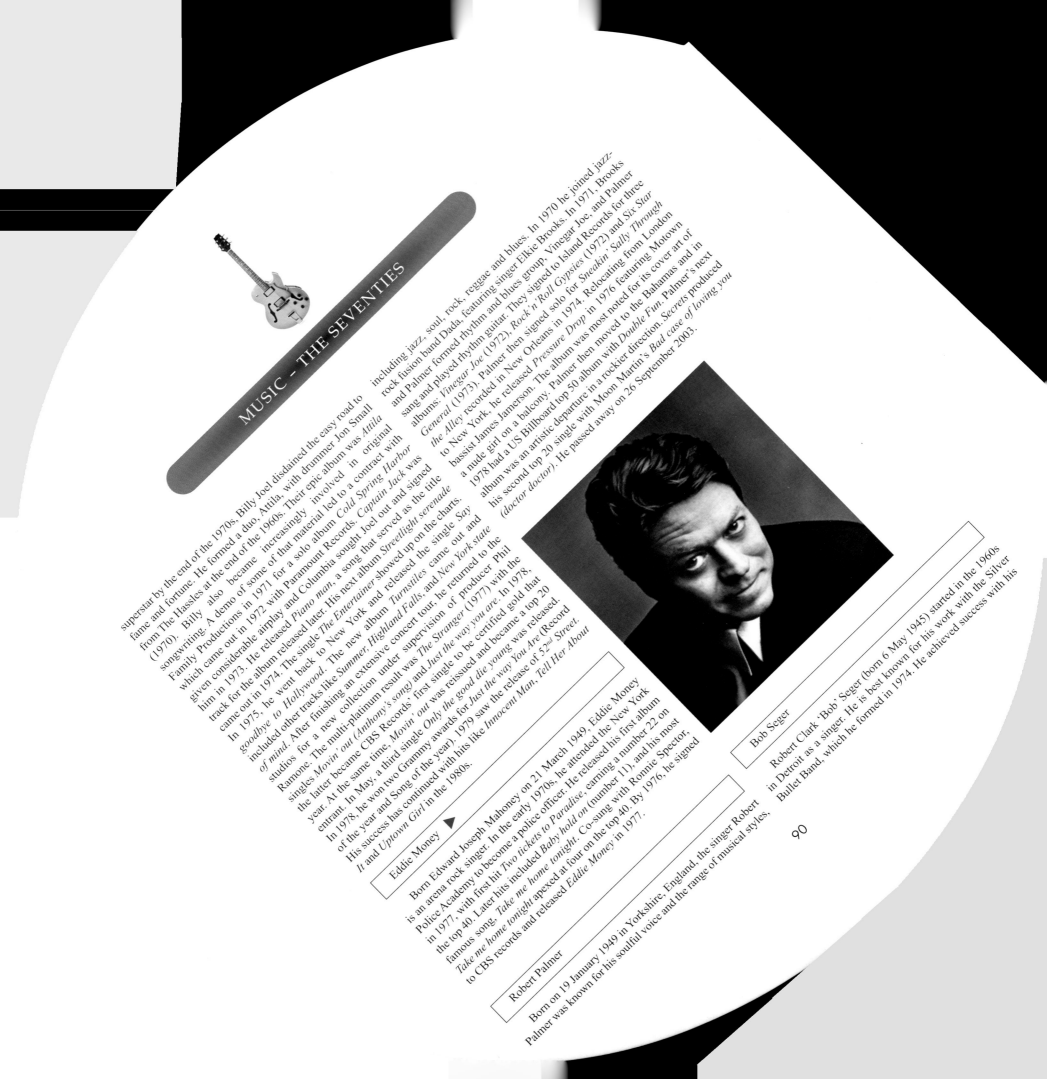

Bob Seger

Robert Clark 'Bob' Seger (born 6 May 1945) started in the 1960s in Detroit as a singer. He is best known for his work with the Silver Bullet Band, which he formed in 1974. He achieved success with his

Eddie Money ▶

Born Edward Joseph Mahoney on 21 March 1949, Eddie Money is an arena rock singer. In the early 1970s, he attended the New York Police Academy to become a police officer. He released his first album in 1977, with first hit *Two tickets to Paradise*, earning a number 22 on the top 40. Later hits included *Baby hold on* (number 11), and his most famous song, *Take me home tonight*. Co-sung with Ronnie Spector, *Take me home tonight* apexed at four on the top 40. By 1976, he signed to CBS records and released *Eddie Money* in 1977.

Robert Palmer

Born on 19 January 1949 in Yorkshire, England, the singer Robert Palmer was known for his soulful voice and the range of musical styles,

1976 album *Night Moves* which featured several hits including the highly evocative title song. Subsequently, Seger had success with *Hollywood nights*, *We've got tonight* and *Against the wind*. His most recognisable single is probably *Old time rock and roll* which featured in the Tom Cruise film *Risky Business*. Also widely recognised is *Like a rock*. He was inducted into the Rock and Roll Hall of Fame in 2004.

Boomtown Rats

The Boomtown Rats was an Irish rock band that scored a series of UK hits between 1977 and 1980. It was led by singer Bob Geldof (a former journalist) who organised the Ethiopian relief efforts Band Aid and Live Aid. Formed in 1975 they took their name from Woody Guthrie's novel 'Bound for Glory'. They moved to London in 1976 and became associated with punk rock. Their self-titled debut album was released in 1977. Their second album *Tonic for the troops* appeared in 1978 in the UK along with their first UK top ten hit *Like clockwork*. *Rat trap*, from the album, also hit number one. Their second straight UK number one came in the summer of 1979 with *I don't like Mondays*, a song inspired by a disturbed California teenager who had gone on a killing spree at school and glibly explained her action with the title line. This hit was on the Rats' third album, *The Fine Art of Surfacing* (1979), and subsequently became the band's only US singles-chart entry.

The Knack

Founding members of The Knack were Doug Fieger, Berton Averre, Bruce Gary and Prescott Niles, creating a rock sound which was core rock but at the same time new and unlike anything else playing on the radio. A huge draw on the LA club scene, The Knack played throughout California in 1978 and early 1979, repositioning live music in many of the older establishments which had been converted to disco dance halls. Debut album *Get the Knack* went platinum in less than seven weeks, one of the fastest to gold/platinum of all time. *My Sharona* hit number one on the charts in August 1979 and remained there for six weeks. A sold-out world tour followed the album's release. The band's second single *Good girls don't* reached number 17.

Dire Straits ▶

The British rock band Dire Straits was formed in 1977 by Mark Knopfler (virtuoso lead guitar and husky, weary, night club vocals), David Knopfler (guitar), John Illsley (bass) and Pick Withers (drums) and managed by Ed Bicknell. Dire Straits recorded and released the self-titled album in 1978 to little fanfare but in the same year the single *Sultans of swing* became a chart hit and album sales took off. Backed by a far-ranging US tour, the album earned a gold record as did the follow-up, *Communiqué*, in 1979. *Making Movies* (1980) had classics in *Tunnel of love* and *Romeo and Juliet*. Tired-tough real-world music and lyrics were, and remain, the hook for fans. The hard work of their early days is legendary with several gigs per day on rambling pub tours. Their 1985 album *Brothers in Arms* went to to be the UK's biggest selling album of that year, with the US number one hit *Money for Nothing*. The group disbanded quietly in 1995.

Rickie Lee Jones

The vocalist, musician and songwriter Rickie Lee Jones was born on 8 November 1954 in Chicago. She emerged from a thriving LA bohemian sub-culture in 1979 with her debut album, *Rickie Lee Jones*, in 1979. Her big hit from the album was *Chuck E.'s in Love*, a jazzy/swing US top five single (her best known song). The next most remembered and repeated track is probably *Easy Money*.

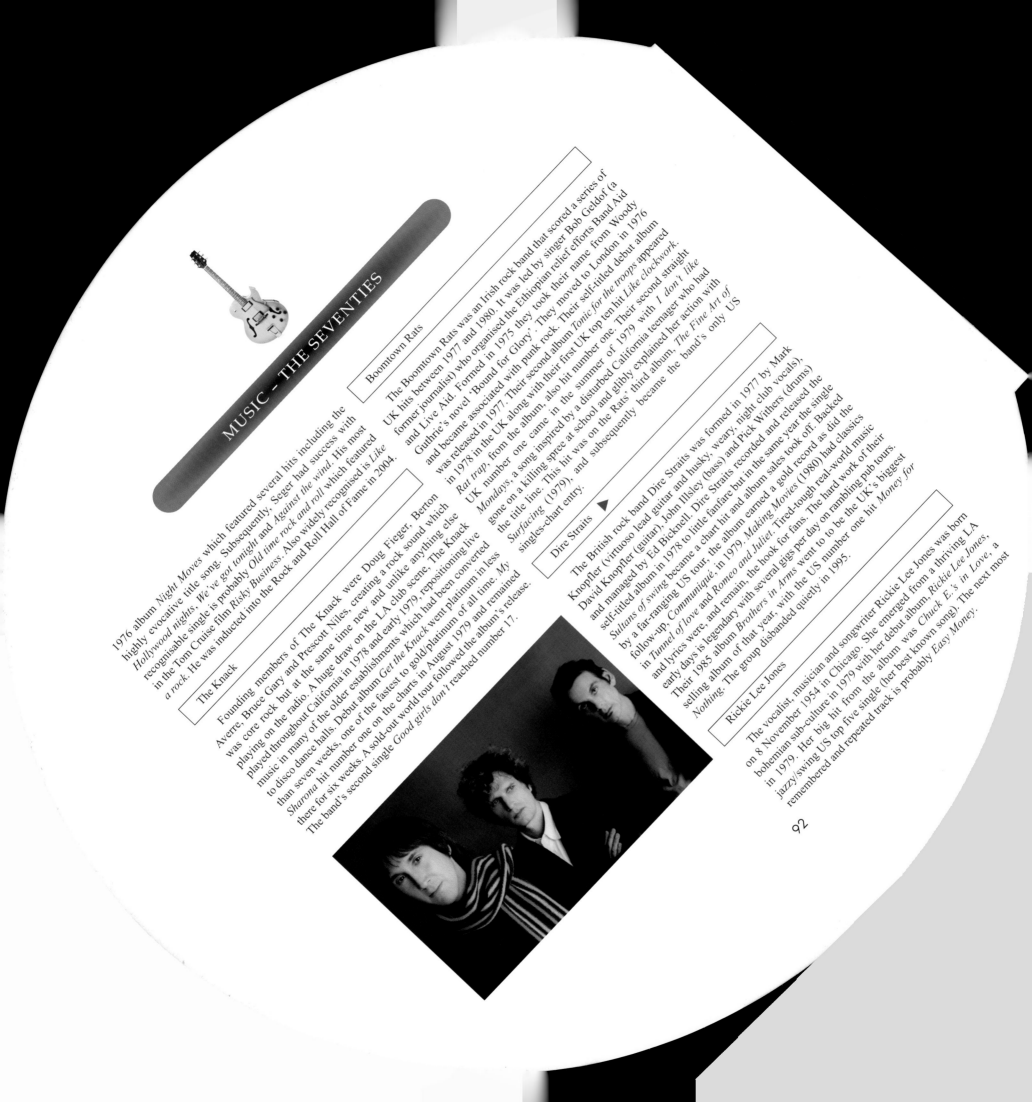

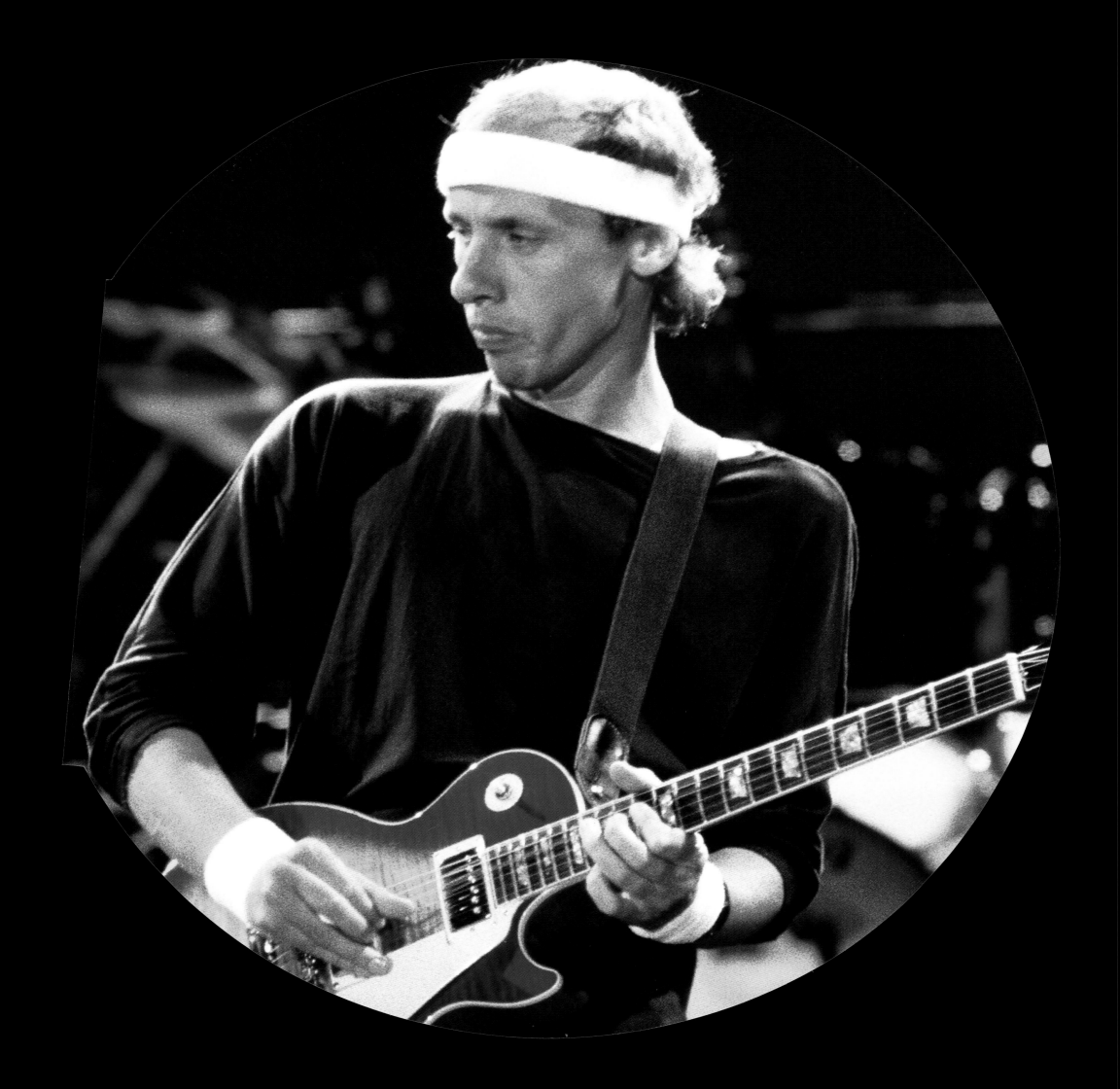

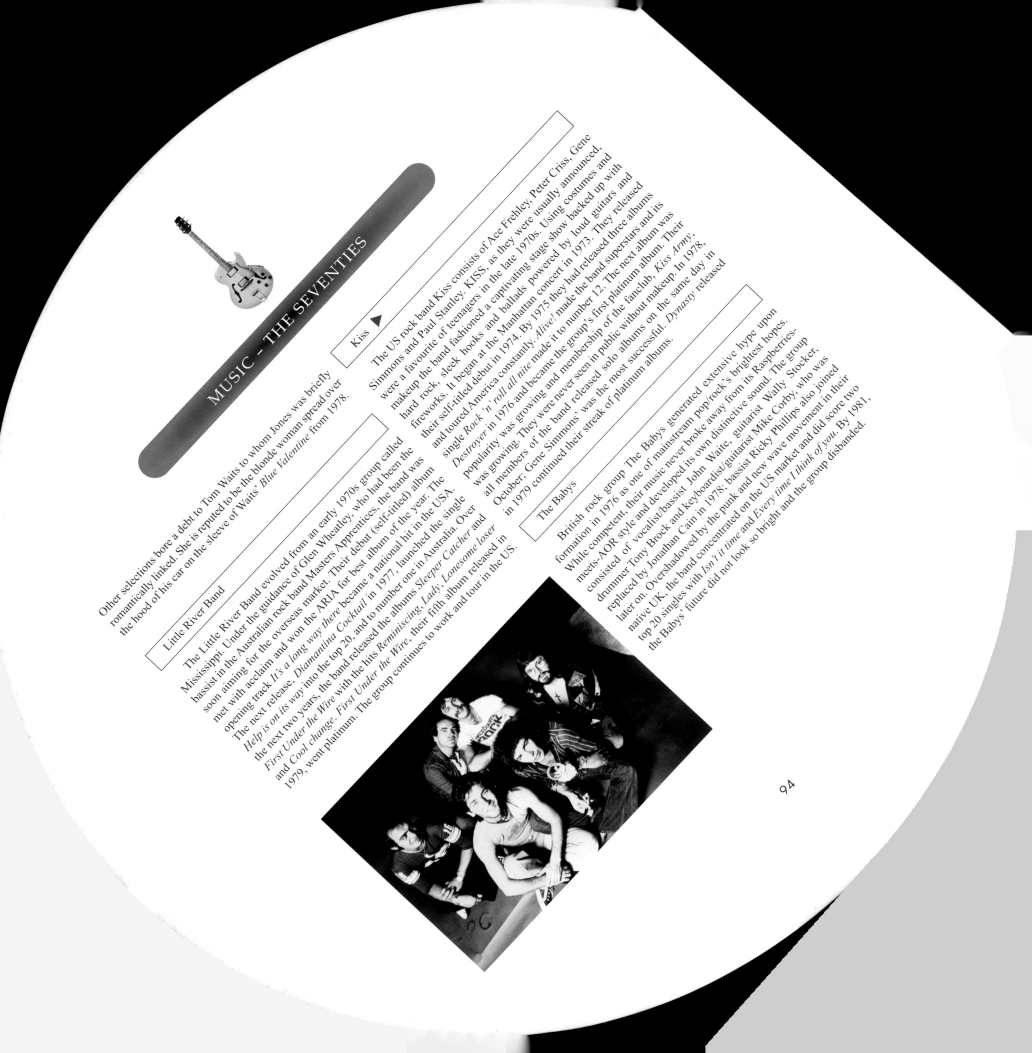

Other selections bore a debt to Tom Waits to whom Jones was briefly romantically linked. She is reputed to be the blonde woman spread over the hood of his car on the sleeve of Waits' *Blue Valentine* from 1978.

Little River Band

The Little River Band evolved from an early 1970s group called Mississippi. Under the guidance of Glen Wheatley, who had been the bassist in the Australian rock band Masters Apprentices, the band was soon aiming for the overseas market. Their debut (self-titled) album met with acclaim and won the ARIA for best album of the year. The opening track *It's a long way there* became a national hit in the USA. The next release, *Diamantina Cocktail* in 1977, launched the single *Help is on its way* into the top 20, and to number one in Australia. Over the next two years, the band released the albums *Sleeper Catcher* and *First Under the Wire* with the hits *Reminiscing, Lady, Lonesome loser* and *Cool change*. *First Under the Wire*, their fifth album released in 1979, went platinum. The group continues to work and tour in the US.

Kiss ▶

The US rock band Kiss consists of Ace Frehley, Peter Criss, Gene Simmons and Paul Stanley. KISS, as they were usually announced, were a favourite of teenagers in the late 1970s. Using costumes and makeup the band fashioned a captivating stage show backed up with hard rock, sleek hooks and ballads powered by loud guitars and fireworks. It began at the Manhattan concert in 1973. They released their self-titled debut in 1974. By 1975 they had released three albums and toured America constantly. *Alive!* made it to number 12. The next album was single *Rock 'n' roll all nite* made it to number 12. The next album was *Destroyer* in 1976 and became the group's first platinum album. Their popularity was growing and membership of the fanclub, *Kiss Army*, was growing. They were never seen in public without makeup. In 1978, all members of the band released solo albums on the same day in October; Gene Simmons' was the most successful. *Dynasty* released in 1979 continued their streak of platinum albums.

The Babys

British rock group The Babys generated extensive hype upon formation in 1976 as one of mainstream pop/rock's brightest hopes. While competent, their music never broke away from its Raspberries-meets-AOR style and developed its own distinctive sound. The group consisted of vocalist/bassist John Waite, guitarist Wally Stocker, drummer Tony Brock and keyboardist/guitarist Mike Corby, who was replaced by vocalist/bassist Ricky Phillips also joined later on. Overshadowed by the punk and new wave movement in their native UK, the band concentrated on the US market and did score two top 20 singles with *Isn't it time* and *Every time I think of you*. By 1981, the Babys' future did not look so bright and the group disbanded.

94

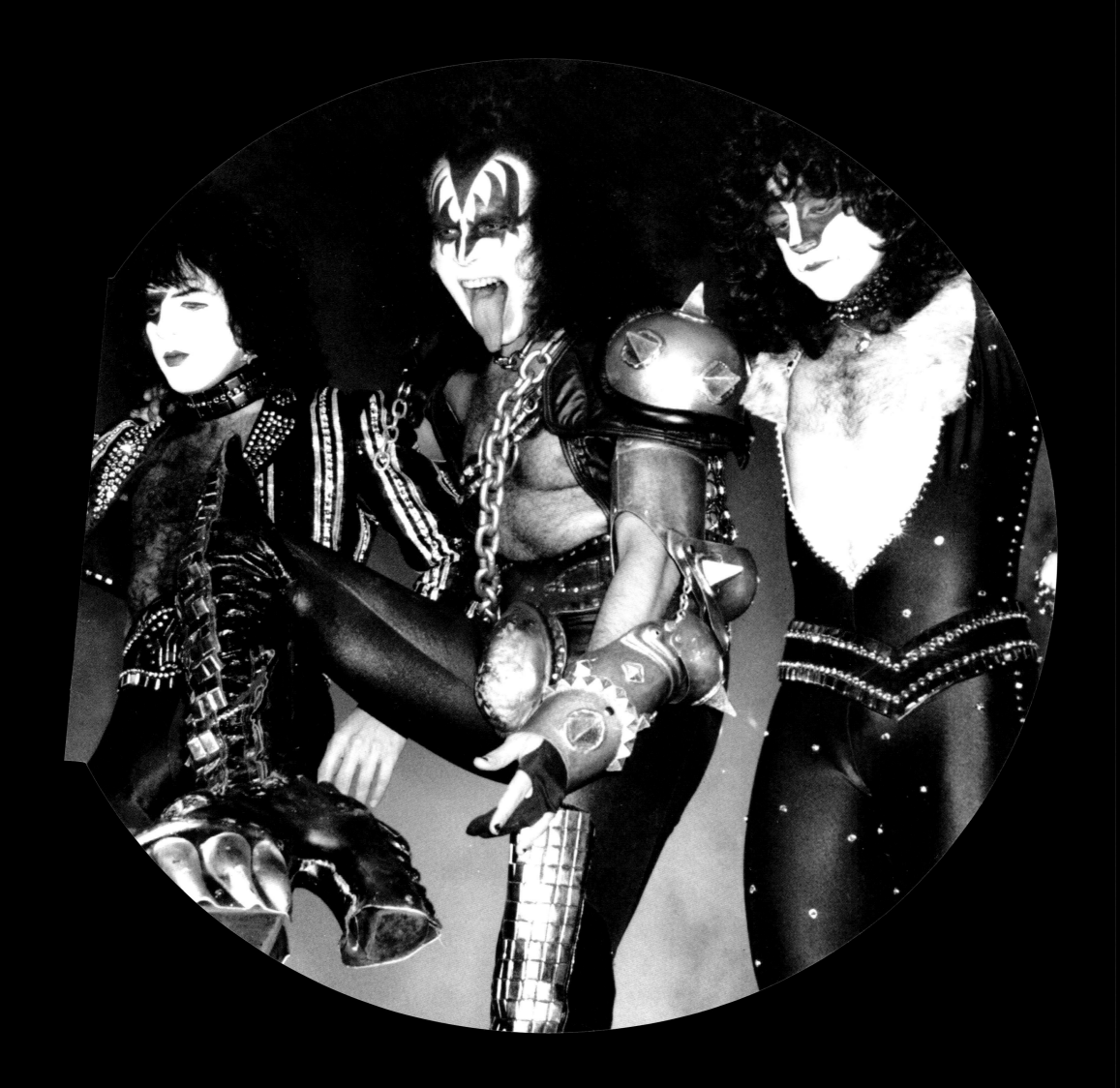

THE JACKSON FIVE

The Jackson Five comprised five brothers: Jackie, (born Sigmund Esco Jackson on 4 May 1951), Tito (born Toriano Adaryll Jackson on 15 October 1953), Jermaine (born 11 December 1954), Marlon (born 12 March 1957) and Michael (born 29 August 1958). They were raised in Gary, Indiana and their father Joe Jackson was a blues guitarist. They started their informal music education by sneaking off with his guitar. When he discovered the thefts he bought them their own instruments. The group rose from its humble beginnings and began playing local clubs in 1962 with youthful prodigy Michael as lead vocalist — combining dance routines influenced by the Temptations and music inspired by James Brown.

After being discovered by Diana Ross and Berry Gordy, a team of Motown writers known as the Corporation composed a series of songs for the group's early releases, all accentuating their youthful enthusiasm and vocal interplay. Their debut single, I Want You Back was a hit in 1970 and three of their next five singles topped the US charts. Their first album was Diana Ross Presents the Jackson Five followed by ABC. In the meantime, Michael, Jermaine and Jackie were groomed for solo recording careers.

As the Jackson 5 became more and more well-known, they became the subjects of a cartoon series on US television 'the Jackson 5' and hosted a television special 'Goin' Back To Indiana.' The soundtrack from this show was also a hit. 'Jacksonmania' was in full swing and they made regular appearances on the Ed Sullivan Show. After the Corporation was disbanded in 1971, the group recorded covers of pop and R & B hits from the 1950s and other Motown standards. Following this, they started to record their own compositions along with more diverse material, such as Jackson Browne's Doctor My Eyes.

The Jackson 5 reached the peak of their popularity in the UK when they toured there in 1972, but after returning to the US, their record sales decreased. By 1973 their live performances took more of a cabaret approach and their recordings became intensely funky. By 1975, they were writing and producing most of the songs on their albums and their record contract with Motown expired in the same year. Jermaine Jackson, who married the daughter of Motown boss Berry Gordy, left the group and stayed with Motown. Gordy sued The Jackson 5 for alleged breach of contract in 1976 and the group were forced to change their name to The Jacksons. The case was settled in 1978 and The Jacksons paid Gordy $600,000 and allowed Motown all rights to 'The Jackson 5' name. Michael signed a solo contract with Epic and Randy Jackson joined to handle the percussion and backing vocals. Temporary additions to the group included sisters LaToya and Rebbie.

The Jacksons' 1978 album, Destiny, saw the release of the disco oriented hit Blame it on The Boogie. At the same time, Michael Jackson released his solo album, Off The Wall. The single, Can You Feel It, from 1980's Grammy Award nominated album Triumph, was a hit in the UK and US. The same year, the Jackson family was shaken when Randy was badly injured in a car accident. The Jacksons' 1981 US tour emphasised Michael's leading role in the group. Between the release of 1981's The Jacksons Live and Victory, Michael issued Thriller — the best-selling album of all time. The explosion of the music video and associated television shows during the 1970s was especially suited to The Jacksons' style and their adept use of the 'film clip' was a great part of the success of their music.

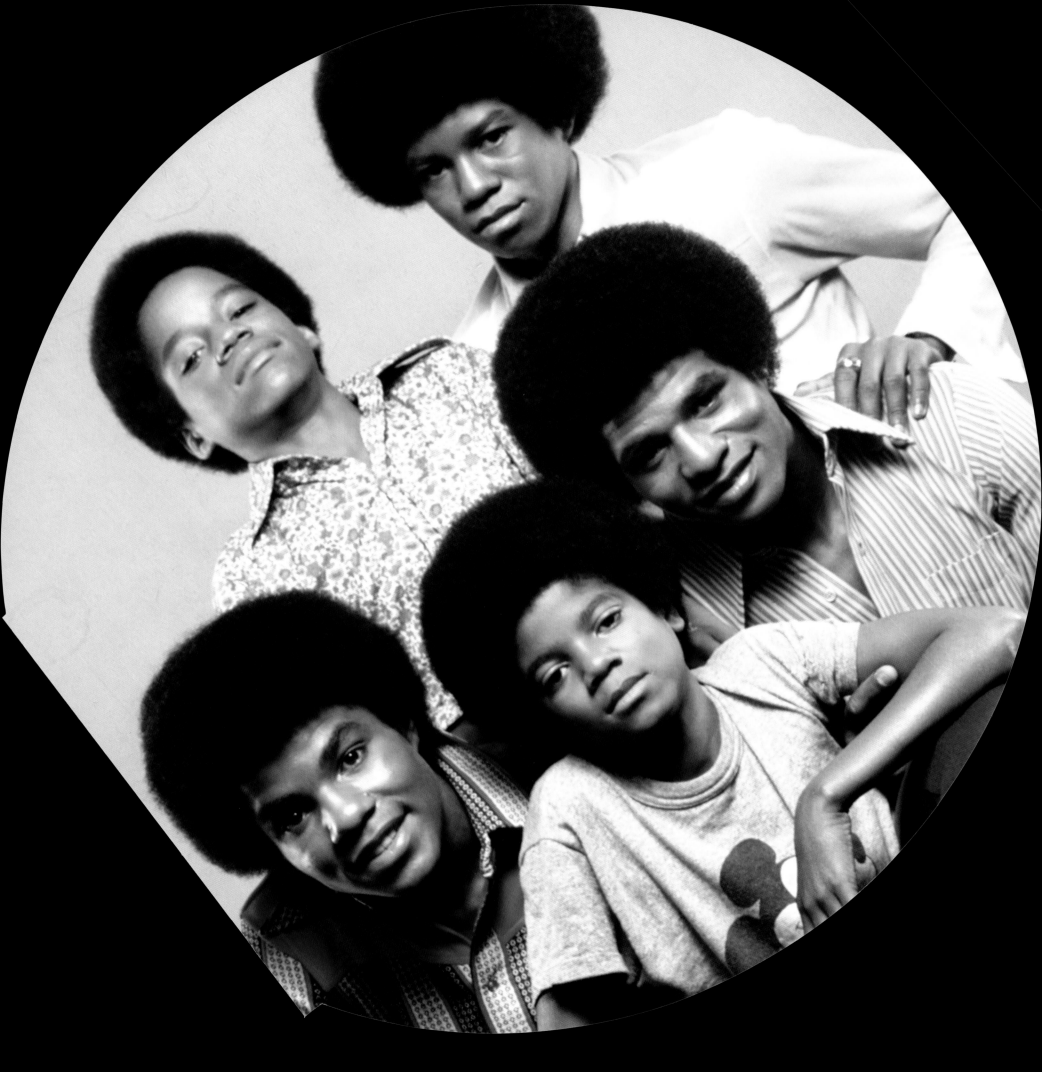

LED ZEPPELIN

T he English rock band Led Zeppelin were formed in 1968 by guitarist Jimmy Page following the demise of his former band, the Yardbirds. He and the other members, John Paul Jones (bass, keyboards), Robert Plant and John Bonham, were first known as 'New Yardbirds', became Led Zeppelin following a quip by the Who's Keith Moon who, when assessing their prospects, commented that they would probably 'go down like a lead Zeppelin'.

Guided by Peter Grant, their 'heavyweight manager' Led Zeppelin rarely gave interviews, as they were unpopular with the music press. The only connection the audience had with the band was through their albums and concerts, where they played extremely loud heavy metal music. Led Zeppelin established the concept of album-oriented rock, refusing to release popular songs from their albums as singles. In 1969, Led Zeppelin set out on their first US tour which set the stage for the release of their debut album, *Led Zeppelin*. Recorded in less than 30 hours, *Led Zeppelin* included the singles, *Good Times, Bad Times, Communication Breakdown, Dazed And Confused* and interpretations of R & B standards *How Many More Times?* and *You Shook Me*. Their next release was *Led Zeppelin II*, which was recorded while they were on the road. This album included the smash hit, *Whole Lotta Love*.

In 1970 the band released *Led Zeppelin III* which had more of a folk sound. In concert, Plant's powerful vocals, raw performance and sexuality perfectly counterbalanced Page's flexibility and changeable character. In 1971 they released their biggest selling album ever, *Led Zeppelin IV* (also known as *Four Symbols*, the *Runes* album or *Zoso* – in deference to the fact that the set bore no official title). It sold 16 million copies in the USA by 1996 and was Led Zeppelin's most musically diverse album featuring the hit singles, *Black Dog, The Battle Of Evermore* and *Stairway to Heaven*. An immediate radio hit, *Stairway to Heaven* became the most played song in the history of

album-oriented radio. With touches of funk and reggae as well as Led Zeppelin's usual rock and folk, *Houses of the Holy* was released in 1973 and continued the band's musical experimentation. Throughout their 1973 tour, Led Zeppelin broke box-office records – most of which were previously held by the Beatles – across the US. Their concert at Madison Square Garden was filmed for use in the feature film *The Song Remains the Same* which was released three years later. In 1974, they established their own record label, Swan Song, and released the double album *Physical Graffiti*.

Robert Plant and his wife sustained multiple injuries in a car crash in August 1975. Led Zeppelin returned in 1976 with the release of the album *Presence*. In 1977, Plant's son, Karac passed away and he spent the latter half of 1977 and most of 1978 in seclusion. The group did not work on a new album until 1978. *In Through the Out Door* was released in 1979 and in 1980, Led Zeppelin embarked on their final European tour. On 25 September 1980, Bonham was found dead following a long drinking session. In December that year, Led Zeppelin officially retired, as they could not continue without Bonham.

Following the breakup, a collection of archive material entitled *Coda* was released. Plant and Page pursued solo careers while Jones went on to become a successful producer. John Bonham's son, Jason, drummed with them on their appearance at Atlantic Records' 25th Anniversary Concert in 1988. Page remastered Led Zeppelin's catalogue for release on the self-titled 1990 box set. In 1994, Page and Plant reunited to record a segment for MTV unplugged which was released as *No Quarter* that same year. The following year Page and Plant embarked on a successful international tour which lead to the album *Walking into Clarksdale*. Led Zeppelin remain one of the most influential bands of the rock era.

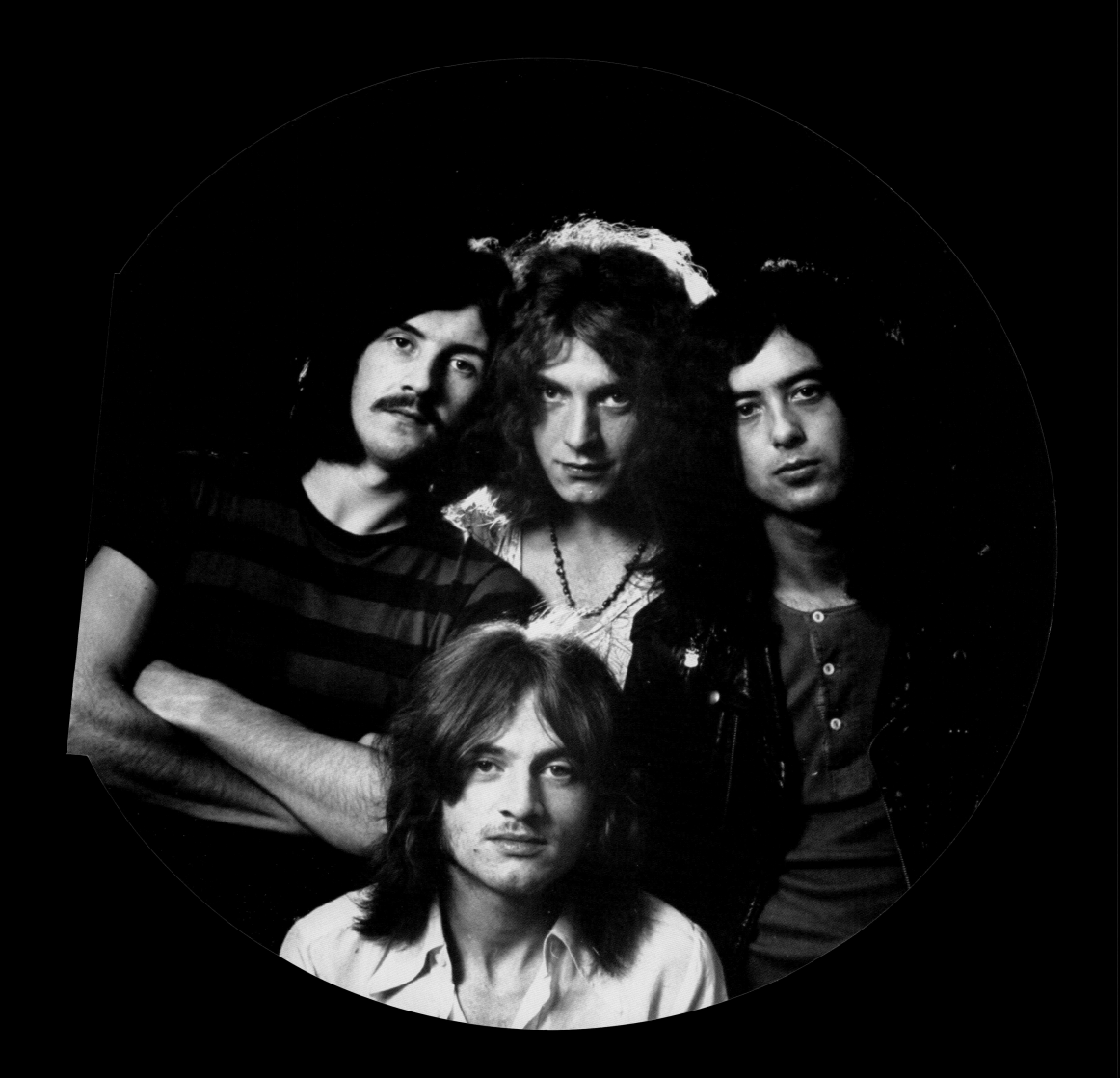

ABBA

Consisting of two couples, ABBA was the most commercially successful pop group of the 1970s as well as one of the biggest phenomena of the 20th century. In the mid-1960s, guitarist/vocalist Bjorn Ulvaeus, member of the popular beat outfit the Hep Stars, collaborated with keyboardist/vocalist Benny Andersson, who, at the time, had a number one Swedish hit, *I Was So In Love*. Meanwhile, Andersson met Anni-Frid Lyngstad, a jazz singer who had already secured fame after winning a national talent contest. In 1970 the foursome performed as the cabaret act 'Festfolk', which has a double meaning of 'engaged couples' and 'party people'. In 1971, Faltskog played Mary Magdalene in Andrew Lloyd Webber's 'Jesus Christ Superstar' and her version, like many others who played the role elsewhere, of *Don't Know How to Love Him* became a hit. Ulvaeus and Faltskog were married that year. Ulvaeus and Andersson started working as house producers at Stig Anderson's record company, Polar. In 1972, Andersson and Ulvaeus scored a Swedish hit with *People Need Love*, which featured Faltskog and Lyngstad on backing vocals.

The group entered the 1973 Eurovision Song Contest with *Ring Ring* and were placed third. At the time, Faltskog was heavily pregnant with their first child. At the suggestion of Stig Anderson, their producer and manager, they became ABBA, which was an acronym of their Christian names. In 1974 they entered the Eurovision Song Contest again, this time with *Waterloo*, and became the first Swedish act to win. *Waterloo* went on to top the UK and US charts and launched ABBA as the first internationally successful superstar act who sang in a language other than their native tongue.

In 1975, they released *S.O.S.*, followed by a string of other hits with a blend of well-crafted counter harmonies and catchy melodic arrangements including: *Mamma Mia*, *Fernando* and *Dancing Queen*.

Between 1977 and 1978, they released *Knowing Me, Knowing You*, *The Name of the Game*, and *Take a Chance On Me*. They undertook a tour of Europe and Australia in 1977, which is remembered for its extravagant sets and costuming. The band also starred in the feature film *ABBA – The Movie* which was released in 1978. That same year Andersson and Lyngstad were married. Sadly Ulvaeus and Faltskog separated shortly after.

Heartache was the theme of 1979's *Voulez-Vous*, which was seen as a departure from their previous work. The group's members soon divorced. After the release of the 1980 album *Super Trouper*, Andersson and Lyngstad embarked on new projects. *The Winner Takes It All* and *Super Trouper* was recorded live at Wembley Arena with a large choir of children. *The Visitors*, which was released in 1981, was ABBA's final album and they disbanded in 1982. The group's members soon Lyngstad and Faltskog released solo albums and Andersson and Ulvaeus collaborated with Tim Rice on the musical 'Chess'. Manager, Stig Anderson, who was responsible for ABBA's sound on their international hits, passed away in September 1997 after a heart attack.

ABBA were pioneers of Europop and because they disbanded at their creative peak, their popularity endures. They were second only to Volvo as Sweden's biggest export earners. The compilation album *ABBA Gold*, was released in 1992 and topped the charts all around the world, becoming the group's biggest seller ever. In 1993, *Dancing Queen* was included in U2's 'Zoo TV' tour and the 1995 Australian movie *Muriel's Wedding* was a hit with its portrayal of a lonely girl who seeks solace in the music of ABBA. In 2000, ABBA turned down an offer of $1 billion to reunite for a series of concerts to cash in on the international revival of their music.

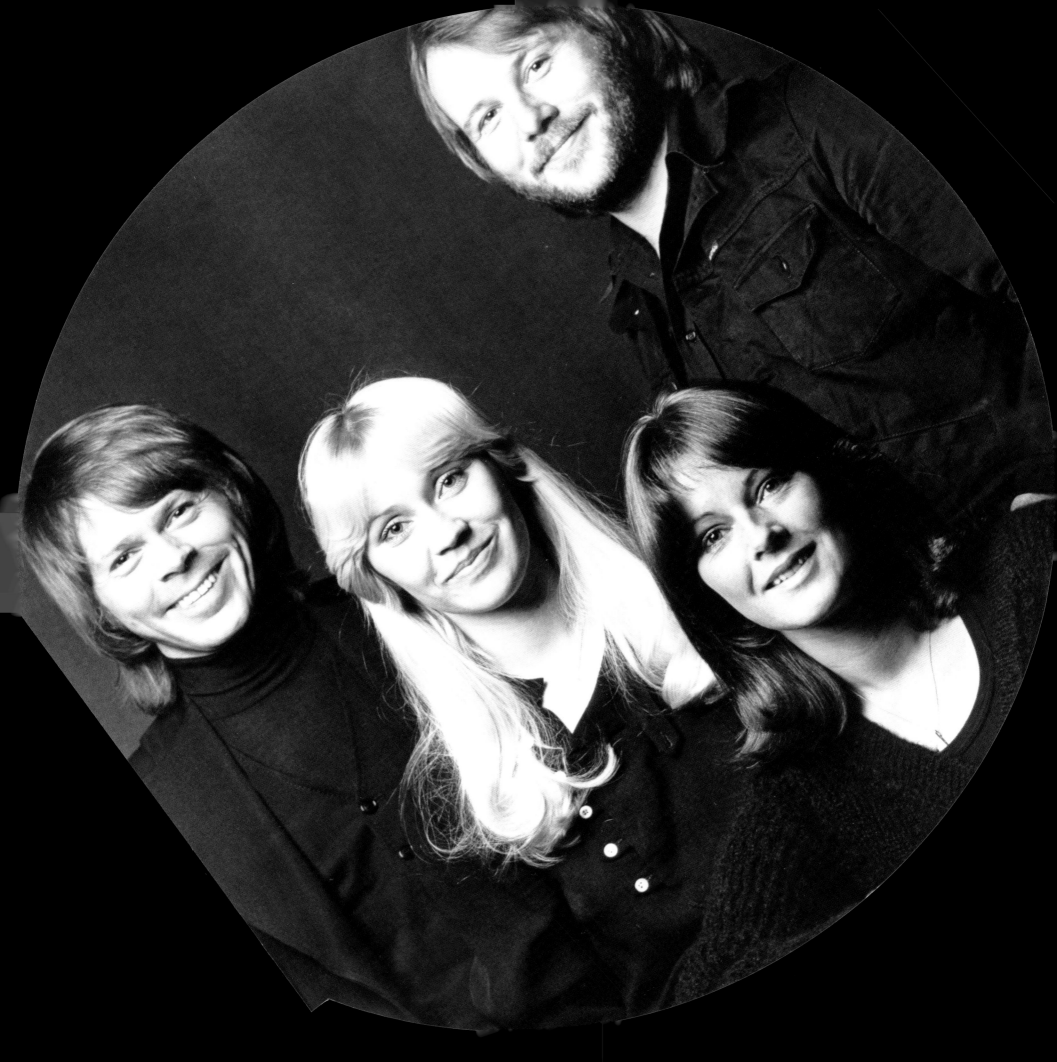

THE EAGLES

Formed in Los Angeles in 1971, the original rock band Eagles comprised Bernie Leadon from the Flying Burrito Brothers (guitar, banjo, mandolin, vocals), Randy Meisner (bass, vocals), Glenn Frey (guitar, vocals) and Don Henley (drums, vocals). With five number one singles and four number one albums, the Eagles were among the most successful recording artists of the 1970s. Two of those albums, *Eagles: Their Greatest Hits 1970 -1975* and *Hotel California* ranked among the ten best-selling albums ever.

In 1971, Frey and Henley were hired to play in Linda Ronstadt's backup band. Frey, Henley, Meisner and Leadon appeared on Ronstadt's album *Linda Ronstadt*. Following its release in 1972, the Eagles went to England and recorded their debut album, *Eagles*, which included the hits *Take It Easy, Witchy Woman* and *Peaceful Easy Feeling*. This album set the tone for future releases – a blend of country rock, bluegrass and ballads, topped with sweet harmonies. In 1973, they released *Desperado*, which recounted the tales of a band of outlaws, the Doolin-Dalton gang. It contained the top 40 single *Tequila Sunrise* – one of the Eagles' better known songs.

On the Border was released in 1974 and was the fastest selling Eagles record. The hit from this album was *The Best of my Love* which was number one in 1975. Don Felder (guitar, vocals) joined the group in 1974. The Eagles' fourth album, the Grammy Award nominated *One Of These Nights*, was released in 1975 and had the hits *Lyin' Eyes* and *Take it to the Limit*. *Lyin' Eyes* won a 1975 Grammy Award for best pop vocal performance. The Eagles were now established as an

international act but the pressure was too much for Leadon who left in 1975 and was replaced by Joe Walsh.

In 1976, *Eagles: Their Greatest Hits 1971-1975* was, until Michael Jackson's *Thriller*, the best-selling album of all time in the US. The same year, *Hotel California* was released along with the hits *New Kid in Town. Hotel California* and *Life in the Fast Lane.* The album won the 1977 Grammy Award for record of the year and has become an all-time classic. At the conclusion of the Eagles' 1977 world tour, Meisner departed and was replaced by Timothy B. Schmit from the band Poco. 1979 saw the release of the album, *The Long Run*, which went platinum and featured the Grammy Award winning hit *Heartache Tonight* and *I Can't Tell You Why*.

The Eagles embarked on a US tour in 1980 and released *Eagles Live* the same year. By 1981, the members had grown apart. They broke up in 1982 and Henley, Frey and Felder pursued solo careers. In 1994, the Eagles reunited for an MTV special, followed by the album *Hell Freezes Over* and a US tour in 1994/95. They won three 1995 American Music Awards: Favourite Pop Group, Favourite Adult Contemporary Artist and Favourite Album for *Hell Freezes Over.* The Eagles were inducted into the Rock and Roll Hall of Fame in 1998.

Although the Eagles have been criticised for representing 1970s musical conservatism, they continue to be viewed as one of the era's most successful bands. They have sold more than 83 million albums world-wide, earning five number one albums and five number one singles. They sold more albums in the 1970s than any other US band.

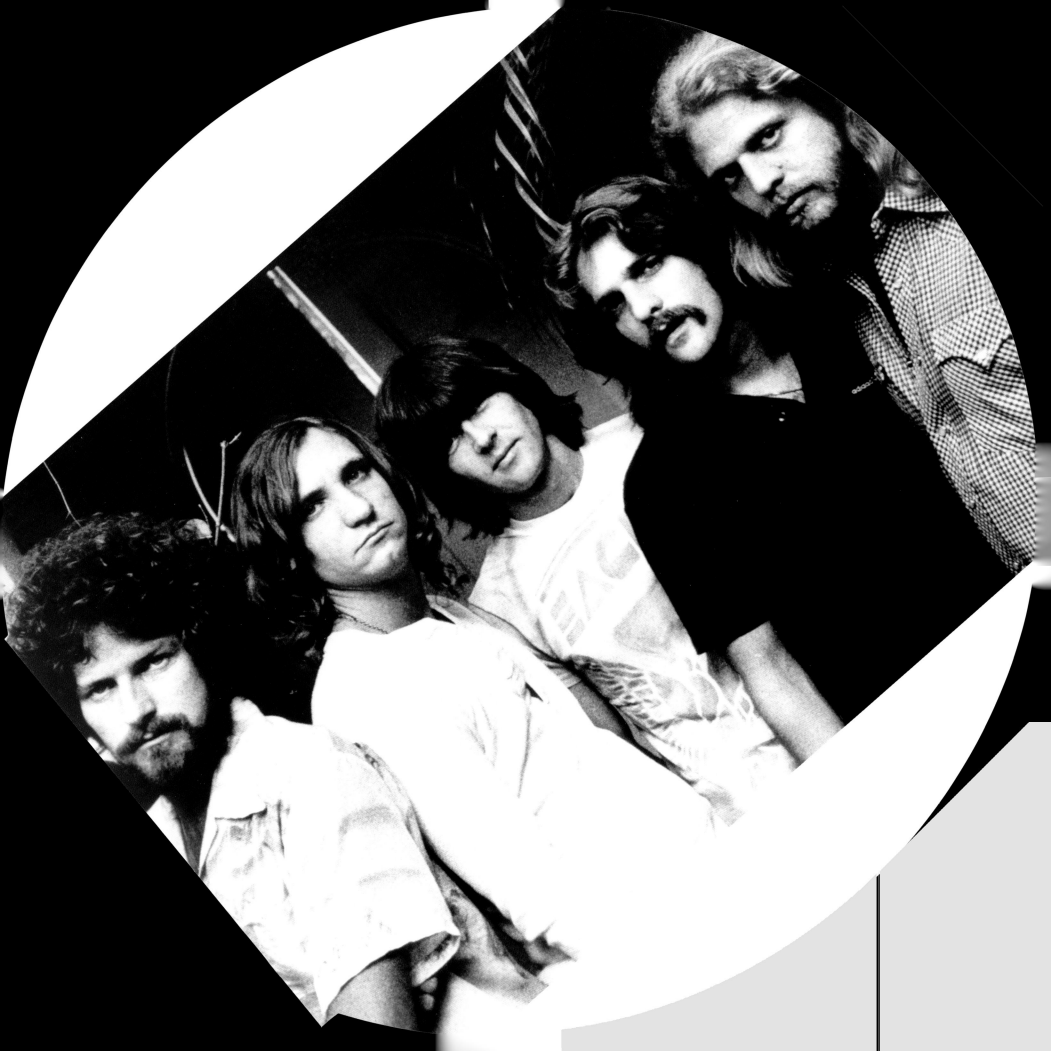

STEVIE WONDER

Singer, harmonica player, organist, pianist, drummer, songwriter, arranger and record producer, Stevie Wonder was born Stevland Hardaway Judkins on 13 May 1950 in Michigan. He changed his name to Stevland Morris when his mother remarried. Born blind, at five years he started playing the piano and harmonica. By the age of 12, he had mastered a variety of instruments and sang in the church choir. By the age of 12, he was discovered by Berry Gordy of Motown Records. He became known as the 12-year old genius, Little Stevie Wonder. Wonder's hits throughout the 1960s included, *I Was Made to Love Her*, *Shoo-Be-Do-Be-Do-Da-Day*, *For Once In My Life*, *My Cherie Amour*, *Yester-me, Yester-you*, and *Yesterday*.

In the 1970s, he studied at the University of Southern California and produced records with the Spinners. In 1971, he released the personal album *Where I'm Coming From* and such hits as, *It's A Shame*, and *We'll Have it Made* in the early 1970s. The album *Stevie Wonder Live* was released at that time and included the track, *Signed Sealed & Delivered*. He wrote this song and included the track, *Signed Sealed &* married in 1970 (they divorced two years later). He then released the album *Where I'm Coming From*.

In 1973, Wonder wrote his number one composition *Superstition* as well as the classics, *You Are The Sunshine Of My Life*, *Higher Ground* and *Living In The City*. He won three awards at the 1973 Grammy Awards. In August 1973, he was severely injured in a car accident in North Carolina. His 1974 hit singles were, *Living For The City*, *Don't You Worry 'Bout A Thing*, and *You Haven't Done Nothin'*

(a critique of Richard Nixon). He won five Grammy Awards that same year. In 1977, he won two Grammy Awards for the double album *Songs In The Key Of Life*. The singles *Sir Duke* (an ode to Duke Ellington) and *Isn't She Lovely* (about his daughter) were hits from this album. *Pastime Paradise* was sampled in the 1990s by the rap artist Coolio in *Gangsta's Paradise*.

Wonder spoke out against injustice and lobbied the US government to declare 15 January (Martin Luther King's birthday) a national holiday. He paid tribute to the occasion on *Hotter than July*, with his instrumental, *Happy Birthday*. In the late 1970s, he released the mostly instrumental, *Journey Through The Secret Life of Plants* and then *Master Blaster (Jammin')*, which returned him to the top of the R & B charts. He drew some of inspiration for songs in the 1970s and 1980s from Marvin Gaye. In 1982 he and Paul McCartney released the hit single *Ebony and Ivory*. In 1984, he completed the Oscar winning *Just Called To Say I Love You*, for the Gene Wilder movie *The Lady In Red*. Other hits of this era include *Part-time Lover*, *Overjoyed* and *That's what Friends are For*.

Through his music, Wonder has spoken out against drunk driving, apartheid and hunger in Ethiopia. His duet with Bruce Springsteen in the benefit song *We Are The World* is one of the most powerful and memorable musical exchanges. His albums are a blend of soul, funk, rock 'n' roll, jazz, reggae and African sounds. He was awarded a Lifetime Achievement Grammy Award in 1996 and in 2001, married his girlfriend Karen. In 2005, he released a new album *A Time To Love*.

104

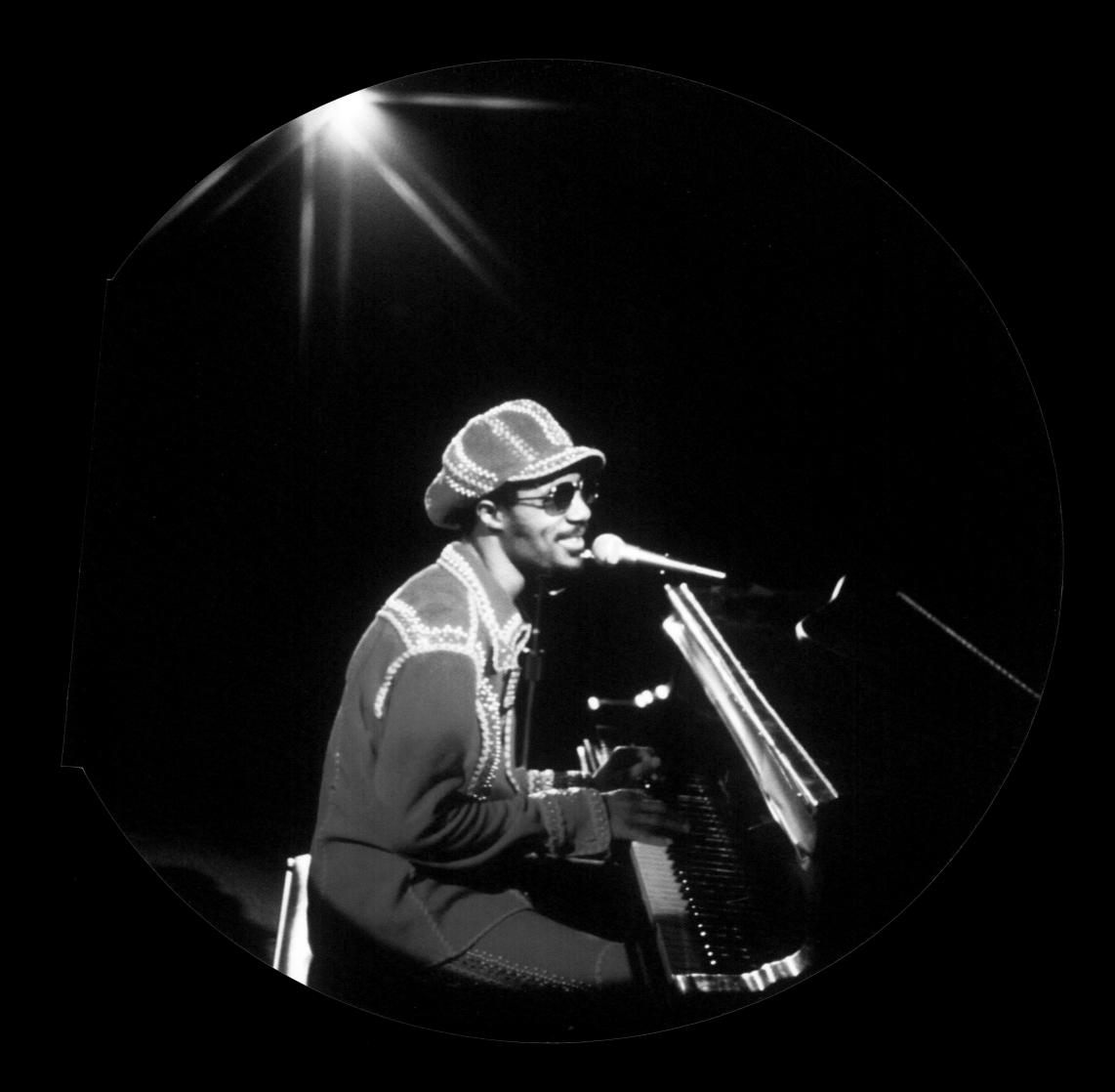

THE EIGHTIES

Often referred to as the "Me" or "Greed" decade, reflecting the economic and social prosperity of the era, the music of the 1980's encompassed what the decade was all about: a self-indulgent attitude, over-the-top fashion and big hairstyles. Kicking off the era was The King of Pop, Michael Jackson, who revolutionized the music industry with his hit album Thriller in 1981. Jackson's onstage mannerisms, distinct fashion sense, particularly his single-glove and his lavish military style jackets and his infamous dance moves set a precedent for how songs were not only sung, but also performed. The Thriller album also set a trend for a new wave of synthesized music. Modern technology introduced new ways for artists to create tunes, combining state-of-the-art mixers and keyboards with modern drum kits, amps and guitars that lent a distinct electronic sound to many songs during the era.

Artists such as Duran Duran, Depeche Mode, Japan, Soft Cell, Bananarama, New Order, Eurythmics and Tears for Fears developed New Wave and Synthpop, which became popular throughout the decade, especially in the early eighties. Electronic and dances music also took off with artists such as the Pet Shop Boys, the Breakfast Club and Robbie Nevil. During the 1980s pop stars in the form of Madonna, Gloria Estefan and Whitney Houston also shot to fame

The 1980's also saw the birth of the American cable television network, Music Television, better known as MTV. MTV transformed the music industry by providing a dedicated video-based outlet for music and bringing together both artists and fans for music events, news and promotion. Fittingly, the very first music video shown on MTV on August 1st, 1981 was Video Killed the Radio Star by British band The Buggles. Soon after bands such as Duran Duran, Devo and Haircut100 and pop artists such as Madonna were made into household names by MTV and quickly converted the channel not only into a music dynasty but a cultural phenomenon.

Rock and roll came back in the 1980's in a major way, bigger and badder than ever before. Alternative rock bands formed in opposition to the increased commercialisation of popular music. Artists and in turn fans revealed radical new hairstyles, tattoos, body piercing and leather jackets as a way to stand apart from mainstream music trends at the time. 'Heavy' metal, 'Glam' Metal and 'Big Hair' bands all developed and became popular music genres during the decade and many converted into mainstream bands. Artists including Van Halen, KISS, Aerosmith, Poison, Mötley Crüe, Queen, Bon Jovi, Guns N' Roses and AC/DC all enjoyed extreme popularity and received extensive promotion through the media.

'Thrash' metal and 'Extreme' metal groups became underground cult sensations but only a few bands of this scene, such as Metallica, Megadeth, Anthrax and Slayer managed to attract mainstream exposure. Punk rock was also a massive phenomenon during the 1980s and often bands fused various elements of rock into their records. The Red Hot Chilli Peppers, who formed in Los Angeles, California in 1983, fused traditional rock with various elements of funk, punk rock, alternative rock, heavy metal and psychedelic rock. This unique blend of music varieties would go on to influence and create other musical genres well into the 21st century.

Hip hop and rap music, introduced by urban youths of predominantly African American descent, also evolved during the 1980's, becoming a powerful music force that still experiences immense popularity today. This genre brought with it several new dance moves and again their own fashion sense and many hip hop artists such as Grandmaster Flash, N.W.A and Kurtis Blow attracted mainstream attention.

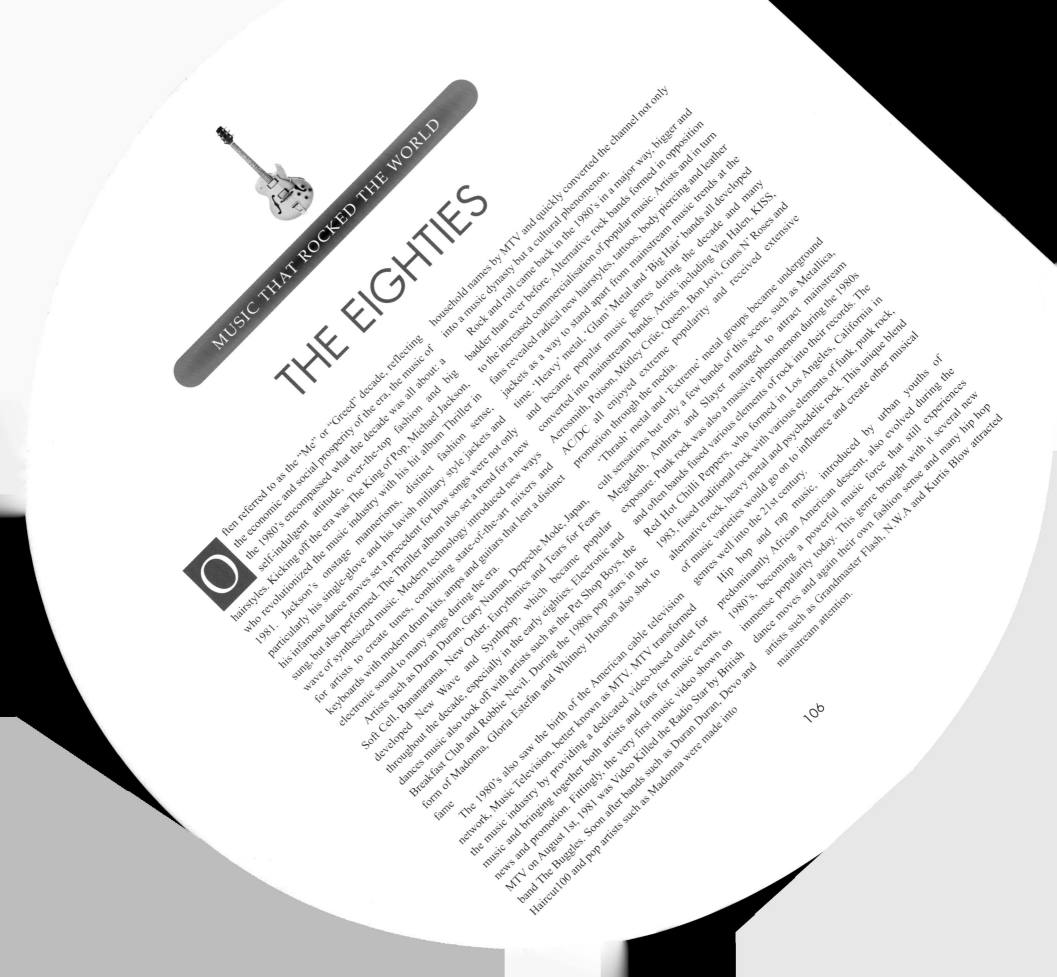

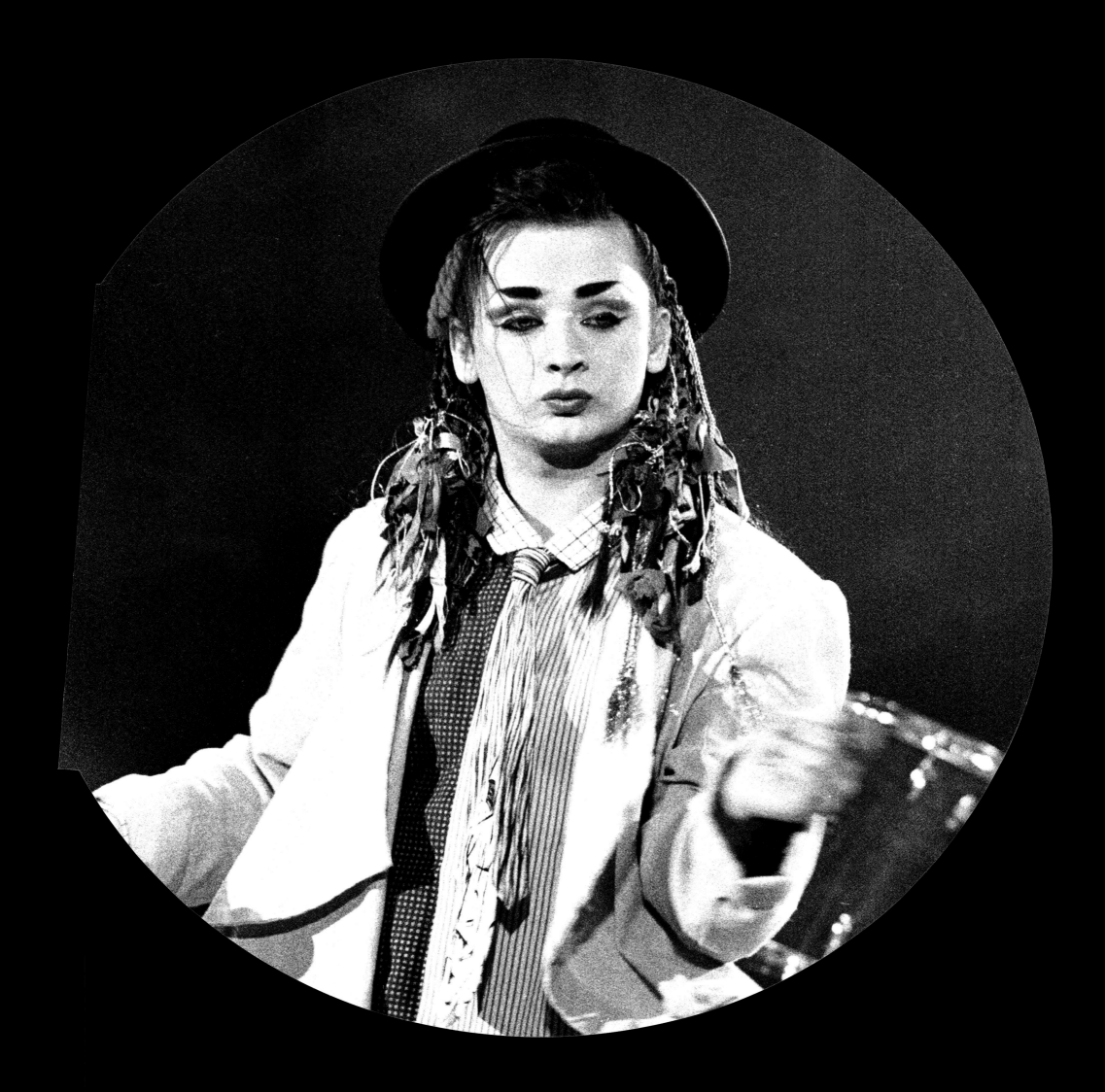

Eurythmics

Formed in 1980 in London, England, Eurythmics were Annie Lennox (vocals, flute) and Dave Stewart (guitar, keyboard). Eurythmics were the most dramatic of the early UK synth-pop bands with Stewart's providing the studio wizardry and Lennox, the theatrical appearance and hypnotizing vocals. They began a musical and romantic partnership and with Pete Coombes, formed a band Catch, which became the Tourists. They released The Tourists, Reality Effect and Luminous Basement and disbanded. Despite their romantic breakup, they continued to work together and named their partnership after a system of musical instruction developed in the 1890s that emphasises physical response – Eurythmics. They released Sweet Dreams in 1983 with its hit title track and Love Is a Stranger. The same year, they produced the soundtrack for 1984, the film based on George Orwell's novel, which featured Here Comes the Rain Again. In 1984 they issued Touch, which included the hit Sexcrime (1984). In the meantime, Lennox married a Hare Krishna and divorced him a year later. 1985's Be Yourself Tonight included a duet with Aretha Franklin, entitled Sisters Are Doin' It For Themselves, and the hit single Would I Lie To You. On 1986's Revenge, Eurythmics produced their last top 20 single, Missionary Man. 1989 saw the release of We Too Are One. Lennox and Stewart pursued separate careers and had not spoken for four years when Lennox called to inform him of the death of Pete Coombes. They produced Peace in 1999 and played a series of concerts, the proceeds of which went to Amnesty International and Greenpeace.

Dan Hartman

Born in Pennysylvania on 8 December 1950, Dan Hartman achieved success in the 1970s with the title track to the disco release, Instant Replay. On the invitation of his older brother David, Hartman joined the group The Legends as keyboardist at the age of 13. The band recorded a number of singles and in 1971 the group's music brought Dan to the attention of Blues/Rock star Edgar Winter. He joined the Edgar Winter Group who topped the record charts in 1973 with the instrumental single Frankenstein and rock classic Free Ride, which he later re-recorded as a disco track. In the late 1970s, he established the Schoolhouse recording studio. He produced James Brown's 1986 comeback hit Living In America, Tina Turner's Steamy Windows, and Nona Hendryx's 1987 album, Female Trouble. He also produced

sessions for Muddy Waters, Foghat, Paul Young, and Johnny and Edgar Winter. His most well known hit was 1984's soul track I Can Dream About You, from the movie Streets Of Fire. He followed this with other hits, We Are The Young and Second Nature. A final Dan Hartman solo album appeared in 1989. An instrumental album, New Green Clear Blue was a complete departure from previous releases. In the 1990s, his music was sampled by dance music acts such as Black Box, who had a hit with Ride On Time, while Take That's version of Relight My Fire reached number one. Suffering from AIDS, Hartman passed away from a brain tumour on 22 March, 1994. Keep the Fire Burnin', a posthumous greatest hits collection, gathered his hit singles.

Tears for Fears

Formed in 1982 in Bath, England, Tears for Fears comprised Roland Orzabal (vocals, guitar) and Curt Smith (bass, vocals). Both from troubled homes, they wrote and sang about the importance of emotions and self-expression. Orzabal and Smith – with assistance from Ian Stanley (keyboards), began writing songs and arranging them for synthesizers. Their debut album The Hurting yielded three top five singles in the UK. Tears for Fears had their commercial breakthrough in 1985 with Songs From the Big Chair. This album fused Beatlesque melodies with techno sounds and included the hits Everybody Wants To Rule The World, Shout and Head Over Heels. They released Sowing the Seeds of Love in 1989 and the title track was a number two hit. This album provided a showcase for rising R & B artist Oleta Adams who sang backup on the track Woman in Chains. Adams joined Tears for Fears on tour and Orzabal went on to co-produce her debut solo album Circle of One in 1990. Tears for Fears released a greatest hits compilation, Tears Roll Down (Greatest Hits '82 – '92) in 1992. 1993's Elemental was essentially Orzabal's solo debut. The same year, Smith released his solo album Soul on Board.

Starship

Previously known as Jefferson Airplane and Jefferson Starship, this group of American rock musicians (Grace Slick, Craig Chaquico, Mickey Thomas, Pete Sears, Donny Baldwin and Donny Johnson) have disbanded and reformed countless times over the years. In the early 1980s, Jefferson Starship released Modern Times, Winds of Change

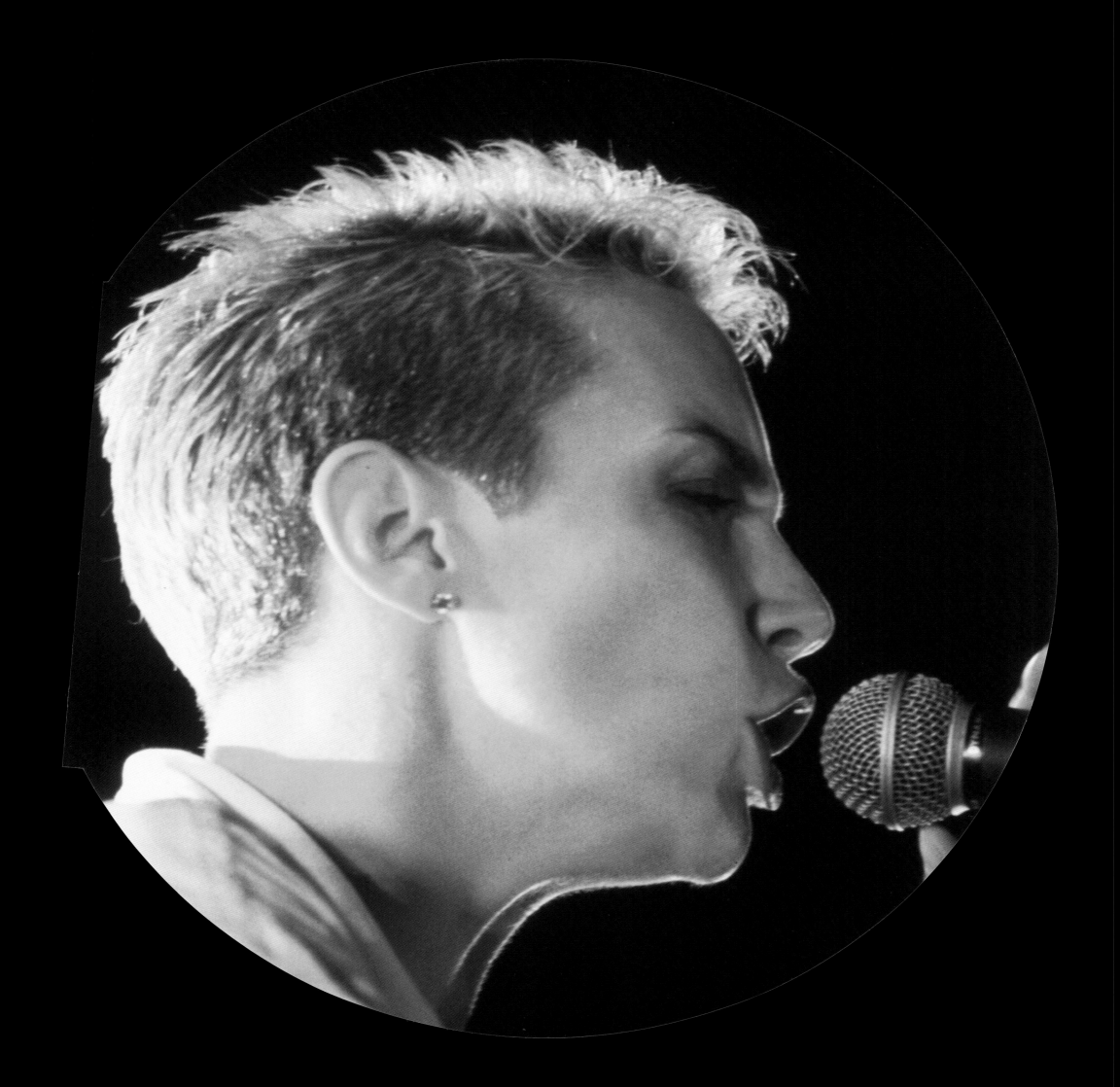

...d *Nuclear Furniture*. After further tension between the members, original member Paul Kantner left the band in 1985 and they became known as Starship. In 1986 they released *Knee Deep in the Hoopla*, which became a platinum seller with two number one singles *We Built This City (On Rock and Roll)* – written by Bernie Taupin and Sara. This album was their most successful since 1975's *Red Octopus*. In 1987, they had a hit with the theme from the movie *Mannequin* and they released *No Protection* and by 1988 that album had gone platinum with its singles *Nothing's Gonna Stop Us Now* and *It's Not Over ('Til It's Over)*. Around this time, Pete Sears left and Starship disbanded after Grace Slick departed. A revamped lineup released *Love Among The Cannibals* in 1989, but had disbanded by 1990.

Julian Lennon

Julian Lennon, the singer, instrumentalist and songwriter from Liverpool, England, was born on 8 April 1963, the son of John Lennon and his first wife Cynthia. Following his father's assassination, Lennon decided to pursue a singing career. His debut album *Valotte* (recorded at a French château of the same name) caught many listeners by surprise. It spawned four charted singles that year including *Valotte* and *Too Late For Goodbyes*. In the 1985 Grammy Awards, he was nominated for the Best New Artist. Success lead to hedonistic indulgence and his follow-up album, *The Secret Value of Daydreaming* was more up-tempo. He returned in 1989 with *Mr. Jordan*, an album that found him trying to break away from his John Lennon influences: the single *Now You're in Heaven* was a minor hit. Following 1991's *Help Yourself*, Lennon temporarily retired from the music industry and spent nearly seven years in seclusion. In the spring of 1998, he returned with *Photograph Smile*, initially issued only in Europe and Japan but released in the US the following year.

USA for Africa

USA for Africa (United Support of Artists for Africa), was the name under which 45 US artists recorded the hit single *We Are the World* in 1985. Harry Belafonte initiated this idea for a fundraising effort. His manager, Ken Kragen, suggested the multi-artist approach, inspired by the success of the British supergroup Band Aid and their 1984 fundraising single *Do They Know It's Christmas?*. *We Are The World* was written by Michael Jackson and Lionel Richie and produced by Quincy Jones. The performers gathered at A&M Recording Studios in Hollywood, California, on 28 January 1985. Kragen selected the night of the American Music Awards to ensure as many artists as possible could attend. Jones famously advised them, to "check your egos at the door". In all, 45 musicians attended the Band Aid effort in the United Kingdom. Lead vocals were rotated around Kim Carnes, Ray Charles, Bob Dylan, Daryl Hall, James Ingram, Michael Jackson, Al Jarreau, Billy Joel, Cyndi Lauper, Huey Lewis, Kenny Loggins, Willie Nelson, Steve Perry, Lionel Richie, Kenny Rogers, Diana Ross, Paul Simon, Bruce Springsteen, Tina Turner, Dionne Warwick and Stevie Wonder. It was a hit and the profits went to the USA for Africa Foundation, which used them for the relief of famine and disease in Africa. The song went on to win 1985 Grammy Awards for Song of

Whitney Houston ▲

Born in New Jersey in September 1963, Whitney Houston began singing at a very young age. Her mother was the gospel singer Cissy Houston. Dionne Warwick was her cousin and Whitney performed in church concerts as a child. In the early 1980s, she was given assignments that helped her gain familiarity with recording and performing – including background vocal work and parts in commercials. In addition, she continued to be part of the vocal group at her mother's concerts. Houston released her debut album *Whitney Houston* in 1985 with its hit singles, *You Give Good Love*, *Saving All My Love For You* and *How Will I Know* (accompanied by a video which brought about her first exposure on MTV). *Greatest Love Of All* was been written for the film biography of Mohammed Ali and had been a hit for George Benson in 1977. Houston won her first Grammy Award in 1986 for *Saving All My Love For You*. Her second album, *Whitney* was issued in 1987 and had the Grammy Award winning hit, *I Wanna Dance With Somebody*; *I'm Your Baby Tonight*, was released in 1990 and although less of a success than her previous albums, the title track and *All The Man That I Need* gave Houston another two US number ones. She has sung on the successful soundtracks to movies *The Bodyguard* (in which she also acted), *Waiting to Exhale* and *The Preacher's Wife*. She released her fourth studio album in 1998, *My Love is Your Love*, *Just Whitney* in 2002 and *One Wish: The Holiday Album* in 2006. On February 11, 2012, Houston was found dead in her guest room at the Beverly Hilton Hotel, in Beverly Hills, California, of causes not immediately known. News of her death coincided with the 2012 Grammy Awards

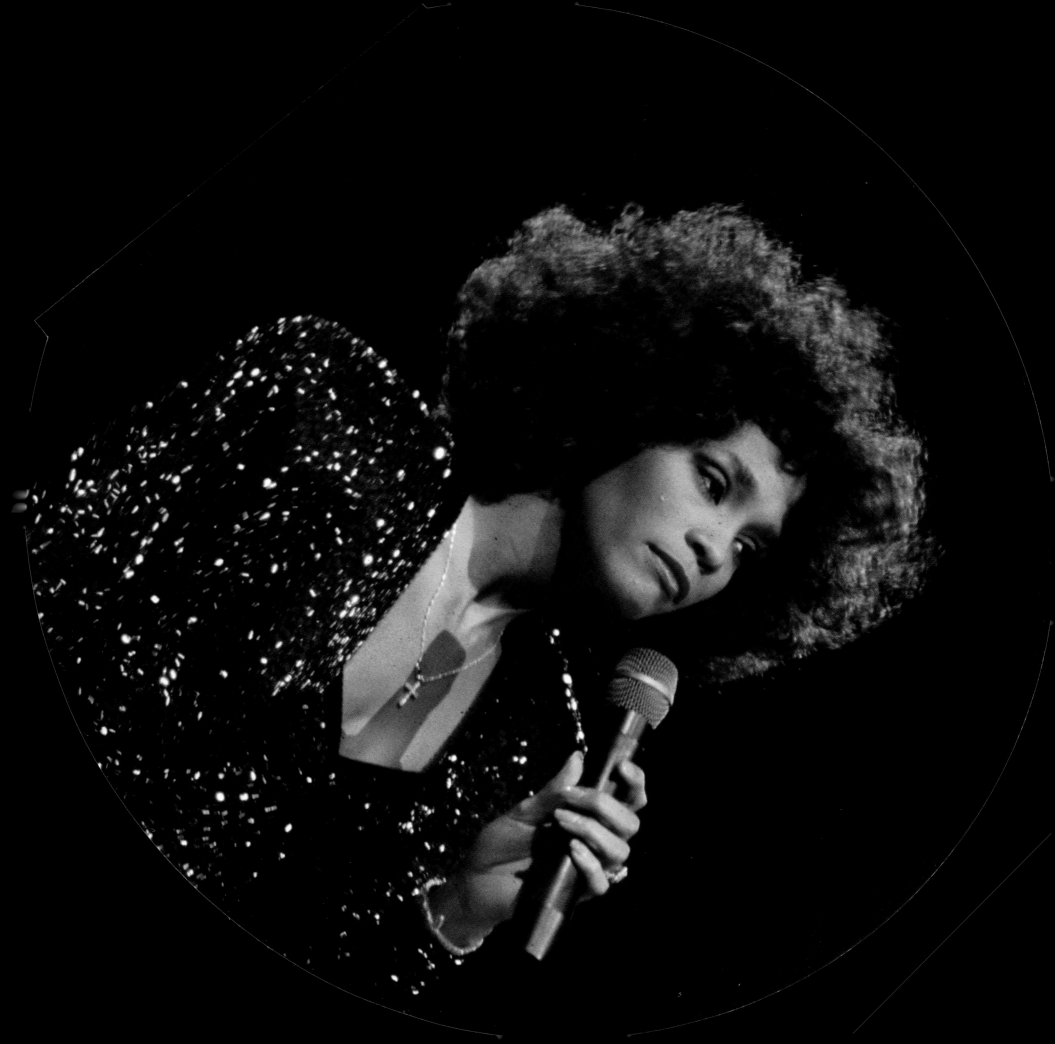

the Year, Record of the Year and Best Pop Performance by a Duo or Group.

Pet Shop Boys

UK electronic music act, the Pet Shop Boys - Neil Tennant and Chris Lowe – were founded in the early 1980s. Tennant and Lowe met by chance at an electronics shop on the Kings Road in Chelsea. They began to write songs together and called themselves the Pet Shop Boys, a name they had previously used to describe some friends of theirs who ran a pet shop. Their first hit single was *West End Girls* in 1985. They have had four number one singles in the UK that reveal their strong studio production. Their first hit singles in the UK that reveal their strong cover of an Elvis Presley hit), and *Heart*. Another well-known single, *What Have I Done to Deserve This?*, was a collaboration with Dusty Springfield. They are one of the most consistently successful duos in pop music. The singles *West End Girls*, *It's A Sin*, *Always on My Mind* (a People's *Go West*, *Can You Forgive Her?* and *It's A Sin*, reflect their influential role as gay icons. Their 1990s single *Being Boring* is an observational piece about the devastating impact of AIDS. Initially, Pet Shop Boys were criticised for their lack of stage presence but later concert performances were elaborate exercises in costume and production design. Their latest studio album, *Fundamental*, was released in 2006 and features the single *I'm With Stupid*, marking a strong return to the charts.

The Bangles

▲

Formed in 1981, by Debbie (guitar) and Vicki Peterson (vocals, drums), The Bangles line-up comprised: Debbi Peterson, Vicki Peterson, Susanna Hoffs (vocals/guitar), and Annette Zalinskas (replaced by Michael Steele in 1983) Their debut album *All Over the Place* was backed with concert dates ranging from work as club headliners to opening act for Cyndi Lauper and performances in the UK. In 1985, the band started work on its follow-up album, *Different Light*. Most of the material was written or co-written by the band members, but other compositions included Christopher Jules Shear's, *If She Knew What She Wants* and someone called Christopher wrote *Manic Monday* (Christopher was Prince). During 1986, *Different Light* became a best seller and was still on the Billboard top 10 in 1987, by which time it had sold several million copies. The album also provided the hit single,

and colourful videoclip, *Walk Like an Egyptian*, which won Best Group Performance at the 1987 American Video Awards. In 1987, Susanna Hoffs made her feature film debut, starring in a movie called *The Allnighter*, directed by her mother, Tamar Hoffs. The 1998 album *Everything* included the hit single *Eternal Flame*. After going their separate ways for a while, the band reformed in 2000 for a tour and released the album *Doll Revolution*.

Wang Chung

Wang Chung was a British new wave musical group who formed in 1980. The line-up consisted of Jack Hues (vocalist/guitarist), Nick Feldman (bass) and Darren Costin (drums). Their self-titled debut was released in 1982 after several singles, including the minor post-punk hit *Isn't It About Time We Were On TV*. In 1984, they released *Points on the Curve*, which yielded two major hits, *Don't Let Go* and the catchy *Dance Hall Days*. They scored the 1985 film *To Live and Die in L.A.*. In 1986, Costin left the band but Hues and Feldman continued to record and that year released their biggest hits, *Everybody Have Fun Tonight* and *Let's Go*, both from the album *Mosaic*. Following the release of their final album, *The Warmer Side of Cool* in 1989, Wang Chung disbanded.

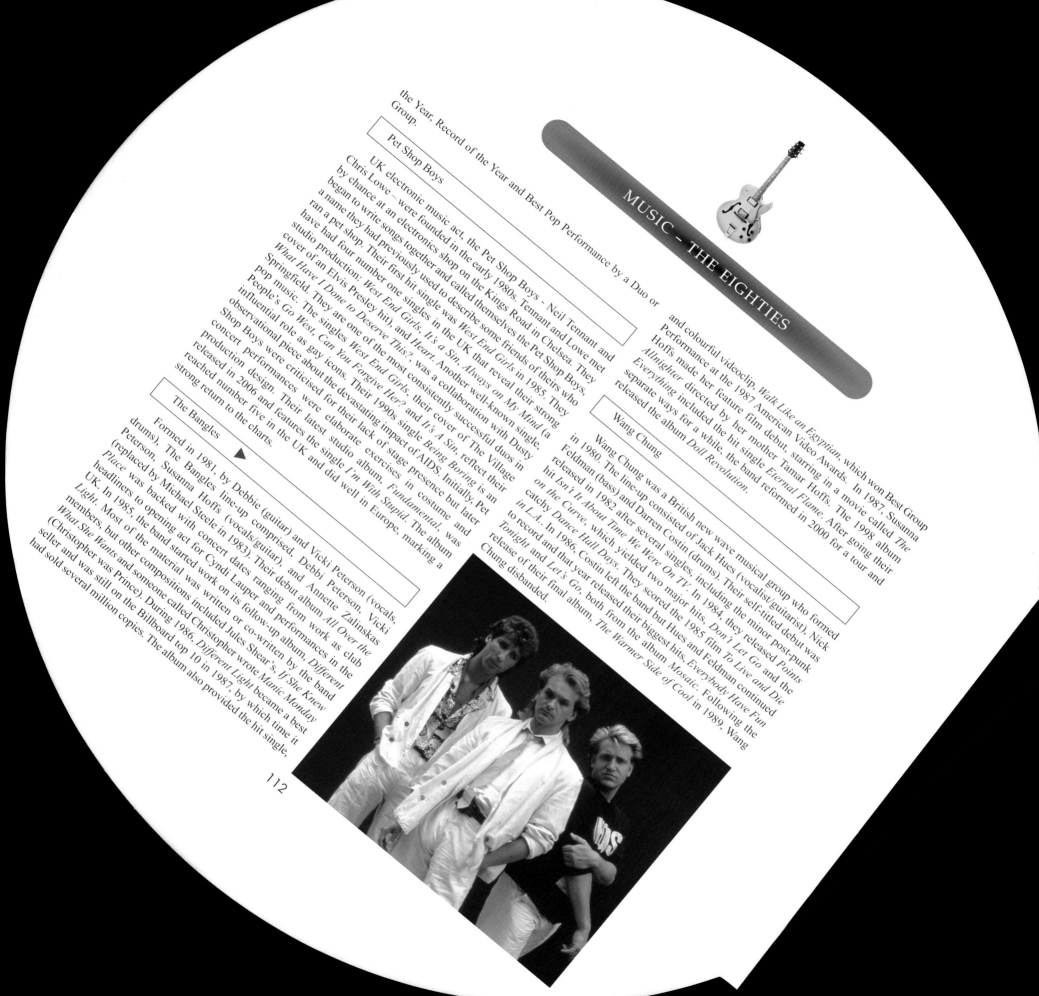

112

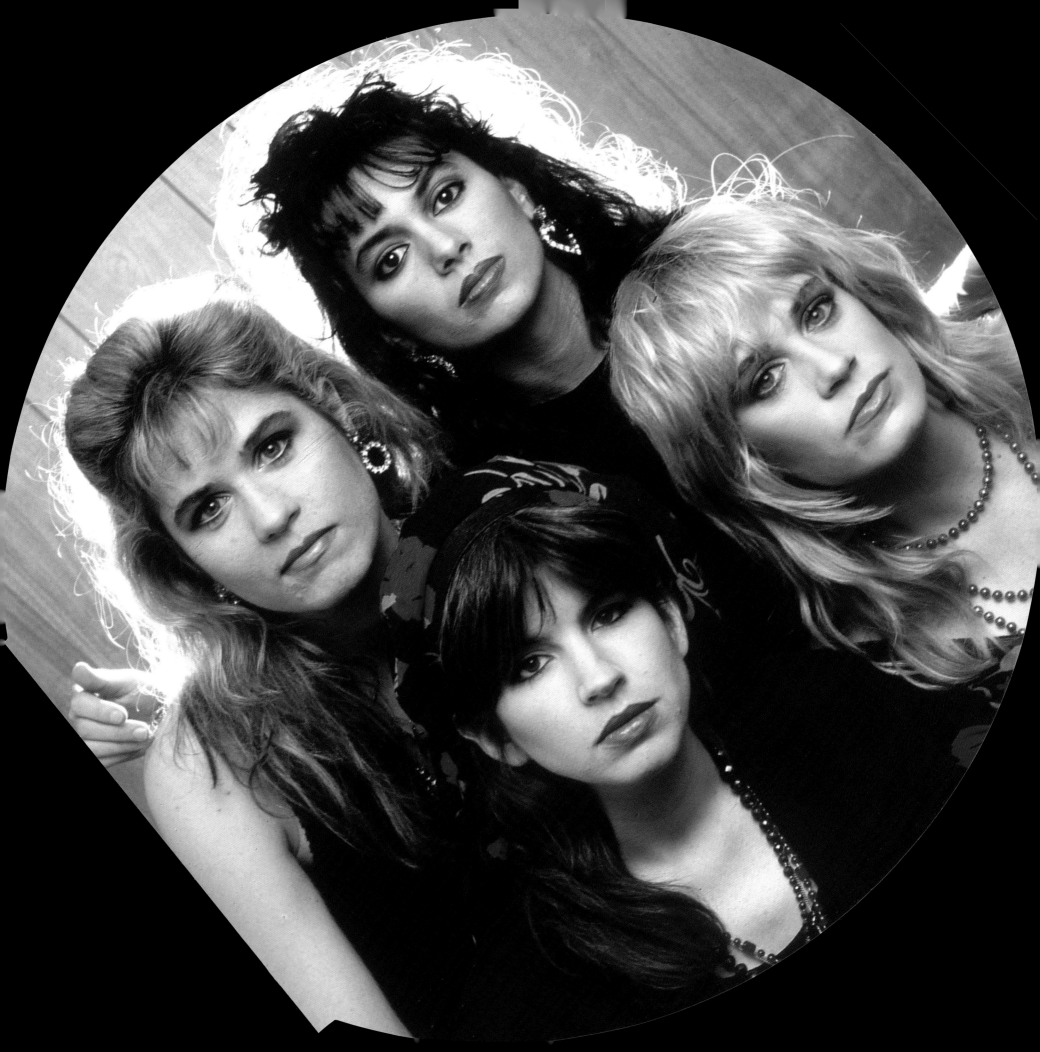

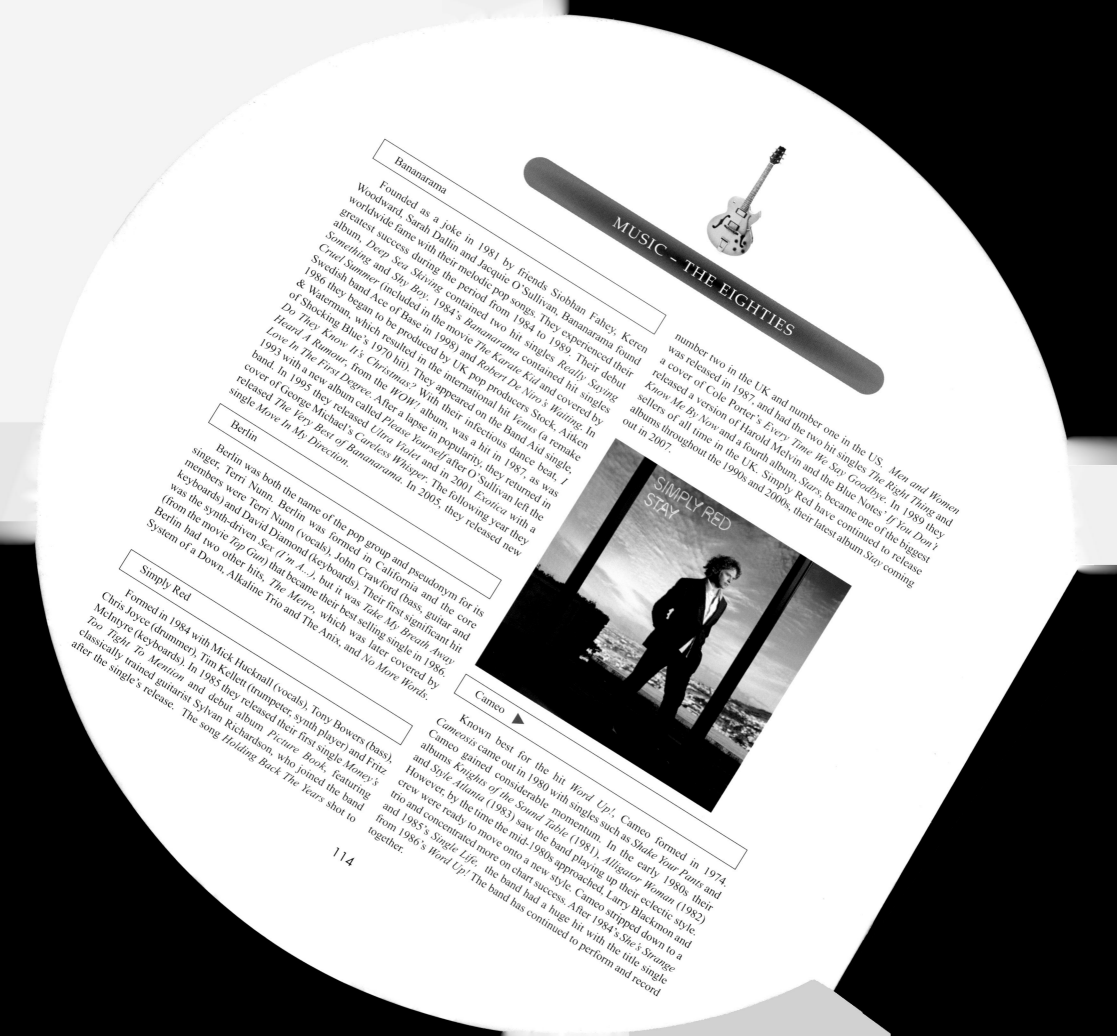

Bananarama

Founded as a joke in 1981 by friends Siobhan Fahey, Keren Woodward, Sarah Dallin and Jacquie O'Sullivan. Bananarama found worldwide fame with their melodic pop songs. They experienced their greatest success during the period from 1984 to 1989. Their debut album, *Deep Sea Skiving* contained two hit singles *Really Saying Something* and *Shy Boy*. 1984's *Bananarama* contained hit singles *Cruel Summer* (included in the movie *The Karate Kid* and covered by Swedish band Ace of Base in 1998) and *Robert De Niro's Waiting*. In 1986 they began to be produced by UK pop producers Stock, Aitken & Waterman, which resulted in the international hit *Venus* (a remake of Shocking Blue's 1970 hit). They appeared on the Band Aid single, *Do They Know It's Christmas?* With their infectious dance beat, *I Heard A Rumour*, from the *WOW!* album, was a hit in 1987, as was *Love In The First Degree*. After a lapse in popularity, they returned in 1993 with a new album called *Please Yourself* after O'Sullivan left the band. In 1995 they released *Ultra Violet* and in 2001 *Exotica* with a cover of George Michael's *Careless Whisper*. The following year they released *The Very Best of Bananarama*. In 2005, they released new single *Move In My Direction*.

Berlin

Berlin was both the name of the pop group and pseudonym for its singer, Terri Nunn. Berlin was formed in California and the core members were Terri Nunn (keyboards) and David Diamond (vocals), John Crawford (bass, guitar and keyboards). Their first significant hit was the synth-driven *Sex (I'm A...)*, but it was *Take My Breath Away* (from the movie *Top Gun*) that became their best selling single in 1986. Berlin had two other hits, *The Metro*, which was later covered by System of a Down, Alkaline Trio and The Anix, and *No More Words*.

Simply Red

Formed in 1984 with Mick Hucknall (vocals), Tony Bowers (bass), Chris Joyce (drummer), Tim Kellett (trumpeter, synth player) and Fritz McIntyre (keyboards). In 1985 they released their first single *Money's Too Tight To Mention* and debut album *Picture Book*, featuring classically trained guitarist Sylvan Richardson, who joined the band after the single's release. The song *Holding Back The Years* shot to

number two in the UK and number one in the US. *Men and Women* was released in 1987, and had the two hit singles *The Right Thing* and a cover of Cole Porter's *Every Time We Say Goodbye*. In 1989 they released a version of Harold Melvin and the Blue Notes' *If You Don't Know Me By Now* and a fourth album, *Stars*, became one of the biggest sellers of all time in the UK. Simply Red have continued to release albums throughout the 1990s and 2000s, their latest album *Stay* coming out in 2007.

Cameo ▲

Known best for the hit *Word Up!*, Cameo formed in 1974. *Cameosis* came out in 1980 with singles such as *Shake Your Pants* and Cameo gained considerable momentum. In the early 1980s their albums *Knights of the Sound Table* (1981), *Alligator Woman* (1982) and *Style Atlanta* (1983) saw the band playing up their eclectic style. However, by the time the mid-1980s approached, Larry Blackmon and crew were ready to move onto a new style. Cameo stripped down to a trio and concentrated more on chart success. After 1984's *She's Strange* and 1985's *Single Life*, the band had a huge hit with the title single from 1986's *Word Up!* The band has continued to perform and record together.

Howard Jones

Born John Howard Jones on 23 February 1955 in Southampton, England, Howard Jones, with his endearing pop sensibility and canny ear for a melodic hook, has been responsible for some of the warmest and most accessible techno pop released in the mid-1980s. Howard Jones wrote lyrics as buoyant as his music, revealing humanist ideals and encouraging positive action and self-esteem convincingly without pretence. His 1984 debut album *Human's Lib* contained the hit *Things Can Only Get Better* and *What is Love?*. *Dream Into Action* yielded the hit *New Song* and his most successful song to date is *No One Is To Blame*, a ballad from his 1986 EP *Action Replay* produced by Phil Collins. He has continued to record his own material.

Gregory Abbott

Born in 1954 in New York, Gregory Abbott was singing as a child in the famed St. Patrick's Cathedral Choir. Eventually, Abbott taught English at Berkeley, while maintaining his love and appreciation of music. He eventually decided to become a professional musician, build a studio, and apply his academic discipline to developing skills as a singer/songwriter, guitarist, composer, producer, keyboard player, and drummer. One of his first endeavours was a duet with Whitney Houston along with her mother, Cissy Houston, singing background vocals. His platinum single *Shake You Down* became the fastest song in the history of BMI to reach one million airplays, and won BMI's Pop Song of the Year award as the most performed song. He continued to write songs for many acts including EQ, Rosanna, Emmanuel, Mona Lisa, Ronnie Spector, Freda Payne, and Jennifer Warnes.

although he did get number 34 with *Back on Holiday*.

Crowded House ▶

Crowded House is a rock band formed in 1985 in Melbourne, Australia, by Neil Finn, Nicholas Seymour and Paul Hester. When their New Zealand rock band Split Enz broke up in 1984, Neil Finn and Paul Hester decided to form a new band. Their debut *Crowded House* revealed the extraordinary breadth of Neil Finn's songwriting talents and included the classics *Mean To Me*, *World Where You Live*, *Don't Dream It's Over*, *Love You 'Til The Day I Die* and *Something So Strong*. With the success of the album in the US, they embarked on a concert tour. The second album *Temple of Low Men* won best Album and Best Cover Artwork at the 1988 ARIA Awards. *Better Be Home Soon* was named song of the year. The album's other hits included *Into Temptation* and *Never Be The Same*. Tim Finn joined Crowded House in 1990 and they released *Woodface* in 1991 with the hits *Chocolate Cake*, *Fall At Your Feet*, *It's only Natural* and *Weather With You* and *Four Seasons in One Day*. Tim Finn left the band in late 1991 and was replaced by Mark Hart. They released *Together Alone*, which was recorded in the isolated environment of Karekare Beach in the North Island of New Zealand, and continued releasing popular singles until 1996 when they made their farewell performance on the steps of the Sydney Opera House. The members continue to record and perform. Paul Hester committed suicide in 2005.

Mike + The Mechanics

Mike + the Mechanics is a British band started in 1985 and led by Mike Rutherford, who was a founding member of Genesis. They are best known for hit songs *Silent Running*, *All I Need Is a Miracle*, *Taken In*, and *The Living Years*. The original line-up included Paul Carrack and the late Paul Young (formerly of chart band Sad Café and not to be confused with the solo singer Paul Young). After a hiatus, the band reformed in 2004 as Mike + the Mechanics featuring Paul Carrack. The debut album *Mike + the Mechanics* (1985) reached number 26 in the USA but their best performing album of the 1980s was 1988's *The Living Years*, which reached number two in the UK and number 13 in the USA.

Robbie Nevil

The American pop singer and songwriter Robbie Nevil burst onto the music scene in 1986 with the infectious *C'est la Vie*. Nevil had been a working songwriter prior to making a name for himself as a solo artist. In 1983, he signed a publishing deal and managed to place tracks on albums by artists including the Pointer Sisters, El DeBarge and Earth, Wind & Fire. By 1986, Nevil had signed a recording deal with Manhattan and proceeded to record his debut album with producers Alex Sadkin and Phil Thornalley. Buoyed by the lead single *C'est la Vie*, his self-titled album had two more hits, *Dominoes* and *Wot's It to Ya*. It would be four years before Nevil would release his next effort, *A Place Like This*, and its sales failed to come close to his debut,

116

Chris de Burgh

Born in 1948, the Irish musician and songwriter Chris de Burgh's most famous songs are 1983's *Don't Pay the Ferryman* and the ballad *The Lady in Red* (1986). De Burgh signed with A&M Records in 1974, and supported Supertramp on their Crime of the Century tour, building a fan base. His debut was *Far Beyond These Castle Walls* and failed to chart upon its release in February of 1975. In 1981, he had his first UK chart entry with *Best Moves*, a collection culled from his early albums. Rupert Hine-produced *The Getaway* in 1982, which reached number 30 in the UK charts and number 43 in the US, thanks to the eerie single *Don't Pay the Ferryman*. De Burgh's follow-up album, *Man on the Line*, also performed well. *Flying Colours*, his follow-up its 1988 release, yet it failed to make the American charts. He has released almost one album per year through the 1990s and 2000s, including *Power of Ten* in 1992 and most recently *The Storyman* in 2006.

Gloria Estefan ▶

Born Gloria Fajardo in Cuba on 1 September 1957, Gloria Estefan emerged from Miami to become a top-selling international pop star, first with the dance band Miami Sound Machine and then with her own ballads. In 1978 she married Emelio Estefan, keyboardist with the Miami Sound Machine and the following year the Miami Sound Machine released the first of several Spanish language albums. Estefan sang in English on the album *Eyes Of Innocence* in 1984 with *Dr Beat* becoming a top dance hit in the UK. In 1985 Miami Sound Machine released their first all English album, *Primitive Love*, which contained the hits *Conga*, *Bad Boy* and *Words Get In the Way*. At this point the Miami Sound Machine became Gloria Estefan and the Miami Sound Machine with the hits *Rhythm Is Gonna Get You*, *Can't Stay Away From You*, *Anything for You* and *1-2-3*. Her solo debut *Cuts Both Ways* in 1989 included the number one hit *Don't Wanna Lose You* as well as *Here We Are*. Estefan was severely injured in March 1990 when her tour bus was hit and had to have spinal surgery. Her 1991 comeback song *Coming Out of The Dark* went to number one. The double platinum album, *Into The Light* also had the hits *Can't Forget You* and *Live for Loving You*. She continued recording (in Spanish, as well as English) throughout the 1990s and beyond.

music, dance beats and industrial music. *Nine Objects of Desire* was released in 1996, and *Songs In Red and Gray* followed in 2001. Her latest release in 2007 is *Beauty and Crime*.

Lou Gramm

Born in New York state on 2 May 1950, Lou Gramm first rose to prominence as the frontman for hard rock outfit Foreigner and later pursued a successful solo career. Gramm's powerful vocals were intrinsic to Foreigner's overall sound and hits throughout the 1980s including, *Hot Blooded*, *Double Vision*, *Urgent* and *Waiting for a Girl Like You* and the chart-topping ballad *I Want to Know What Love Is*. Gramm made his solo debut in 1987 with *Ready or Not*, scoring a major hit with *Midnight Blue*. The same year, Foreigner issued *Inside Information*, but after his success with the 1989 solo effort *Long Hard Look* and its hit single *Just Between You and Me* he left the group to form Shadow King, which released its self-titled debut in 1991. Shadow King proved short-lived, however, and in 1994 Gramm

Suzanne Vega

Suzanne Vega was born on 11 July 1959 in California. Her mother (a jazz guitarist) remarried Puerto Rican novelist Ed Vega and they moved to Manhattan. Her parents often sang folk songs around the house, and when she began playing the guitar at age 11, she found herself attracted to the work of Bob Dylan, Leonard Cohen, Woody Guthrie, Pete Seeger, Judy Collins and Joan Baez. She attended the High School for the Performing Arts to study dance and made her first attempts at songwriting. Whilst studying literature at Barnard College, she began playing at coffeehouses and folk festivals. Her debut, *Suzanne Vega*, with the single *Marlene On The Wall*, was released in 1985 to much critical acclaim. For the 1987 follow-up, Vega crafted the songs for *Solitude Standing*. The album's hit single, *Luka*, was a haunting first-person account of child abuse, was nominated for three Grammy Awards. *Days of Open Hand*, was released in 1990, yet did not produce another hit single, however, she was involved in one of 1990's most unusual hits when DNA took the a cappella *Solitude Standing* track *Tom's Diner* and set it to an electronic dance beat, releasing it as *Oh Suzanne*. Vega decided to allow the single's official release under its original title, and it became a hit in the US and UK. In 1992 she released the album *99.9F°*, with an eclectic mixture of folk

118

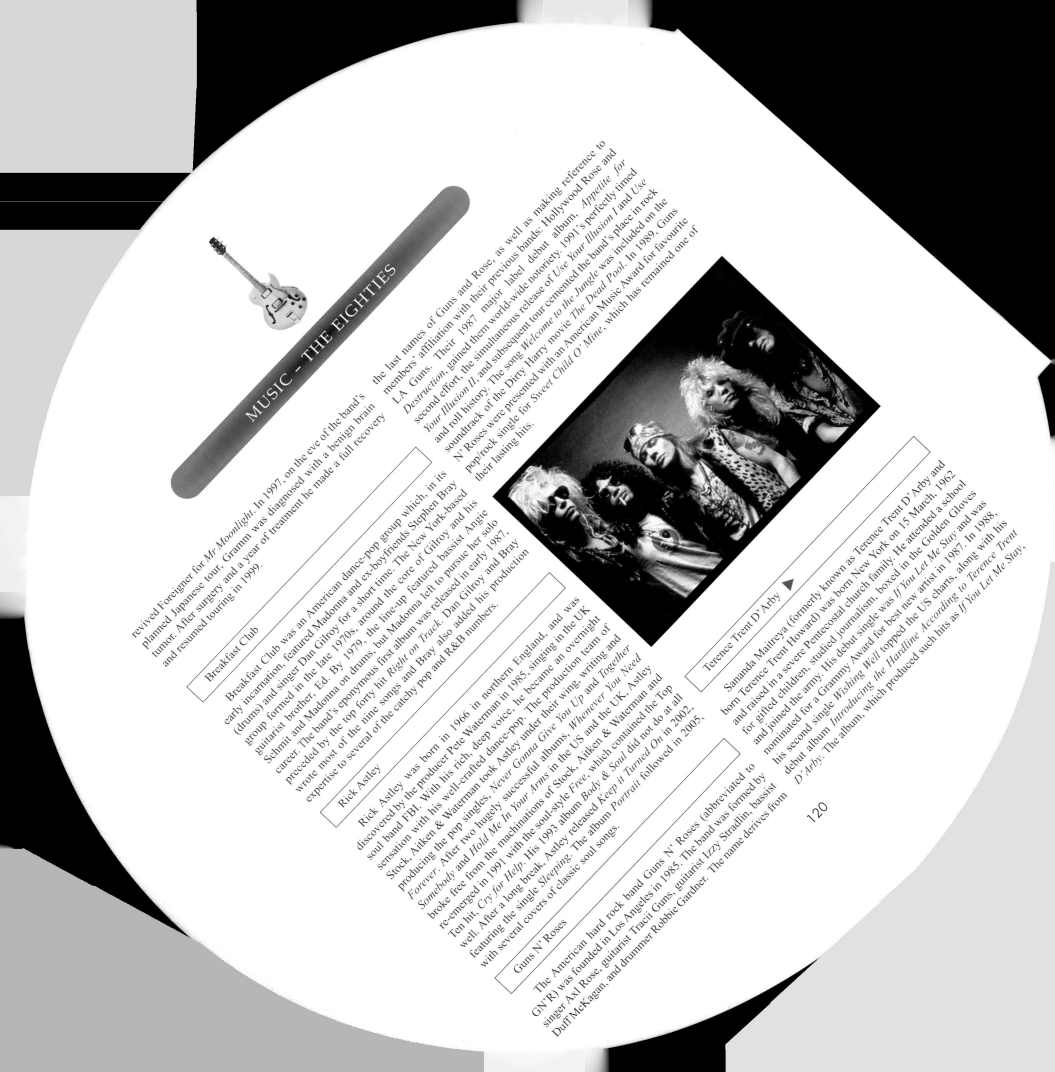

revived Foreigner for *Mr Moonlight*. In 1997, on the eve of the band's planned Japanese tour, Gramm was diagnosed with a benign brain tumor. After surgery and a year of treatment he made a full recovery and resumed touring in 1999.

the last names of Guns and Rose, as well as making reference to members' affiliation with their previous bands; Hollywood Rose and LA Guns. Their 1987 major label debut album, *Appetite for Destruction*, gained them world-wide notoriety. 1991's perfectly timed second effort, the simultaneous release of *Use Your Illusion I* and *Use Your Illusion II*, and subsequent tour cemented the band's place in rock and roll history. The song *Welcome to the Jungle* was included on the soundtrack of the Dirty Harry movie *The Dead Pool*. In 1989, Guns N' Roses were presented with an American Music Award for favourite pop/rock single for *Sweet Child O' Mine*, which has remained one of their lasting hits.

Breakfast Club

Breakfast Club was an American dance-pop group which, in its early incarnation, featured Madonna and ex-boyfriends Stephen Bray (drums) and singer Dan Gilroy for a short time. The New York-based group formed in the late 1970s, around the core of Gilroy and his guitarist brother, Ed. By 1979, the line-up featured bassist Angie Schmit and Madonna on drums, but Madonna left to pursue her solo career. The band's eponymous first album was released in early 1987, preceded by the top forty hit *Right on Track*. Dan Gilroy and Bray wrote most of the nine songs and Bray also added his production expertise to several of the catchy pop and R&B numbers.

Rick Astley

Rick Astley was born in 1966 in northern England, and was discovered by the producer Pete Waterman in 1985, singing in the UK soul band FBI. With his rich, deep voice, he became an overnight sensation with his well-crafted dance-pop. The production team of Stock, Aitken & Waterman took Astley under their wing, writing and producing the pop singles, *Never Gonna Give You Up* and *Together Forever*. After two hugely successful albums, *Whenever You Need Somebody* and *Hold Me In Your Arms* in the US and the UK, Astley broke free from the machinations of Stock, Aitken & Waterman and re-emerged in 1991 with the soul-style *Free*, which contained the Top Ten hit, *Cry for Help*. His 1993 album *Body & Soul* did not do at all well. After a long break, Astley released *Keep it Turned On* in 2002, featuring the single *Sleeping*. The album *Portrait* followed in 2005, with several covers of classic soul songs.

Terence Trent D'Arby ▶

Sananda Maitreya (formerly known as Terence Trent D'Arby and born Terence Trent Howard) was born in New York on 15 March, 1962 and raised in a severe Pentecostal church family. He attended a school for gifted children, studied journalism, boxed in the Golden Gloves and joined the army. His debut single was *If You Let Me Stay* and was nominated for a Grammy Award for best new artist in 1987. In 1988, his second single *Wishing Well* topped the US charts, along with his debut album *Introducing the Hardline According to Terence Trent D'Arby*. The album, which produced such hits as *If You Let Me Stay*,

Guns N' Roses

The American hard rock band Guns N' Roses (abbreviated to GN'R) was founded in Los Angeles in 1985. The band was formed by singer Axl Rose, guitarist Tracii Guns, guitarist Izzy Stradlin, bassist Duff McKagan, and drummer Robbie Gardner. The name derives from

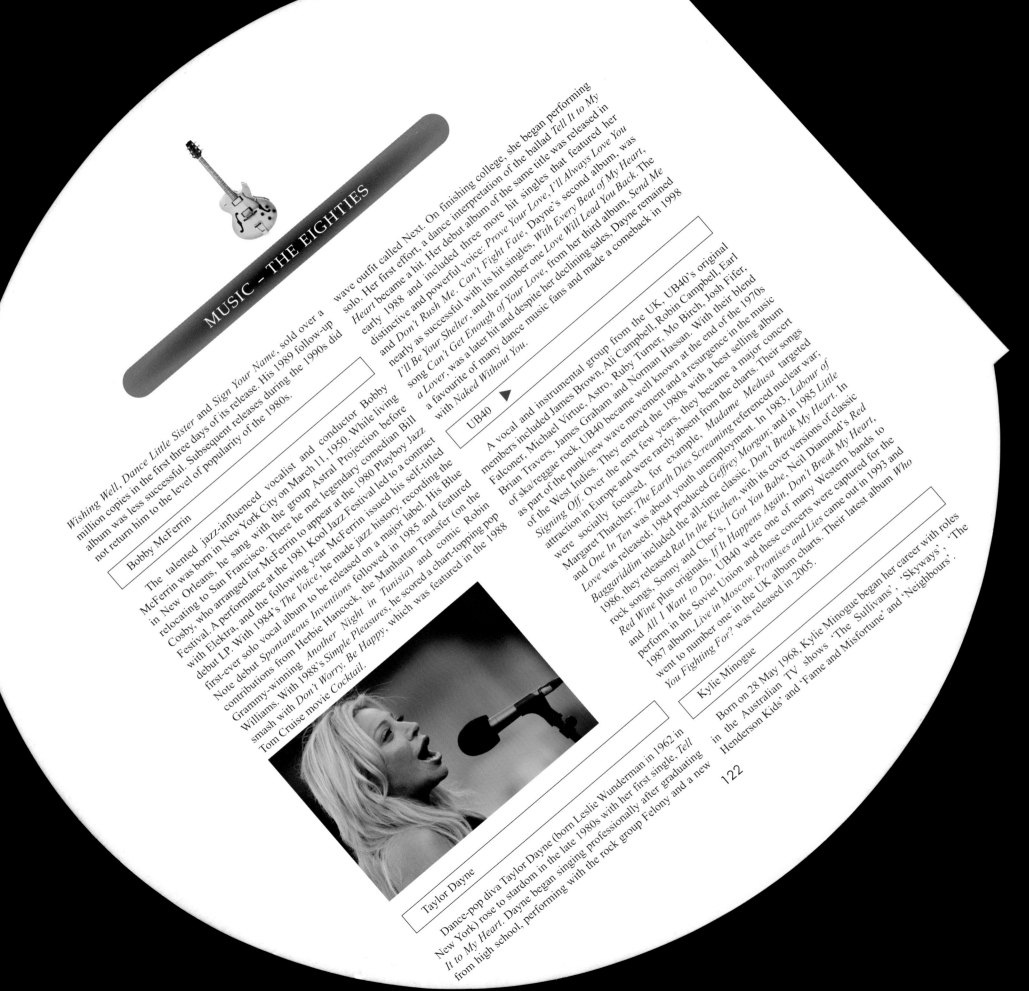

Wishing Well, Dance Little Sister and *Sign Your Name*, sold over a million copies in the first three days of its release. His 1989 follow-up album was less successful. Subsequent releases during the 1990s did not return him to the level of popularity of the 1980s.

Bobby McFerrin

The talented jazz-influenced vocalist and conductor Bobby McFerrin was born in New York City on March 11, 1950. While living in New Orleans, he sang with the group Astral Projection before relocating to San Francisco. There he met legendary comedian Bill Cosby, who arranged for McFerrin to appear at the 1980 Playboy Jazz Festival. A performance at the 1981 Kool Jazz Festival led to a contract with Elektra, and the following year McFerrin issued his self-titled debut LP. With 1984's *The Voice*, he made jazz history, recording the first-ever solo vocal album to be released on a major label. His Blue Note debut *Spontaneous Inventions* followed in 1985 and featured contributions from Herbie Hancock, the Manhattan Transfer (on the Grammy-winning *Another Night in Tunisia*) and comic Robin Williams. With 1988's *Simple Pleasures*, he scored a chart-topping pop smash with *Don't Worry, Be Happy*, which was featured in the 1988 Tom Cruise movie *Cocktail*.

wave outfit called Next. On finishing college, she began performing solo. Her first effort, a dance interpretation of the ballad *Tell It to My Heart* became a hit. Her debut album of the same title was released in early 1988 and included three more hit singles that featured her distinctive and powerful voice: *Prove Your Love, I'll Always Love You* and *Don't Rush Me. Can't Fight Fate*, Dayne's second album, was nearly as successful with its hit singles, *With Every Beat of My Heart, I'll Be Your Shelter*, and the number one *Love Will Lead You Back.* The song *Can't Get Enough of Your Love*, from her third album, *Send Me a Lover*, was a later hit and despite her declining sales, Dayne remained a favourite of many dance music fans and made a comeback in 1998 with *Naked Without You.*

UB40 ▼

A vocal and instrumental group from the UK. UB40's original members included James Brown, Ali Campbell, Robin Campbell, Earl Falconer, Michael Virtue, Astro, Ruby Turner, Mo Birch, Josh Fifer, Brian Travers, James Graham and Norman Hassan. With their blend of ska/reggae rock, UB40 became well known at the end of the 1970s as part of the punk/new wave movement and a resurgence in the music of the West Indies. They entered the 1980s with a best selling album *Signing Off.* Over the next few years, they became a major concert attraction in Europe and were rarely absent from the charts. Their songs were socially focused, for example, *Madame Medusa* targeted Margaret Thatcher; *The Earth Dies Screaming* referenced nuclear war; and *One In Ten* was about youth unemployment. In 1983, *Labour of Love* was released; 1984 produced *Geffrey Morgan*; and in 1985 *Little Baggariddim* included the all-time classic, *Don't Break My Heart.* In 1986, they released *Rat In the Kitchen*, with its cover versions of classic rock songs, Sonny and Cher's, *I Got You Babe*, Neil Diamond's *Red Red Wine* plus originals, *If It Happens Again, Don't Break My Heart,* and *All I Want to Do.* UB40 were one of many Western bands to perform in the Soviet Union and these concerts were captured for the 1987 album, *Live in Moscow. Promises and Lies* came out in 1993 and went to number one in the UK album charts. Their latest album *Who You Fighting For?* was released in 2005.

Kylie Minogue

Born on 28 May 1968, Kylie Minogue began her career with roles in the Australian TV shows 'The Sullivans', 'Skyways', 'The Henderson Kids' and 'Fame and Misfortune' and 'Neighbours'.

Taylor Dayne

Dance-pop diva Taylor Dayne (born Leslie Wunderman in 1962 in New York) rose to stardom in the late 1980s with her first single, *Tell It to My Heart*. Dayne began singing professionally after graduating from high school, performing with the rock group Felony and a new

122

Her petite figure and girl-next-door charms made her an international success. Her first single was a cover of the Little Eva 1960s hit *Loco-Motion*. In 1988, she signed a deals with producers Stock Aitken & Waterman and her international success was immediate with the release of *I Should Be So Lucky* and *Got to Be Certain*. That year, she also released a duet with Jason Donovan, *Especially for You* and the best-selling *Kylie* album. After winning a Gold Logie, Kylie left 'Neighbours' and continued releasing hits along with the *Enjoy Yourself* album. She starred in the movie *The Delinquents* in 1989. After touring the UK, she was romantically involved with Michael Hutchence. Following the release of *Rhythm of Love* in 1990, she embarked on a sold-out tour of Australia. Throughout the 1990s, she has remained steadfast in her career and her new sound and attitude have continuously evolved. Her *Light Years* album of 2000 gave Minogue her first UK number one single in ten years, with *Spinning Around*. Her 2001 album *Fever* featured *Can't Get You Out of My Head*, which became one of the biggest hits of her career. In May, 2005 she was diagnosed with breast cancer and was forced to cancel a world tour to undergo treatment in Australia. She has subsequently returned to the stage and is working on a new album.

Bobby Brown ▶

One of the brightest R&B stars of the late 1980s and early 1990s, Bobby Brown was born on February 5 1969 in Boston, and began singing with Roxbury schoolmates Michael Bivins and Ricky Bell in 1978. The group, which was to become New Edition, was discovered by producer Maurice Starr, who signed them to his label and co-authored the debut hit *Candy Girl*. After a few years he released his debut solo album, *King of Stage*, in 1987. *Don't Be Cruel*, released in the summer of 1988, produced Brown's first big hit with the title track. The ballad *Roni*, the dance tune *Every Little Step* (which showed off Brown's rapping skills), and another ballad *Rock Wit'cha* all hit the Top Ten in 1989. *Don't Be Cruel* topped the album charts and sold seven million copies, making Brown a superstar. His momentum then slowed and he had very public personal and legal problems. Brown has since rejoined New Edition.

Milli Vanilli

Milli Vanilli was the duo, Fabrice Morvan and Rob Pilatus, formed in Germany in the mid-1980s. They are notorious for being the only group to have their Grammy Award stripped from them after it was revealed that they had not been involved in the creation of their breakthrough album, *Girl You Know It's True* and did not sing in concert. Their photos were pictured on the album cover and they lip-synched in concert. Despite the scandal, the Milli Vanilli sound created by Frank Farian was ground-breaking in pop-music. Frank Farian used Pilatus and Morvan to front Charles Shaw, Johnny Davis and Brad Howell; he felt that these musicians were talented but unmarketable. Their first album was *All or Nothing*, which was both a European hit and an American hit.

Paula Abdul

Born in 1962 in California, Paula Abdul starting her performing career as a dancer and choreographer. She choreographed music videos for Duran Duran, Heart, Prince, The Jacksons, Janet Jackson, Kool & the Gang, the Pointer Sisters, Steve Winwood, INXS, ZZ Top, George Michael, Dolly Parton and many more famous artists. Abdul began a recording career, releasing her debut album, *Forever Your Girl*, in 1988. The release of *Straight Up* at the end of the year made her a superstar. Staying at the top of the charts for three weeks, *Straight Up* began a string of hit singles that ran through to the summer of 1991.

Abdul's spectacular big-budget videos helped push the sales of *Forever Your Girl* past seven million in the US alone. While her second album, 1991's *Spellbound*, was less successful, it still sold over three million copies and spent two weeks at number one.

Fine Young Cannibals

Fine Young Cannibals are an English band best known for their 1988 hits *She Drives Me Crazy* and *Good Thing*. They appeared in the 1987 comedy film *Tin Men*, starring Danny deVito and Richard Dreyfuss. The band comprised Roland Gift (singer), Andy Cox (guitarist) and David Steele (musician and bassist) and was formed in Birmingham, England by the guitarist and bassist from The Beat and actor/model Roland Gift. Their name came from the 1960 film *All The Fine Young Cannibals* starring Robert Wagner and Natalie Wood. Their albums were: *Fine Young Cannibals* (1986), *The Raw and the Cooked* (1989), *The Raw and the Remix* (1990) and *The Finest* (1996).

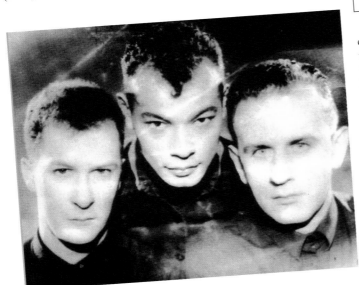

Roxette ▶

Roxette grew out of the cooperation between the Swedish singers Per Gessle and Marie Fredriksson, who both were established artists, and had been friends since 1979. Marie performed with Per's band Gyllene Tider on some tracks of their album *The Heartland Café*, an album which was later to be released in the USA. Because the name Gyllene Tider was deemed too complex for the American audience, a new name was needed. The name chosen came from a Dr Feelgood song, *Roxette*. In 1995 they recorded a surprise number one single *Neverending Love*. In 1990, a track, which was by this time three years old, *It Must Have Been Love (Christmas For The Broken Hearted)*, was used in the hit movie *Pretty Woman*, without the Christmas references. The soundtrack sold over eight million copies in the US. The lead vocals alternated between Gessle's lighter voice for hits such as *The Look* and *Joyride*, and Fredriksson's throatier vocals on *Fading Like a Flower*, *It Must Have Been Love*, and *Listen to Your Heart*.

New Kids on the Block

New Kids On The Block (later known as NKOTB) was a commercially successful boy band of the late 1980s and early 1990s, formed in Boston in 1984. The members of the band were Donnie Wahlberg, Jordan and Jonathan Knight, Danny Wood, and Joey McIntyre. Based on R&B/pop quintet New Edition and assembled by their former manager and producer Maurice Starr, their self-titled first album in 1986 was largely ignored. Their second album, 1988's *Hangin' Tough*, sold eight million copies around the world, with three top ten singles, the title track, *I'll Be Loving You (Forever)*, and *You Got It (The Right Stuff)*. The 1990 album *Step by Step* went to number one in the UK and US and featured the singles *Step by Step*, *Tonight* and *Let's Try It Again*. The group broke up in 1994 and Donnie Wahlberg went on to pursue a successful solo career.

Christopher Cross

Born Christopher Geppert in 1951 and raised in Texas, Christopher Cross sang in a cover band as a teenager. He wrote his own songs and was signed to Warner Brothers in 1978. When his debut album *Christopher Cross* was released the following year, it went quadruple platinum and yielded the top 20 hits, *Sailing*, *Ride Like The Wind*

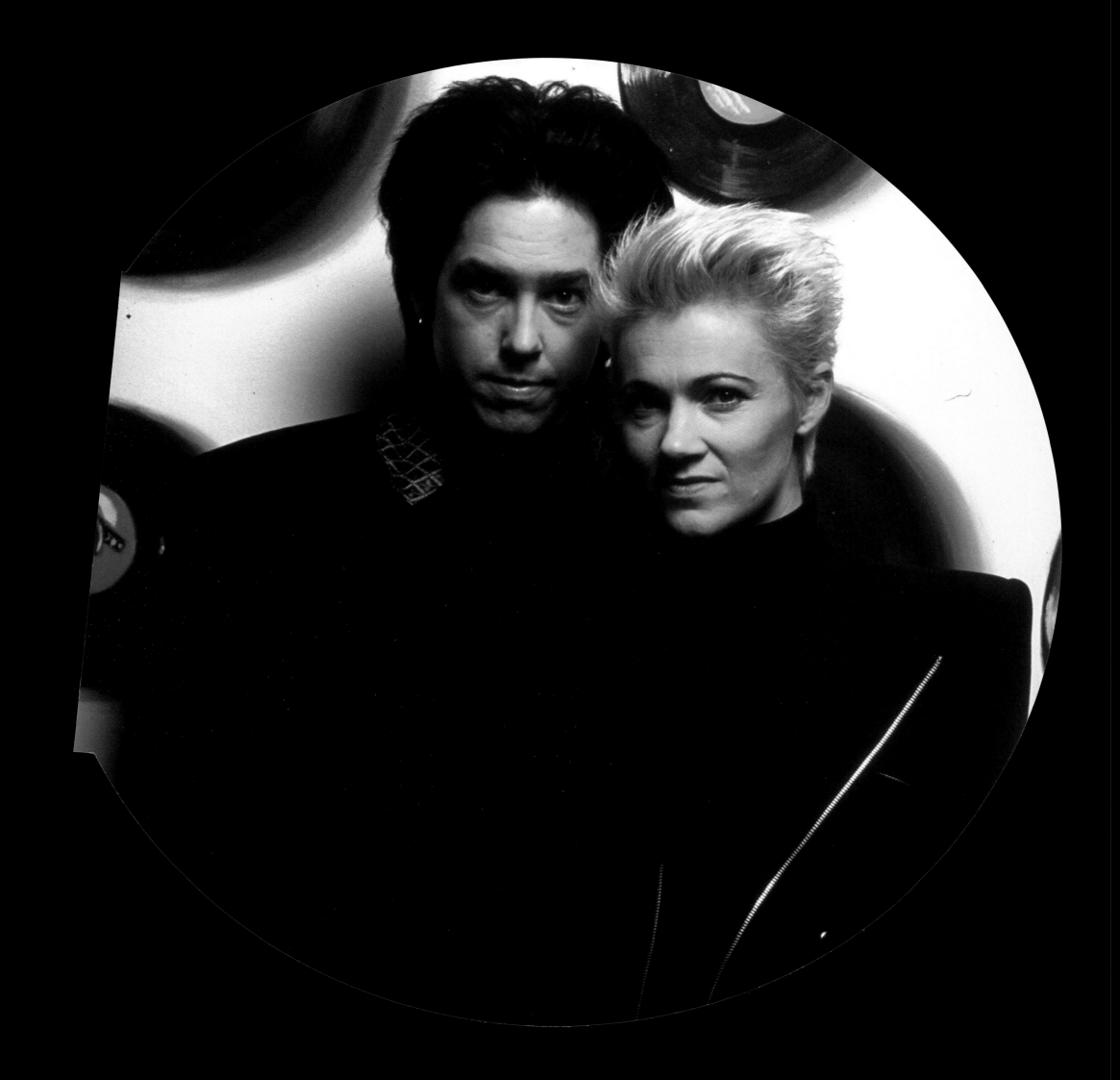

(which featured backing vocals by Michael McDonald of the Doobie Brothers), *Never Be the Same* and *Say You'll be Mine*. In 1981, he won five Grammy Awards, including Best Record, Best Album and Best Song. Later that year. Cross, Peter Allen, Burt Bacharach and Carole Bayer Sager, had a hit together with the Academy Award winning, *Arthur's Theme (The Best That You Can Do)* from the movie *Arthur*. *Every Turn Of The World*, released in 1985, met mediocre sales but had one minor hit *Charm The Snake*, as was also the case with *Back Of My Mind*. Fans consider Cross' 1995 comeback album *Window* his most accomplished work. He released a double album in 1998 - *Walking In Avalon*, and *Red Room* followed in 2000.

Air Supply

Formed in 1976 in Melbourne, Australia, Air Supply is a soft rock band, with members Graham Russell (vocals, guitar), Russell Hitchcock (vocals), Ralph Cooper (drums) David Moyse (guitar), David Green (bass), Rex Goh (guitar) and Frank Esler-Smith (keyboards). Air Supply is based around the duo of Russell (the main songwriter) and Hitchcock. Their easy listening hits have earned them several platinum albums and gold singles world-wide. *Greatest Hits* went quadruple platinum in the US and *The Earth Is* achieved gold status in Australia including *Love And Other Bruises*, *Empty Pages* and *Do What You Do*. 1979's *Lost in Love* was one of the year's biggest hits in the US and was followed by a series of top ten hits, *Every Woman In The World*, *The One That You Love*, *Even The Nights Are Better* and *Making Love Out Of Nothing At All*. Air Supply have sold over 15 million records world-wide. They disbanded in 1988 but Russell, Hitchcock and Cooper re-formed in 1991. They have continued to tour with various backing configurations.

Dr Hook

Dr Hook formed in 1968 with Ray Sawyer (vocals, guitar), Dennis Locorriere (vocals, guitar), William Francis (keyboards, percussion), George Cummings (guitar) and John 'Jay' David (drums), and the band began by performing covers in New Jersey. Locorriere and Sawyer (who wears an eye patch after losing an eye in a 1967 car crash – hence Dr Hook) were discovered by their manager, Ron Haffkine while looking for backup musicians to perform 'Playboy',

cartoonist Shel Silverstein's material in the 1971 movie *Who Is Harry Kellerman and Why Is He Saying Those Terrible Things About Me?* Dr Hook played *Last Morning* on the soundtrack and also appeared in the movie. Their debut album *Dr Hook and The Medicine Show* featured *Sylvia's Mother*. *Sloppy Seconds* was their follow-up and the group had the hit *The Cover of Rolling Stone*, a satirical examination of rock culture that actually put them on the cover of *Rolling Stone* magazine. The song was released in the UK as *Cover of the Radio Times* and the single was a success.

In 1976, the band had a hit with a cover of Sam Cooke's *Only Sixteen* and *A Little Bit More*. The next few years elicited further hits including, *Sharing The Night Together*, *When You're in Love With a Beautiful Woman*, *Better Love Next Time*, *Sexy Eyes* and *Baby Makes Her Blue Jeans Talk*. By late 1979, Dr Hook were internationally popular. They disbanded in 1982, but a couple of years later Sawyer (who'd recorded a solo country album in 1977) revived the name and has toured ever since. Drummer John Wolters passed away in 1997 after battling liver cancer. In the late 1980s, Locorriere provided backup vocals on Randy Travis' album *Always & Forever* and released a solo album in 2000.

▲

Bruce Springsteen

Born 23 September 1949, Bruce Springsteen is a rock and roll hero whose music reflects an innate insight into everyday life in America's heartland. He took up playing the guitar as a teenager and throughout the 1970s released classics such as *Greetings From Asbury Park, The Wild, The Innocent and The E Street Shuffle, Born to Run* and *Darkness On The Edge of Town*. In the early 1980s, *The River*, with its compilation of songs that were short stories and character portraits, embarked on a tour of the US and UK – every one of his four hour shows was sold out. He also played benefit concerts for Vietnam War Veterans. In 1982, Springsteen released *Nebraska*, a commentary on the social problems of America under President Reagan, which he recorded at home. He released *Born In the USA* in 1984 and with its hits *I'm on Fire, Glory Days, I'm Goin' Down* and *My Hometown* it remained in the top ten for more than two years. One of his first videos was for *Dancing In The Dark* (directed by Brian DePalma) which later won a Grammy Award. In 1985, he sang on USA for Africa's *We Are The World*, and on the anti-apartheid project *Sun City*. His 40-song live album package *Live/1975-85* was released in 1986 and featured a cover

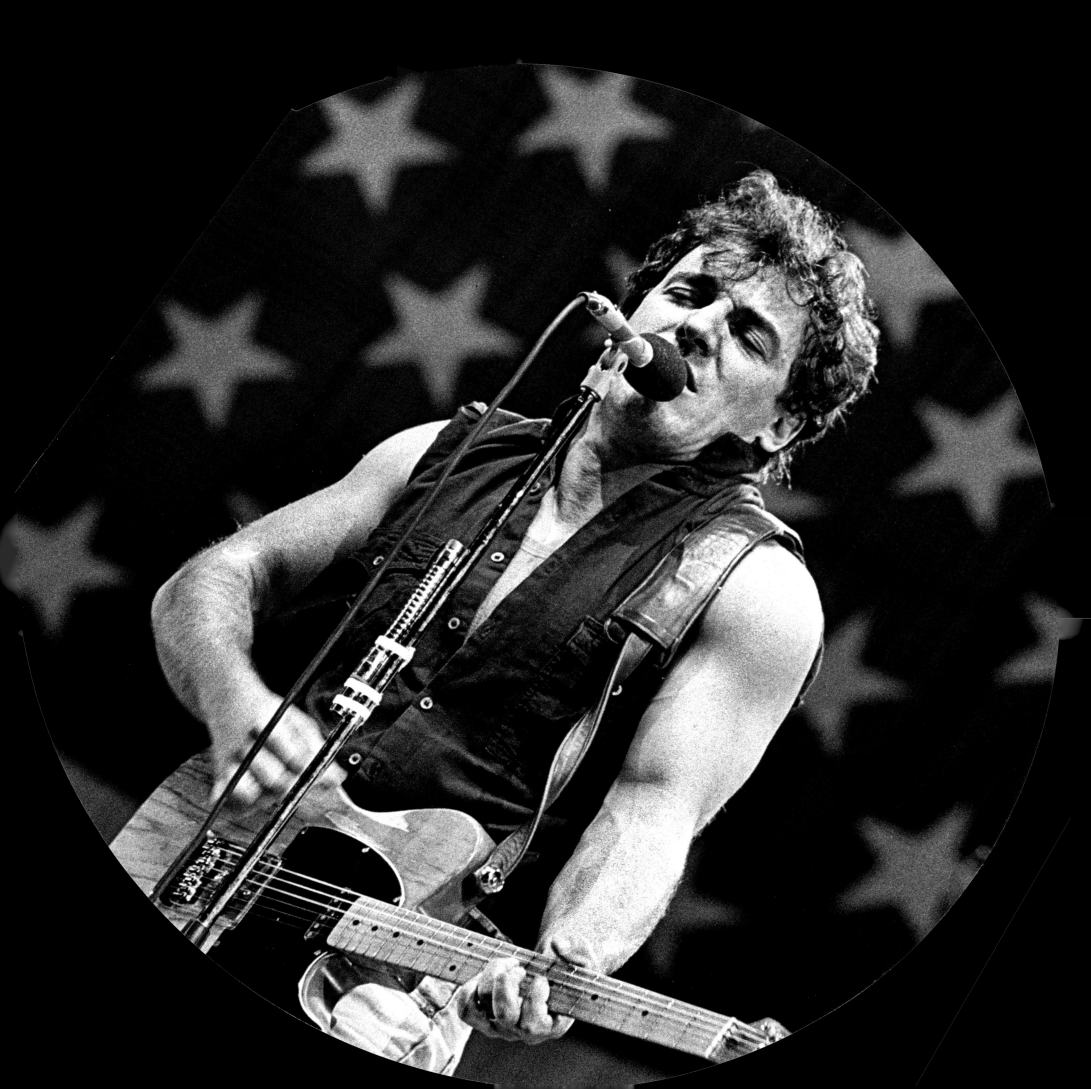

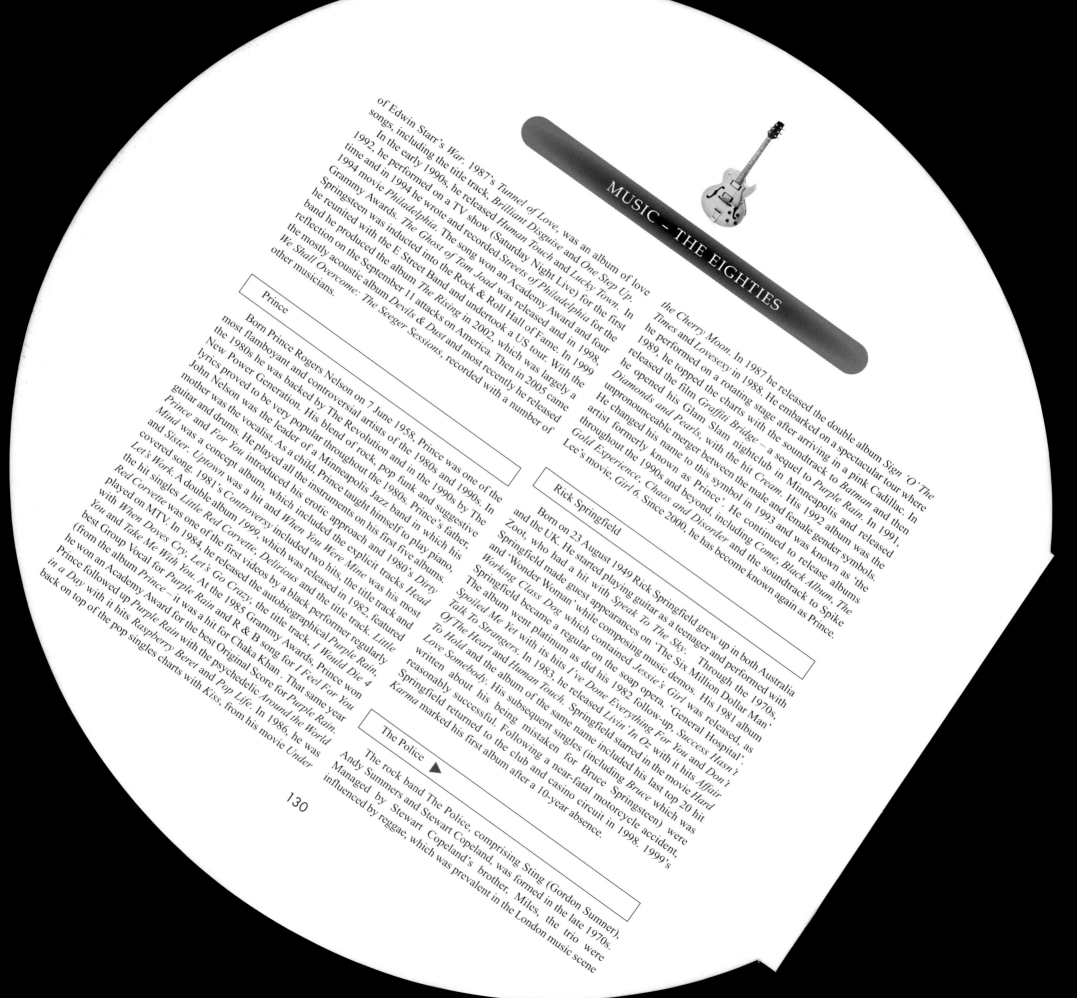

of Edwin Starr's *War*. 1987's *Tunnel of Love*, was an album of love songs, including the title track.

In the early 1990s, he released *Human Disguise* and *One Step Up*. In 1992, he performed on a TV show (Saturday Night Live) for the first time and in 1994 he wrote and recorded *Streets of Philadelphia* for the 1994 movie *Philadelphia*. The song won an Academy Award and four Grammy Awards. *The Ghost of Tom Joad* was released and in 1998, Springsteen was inducted into the Rock & Roll Hall of Fame. In 1999, he reunited with the E Street Band and undertook a US tour. With the band he produced the album *The Rising* in 2002, which was largely a reflection on the September 11 attacks on America. Then in 2005 came the mostly acoustic album *Devils & Dust* and most recently he released *We Shall Overcome: The Seeger Sessions*, recorded with a number of other musicians.

Prince

Born Prince Rogers Nelson on 7 June 1958, Prince was one of the most flamboyant and controversial artists of the 1980s and in the 1980s he was backed by The Revolution and in the 1990s by The New Power Generation. His blend of rock, pop funk and suggestive lyrics proved to be very popular throughout the 1980s. Prince's father, John Nelson was the leader of a Minneapolis Jazz band in which his mother was the vocalist. As a child, Prince taught himself to play piano, guitar and drums. He played all the instruments on his first five albums. *Prince* and *For You* introduced his erotic approach and 1980's *Dirty Mind* was a concept album, which included the explicit tracks *Head* and *Sister*. *Uptown* was a hit and *When You Were Mine* was his most covered song. 1981's *Controversy* included two hits, the title track and the hit singles *Little Red Corvette*, *Delirious* and the title track. *Little Red Corvette* was one of the first videos by a black performer regularly played on MTV. In 1984, he released the autobiographical *Purple Rain*, with *When Doves Cry*, *Let's Go Crazy*, the title track, *I Would Die 4 You* and *Take Me With You*. At the 1985 Grammy Awards, Prince won best Group Vocal for *Purple Rain* and R & B song for *I Feel For You* (from the album *Prince* – it was a hit for Chaka Khan . That same year he won an Academy Award for the best Original Score for *Purple Rain*. Prince followed up *Purple Rain* with the psychedelic *Around the World in a Day* followed up *Purple Rain*. In 1986, he was back on top of the pop singles charts with *Kiss*, from his movie *Under*

the Cherry Moon. In 1987 he released the double album *Sign 'O' The Times* and *Lovesexy* in 1988. He embarked on a spectacular tour where he performed on a rotating stage after arriving in a pink Cadillac. In 1989, he topped the charts with the soundtrack to *Batman* and then released the film *Graffiti Bridge* – a sequel to *Purple Rain*. In 1991, he opened his Glam Slam nightclub in Minneapolis and released *Diamonds and Pearls*, with the hit *Cream*. His 1992 album was the unpronounceable merger between the male and female gender symbols. He changed his name to this symbol in 1993 and was known as 'the artist formerly known as Prince'. He continued to release albums throughout the 1990s and beyond, including *Come*, *Black Album*, *The Gold Experience*, *Chaos and Disorder* and the soundtrack to Spike Lee's movie, *Girl 6*. Since 2000, he has become known again as Prince.

Rick Springfield

Born on 23 August 1949 Rick Springfield grew up in both Australia and the UK. He started playing guitar as a teenager and performed with Zoot, who had a hit with *Speak To The Sky*. Through the 1970s, Springfield made guest appearances on 'The Six Million Dollar Man', and 'Wonder Woman' while composing music demos. His 1981 album *Working Class Dog* which contained *Jessie's Girl* was released as Springfield became a regular on the soap opera, 'General Hospital'. The album went platinum as did his 1982 follow-up, *Success Hasn't Spoiled Me Yet* with its hits *I've Done Everything For You* and *Don't Talk To Strangers*. In 1983, he released *Livin' In Oz* with it hits *Affair Of The Heart* and *Human Touch*. Springfield starred in the movie *Hard To Hold* and the album of the same name included his last top 20 hit *Love Somebody*. His subsequent singles (including *Bruce* which was written about his being mistaken for Bruce Springsteen) were reasonably successful. Following a near-fatal motorcycle accident, Springfield returned to the club and casino circuit in 1998. 1999's *Karma* marked his first album after a 10-year absence.

The Police ▲

The rock band The Police, comprising Sting (Gordon Sumner), Andy Summers and Stewart Copeland, was formed in the late 1970s. Managed by Stewart Copeland's brother, Miles, the trio were influenced by reggae, which was prevalent in the London music scene

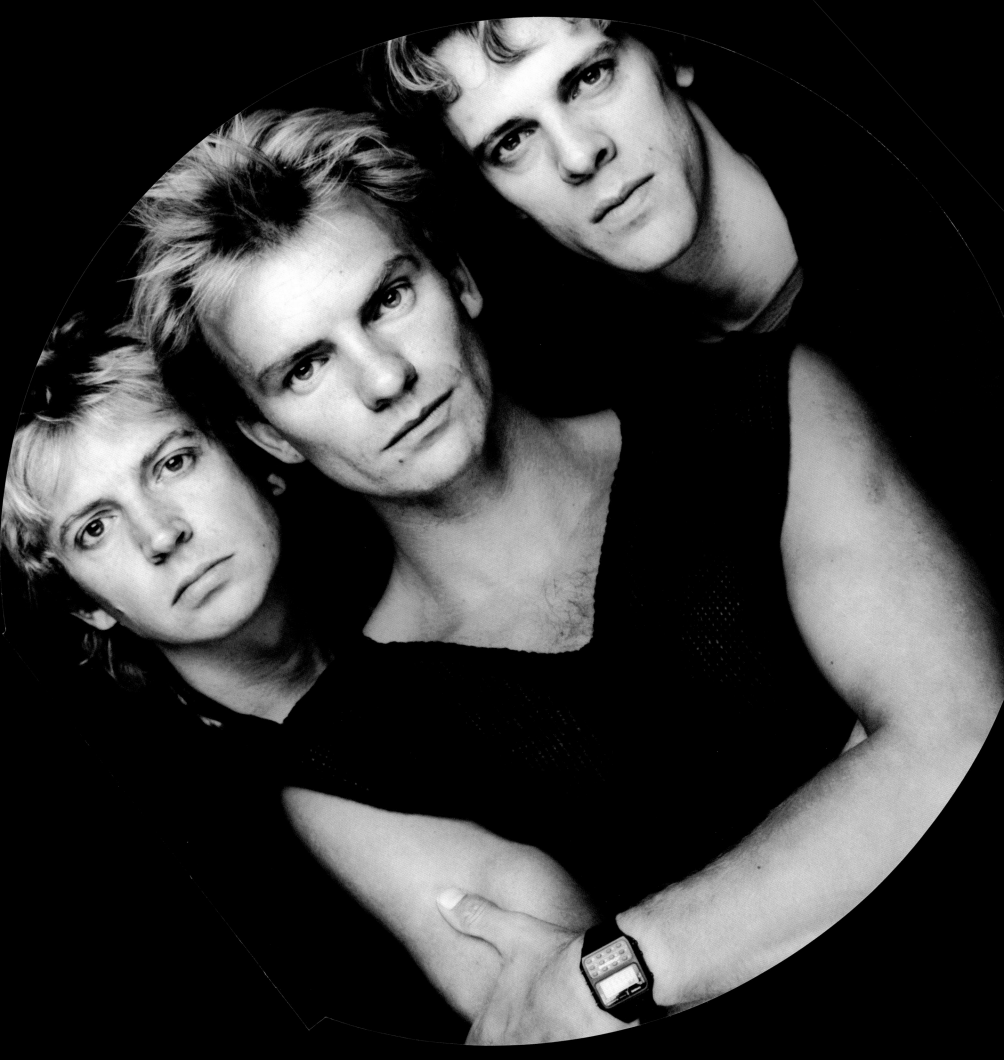

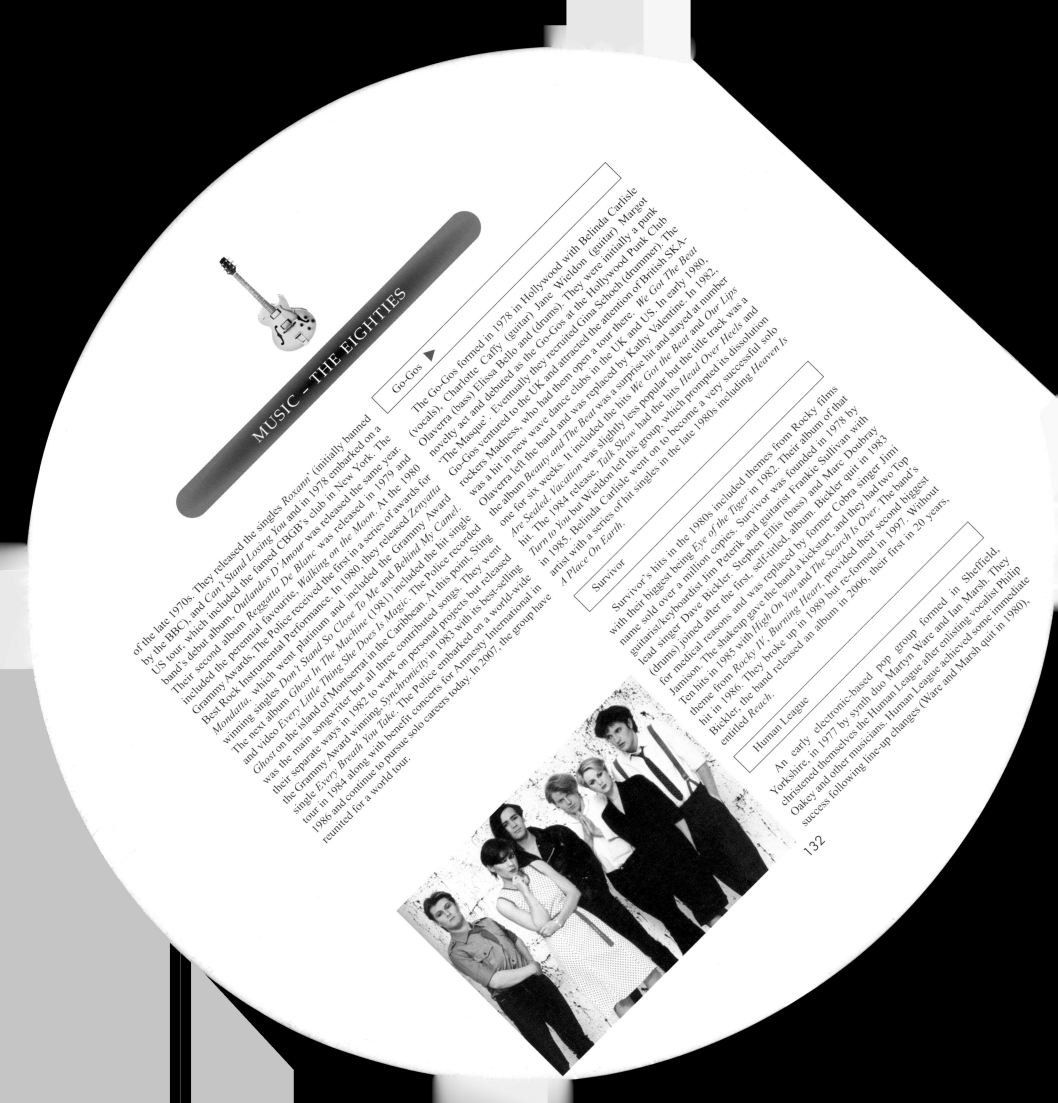

...of the late 1970s. They released the singles *Roxann*' (initially banned by the BBC), and *Can't Stand Losing You* and in 1978 embarked on a US tour, which included the famed CBGB's club in New York. The band's debut album, *Outlandos D'Amour* was released the same year. Their second album, *Reggatta De Blanc* was released in 1979 and included the perennial favourite, *Walking on the Moon*. At the 1980 Grammy Awards, The Police received the first in a series of awards for Best Rock Instrumental Performance. In 1980, they released *Zenyatta Mondatta*, which went platinum and included the Grammy Award winning singles *Don't Stand So Close To Me* and *Behind My Camel*. The next album *Ghost In The Machine* (1981) included the hit single and video *Every Little Thing She Does Is Magic*. The Police recorded *Ghost* on the island of Montserrat in the Caribbean. At this point, Sting was the main songwriter but all three contributed songs. They went their separate ways in 1982 to work on personal projects but released the Grammy Award winning, *Synchronicity* in 1983 with its best-selling single *Every Breath You Take*. The Police embarked on a world-wide tour in 1984 along with benefit concerts for Amnesty International in 1986 and continue to pursue solo careers today. In 2007, the group have reunited for a world tour.

Go-Gos ▶

The Go-Gos formed in 1978 in Hollywood with Belinda Carlisle (vocals), Charlotte Caffy (guitar) Jane Wieldon (guitar) Margot Olaverra (bass) Elissa Bello and (drums). They were initially a punk novelty act and debuted as the Go-Gos at the Hollywood Punk Club 'The Masque'. Eventually they recruited Gina Schoch (drummer). The Go-Gos ventured to the UK and attracted the attention of British SKA-rockers Madness, who had them open a tour there. *We Got The Beat* was a hit in new wave dance clubs in the UK and US. In early 1980, Olaverra left the band and was replaced by Kathy Valentine. In 1982, the album *Beauty and The Beat* was a surprise hit and stayed at number one for six weeks. It included the hits *We Got the Beat* and *Our Lips Are Sealed*. *Vacation* was slightly less popular but the title track was a hit. The 1984 release, *Talk Show* had the hits *Head Over Heels* and *Turn to You* but Wieldon left the group, which prompted its dissolution in 1985. Belinda Carlisle went on to become a very successful solo artist with a series of hit singles in the late 1980s including *Heaven Is A Place On Earth*.

Survivor

Survivor's hits in the 1980s included themes from Rocky films with their biggest being *Eye of the Tiger* in 1982. Their album of that name sold over a million copies. Survivor was founded in 1978 by guitarist/keyboardist Jim Peterik and guitarist Frankie Sullivan with lead singer Dave Bickler. Stephen Ellis (bass) and Marc Doubray (drums) joined after the first, self-titled, album. Bickler quit in 1983 for medical reasons and was replaced by former Cobra singer Jimi Jamison. The shakeup gave the band a kickstart, and they had two Top Ten hits in 1985 with *High On You* and *The Search Is Over*. The band's theme from *Rocky IV*, *Burning Heart*, provided their second biggest hit in 1986. They broke up in 1989 but re-formed in 1997. Without Bickler, the band released an album in 2006, their first in 20 years, entitled *Reach*.

Human League

An early electronic-based pop group formed in Sheffield, Yorkshire, in 1977 by synth duo Martyn Ware and Ian Marsh. They christened themselves the Human League after enlisting vocalist Philip Oakey and other musicians. Human League achieved some immediate success following line-up changes (Ware and Marsh quit in 1980),

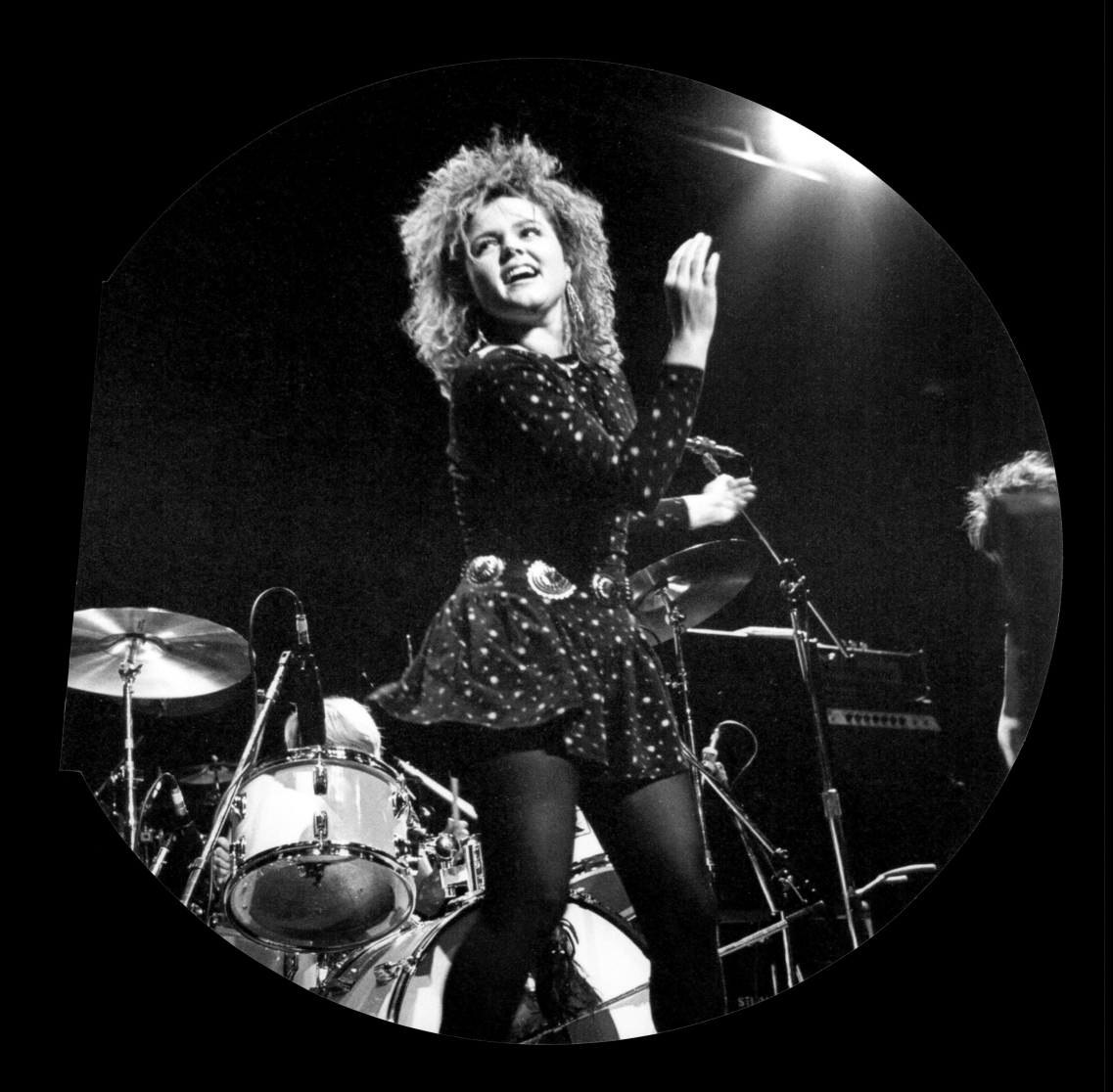

which left the group Phil Oakey, Adrian Wright, Ian Burden, Jo Callis (synthesizers) and Joanne Cathererall and Suzanne Sulley (vocalists). Synthesizer expert Martin Rushent produced their recordings and they had a series of hits in 1980 and 1981. Their melodic songs and polished presentation made them internationally popular. Their single *Love Action* and *Open Up Your Heart* were instant hits. Their second album *Dare!* gave Human League the lasting hit *Don't you Want me*. 1983's *Fascination* EP scored hits with *Mirror Man* and *(Keep Feeling) Fascination*. *Hysteria* finally surfaced in mid-1984 but did not chart well. Human League had a break before 1986's *Crash* produced single *Human*, which soon topped the US charts. Subsequent albums did not achieve the success of the 1980s, the latest release being *Secrets* in 2001. The band continues to tour.

Laura Branigan

Pop singer/actress Laura Branigan was born on 3 July 1957 in New York state. In the mid-1970s, Branigan supplied backing vocals for Leonard Cohen resulting in the singer landing a recording contract with Atlantic Records. After a split and legal battle she was free to launch her solo career and her debut album, *Branigan*, was issued in 1982. One of the year's top international hits was the single *Gloria*. 1983's *Branigan 2* spawned another two sizeable U.S. hit singles, *Solitaire* and *How Am I Supposed to Live Without You* (the latter of which was co-written by a then-unknown Michael Bolton), while she also appeared on the hit soundtrack to *Flashdance* that same year with the track *Imagination*. 1984's *Self Control*, 1985's *Hold Me* and 1987's *Touch* included hit singles *The Lucky One*, *Ti Amo*, *Spanish Eddie*, *I Found Someone*, *Hold Me*, *Shattered Glass*, and *The Power of Love*. Her music career had reached its peak although she continued to appear on television and theatre. She passed away on August 26, 2004.

Men at Work ▶

In the late 1970s, the Australian reggae/rock band Men At Work consisted of Colin Hay (vocals, guitar), Greg Ham (flute, sax, keyboards, vocals), Ron Strykert (guitar, vocals), John Rees (bass) and Jerry Speiser (drums), and started out by performing in Melbourne pubs. In 1980, they released a self-financed independent single *Keypunch Operator/Downunder* on their own M.A.W. imprint. This

became a collector's item when they became famous. They released the single *Who Can it Be Now?* in 1981, which stayed on the Australian charts for 16 weeks. Their second single, a re-released version of *Downunder*, stayed in the charts for 18 weeks. *Business As Usual* was released that year and went on to sell over 400 000 copies in Australia. By the end of the year they had achieved international fame. Their second album, 1982's *Cargo*, included the hits *Dr Heckyll and Mr. Jive*, *Overkill* and *It's A Mistake*. Their success in the US coincided with the launch of MTV in 1983 and the quirky video of *Downunder* proved to be popular. Men at Work won a Grammy Award for Best New Artist and embarked on a concert tour of the US and the UK. After the 1983 tour, they returned to Australia for a break. In 1985, Hay, Ham and Strykert were joined by session players Jeremy Alsop (bass) and Mark Kennedy (drums) for *Two Hearts*. The single *Everything I Need* was a hit. Men at Work disbanded in 1986 following their *Back To Business* tour. They were inducted into the Hall of Fame at the 1993 ARIA awards and in1996 Hay and Ham took the re-formed version of the band on a tour of Brazil.

Toto

Toto comprised the session musicians Bobby Kimball (vocals) Steve Lukather (guitar) David Paich (keyboard, vocals), brothers Steve (keyboards, vocals) and Jeff Porcaro (drums), David Hungate (bass) who formed their own band in 1978. Toto's most successful years were *Toto*, had a hit with *Hold the Line*. That same year their first release, 1982 and 1983, when the Grammy Award winning *Toto IV* generated the hits *Africa*, *Rosanna* and *I Won't Hold You Back*. The following year, Kimball and Hungate were replaced by Dave Fergie Frederikson and Mike Porcaro. *Isolation* and the band's soundtrack to the movie *Dune* were not so successful. Their contribution to the backing track of USA For Africa's single *We Are The World* was more favourably received. With new lead singer, Joseph Williams, the band reached number 11 in the US with *I'll be Over You*, a composition by Lukather and Randy Goodrun from 1986's *Fahrenheit*. Two years later, *Pamela* reached number 22 in the US. By then Steve Porcaro had departed to continue his studio work and as the other members were immersed in side-projects. In 1990, Jean-Michel Byron briefly replaced Williams, before Lukather became the band's vocalist. It was reported that Jeff Porcaro died in 1992 after a heart attack caused by an allergic reaction to pesticide. Evidently a coroner ruled his death was from a heart attack resulting from long-term cocaine use. His replacement was Simon

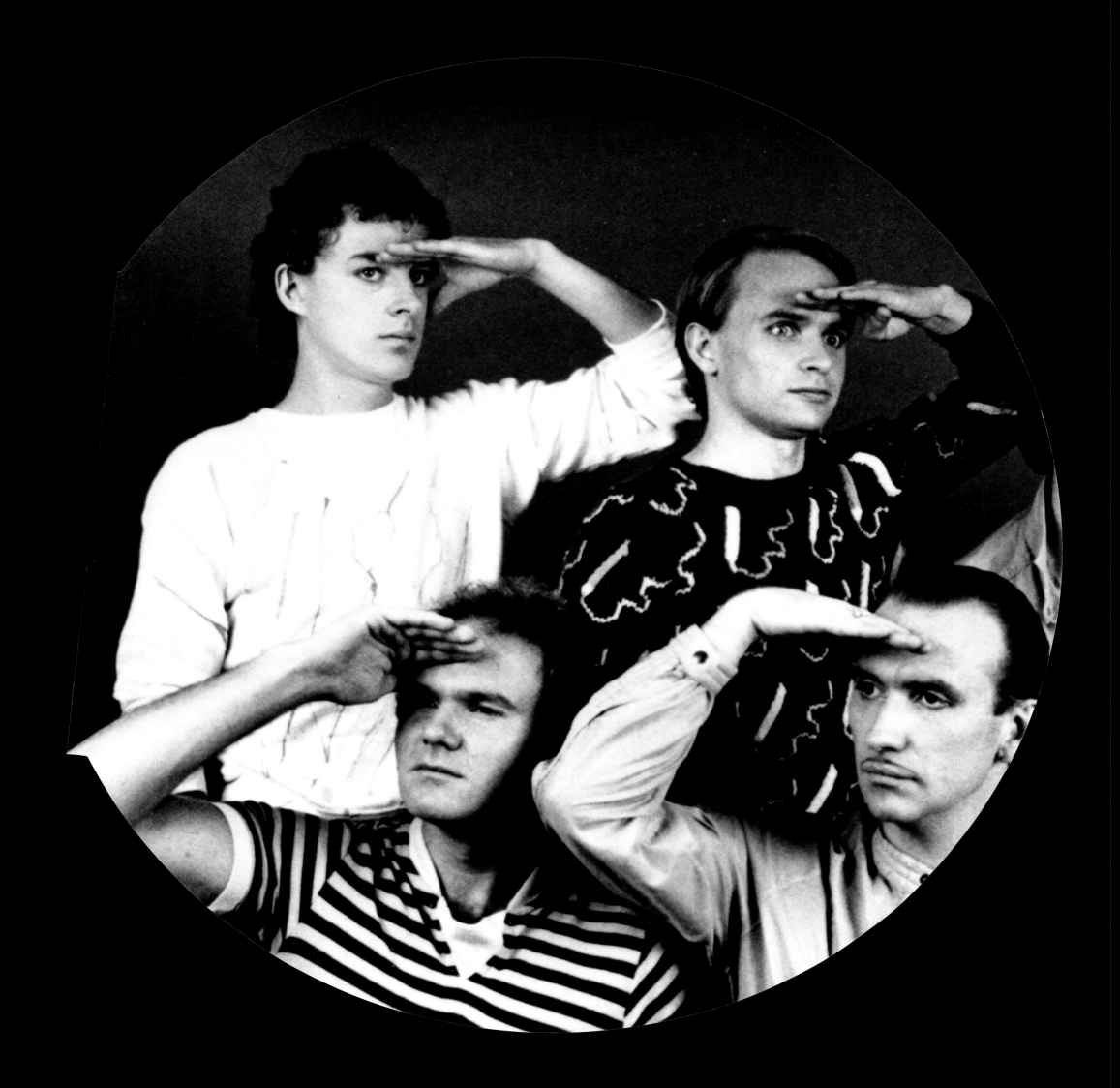

Toni Basil ▶

Toni Basil was born Antonia Christina Basilotta in Philadelphia. She was chiefly a choreographer but, in 1981, she signed to Chrysalis as a recording artist and cut her debut album, *Word of Mouth*. She was a one-hit wonder with her chart topping single *Mickey*. It was originally titled *Kitty* and recorded by the group Racey. Helped along by Basil's self-directed, cheerleader-themed video, *Mickey* hit number one in America. Follow-up singles, however, *Shoppin' From A to Z* and *Over My Head* only scraped the lower reaches of the charts, and her self-titled 1983 album was not a success and Basil returned to her earlier careers.

Huey Lewis and The News

Formed in San Francisco by Huey Lewis in 1979, the original members of Huey Lewis and The News included Sean Hopper, Johnny Colla, Mario Cipolina and Bill Gibson. In 1980, they released and recorded all the tracks for their self-titled debut album in three weeks. The follow-up, *Picture This* with the single *Do You Believe In Love*, which was supported by a video shot in LA, was a hit in the US. *Sports* was released in 1983 and included singles, *I Want A New Drug* (they later took legal action against Ray Parker, Jr., claiming his song *Ghostbusters* plagiarised *I Want a New Drug* – the suit was settled out of court), *The Heart of Rock And Roll*, *Bad is Bad*, *Finally Found A Home*, *If This Is It* and *You Crack Me Up*. *Sports* also featured a version of Hank Williams' *Honky Tonk Blues*, a remake of the standard *Heart And Soul* (which had a highly successful video), and *Walking On A Thin Line*, a song that sought solace for Vietnam Veterans. By the end of 1985, *Sports* had sold over 8 million copies. At the first annual MTV awards at New York's Radio City Music Hall, *The Heart of Rock and Roll* was nominated for Best Group Video. At the 1985 Grammy Awards, they were nominated for record of the year and best pop performance by a duo or group with vocal for *Power of Love* (from the soundtrack to the hit film *Back To The Future*). They won a Grammy Award for best music video, long form for *Heart of Rock and Roll* and as participants of USA for Africa's *We Are The World* recording. In 1986, *Power of Love* won an Academy Award for best original song from a movie category. The group's 1986 album *Fore!* contained the

Phillips. In 1995, they released *Tambu* and Kimball returned in 1999, although the subsequent *Mindfields* was disappointing.

very popular hits, *Stuck with You*, *Naturally*, *I Know What I Like*, *Hip to Be Square*, and *Whole Lotta Lovin'*. By the beginning of the 1990s, the appeal of their formula had decreased. The band continues to tour.

Irene Cara

Born in New York in March 1959, Irene Cara was part of a family of musicians and began performing at the age of five. By the early 1980s, she was an established and accomplished singer, actor and writer, and worked on Broadway and in film. Her performance of a cult member in the 1980 CBS docudrama 'The Guyana Tragedy' brought her critical acclaim in 1980. Cara contributed to the soundtrack album of *Fame*, a popular movie about students from New York's High School of Performing Arts that was later developed into a TV series. Her rendition of the title song, and *Out Here On My Own*, were immediate hits. Cara was a finalist in the Best New Female Artist and Best New Pop Artist categories in the 1980 Grammy Awards and the Golden Globes and won an Academy Award. She starred in *The Wiz* and in 1983 contributed to the *Flashdance* soundtrack. Her single *What a Feelin'* the movie's theme, was a top selling single in 1983. She won two Grammy Awards in 1983 for Best Vocal Performance for *What A Feelin'* and for her contribution to the *Flashdance* soundtrack.

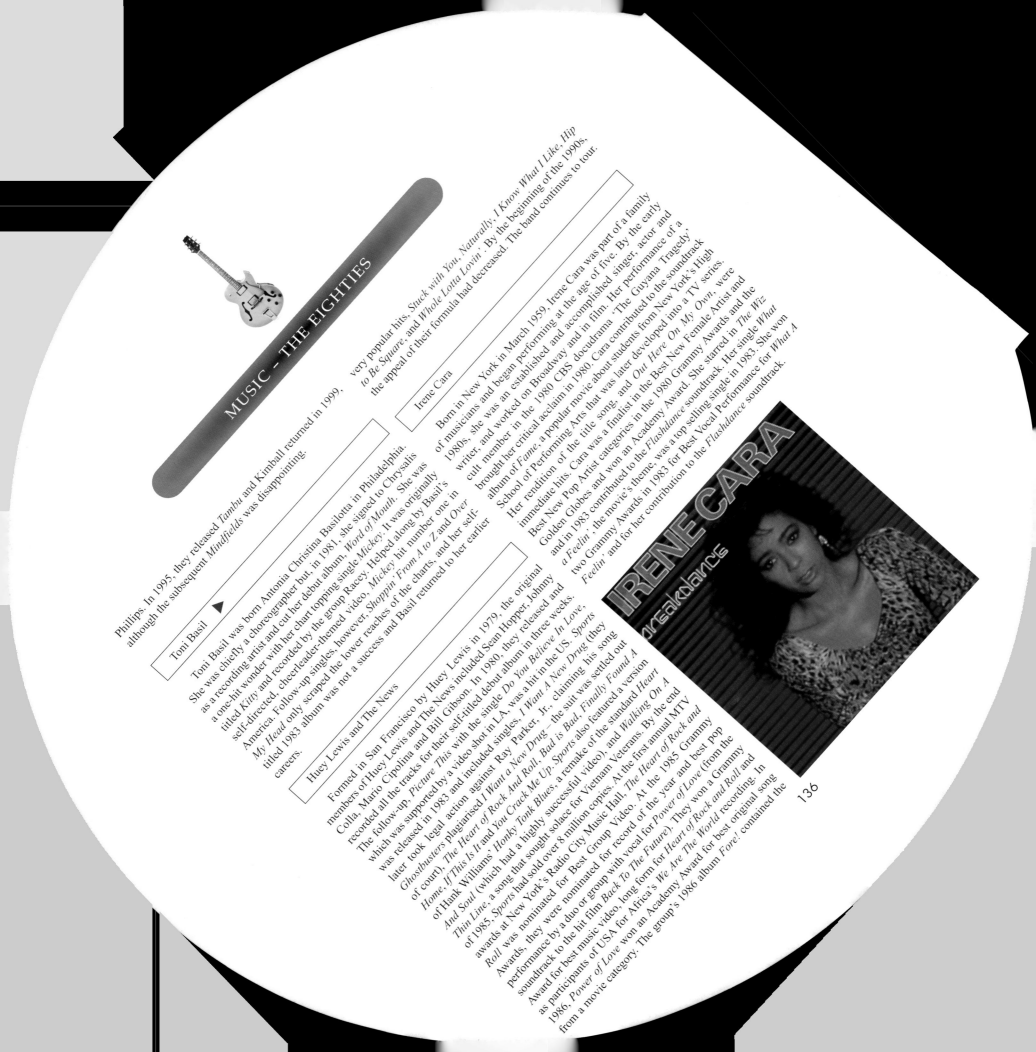

IRENE CARA
breakdance

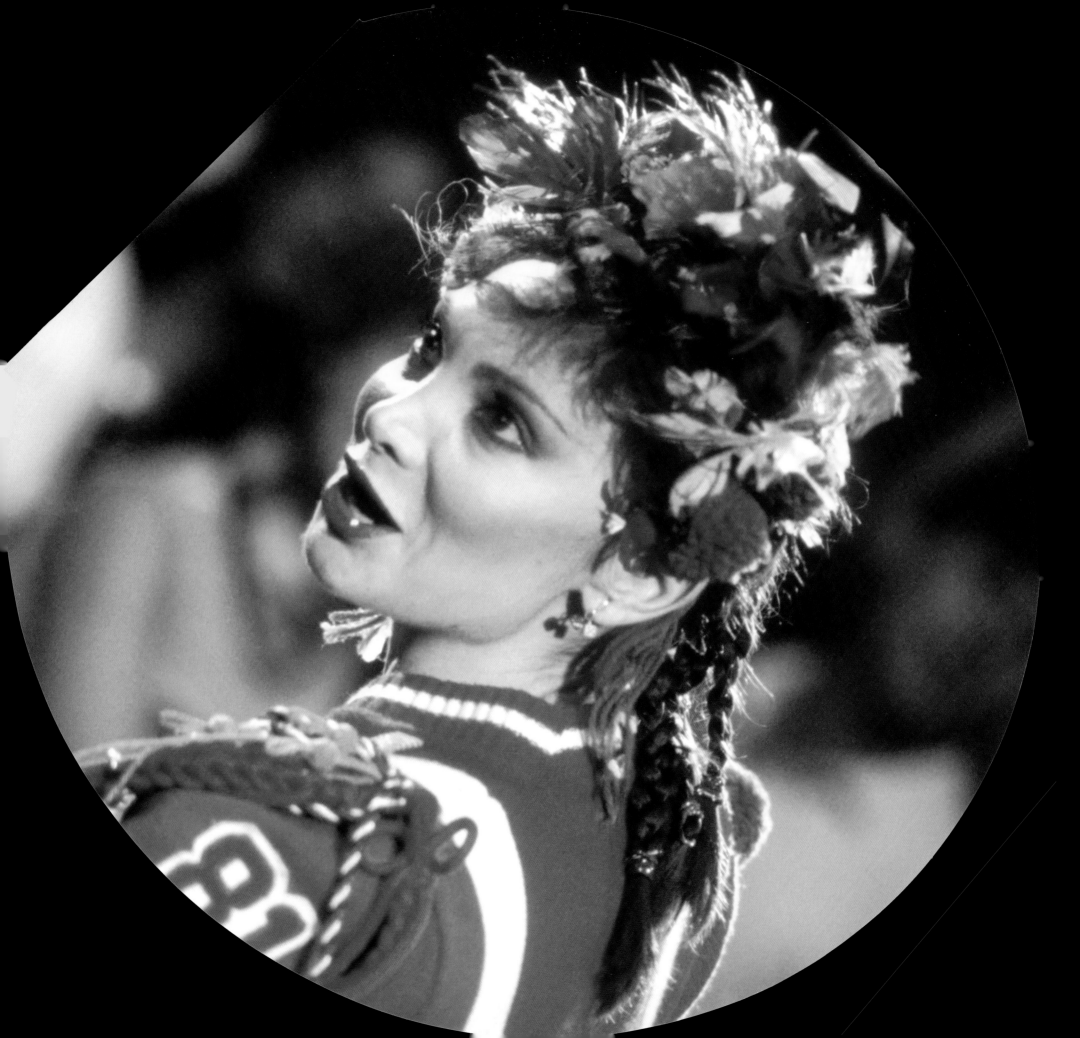

Michael Jackson

Michael Jackson was born in Gary, Indiana on 29 August 1958. As part of the Jacksons and as a solo artist, he became one of Motown's greatest successes. In 1971, Jackson's first solo single *Got To Be There* reached the top five. In 1972, he had an even bigger hit with his version of Bobby Day's *Rockin Robin*. Jackson also made the charts with a series of albums, *Ben*, *Got To Be There* and *One Day In Your Life*. With producer Quincy Jones, he recorded the extremely successful, *Off the Wall* in 1979. His duet with Paul McCartney, *The Girl Is Mine* was the first single issued from the album in 1982. The international bestseller, *Thriller* was released the same year and included *Billie Jean* and *Beat It* which was also a hit video on MTV. In 1983, Jackson again collaborated with Paul McCartney for *Say, Say, Say* and *The Man for* McCartney's album *Pipes of Peace*. *Thriller* was still at the top of the charts. Jackson dominated the 1983 Grammy Awards winning eight awards. In 1984 he concentrated on the Jacksons album *Victory* and the subsequent tour set attendance records across the US. Around this time he was contracted for do Pepsi-Cola commercials and during a taping was seriously burned. His next solo release *Bad* was issued in 1987 with the singles *I Just Can't Stop Loving You*, *Bad*, *The Way You Make Me Feel* and *The Man In the Mirror*. While preparing for his concert series *This Is It*, Jackson died of acute propofol intoxication on June 25, 2009, after suffering from cardiac arrest.

Culture Club

Formed in the early 1980s, Culture Club comprised Boy George (George O'Dowd), Jon Moss, Roy Hay and Michael Craig. During 1979, George and a friend opened the Foundry, a shop that sold cutting edge, fantasy apparel. After working briefly with Malcolm McLaren and in other bands, he formed a group with Moss and Hay. Initially, the publicity surrounding Culture Club focused on their clothes and George's androgynous appearance. Their music was soft, melodic rock that focused on escapism rather than the contemporary and more punk concerns with unemployment and other social problems. In 1982 they released the singles, *White Boy*, *I'm Afraid Of Me* and the hits *Do You Really Want To Hurt Me*, *Time (Clock of the Heart)* and *I'll Tumble For Ya* from their debut album *Kissing to Be Clever*. Their second release *Colour By Numbers* was issued in 1983 with its hits *Church of the Poison Mind* and *Karma Chameleon*. They won Best New Band at the 1983 Grammy Awards. In 1984 they released their third album *Waking Up With The House On Fire* amidst rumours about George's

Duran Duran

apparent drug problems. He has since overcome his addictions but the members of Culture Club went on to pursue separate musical interests. In 1987 a greatest hits package *This Time/The First Four Years* was released.

Named after a character in Roger Vadim's sex kitten sci-fi movie, Duran Duran formed in Birmingham, England in 1978. After many lineup changes, the new romantic group finally comprised Nick Rhodes (keyboards), John Taylor (bass, guitar), Andy Taylor (guitar), Roger Taylor (drums) and Simon Le Bon (vocals). Their debut single, *Planet Earth* was a hit in Europe in 1981. Other early hits included *Hungry Like the Wolf*, *Rio*, *Is There Something I Should Know* and *Union Of The Snake*, breaking into the US charts in 1983. Lead singer Simon LeBon became a popular pin-up boy among UK and US teens and the group achieved notoriety for its videos, particularly *Girls on Film* (produced by video makers, Godley and Crème) which was banned by BBC-TV and in the US by MTV. The album *Seven and the Ragged Tiger*, which included the hits *New Moon On Monday* and *The Reflex* reached number one in the UK in 1984. The live Arena included one studio single *Wild Boys* and a concert version of *Save A Prayer*. In 1985, Duran Duran's title track for the James Bond movie *A View To A Kill* became their second number one hit. After pursuing a variety of separate musical projects, Duran Duran appeared together at the US Live Aid Concert and released *Notorious* with the hit singles *Notorious* and *Skin Trade*. *Big Thing* featured *I Don't Want Your Love* and *All She Wants Is*. They made a comeback in 1993 with the singles *Ordinary World* and *Come Undone*. Their 1995 release *Thankyou* was an album of covers, including a version of Grandmaster Flash and the Furious Five's *White Lines (Don't Do It)*. Duran Duran have sold over 60 million records world-wide. They released the albums *Astronaut* in 2004 and *Red Carpet Massacre* in 2007.

Dexys Midnight Runners

Dexys Midnight Runners achieved their major success in the early to mid-1980s. Kevin Rowland (vocals, guitar) and Kevin 'Al' Archer (vocals, guitar) founded the band in 1978 in Birmingham, England, naming the band after Dexedrine, a recreational drug. 'Big' Jim Paterson (trombone), Geoff 'JB' Blythe (saxophone), Steve 'Babyface' Spooner (alto saxophone), Pete Saunders (keyboard), Pete Williams (bass) and Bobby 'Jnr' Ward (drums) formed the first line-up of the

138

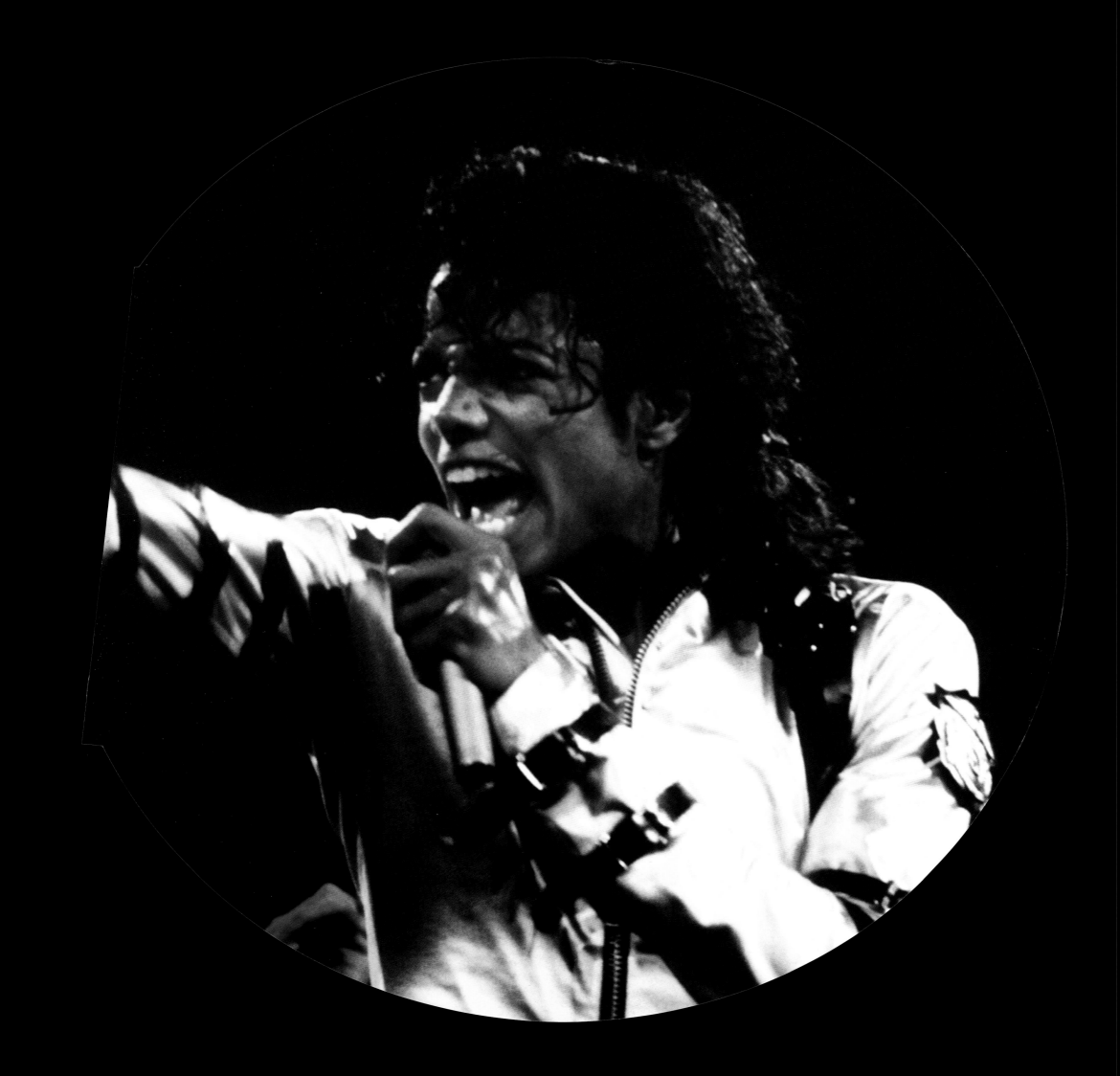

Adam Ant

Adam Ant was born Stuart Goddard on 3 November 1954 in London, England. He was the lead singer of the New Wave/punk rock band Adam and The Ants, which was formed in 1977 and comprised David Barbe a.k.a. Barboarossa (drums, percussion), Matthew Ashman (guitar, piano) and Andrew Warren (bass). Part of the new romantic movement of the early 1980s, they used their music as a component of an imaginary world with its own mottos like *Antmusic for Sexpeople* and vocabulary (fans were antpeople). Their music featured double-drum rhythms and yodeling. Adam and the Ants were promoted by Malcolm McLaren. McLaren left in 1980 and Adam Ant released *Dirk Wears White Sox*. McLaren, who worked on their debut album, *Dirk Wears White Sox*. McLaren, who worked on their debut album, *Dirk Wears White Sox*. McLaren, who worked on their debut album, and developed the Antpeople image for Rema guitarist, Marco Pirroni and developed the Antpeople image for the number one album *Kings of the Wild Frontier*. They produced several hit singles in the UK charts including *Ant Music* and *Dog Eat Dog*.

In 1981, *Prince Charming*, which was recorded with ex-Roxy music bassist Gary Tibbs, spent over six months on the UK charts. The Ants disbanded in 1982. Adam Ant's debut solo effort, the single *Goody Two Shoes* was a hit, and made the album *Friend or Foe* a top 20 album. Adam Ant pursued acting and made appearances in the movies *World Gone Wild* and *Slam Dance*, along with TV series 'The Equaliser' and 'Northern Exposure'. Following a 1993 comeback tour, Adam Ant made several live appearances with group Nine Inch Nails. This led to the production of the album *Wonderful*.

Phil Collins

Born in London on 30 January 1951, Phil Collins joined the progressive rock group Genesis in the early 1970s. Peter Gabriel left Genesis in the mid-1970s after recording *Lamb Lies Down On Broadway* and the follow-up tour. After much deliberation, Collins was chosen to replace him as the lead singer. By 1981, Collins had embarked on a solo career and his debut *Face Value* featured the top 20 singles *I Missed Again* and *In The Air Tonight*. He continued writing and performing for Genesis who had a hit with, *Abacab*, *Hello I Must Be Going* was another bestselling solo album, which included a cover of the Supremes' *You Can't Hurry Love*. Collins wrote and recorded the theme for the movie *Against All Odds* and the single *Against All Odds (Take A Look At Me Now)* was nominated for an Academy Award. He produced a solo album for Frida from ABBA and played drums on Robert Plant's *Pictures At An Exhibition*. He released *No Jacket Required* in 1985 with the hit single *One More Night*. Collins began 1988 by acting in the movie *Buster*, in which he starred as train robber Buster Edwards. His rendition of *A Groovy Kind of Love* for that movie reached Number One on the charts. He also had a cameo role in 'Miami Vice' and guest starred in some sketches with 'The Two Ronnies'. In 1989, Collins produced another hugely successful album, *...But Seriously...* which featured the anti-homelessness anthem, *Another Day In Paradise*. The song went to Number 1 on the Billboard US Charts and won Phil Collins a 1990 Grammy Award for Record of the Year. Collins left Genesis in 1996 and formed the Phil Collins Big Band which did a world tour in 1998.

band to record the single, *Dance Stance* in 1979. The next single, *Geno* was a British number one in 1980. It featured the band's newest recruits, Andy Leek (keyboards) and Andy 'Stoker' Growcott (drums). Relationships between band members were very volatile and the band broke into several factions some of whom became successful in new ventures. Rowland made some changes and a new line-up recorded *Too-Rye-Ay* in 1982 with the international hit *Come on Eileen*. After a two-year break, Dexys Midnight Runners returned in 1985 with the critically acclaimed album, *Don't Stand Me Down*. The group disbanded the following year after a brief return to the charts with the single *Because Of You*.

140

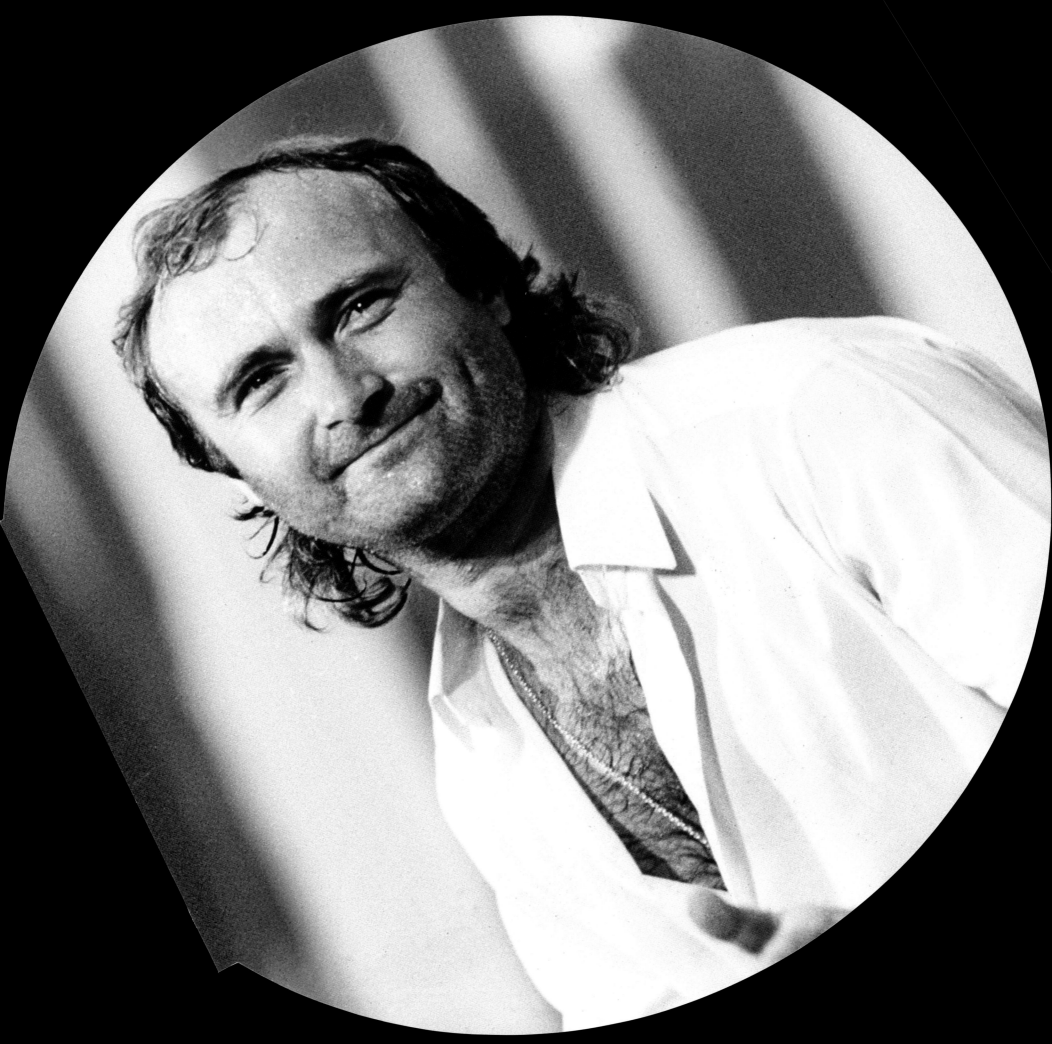

Madness

Formed in Camden, London in 1976, the pop/ska band Madness were named after a favourite Prince Buster ska song and came to prominence in 1978 as part of a ska revival in the UK. After a series of line-up changes, the group became Lee Thompson (sax), Chris Foreman (guitar), Mike Barson (keyboards), Dan Woodgate (drums), Mark Bedford (bass) Graham 'Suggs' McPherson (vocals) and Chas Smash (MC, steps, trumpet). In 1979, Madness recorded the album *One Step Beyond* and the hit single *Baggy Trousers*. The 1980 follow-up, the title track was a hit. The 1980 follow-up album *Absolutely* included the hit single *My Girl*, *Work, Rest and Play*; singles from this period included *Embarrassment*, *The Return of the Los Palmas Seven*, *Grey Day*, and *Shut Up* revealed lyrics that spoke for Cockney youth. In 1981, Madness produced *Take It Or Leave It* which was a film (in which they played themselves) about starting a group. Their album *7* included *It Must Be Love*, *Cardiac Arrest* and their first number one UK single *House of Fun*. Throughout this period they released *Driving in My Car*, *Our House*, *Tomorrow's (Just Another Day)*, *Wings of a Dove* and *The Sun and Rain*. These hits were promoted by lively videos. Throughout the mid-1980s, Madness had a run of hits. *Michael Caine*, *Yesterday's Men* and *(Waiting for) The Ghost Train*. In 1986, they disbanded, although several members regrouped later on. Thompson and Foreman continued as the Nutty Boys and Woodgate joined Voice of the Beehive. McPherson went into management before releasing a solo album *The Lone Ranger*, in 1995. They reunited each year for 'Madstock' in London's Finsbury Park. In 1998 they had a tour and that same year released *Wonderful*, which contained the hit single *Lovestruck* and was their first album of originals for over a decade. In 2006, Madness began working on their next original album.

ABC

Formed in 1980 in Sheffield, England, ABC were a white, neo-soul group comprising Martin Fry (vocals), David Robinson (drums), Mark White (guitar, Keyboard), Mark Lickley (bass) and Stephen Singleton (sax). Fry produced a music fanzine, *Modern Drugs* and interviewed White and Singleton about their electric rock band, Vice Versa. They subsequently asked him to join the band and they became ABC. The group recorded *Tears Are Not Enough* and released it on their own record label Neutron Records. A British Top 20 hit in 1981, it was followed by a series of songs about romance and worldly fatalism: *Poison Arrow*, *The Look of Love*, and *All of My Heart* from the album *Lexicon of Love*. The hit songs were bolstered by evocative music videos. A follow-up album *Beauty Stab*, released in 1983, was harder-rocking and produced only one hit *That Was Then but This is Now*. With female percussionist Eden and American keyboardist David Yarritu replacing David Palmer and Stephen Singleton, ABC adopted a cartoonish image and in 1985 released *Zillionaire*, ABC released *Be Near Me* and *(How To Be A) Millionaire*. Shortly after, Fry was diagnosed with non-Hodgkin's lymphoma. ABC released *Alphabet City* in 1987, which featured their biggest hit the Motown tribute *When Smokey Sings*. Fry left the band after the release of *Up*. He made a full recovery from his illness and was back onstage in 1997. A new lineup of ABC featuring Fry, released *Skyscraping* and the live album *Lexicon of Live* and toured the US in 1999.

Talking Heads ▲

Formed in 1975 in New York, the rock band Talking Heads were fascinated by the rhythms and spirit of black music and ultimately produced a prolific collection of original and danceable new wave music. The band comprised David Byrne (vocals, guitar), Chris Frantz (drums), and Tina Weymouth (bass, synth), and they played their first shows at CBGB in 1975. Jerry Harrison (keyboards, guitar) joined the group in 1977 and they toured with The Ramones. Their first album, *Talking Heads: 77*, contained the well-known *Psycho Killer*. With the release of *More Songs about Buildings and Food*, Talking Heads began collaborating with producer Brian Eno. The album featured a cover of Al Green's *Take Me To The River*. *Fear of Music* followed and 1980's *Remain in Light* used rhythm tracks and a blend of African vocals and Western technology. Following a world tour, the group began to pursue solo projects. In 1983, they released *Speaking in Tongues*. It was their highest charting album and included their biggest hit *Burning Down The House* which had a video that was regularly played on MTV. Their subsequent tour was documented in the 1984 movie *Stop Making Sense*. In 1985, they released *Little Creatures*, with the hit tracks *Road to Nowhere* and *Stay Up Late* (an ode to parenting). In 1986, Byrne directed the feature film *True Stories*. The soundtrack album elicited a hit single *Wild Wild Life*. *Naked* was produced in 1988 and Talking Heads disbanded in 1991. The four original members reunited in 1999 for to release an anniversary

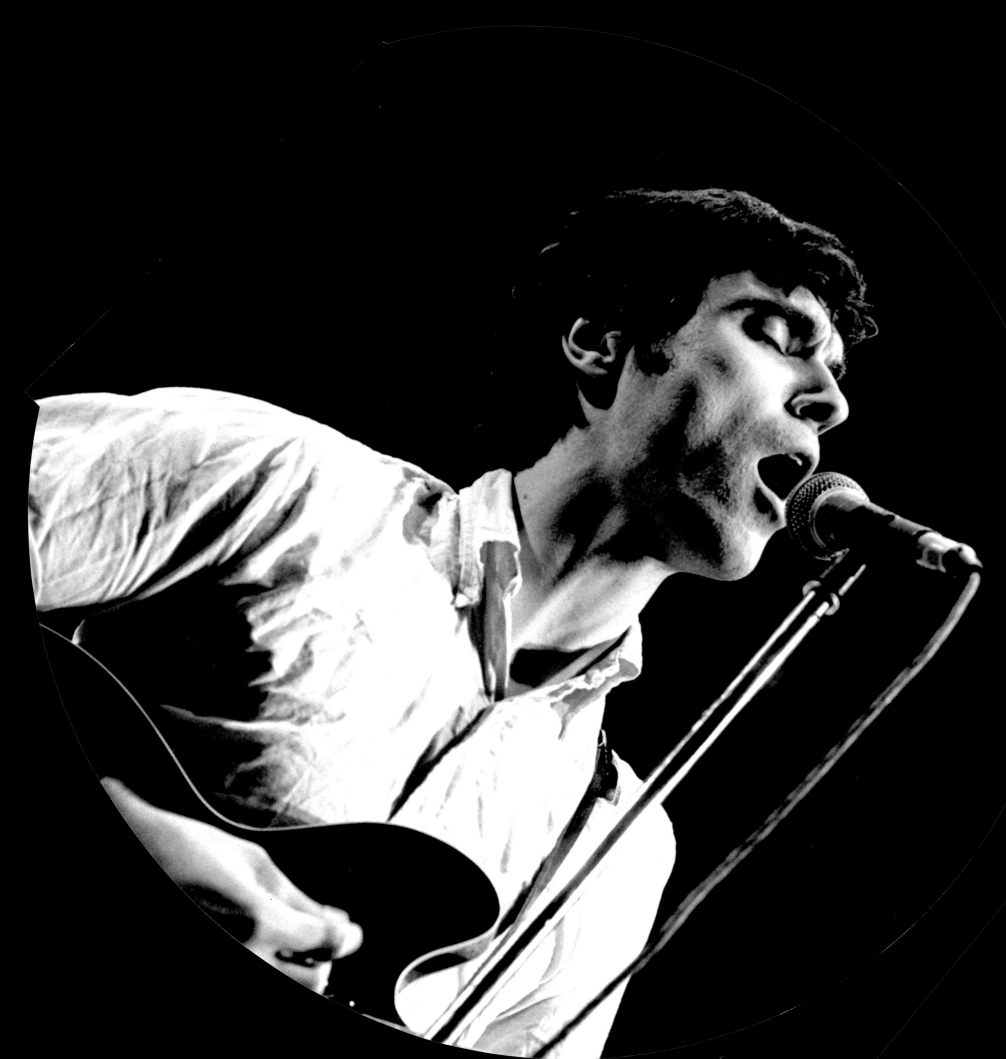

addition of *Stop Making Sense*.

Wham! ▲

Formed in 1981, London, Wham! comprised George Michael (born Georgios Kyriacos Panayiotou, 25 June 1963) on vocals, and Andrew Ridgley (born 26 January 1963) on guitar. Wham! are remembered for the upbeat dance tracks and vibrant video clips. Their debut album *Fantastic* entered the UK chart in 1984 and featured an energetic video. *Wake Me Up Before You Go Go* was an instant hit in 1984 and featured an energetic video. As a counterpoint, the ballad *Careless Whisper* was also released at this time. Wham!'s follow-up *Make It Big* included the hits *Everything She Wants*, *Freedom* and *I'm Your Man*. They split in 1986, the year of their third album, *Music From the Edge Of Heaven*. George Michael went on to pursue a successful solo career. Andrew Ridgley released an album *Son of Albert* in 1990, married Keren Woodwood from Bananarama and became an environmental activist.

Billy Ocean

Born Leslie Sebastian Charles on 21 January 1950 in the West Indies, Billy Ocean is a UK-based popular music performer who had a series of rhythm and blues tinged hits throughout the 1970s and 1980s. In his teenage years, Ocean performed in London clubs and he released his first single in 1974 under the alias Scorched Earth. His musical career broke in 1976 with the Motown-style *Love Really Hurts Without You*, a major hit in the UK and US. In 1984, he released *Caribbean Queen (No More Love on the Run)* which was a number one hit from the album *Suddenly*. Major hits throughout the 80s included *Loverboy*; *Suddenly*; *When the Going Gets Tough, the Tough Get Going*, (which was used in the movie *The Jewel of the Nile*), *Love Zone* and *Get Outta My Dreams*, *Get Into My Car* and *The Colour of Love*. His later albums, such as *Time to Move On*, *L.I.F.E.* and *Showdown*, failed to elicits hits, but his 1989 *Greatest Hits* collection has remained a steady seller over the years. He continued to record into the 1990s.

144

Sheila E.

Born in California on 12 December 1957, singer, percussionist and violinist, Sheila Escovedo (better known as Sheila E.) is the daughter of percussionist Pete Escovedo. She made her debut with jazz pianist George Duke and had performed with Lionel Richie, Marvin Gaye, Herbie Hancock and Diana Ross by the time she was in her early 20s. She became a Prince protégée in 1984 and scored major hits with *The Glamourous Life* and *Love Bizarre*. Sheila E. was nominated for American Music and Grammy Awards for *The Glamourous Life* and *Love Bizarre*. Sheila E. was nominated for American Music and Grammy Awards for *The Glamourous Life* and 1985, she recorded *The Glamourous Life*, *Romance 1600* and *Sheila E* under Prince's direction. She appeared in two movies, *Krush Groove* with Run-DMC, LL Cool J and Blair Underwood and *Sign 'O' the Times* and *Lovesexy* period of Prince's career. During the Prince organisation in 1989, Sheila recorded a few more albums, percussionist and musical director in his backup band. After leaving the Prince organisation in 1989, Sheila recorded a few more albums, *Sex Cymbal*, *Writes of Passage* and *Heaven*. Sheila E. is the aunt of socialite Nicole Richie and business partner of singer and former Bride of Funkenstein, Lynn Mabry. They formed a foundation for abused children called the Lil Angel Bunny Foundation.

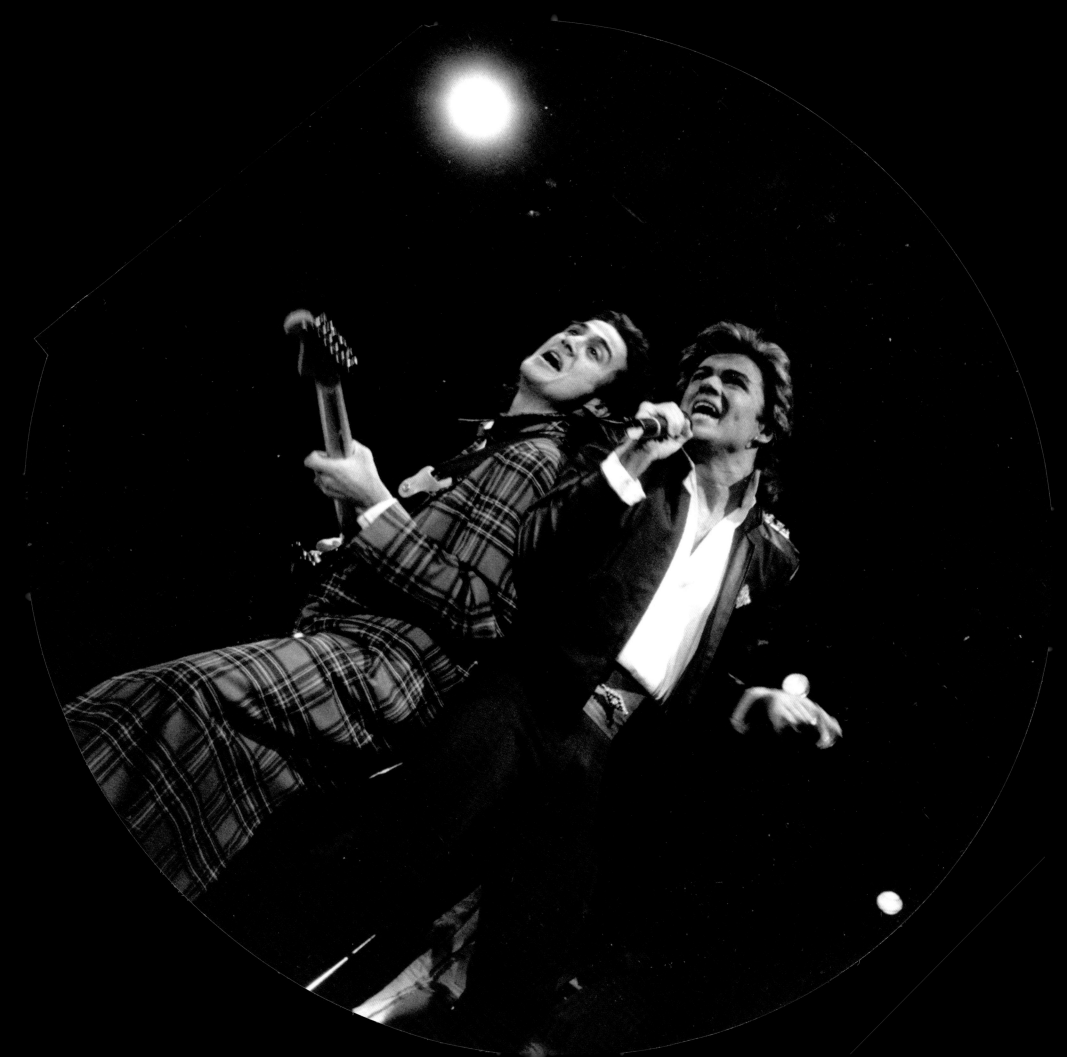

THE EUROPEAN INFLUENCE

▶ Mireille Mathieu

Mireille Mathieu was born in Avignon, France on 22 July 1946, the oldest of 14 children. With her haunting voice she is one of France's most successful singers and has also had huge international success, recording in several languages. Her career has spanned over 40 years, during which she had sold around 150 million copies of her albums and sung duets with stars including Charles Aznavour, Plácido Domingo, Julio Iglesias and Tom Jones.

Mathieu was discovered by Johnny Stark, the manager of Johnny Hallyday. Stark encouraged her to take singing, dancing and language lessons. In 1965 she appeared on French television and debuted at the Paris Olympia. Her first singles *Mon Credo* and *C'est Ton Nom* were hits and propelled her to stardom in France and across Europe. She also became popular in the UK, breaking the ground with a French version of Engelbert Humperdinck's *The Last Waltz* and following up with subsequent hits.

She set off on a tour of Canada and the United States, where she appeared on the Ed Sullivan Show, the nation's most popular television programme, and she became a household name, cementing her celebrity status with an appearance on the Danny Kaye Show. In Las Vegas, she sang with legendary crooners Dean Martin and Frank Sinatra.

Mathieu's repertoire included both originals and covers, and French versions of English-language songs. Some of her original titles were composed by the best French writers, like Jacques Revaux, Pierre Delanoë, Claude Lemesle and Eddy Marnay, giving her the wonderful *Tous les enfants chantent avec moi* and *Milles colombes*, as just two examples of many. Her friend Charles Aznavour also wrote several songs for her, such as *Encore et encore*. Meanwhile, she made some memorable covers, notably her French version of Roy Orbison's *Blue Bayou* and Barbra Streisand's *Woman in Love*. Her trademark songs include *Ne me quitte pas*, *Acropolis adieu* and *Santa Maria de la mer*. An enduring French icon, in 1989, French President Mitterrand invited Mathieu to sing at a tribute to General de Gaulle. She has also been invited to sing at some of the most famous venues around the

world, particularly Carnegie Hall in New York, the Universal Amphitheatre in Los Angeles, the Sport Palace in Montreal, and the Ice Palace in St Petersburg. In May 2005, Russian president Vladimir Putin even invited her to perform in Moscow's Red Square in a concert marking the 60th anniversary of the end of the Second World War. Furthermore, she was the first western singer in history to perform concerts in China.

In 1993, Mathieu produced an album devoted to her idol, the French singer Edith Piaf. Then in 1996, she produced *Vous lui direz…* which she promoted on a tour to the United States, and dedicated her performance to another of her idols, Judy Garland. In December 1997, she had the rare honour to sing at the Vatican in a Christmas concert broadcast world-wide.

In 2005, Mathieu released her 38th French album, entitled simply *Mireille Mathieu*, and that same year celebrated the 40th anniversary of her career at the Paris Olympia. The 'Demoiselle d'Avignon' continues to perform regularly and has a following all round the world.

Patricia Kaas

The French singer and actress Patricia Kaas was born on 5 December 1966 in Lorraine, France, to a German mother and French father. She is one of the world's most successful French-speaking singers, blending French chanson with jazz and pop music. Kaas has sold more than 14 million records, and is popular not only in France, but globally, particularly in Germany, Russia, Finland and Korea. She tours prolifically and in 2002 made her movie debut when she played a jazz singer alongside Jeremy Irons in *And now… Ladies and Gentlemen*.

Singing from a young age, she started her professional music career at the age of 13 under the name *Pady Pax*, after the brass band *Pax Majorettes* from Stiring-Wendel where she grew up. She also sang for several years with the band *Dob's Lady Killers*.

In 1985, French actor Gérard Depardieu produced Kaas' first single

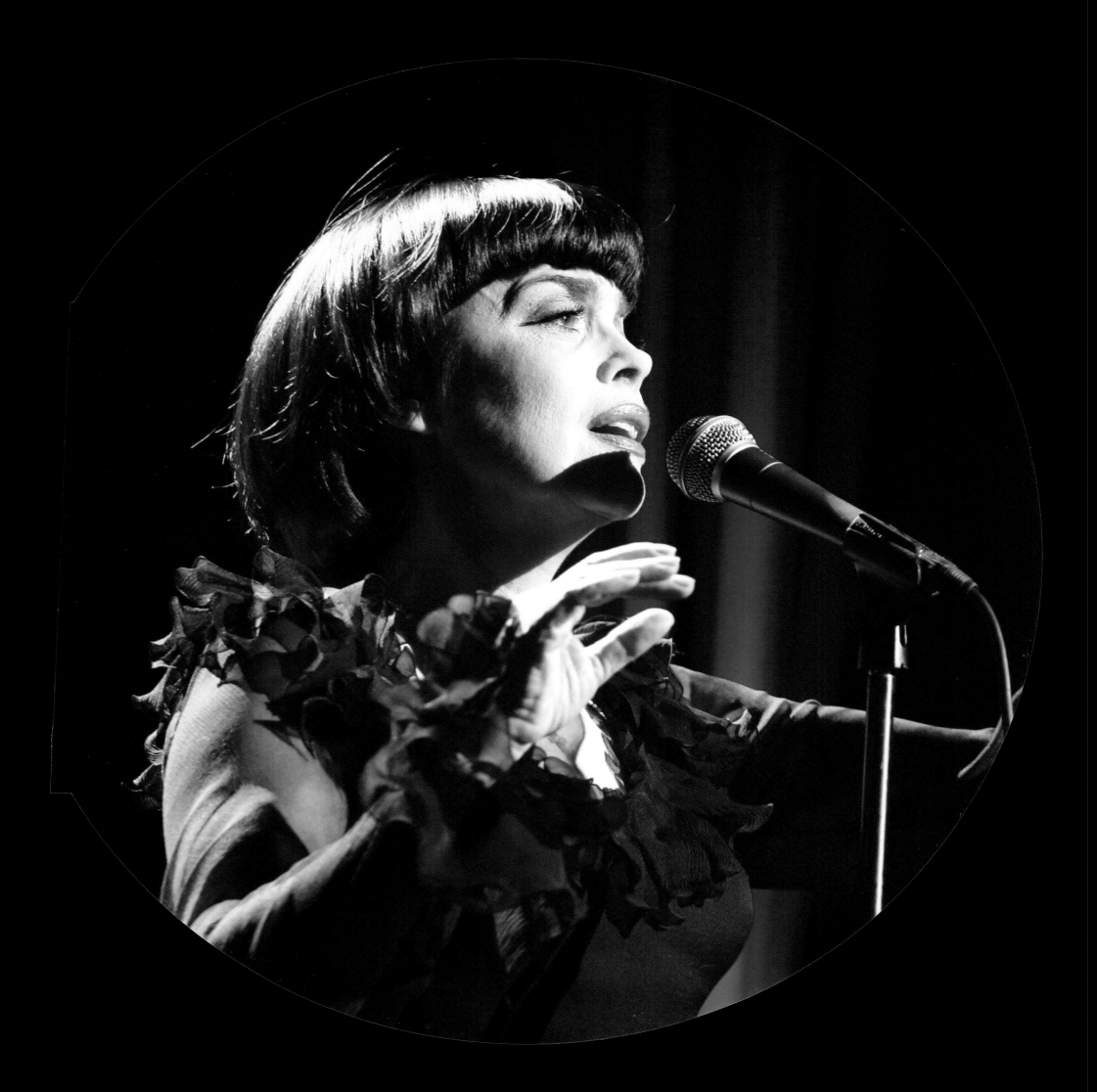

Indochine ▶

Jalouse, which flopped. Kaas first hit came in 1987, written by Didier Barbelivien, entitled *Mademoiselle chante le blues*. The following year she had her second hit, *D'Allemagne*. Her 1988 debut album *Mademoiselle chante...* went diamond in France, platinum in Belgium and Switzerland, and gold in Canada. Her smoky voice had her compared to Édith Piaf and Marlene Dietrich.

Kaas set off on her first world tour in 1990, lasting 16 months and covering 12 countries. Her 1990 album *Scène de vie* went diamond, staying at the top of the French charts for 10 weeks. Also in 1990 and 1992 she received the Golden Europa, an important music award in Germany.

Her 1993 album *Je te dis vous* was produced in London. It included her first song in German, *Ganz und gar* (*Absolutely*) and three tracks in English, including a cover of James Brown's *It's A Man's World*. It sold over three million copies world-wide and was her third album to go diamond. The single *Il me dit que je suis belle* achieved her first top 10 single in France.

She then produced the album *Black Coffee*, specifically for the American market with English lyrics. The title track is a cover version of the Billie Holiday song of the same name Other cover versions include 1970s hits *Ain't No Sunshine* (Bill Withers, 1971) and *If You Leave Me Now* (Chicago, 1976).

In December 1998 Kaas sang with the famous tenors Plácido Domingo and Alejandro Fernández in Vienna's Guildhall, accompanied by the Vienna Philharmonic Orchestra. Staying with the classical theme, on her 1999 album *Le mot de passe*, Kaas was accompanied by an orchestra on several tracks. Later that year, she took part in at the *Michael Jackson & Friends* charity concert in Seoul and Munich, alongside Status Quo, Luther Vandross and Mariah Carey, and broadcast to 39 countries.

In 2005 Kaas embarked on her seventh world tour, performing in 175 concerts in 25 countries, including China and Russia. Accompanying the tour was the live album *Toute la musique...* and a 'best of' album. The title track *Toute la musique que j'aime* was written by the French singer Johnny Hallyday. The album also has a bonus track *Herz eines Kämpfers* (*Heart of a Fighter*), which Kaas produced with Peter Plate of German pop band Rosenstolz. The French-speaking star continues to travel internationally and to attract huge audiences with her impressive stage performances.

Indochine (French for Indochina) is a French new wave/rock band which had its heyday in the 1980s in France and across Europe and has recently made a resounding comeback. The band was formed in May 1981 by Nicola Sirkis and Dominique Nicolas in Paris, later adding more members - Dimitri Bodianski and Nicola's twin brother Stéphane. They have been likened to a French version of the British band The Cure. Their trademark songs include *L'Aventurier*, *Tes Yeux Noirs* and *Canary Bay*. The group's line-up has changed over the years, with only Nicola Sirkis remaining from the original members. After a quiet period in the 1990s, the band has re-established itself with chart-toppers and international concerts in the 2000s.

Indochine's first ever concert was at a café in Paris in September 1981, which resulted in their first contract with a record company. Their first single later that year featured two songs *Dizzidence Politik* and *Françoise*, but only reached *L'aventurier*. Both the public and the press were impressed, and it sold more than 250,000 copies. Their second album, *Le Péril Jaune*, was released the following year, and was also well received. In 1984 they toured France, and by 1985, with songs like *3e sexe* (third sex), *Canary Bay* and *3 Nuits Par Semaine*. they had a loyal following, and their third album, entitled simply, *3*, sold 750,000 copies in Europe.

The fourth album, *7,000 Danses*, was released in 1987 amid concerns in the music industry that Indochine were too similar to the British band The Cure. With the album also intended to be less mainstream, it sold less well than *3*, although the true fans remained loyal.

In March 1988, Indochine embarked upon their first world tour. After several months of touring, the band took a break, and the saxophonist Bodianski chose to leave the group, as he found that he had less to do as the music style evolved, as well as citing personal reasons. Since his departure he has sometimes guest-starred with the band on stage. Their next studio album *Le Baiser* was released in early 1990, without Bodianski's input.

Le Birthday Album was released in 1991 to mark the band's tenth anniversary. A 'best of' compilation, it including one new track, *La Guerre Est Finie*, which was released as a single. However, the timing proved unfortunate as the Gulf War had just started, so radio stations erred on the side of caution and chose not to give it air time.

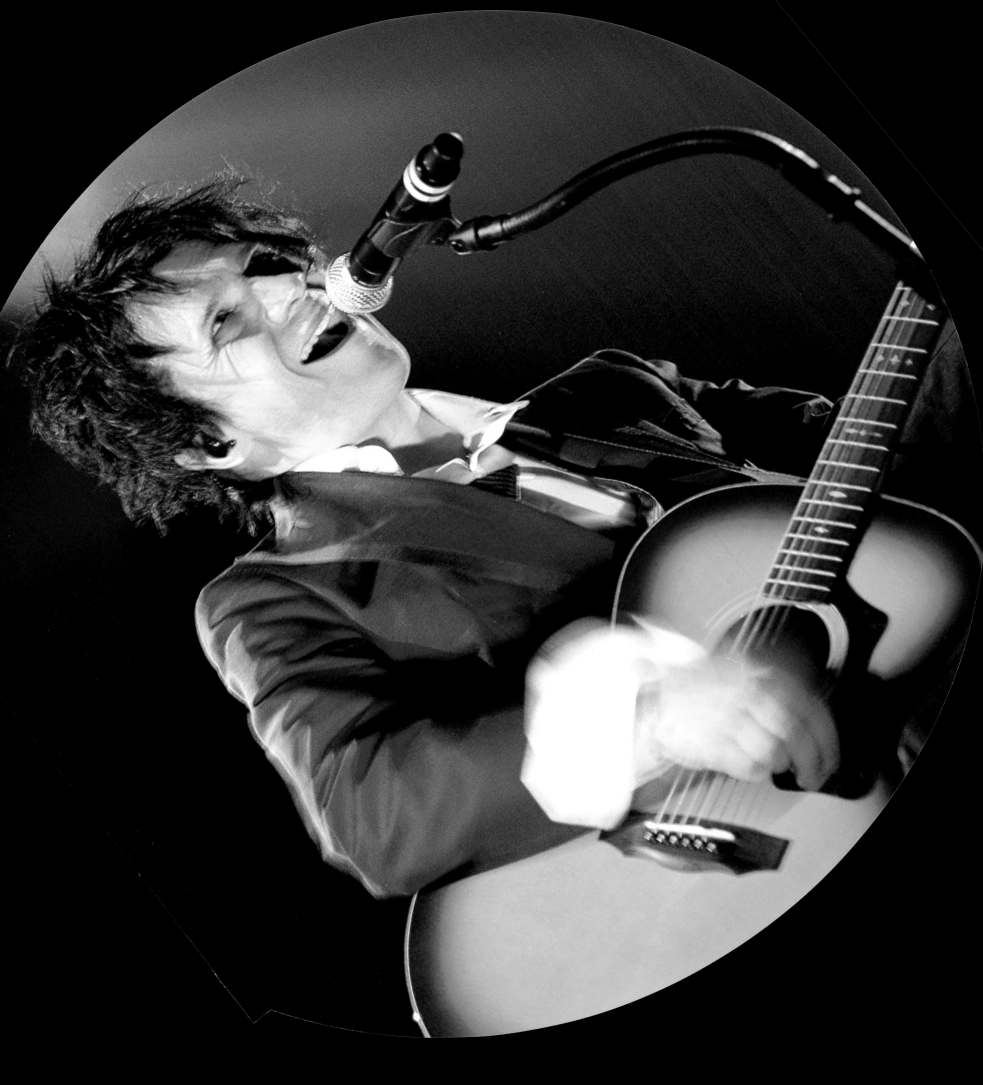

Nevertheless, the album was successful, selling 600,000 copies across Europe.

Their sixth studio album, the 1993 *Un Jour Dans Notre Vie*, did not do well, either with critics or fans. The band then did very little for the rest of the 1990s.

Indochine made a comeback in 2002 with their *Paradize* album which sold one million copies. It featured the hit single *J'ai Demandé à La Lune*. Back in the limelight, they started working with eminent musicians of the day. Their 2005 album *Alice Et June* features a track called *Pink Water*, recorded with Brian Molko from British band Placebo. There is also a track with French nu metal band AqME and another with Les Wampas, a French punk band.

In June 2006, Indochine played a concert in Hanoi Opera House to celebrate their 25th birthday. Current members are: Nicola Sirkis (vocals, guitar, synthesizer and harmonica), Marc Eliard (bass), Boris Jardel (guitar), François Soulier (drums), François Matuszenski (keyboards), and Olivier Gérard (keyboards and guitar).

Eddy Mitchell

The French singer and actor Eddy Mitchell was born Claude Moine on 3 July 1942 in Paris. He started his career as a teenager with the group Les Chaussettes Noires (The Black Socks) in the late 1950s, before going solo in 1963, his main inspiration coming from American rock and roll. 'Monsieur Eddy', the French daddy of rock and roll, made America his second home, while also remaining true to the tradition of the French chanson genre.

Les Chaussettes Noires were an almost instant success, releasing six singles and selling two million records in 1961 alone, the best-selling single being *Daniela*. Claude Moine then became Eddy Mitchell and in 1962 recorded a solo four-track EP, *Mais reviens-moi*. He went to London to record with English musicians, including guitarist Jimmy Page. In 1963 he released the album *Eddy in London*, with cover versions of hits by his rock and roll heroes Bill Haley, Gene Vincent, Elvis Presley and Eddie Cochrane. In 1964 he produced two more solo albums *Panorama* and *Toute la ville en parle, Eddy est en ville*, the latter of which was his first recording of his own original material.

His next material reflected the soul genre, in the 1965 album *Du rock 'n' roll au rhythm 'n' blues*. Around this time, the yéyé trend had arrived, but Mitchell was not interested. He continued to record in London, producing *Seul* in 1966 which included the later hit *J'ai oublié*

de l'oublier. He then followed his dream of recording in America, producing *De Londres à Memphis* in 1967 and the hit *Alice*, before returning to appear at the Paris Olympia.

His career then seemed to falter as his albums fell out of favour, until 1974, when the record company Barclay re-released some of Les Chaussettes Noires' hits. They sold so well that the band thought about re-forming. Mitchell refused and continued to record in Nashville, his album *Rocking in Nashville* going to number one in France for several weeks.

He toured France in 1976 and then produced albums at a rate of roughly one every year. His 1980 album *Happy Birthday*, featuring his signature tune *Couleur menthe à l'eau*, commemorated 20 years in the music business and sold 500,000 copies. In the early 1980s, he produced *Racines*, his most accomplished album, for which he received the Académie Charles Cros award. It included *Nashville ou Belleville* and *Comme quand j'étais môme*.

During the 1980s and 1990s he also indulged his interest in cinema and television. He won a César for his role in the movie *Le bonheur est dans le pré*, and in 1996 won the Oscar de la Chanson française. He pleased his fans in 1998 by performing a series of intimate concerts in Paris.

Mitchell's 1999 album, *Les Nouvelles aventures d'Eddy Mitchell*, was a fusion of his older music style with the trends of the 1990s. It features rock and roll and Cajun sounds from New Orleans, rhythm 'n' blues from Memphis, and soaring violins and crooning from Los Angeles.

After more than 40 years in the business, his 2003 album *Frenchy* topped the French charts. The track *Au bar du Lutétia* was a tribute to Mitchell's friend, the late Serge Gainsbourg. He then returned to the Louisiana influence for the 2006 album *Jambalaya*, featuring composers Pierre Papadiamandis, JP Nataf, Art Mengo and Henri Salvador, and American singers Little Richard and Beverly Jo Scott. His friend Johnny Hallyday sang on the duo *On veut des légendes*.

Sacha Distel

The world famous French crooner Sacha Distel was born in Paris on 29 January 1933, the son of a Russian father and French mother. He is best remembered for the hits *Raindrops Keep Falling On My Head*, *Scoubidou* and his French version of Stevie Wonder's *You Are the Sunshine of My Life*. Over his career he worked with many legendary musicians and singers, among them Dizzy Gillespie, Tony

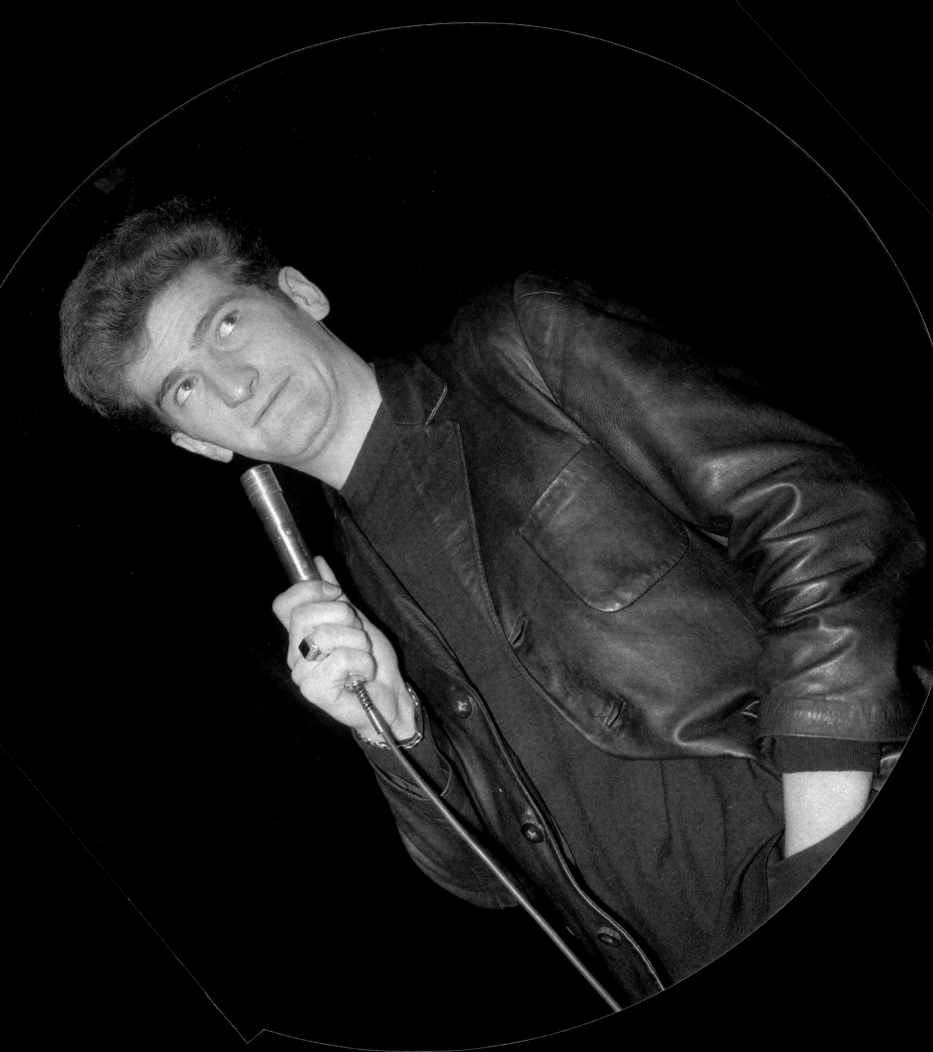

THE EUROPEAN INFLUENCE

Andrea Bocelli ▶

Bennett, Liza Minelli and Dionne Warwick. With his good looks, French masculine charm and soft voice, combined with musical talent, he was popular across the generations and had enduring appeal in Britain and America, as well as France.

Distel's uncle was Ray Ventura, one of the top bandleaders in France in the 1940s and 1950s. Ventura encouraged him to take guitar lessons with the famous guitarist and composer Henri Salvador. Distel excelled, and became a professional jazz guitarist aged 16. Distel played with the Modern Jazz Quartet, and several jazz greats, including Dizzy Gillespie, Lionel Hampton and Miles Davis, and appeared on The Ed Sullivan Show in the late 1950s.

Distel then turned to singing in 1958. After a short but much-publicised romance with actress Brigitte Bardot, his face became well-known in France. One of his first singles *Brigitte À Jamais* was a tribute to Bardot. That year, his singing career took off with his hugely popular French version of an American hit *Scoubidou*, adopted by the youth of France. He followed up this success with many more songs, including *O Quelle Nuit*, *Le Boogie Du Bébé*, *Scandale Dans La Famille*, *Ces Mots Stupides* and *L'Incendie À Rio*.

In 1964, Distel composed *La Belle Vie*, which was most famously performed by Tony Bennett and Frank Sinatra as *The Good Life*. *La Belle Vie* became Distel's signature tune. Then in 1967, he covered Stevie Wonder's *You Are the Sunshine of My Life* with Bardot, as *Le Soleil De Ma Vie*. In 1971, his French version of Burt Bacharach's *Raindrops Keep Falling On My Head* became an international hit for Distel.

His great singing successes launched him as a television music-show host, heading the Sacha show for several years. During the 1970s, while his singing career flagged, he continued to enjoy huge popularity. He spent a lot of time in Britain, and even hosted the Miss World contest in London. He also appeared regularly on French television and did some film acting. He also returned to his first love, the guitar, recording the albums *Ma Première Guitare* and *Ma Guitare and All That Jazz*.

In 2001, Distel appeared as Billy Flynn in the London production of the musical *Chicago*. He then brought out two new albums – one a collection of American songs, in which he was joined by Liza Minnelli; the other a new collection of French songs, critically acclaimed by the French music industry.

The international entertainer Sacha Distel, died in July 2004 aged 71 after a long illness. The world lost not just a pretty face and suave voice, but a talented musician and popular ambassador for his native France.

The Italian singer, writer and music producer Andrea Bocelli was born on 22 September 1958 in Tuscany. His is both a talented opera singer and pop artist, unhindered by his blindness. He has sung with classical greats including tenor Luciano Pavarotti and soprano Sarah Brightman, and recorded four complete operas – *La Bohème*, *Il Trovatore*, *Werther* and *Tosca*. His singles *Con Te Partirò* and its English version *Time to Say Goodbye* have smashed sales records in several countries and his classical and pop albums have earned him numerous awards.

Bocelli was tutored by the legendary tenor, Franco Corelli, working in piano bars to pay the fees. In 1992, Italian rock star Zucchero held auditions for tenors to duet with him in the song *Miserere*, which had been co-written with U2's Bono. Both Zucchero and Pavarotti were impressed with Bocelli's audition. Zucchero and Pavarotti's duet of *Miserere* was a Europe-wide hit, and when Zucchero went on his European concert tour, he invited Bocelli along to perform the duet live with him.

In 1993 Bocelli signed to Inseieme/Sugar after their President Caterina Caselli heard Bocelli sing *Miserere* and *Nessun Dorma* at Zucchero's birthday party. That year he also performed at Pavarotti's annual charity gala concert in Modena, Italy, singing not only with Pavarotti himself, but with pop stars like Bryan Adams. Then in November 1993 he entered the prestigious Italian Sanremo Music Festival, performing both parts of the *Miserere* duet. He won the new entrants round with the highest marks ever recorded. At Christmas, he sang for Pope John Paul II.

In 1994 Bocelli won the main competition of the Sanremo Music Festival with *Il mare calmo della sera*, again with a record score. His debut album of the same name was released and quickly went platinum in Italy.

In 1995, Bocelli toured Europe and appeared in Night of the Proms in front of a live audience of 500,000 and televised audiences in the tens of millions. He also released his second album *Bocelli* which was an enormous hit, going multi-platinum in several countries, including Italy, Belgium, Germany and the Netherlands. The single from the album, *Con te partirò*, topped the Belgian and French charts for several weeks. In 1996, he sang a duet version of *Con te partirò*, entitled *Time to Say Goodbye*, with the internationally renowned soprano Sarah Brightman. The single shot to number one in Germany where it stayed for 14 weeks. He also topped Spain's singles chart in 1996, in a duet with Marta Sanchez called *Vivo Por Ella*.

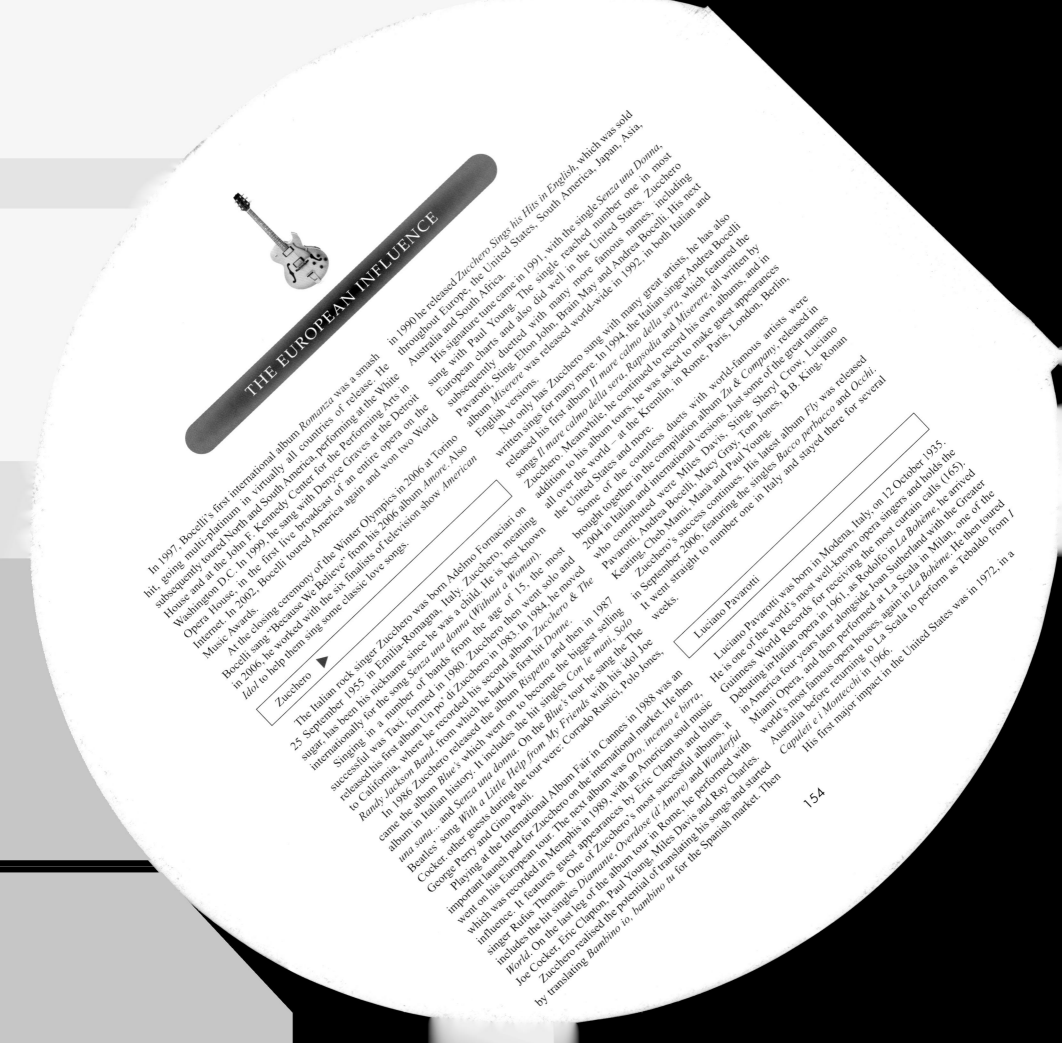

In 1997, Bocelli's first international album *Romanza* was a smash hit, going multi-platinum in virtually all countries of release. He subsequently toured North and South America, performing at the White House and at the John F. Kennedy Center for the Performing Arts in Washington D.C. In 1999, he sang with Denyce Graves at the Detroit Opera House, in the first live broadcast of an entire opera on the Internet. In 2002, Bocelli toured America again and won two World Music Awards.

At the closing ceremony of the Winter Olympics in 2006 at Torino Bocelli sang "Because We Believe" from his 2006 album *Amore*. Also in 2006, he worked with the six finalists of television show *American Idol* to help them sing some classic love songs.

in 1990 he released *Zucchero Sings his Hits in English*, which was sold throughout Europe, the United States, South America, Japan, Asia, Australia and South Africa.

His signature tune came in 1991, with the single *Senza una Donna*, sung with Paul Young. The single reached number one in most European charts and also did well in the United States. Zucchero subsequently duetted with many more famous names, including Pavarotti, Sting, Elton John, Brain May and Andrea Bocelli. His next album *Miserere* was released world-wide in 1992, in both Italian and English versions.

Not only has Zucchero sung with many great artists, he has also written sings for many more. In 1994, the Italian singer Andrea Bocelli released his first album *Il mare calmo della sera*, which featured the songs *Il mare calmo della sera*, *Rapsodia* and *Miserere*, all written by Zucchero. Meanwhile, he continued to record his own albums, and in addition to his album tours, he was asked to make guest appearances all over the world – at the Kremlin, in Rome, Paris, London, Berlin, the United States and more.

Some of the countless duets with world-famous artists were brought together in the compilation album *Zu & Company*, released in 2004 in Italian and international versions. Just some of the great names who contributed were Miles Davis, Sting, Sheryl Crow, Luciano Pavarotti, Andrea Bocelli, Macy Gray, Tom Jones, B.B. King, Ronan Keating, Cheb Mami, Manà and Paul Young.

Zucchero's success continues. His latest album *Fly* was released in September 2006, featuring the singles *Bacco perbacco* and *Occhi*. It went straight to number one in Italy and stayed there for several weeks.

Zucchero ▶

The Italian rock singer Zucchero was born Adelmo Fornaciari on 25 September 1955 in Emilia-Romagna, Italy. Zucchero, meaning sugar, has been his nickname since he was a child. He is best known internationally for the song *Senza una donna* (*Without a Woman*).

Singing in a number of bands from the age of 15, the most successful was Taxi, formed in 1980. Zucchero then went solo and released his first album *Un po' di Zucchero* in 1983. In 1984, he moved to California, where he recorded his second album *Zucchero & The Randy Jackson Band*, from which he had his first hit *Donne*.

In 1986 Zucchero released the album *Rispetto* and then in 1987 came the album *Blue's* which went on to become the biggest selling album in Italian history. It includes the hit singles *Con le mani*, *Solo una sana...* and *Senza una donna*. On the *Blue's* tour he sang the The Beatles' song *With a Little Help from My Friends* with his idol Joe Cocker, other guests during the tour were: Corrado Rustici, Polo Jones, George Perry and Gino Paoli.

Playing at the International Album Fair in Cannes in 1988 was an important launch pad for Zucchero on the international market. He then went on his European tour. The next album was *Oro, incenso e birra*, which was recorded in Memphis in 1989, with an American soul music influence. It features guest appearances by Eric Clapton and blues singer Rufus Thomas. One of Zucchero's most successful albums, it includes the hit singles *Diamante*, *Overdose (d'Amore)* and *Wonderful World*. On the last leg of the album tour in Rome, he performed with Joe Cocker, Eric Clapton, Paul Young, Miles Davis and Ray Charles. Zucchero realised the potential of translating his songs and started by translating *Bambino io, bambino tu* for the Spanish market. Then

Luciano Pavarotti

Luciano Pavarotti was born in Modena, Italy, on 12 October 1935. He is one of the world's most well-known opera singers and holds the Guinness World Records for receiving the most curtain calls (165). Debuting in Italian opera in 1961, as Rodolfo in *La Bohème*, he arrived in America four years later alongside Joan Sutherland with the Greater Miami Opera, and then performed at La Scala in Milan, one of the world's most famous opera houses, again in *La Bohème*. He then toured Australia before returning to La Scala to perform as Tebaldo from *I Capuleti e i Montecchi* in 1966.

His first major impact in the United States was in 1972, in a

154

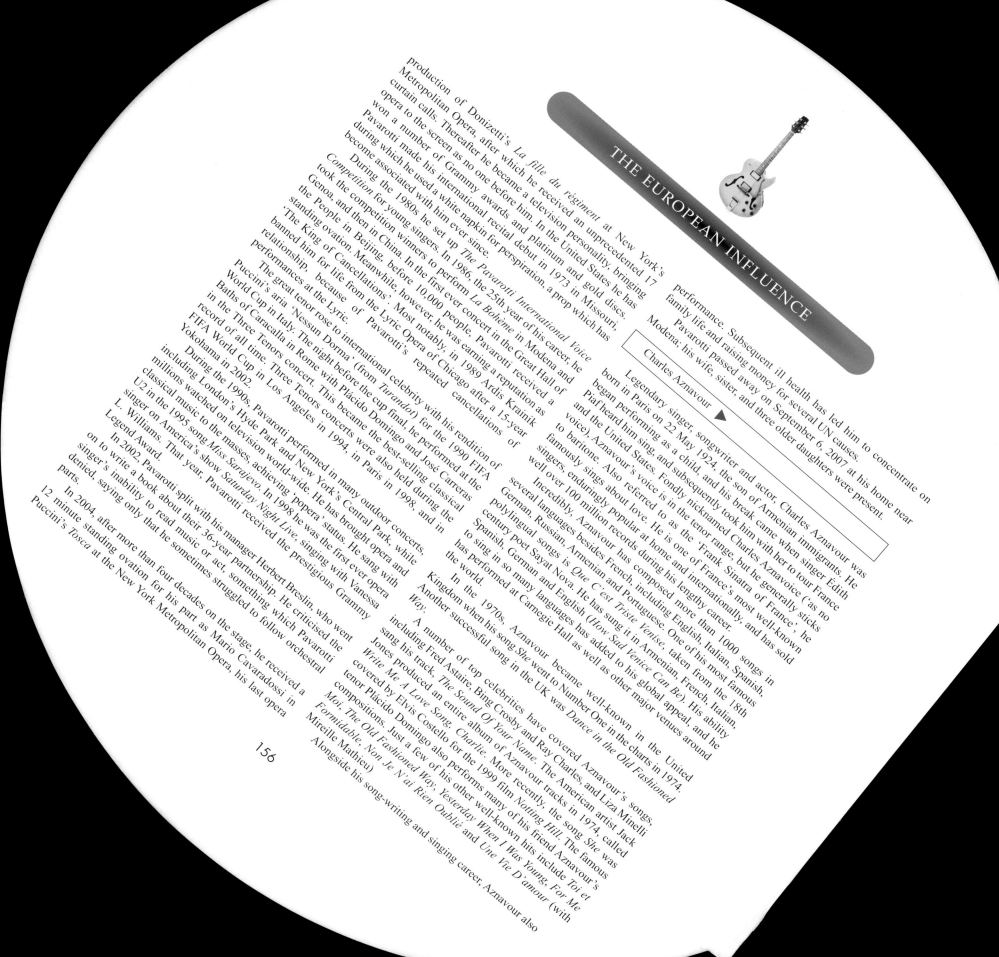

production of Donizetti's *La fille du régiment* at New York's Metropolitan Opera, after which he received an unprecedented 17 curtain calls. Thereafter he became a television personality, bringing opera to the screen as no one before him. In the United States, he has won a number of Grammy awards and platinum and gold discs. Pavarotti made his international recital debut in 1973 in Missouri, during which he used a white napkin for perspiration, a prop which has become associated with him ever since.

During the 1980s he set up *The Pavarotti International Voice Competition* for young singers. In 1986, the 25th year of his career, he took the competition winners to perform *La Bohème* in Modena and Genoa, and then in China. In the first ever concert in the Great Hall of the People in Beijing, before 10,000 people, Pavarotti received a standing ovation. Meanwhile, however, he was earning a reputation as 'The King of Cancellations'. Most notably, in 1989 Ardis Krainik banned him for life from the Lyric Opera of Chicago after a 15-year relationship, because of Pavarotti's repeated cancellations of performances at the Lyric.

The great tenor rose to international celebrity with his rendition of Puccini's aria 'Nessun Dorma' (from *Turandot*) for the 1990 FIFA World Cup in Italy. The night before the cup final, he performed at the Baths of Caracalla in Rome with Plácido Domingo and José Carreras in the Three Tenors concert. This became the best-selling classical record of all time. Three Tenors concerts were also held during the FIFA World Cup in Los Angeles in 1994, in Paris in 1998, and in Yokohama in 2002.

During the 1990s, Pavarotti performed in many outdoor concerts, including London's Hyde Park and New York's Central Park, while millions watched on television world-wide. He has brought opera and classical music to the masses, achieving 'popera' status. He sang with U2 in the 1995 song *Miss Sarajevo*. In 1998 he was the first ever opera singer on America's show *Saturday Night Live*, singing with Vanessa L. Williams. That year, Pavarotti received the prestigious Grammy Legend Award.

In 2002, Pavarotti split with his manager Herbert Breslin, who went on to write a book about their 36-year partnership. He criticised the singer's inability to read music or act, something which Pavarotti denied, saying only that he sometimes struggled to follow orchestral parts.

In 2004, after more than four decades on the stage, he received a 12 minute standing ovation for his part as Mario Cavaradossi in Puccini's *Tosca* at the New York Metropolitan Opera, his last opera

156

performance. Subsequent ill health has led him to concentrate on family life and raising money for several UN causes.

Pavarotti passed away on September 6, 2007 at his home near Modena; his wife, sister, and three older daughters were present.

Charles Aznavour ▲

Legendary singer, songwriter and actor, Charles Aznavour was born in Paris on 22 May 1924, the son of Armenian immigrants. He began performing as a child, and his break came when singer Édith Piaf heard him sing, and subsequently took him with her to tour France and the United States. Fondly nicknamed Charles Aznavoice ('as no voice), Aznavour's voice is in the tenor range, but he generally sticks to baritone. Also referred to as the 'Frank Sinatra of France', he famously sings about love. He is one of France's most well-known singers, enduringly popular at home and internationally, and has sold well over 100 million records during his lengthy career.

Incredibly, Aznavour has composed more than 1000 songs in several languages, including English, Italian, Spanish, German, Russian, Armenian and Portuguese. One of his most famous polylingual songs is *Que C'est Triste Venise*, taken from the 18th century poet Sayat Nova. He has sung it in Armenian, French, Italian, Spanish, German and English (*How Sad Venice Can Be*). His ability to sing in so many languages has added to his global appeal, and he has performed at Carnegie Hall as well as other major venues around the world.

In the 1970s, Aznavour became well-known in the United Kingdom when his song *She* went to Number One in the charts in 1974. Another successful song in the UK was *Dance in the Old Fashioned Way*.

A number of top celebrities have covered Aznavour's songs, including Fred Astaire, Bing Crosby and Ray Charles, and Liza Minelli sang his track, *The Sound Of Your Name*. The American artist Jack Jones produced an entire album of Aznavour tracks in 1974, called *Write Me A Love Song. Charlie*. More recently, the song *She* was covered by Elvis Costello for the 1999 film *Notting Hill*. The famous tenor Plácido Domingo also performs many of his other well-known hits include *Toi et Moi, The Old Fashioned Way, Yesterday When I Was Young, For Me Formidable, Non Je N'ai Rien Oublié* and *Une Vie D'amour* (with Mireille Mathieu). Alongside his song-writing and singing career, Aznavour also

wrote musicals and appeared in over 60 movies. His performance in the 1974 movie *And Then There Were None* was critically acclaimed and he later appeared in *The Tin Drum*, which won the Academy Award for Best Foreign Language Film in 1980. In 2002, he starred alongside Christopher Plummer in the movie *Ararat*, about the Armenian Genocide of the early 20th century, an event that is denied by the government of Turkey.

Aznavour is proud of his Armenian heritage, and after the Armenian earthquake of 1988, set up the charity Aznavour for Armenia.

In 1997 he was honoured in France three times over when he was given the French Victoire award for 1997 male artist of the year, the Honorary César Award, and Officer of the Legion d'honneur. In 1998, Aznavour was named Entertainer of the Century by CNN and Time Online, ahead of Elvis Presley and Bob Dylan.

Now in his eighties, Aznavour continues to tour, starting his global farewell tour in 2006, which he expects to last several years. He recorded his latest album *Colore Ma Vie* in 2006 with Cuban pianist and composer Chucho Valdes. He still sings in several languages, but typically sticks to French or English.

François visited Las Vegas and loved the spectacular style of the shows, incorporating female dancers into his own shows and bringing musicians and even a full orchestra onto the stage. He toured during the 1960s and continued to produce a string of hugely successful hit songs. In the midst of Beatlemania, he also covered Beatles hits in French, but his talent demanded more. He wrote many songs and including romantic ballads.

In 1968, François wrote a song with Jacques Revaux entitled *Comme d'habitude* (*As Usual*), which was a hit in French-speaking countries. The Canadian singer Paul Anka released an English version, which has since been most famously performed by Elvis Presley and by Frank Sinatra as *My Way*. François also established his own record company around this time, while continuing to rework English and American rock-and-roll numbers into French.

Going into the 1970s, François realised that he had to change with the markets, as the disco craze arrived. He released *La plus belle des choses*, a French version of a Bee Gees single, and embraced the disco era. He continued to tour across Europe, Africa and Quebec, Canada, while also releasing several new songs. By the late 1970s, he was still touring and performing to live audiences, and achieving multi-million sales with hits such as *Alexandrie Alexandra*. Alongside performing, he also managed a celebrity magazine and modelling agency.

In 1975, he was lucky to escape when an IRA bomb exploded nearby, and again in 1977, his life was threatened when a fan tried to shoot him. It was third time unlucky when in March 1978, in his own apartment in Paris, he was killed at the age of 39, electrocuted while changing a light bulb and standing in a bath full of water. Twenty-two years later to the day, the square in front of his apartment building was renamed Place Claude-François in his memory.

Claude François ▼

Claude François, a French pop singer of the 1960s and 1970s, was born in Egypt on 1 February 1939, to an Italian mother and French father. The 1950s Suez Crisis caused the family to return to France. When his father became ill, Claude went out to work and at night earned extra money playing drums with an orchestra at hotels along the French Riviera. He then started singing in clubs, and eventually moved to Paris to further his career.

First of all, Claude François took a job with a singing group, but he really wanted to go solo. His first attempt at recording a song based on the Rock and Roll craze, called *Nabout Twist*, was a failure. In 1962, however, he recorded *Belles Belles Belles*, a cover version in French of the Everly Brothers song, *Made to Love* (or *Girls Girls Girls*). It went to the top of the French charts with sales of nearly two million copies and he had arrived on the music scene.

The following year he repeated his success with another French adaptation, this time of Trini Lopez's *If I Had a Hammer*. Teenage fans were mesmerised by his blond good looks and rock-and-roll persona, flocking to his high-energy stage shows. He marked a milestone in 1964 when he headlined at the Paris Olympia.

Gipsy Kings

The Gipsy Kings is a unique group, originating from the south of France. The men are proud of their cultural heritage as gipsies, also known as 'travelling people', as they moved through Europe many centuries ago. The group consists of two bands of brothers from two related families: the Reyes (meaning Kings in Spanish) and the Baliardos. Their 1995 album, *The Best of The Gipsy Kings*, went platinum, and total album sales world-wide have exceeded 18 million, making them the best-selling French music group ever, according to their website.

THE EUROPEAN INFLUENCE

individuality, talent and enduring appeal.

The Reyes boys started out by backing their father, José, a famous flamenco singer of Spanish origin, who performed at Carnegie Hall and was admired by Picasso, Dali and Charlie Chaplin. The family fled to southern France during the Spanish Civil War, but retained their love for Spanish and Latin American music. Carrying on the tradition, the Gipsy Kings are best known for taking flamenco to world audiences.

The Reyes brothers teamed up with the guitar-playing Baliardo brothers, with Nicolas Reyes the lead singer. Mixing flamenco with Latin American beats and complex guitar strumming, the band created more pop-oriented numbers. Their first album, *The Gipsy Kings*, was released in 1987, from which the song *Bamboleo* was a huge international hit, with flamenco version of the rhythm of South American rumba. Their second album *Mosaique* followed, featuring the song *Volare*, a rumba version of an Italian song by Domenico Modugno called *Nel Blu Dipinto Di Blu*.

The band's popularity grew in France and throughout Europe. They then made the big step into the United States, their first album *The Gipsy Kings* spending 40 weeks in the charts in 1989, a rare feat for a Spanish language album.

In 1991 the group provided backing vocals and flamenco guitar on the Bananarama version of *Long Train Running*, released under the title *Alma de Noche* (*Soul of the Night*). That year, they also contributed to a project which re-produced songs from Disney films. They produced a wonderfully fast-paced rumba flamenco version of *I've Got No Strings* from *Pinocchio*, with feverish guitar playing and rhythmic hand-claps. This style was also popular in their lively rendition of *Hotel California*, the version featured in the 1998 Coen Brothers' comedy movie *The Big Lebowski*.

Their album, *Love and Liberté*, won them the 1993 Latin Grammy Award for Best Pop Album of the Year. It featured the emotional song *Montana*, which tells of gipsies being hounded from their birthplace by prejudice and persecution. This album went gold, as did *Mosaique*, *Allegria*, *Este Mundo* and others. In 1995, their compilation album *The Best of the Gipsy Kings* went platinum, and stayed in the charts for over a year. The group's lead guitarist, and writer of their instrumentals, released his own instrumental album in 2003.

While they have received some criticism from Flamenco purists for using modern instruments such as drum kits and electronic keyboards, and adding in rock and reggae beats, it may be more appropriate to appreciate that by so doing they have created a new and delightful style of their own. Their continuing popularity and lively concerts with people dancing and singing along is testament to their

Johnny Hallyday ▶

The French singer and actor Johnny Hallyday was born Jean-Philippe Smet on 15 June 1943 in Paris, France. By age nine he was singing on stage with his dancer cousins, and appeared in his first film, *Les Diaboliques*, aged 11. He became France's first rock star, never achieving recognition in America or Britain, largely because he was mostly sang French-language covers of American rock hits. His career has spanned several decades, including around 400 tours, record sales in the tens of millions, and 18 platinum albums. He continues to play to crowded stadia to this day.

From a young age Hallyday loved the new rock and roll era. He released his first single in 1960, *Laisse les Filles*, and followed it with *Souvenirs, Souvenirs*, which became his first hit. He sang at France's first rock festival in early 1961, and caused such a furore that rock and roll was banned for months afterwards. That year, his album *Salut les Copains!* kicked off the 'yé-yé' era of French pop and he became a teen idol, still just a teenager himself. He toured France and invited an Elvis-like hysteria.

Hallyday made a number of French adaptations of American songs, including Chubby Checker's *Let's Twist Again*, which he covered as *Viens Danser le Twist*. In 1962 he released the album, *Johnny Hallyday sings America's Rockin' Hits*, while also singing more traditional French pop songs, including two of his biggest hits, *L'Idole des Jeunes* and *Da Dou Ron Ron*. Meanwhile, he also appeared in the film *Les Parisiennes*, and starred in Noel Coward's 1963 movie *D'où Viens-Tu, Johnny?*.

In the mid-1960s, rock and roll was overshadowed by the new phenomena of the Beatles and Bob Dylan. Hallyday formed a touring band called the Blackbirds, with British guitarist Mick Jones (later of Foreigner), and played at the Paris Olympia, with the then-unknown opening act, the Jimi Hendrix Experience. In 1967, Hallyday covered the Hendrix version of *Hey Joe* and experimented with heavier psychedelic rock. Also influenced by the British rock band Cream, Hallyday released his album *Que Je T'aime* in 1969, with the hit title track.

Throughout the 1970s and 1980s, he toured internationally and appeared in several more movies. He continued his success in France, with singles like *Gabrielle*, *J'ai Oublié de Vivre*, and *Elle M'oublie*. In 1985, with writer Michel Berger he released what became one of his

biggest and best-known hits, *Quelque Chose de Tennesse*. In 1986, his album *Gang* was a huge hit, with songs *Laura*, *L'Envie* and *Je Te Promets*.

To celebrate his 50th birthday in 1993, Hallyday performed in Paris and his life's work was re-issued on CD. He then released the highly successful *Lorada*, with hit singles *J'la Croise Tous les Matins*, *Quand le Masque Tombe*, and *Ne M'oublie Pas*.

His son David composed the music for his 1999 album *Sang Pour Sang*. His popularity never waning, he gave the concert *100% Johnny: Live a La Tour Eiffel* in 2000 to an audience of 500,000, plus 9.5 million television viewers. In 2002, his double album *A la Vie, à la Mort*, produced the hit singles *Marie* and *Ne Reviens Pas*. As recently as December 2005, Hallyday had his third French number-one single, *Mon Plus Beau Noël*.

Hallyday's life was a journalist's dream, with high-profile romances, drug use, serious tax issues, and a love for racing cars. He is France's most famous and enduring personality, hardly known outside the French-speaking world, despite basing much of his music on foreign cultural phenomena, all the while remaining true to his French roots.

Nana Mouskouri ▲

Ioanna 'Nana' Mouskouri was born on 13 October 1934, in Crete and grew up in Athens. From an early age she displayed exceptional musical talent. Her chosen genre has ranged from jazz to pop, French chansons to opera, religious music to Greek folk songs. Always she has sported the trademark black-rimmed glasses and straight black hair, and has become associated with sentimental songs, suiting her unique voice.

During a singing career lasting more than four decades, Mouskouri has recorded about 450 albums in 15 languages, and has sold more than 300 million records. She is quite simply the best-selling female recording artist of all time.

Mouskouri initially studied classical music with an emphasis on opera, despite having a flaw in her vocal cords, giving her a hoarse spoken voice and affecting her singing. Expelled from the Athens Conservatoire after caught experimenting with jazz music, she began her career as a jazz singer in Athens nightclubs, and recorded her first song *Fascination* in both Greek and English in 1957. The Greek composer Manos Hadjidakis became her mentor and offered to write sings for her. Mouskouri performed Hadjidakis' songs at the Greek

Song Festival in 1959 and 1960 and won first prize in both years. The 1961 German-language single *Weisse Rosen aus Athen* (*White Roses from Athens*) was the soundtrack to a German documentary about Greece. Translated into several languages, it became one of Mouskouri's signature tunes. She then flew to New York to record a jazz album with Quincy Jones, entitled *The Girl From Greece Sings*.

Moving to Paris in 1963, she represented Luxembourg at the Eurovision Song Contest with *À Force de Prier*, which became an international hit. With French hits *Les Parapluies de Cherbourg* and *L'Enfant au Tambour*.

She recorded scores of albums in many languages and styles over the next three decades. Her 1967 French album *Le Jour Où la Colombe* featured a number of hits, including *Au Coeur de Septembre*, *Adieu Angélina* and *Le Temps des Cerises*. More French successes followed, including *Une Voix Qui Vient du Coeur* and *Vielles Chansons de France*.

Her fame also rose in the UK, when she hosted a show called *Nana and Guests* and released the 1969 album *Over and Over*, which stayed in the charts for nearly two years. In the 1970s, the album *Book of Songs* sold millions, and was followed up with *Roses and Sunshine*. Her 1981 international hit, *Je Chante Avec Toi, Liberté*, was translated into several languages.

During the late 1980s, she topped the UK charts with the song *Only Love*, had the Spanish single *Con Todo el Alma*, which was successful also in Argentina and Chile; produced five albums in as many languages in 1987; and went full circle to her classical roots with *The Classical Nana* in 1988.

In 1991, Mouskouri released her best-selling album in the United States, entitled *Only Love: The Best of Nana Mouskouri*. More albums during the 1990s included *Return to Love* (in English), *Nana Latina* (in Spanish) and the French pop classics in *Hommages*. In December 1997, Mouskouri performed at the Paris Olympia to celebrate 40 years in the business.

In 2004, a 34-CD box set of over 600 of Mouskouri's mostly French songs was released. In 2006, she made a guest appearance at the Eurovision Song Contest which was held, for the first time ever, in her native Greece. She still performs about 100 concerts each year.

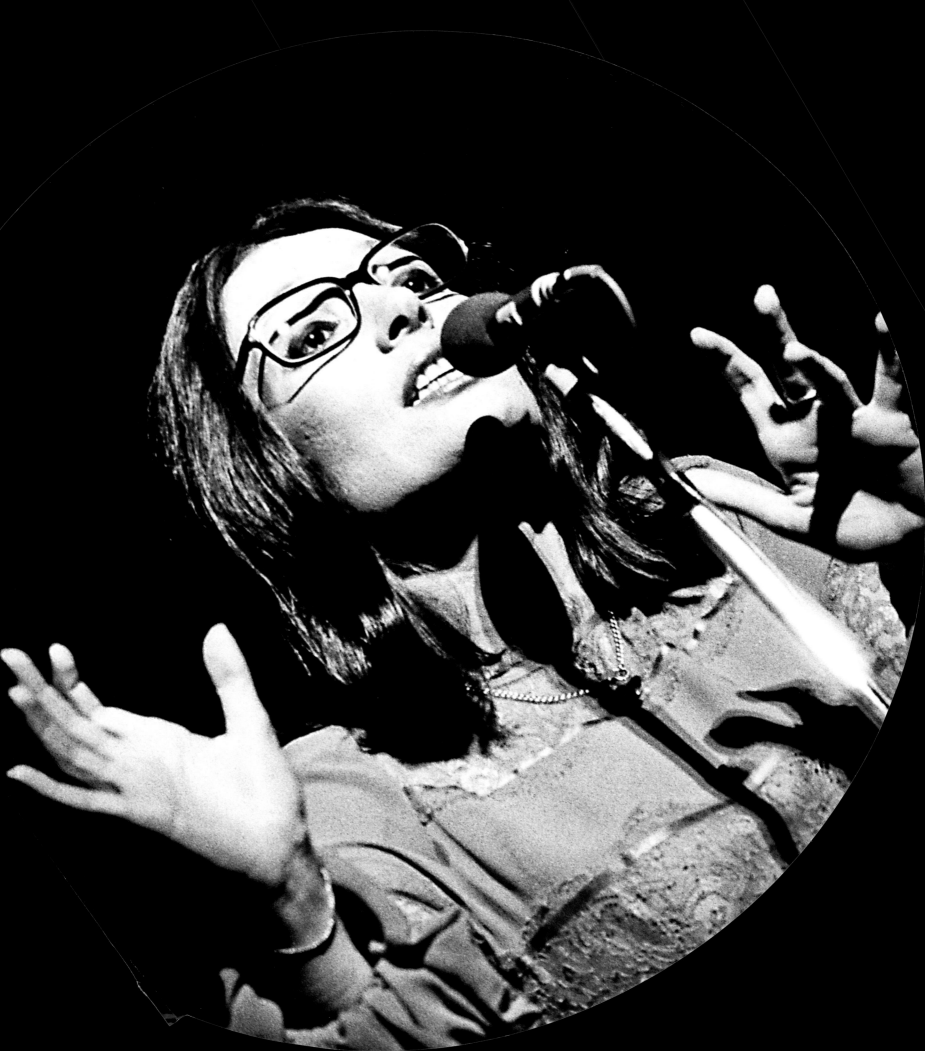

Demis Roussos

Artemios (Demis) Ventouris Roussos was born in Egypt to Greek parents on 15 June 1946. After the Suez Crisis, they moved to Greece, where Demis joined a series of musical groups, with limited success. Moving into progressive rock in 1968, with the band Aphrodite's Child, he sang and played bass guitar. His strong operatic voice helped the band achieve international recognition, especially with their last album *666*, released in 1972. With bandmate Vangelis' influence, the music combined psychedelic and progressive rock and advanced use of synthesizers with choral chanting and ethnic instruments.

The band split and Roussos went on to record with Vangelis. In 1970 they released the album *Sex Power* and in 1977, the album *Magic*. The song *Because* from the *Magic* album became one of the biggest hits of Roussos' career. Vangelis and Roussos later produced a vocal adaptation of the theme from the 1981 Oscar-winning movie *Chariots of Fire*, called *Race to the End*. Roussos also made a guest appearance on the soundtrack to the 1982 movie *Blade Runner*.

Meanwhile, Roussos had aspirations of a solo career. His first song *We Shall Dance* was not an immediate success, but as he toured several European countries it grew in popularity. He released his first solo album, *On The Greek Side Of My Mind*, in 1971. Huge success came with his 1973 single, *Forever and Ever*, which topped the charts in several countries. From the album of the same name, a raft of hits followed, including *My Friend the Wind*; *My Reason*; *Velvet Mornings*;*Goodbye My Love Goodbye*; and *Lovely Lady of Arcadia*. This album was a hit in the UK charts, as was his third solo album *My Only Fascination*, featuring the hit single *Someday Somewhere*. Then followed further success with the album *Souvenirs*.

The mid-1970s was the peak of his career. In July 1976, his *Roussos Phenomenon EP* gave him his only UK number one single. It was the sole EP to reach the top of the charts that decade. Around that time, he was famously mentioned in the Mike Leigh comedic play *Abigail's Party*, and his single *Forever and Ever* was spoofed by British comedian Kenny Everett on his television show. His first appearance in person on English-speaking television was on the *Basil Brush Show*.

Roussos recorded a French album in 1977, and the title song *Ainsi Soit-il* was a hit. In 1978 he went to America and had some success with the single *That Once In A Lifetime* and his self-named album. Then in 1979 he released the album *Universum* in four languages: French, German, Italian and Spanish. He toured Australia and New Zealand promoting a compilation album entitled *The Roussos Phenomenon*.

The 1980s were quiet for Roussos, while he dealt with depression and his weight. Then, in 1985, he was on the hijacked TWA Flight 847. The hijackers celebrated his birthday on board and Roussos was back in the limelight. His comeback album *Time* featured the *Dance of Love* single. In 1993, after 25 years in the business, he released *Insight* to general acclaim, despite including a forgettable attempt at a rap song. He then recorded three albums in Holland, using a range of ethnic and electronic styles.

Roussos toured the UK in 2002 and his album *The Definitive Collection* made the top 20 in the album charts. It is also interesting to see how he has influenced the Indian film music industry, where they have reworked several of his songs into Indian versions.

TOOTS™

"Think out of the Square"

www.tootsbooks.com

TOOTS™

"Think out of the Square"

www.tootsbooks.com